Education, Psychoanalysis, and Social Transformation

Series Editors

jan jagodzinski
Department of Secondary Education
University of Alberta
Edmonton, Alberta, Canada

Mark Bracher
English Department
Kent State University
Kent, Ohio, USA

Aim of the Series

Within the last three decades, education as a political, moral, and ideological practice has become central to rethinking not only the role of public and higher education, but also the emergence of pedagogical sites outside of the schools-which include but are not limited to the Internet, television, film, magazines, and the media of print culture. Education as both a form of schooling and public pedagogy reaches into every aspect of political, economic, and social life. What is particularly important in this highly interdisciplinary and politically nuanced view of education are a number of issues that now connect learning to social change, the operations of democratic public life, and the formation of critically engaged individual and social agents. At the center of this series will be questions regarding what young people, adults, academics, artists, and cultural workers need to know to be able to live in an inclusive and just democracy and what it would mean to develop institutional capacities to reintroduce politics and public commitment into everyday life. Books in this series aim to play a vital role in rethinking the entire project of the related themes of politics, democratic struggles, and critical education within the global public sphere.

More information about this series at
http://www.springer.com/series/14964

jan jagodzinski
Editor

What Is Art Education?

After Deleuze and Guattari

Editor
jan jagodzinski
Department of Secondary Education
University of Alberta
Edmonton, Alberta, Canada

Education, Psychoanalysis, and Social Transformation
ISBN 978-1-137-48126-9 ISBN 978-1-137-48127-6 (eBook)
DOI 10.1057/978-1-137-48127-6

Library of Congress Control Number: 2016962784

Printed on acid-free paper

This Palgrave Macmillan imprint is published by Springer Nature
The registered company is Nature America Inc.
The registered company address is: 1 New York Plaza, New York, NY 10004, U.S.A.

Dedicated to our students
Thank you All for Making Us Better Teachers

him for his meditative essay in this collection. Finally, Jason Wallin, whom I see as a comrade in arms as we have published together, exchanged ideas, and generally tried to stand up for what we are passionate about together. For that I am grateful to have such a colleague. And, last and *never* least is Jessie Beier, who has continually amazed me over these past years. Not only a talented graphic artist, sound experimenter and teacher of great merit but also a resolutely committed spirit to A Life in the best sense of Deleuze. Jessie's continuous insights and experiments make me realize how far I have yet to travel. Jason and Jessie's contribution in this collection is not only innovative but also prescient in its projections.

ACKNOWLEDGEMENTS

I owe special thanks to the authors in this book who have taken upon themselves to rethink art and its education during a precarious era of human existence as we become progressively more aware of the magnitude of the Earth's transformation. Turning to Deleuze and Guattari for inspiration, they reached out into the realms of the unthought and took risks in doing so. In the order that these authors appear in this collection, I would like to start by thanking Charles Garoian for his friendship over these many years. I have had the pleasure of seeing his amazing performances and reading his equally amazing reflections on art and its education. Many thanks to Jack Richardson for his contribution to this collection, the only art educator that I know who takes the Deleuzian notion of experimenting to heart into his classroom. I have had the privilege of sharing conferences presentations with Jack as we worked out what Deleuze and Guattari meant to each of us. And, many thanks to Dennis Atkinson whose writings resonate so close to my own that I feel a kinship that goes back to when he was introducing Lacan to art education; and here I thought that I was doing that! How ignorant we all are. Over the years, I have realized what a thoughtful teacher Dennis is, marrying challenging theory with his graduate work at Goldsmiths University, a powerhouse in terms of leadership. I am so very happy that his contribution in this collection carries the same force as his mentoring students over those many years. John Baldacchino's writings in art and its education are formidable. He has a breadth of philosophical knowledge and art that truly admire. It was fortuitous that I met John when he was at Teacher College, and quickly realized that he was a person with a vision. I tha

ACKNOWLEDGEMENTS

I owe special thanks to the authors in this book who have taken upon themselves to rethink art and its education during a precarious era of human existence as we become progressively more aware of the magnitude of the Earth's transformation. Turning to Deleuze and Guattari for inspiration, they reached out into the realms of the unthought and took risks in doing so. In the order that these authors appear in this collection, I would like to start by thanking Charles Garoian for his friendship over these many years. I have had the pleasure of seeing his amazing performances and reading his equally amazing reflections on art and its education. Many thanks to Jack Richardson for his contribution to this collection, the only art educator that I know who takes the Deleuzian notion of experimenting to heart into his classroom. I have had the privilege of sharing conferences presentations with Jack as we worked out what Deleuze and Guattari meant to each of us. And, many thanks to Dennis Atkinson whose writings resonate so close to my own that I feel a kinship that goes back to when he was introducing Lacan to art education; and here I thought that I was doing that! How ignorant we all are. Over the years, I have realized what a thoughtful teacher Dennis is, marrying challenging theory with his graduate work at Goldsmiths University, a powerhouse in terms of leadership. I am so very happy that his contribution in this collection carries the same force as his mentoring students over those many years. John Baldacchino's writings in art and its education are formidable. He has a breadth of philosophical knowledge and art that I truly admire. It was fortuitous that I met John when he was at Teachers College, and quickly realized that he was a person with a vision. I thank

him for his meditative essay in this collection. Finally, Jason Wallin, whom I see as a comrade in arms as we have published together, exchanged ideas, and generally tried to stand up for what we are passionate about together. For that I am grateful to have such a colleague. And, last and *never* least is Jessie Beier, who has continually amazed me over these past years. Not only a talented graphic artist, sound experimenter and teacher of great merit but also a resolutely committed spirit to A Life in the best sense of Deleuze. Jessie's continuous insights and experiments make me realize how far I have yet to travel. Jason and Jessie's contribution in this collection is not only innovative but also prescient in its projections.

Contents

CONTRIBUTORS

Dennis Atkinson is Professor Emeritus at Goldsmiths University of London, Department of Educational Studies and the Centre for the Arts and Learning. He taught in secondary schools in England from 1971 to 1988 when he was appointed lecturer in art and design education at Goldsmiths University of London. He directed a number of programmes including, PGCE Secondary Art and Design Teacher Education, MA Education: Culture, Language and Identity and the Post Graduate Research Programme in Educational Studies. He was appointed Professor of Art in Education in 2005 and was Head of Department of Educational Studies from 2006 to 2009. He established the Research Centre for The Arts and Learning in the Department of Educational Studies in 2005 and was Director from 2005 to 2013. He was the Principal Editor of *The International Journal of Art and Design Education* from 2002 to 2009 and was a member of the National Society for Education in Art and Design's Publications Board until 2013. He was made a Fellow of the Society in 2009. He has published regularly in a number of international academic journals since 1991 including *The International Journal for Art and Design Education, The International Journal of Inclusive Education, Educational Philosophy and Theory, British Educational Research Journal,* and has contributed chapters to a number of edited collections. He has published five books, *Art in Education: Identity and Practice; Social and Critical Practice in Art Education,* (with Paul Dash); *Regulatory Practices in Education: A Lacanian Perspective,* (with Tony Brown & Janice England,); *Teaching Through Contemporary Art: A report on innovative practices in the classroom,* (with Jeff Adams, Kelly Worwood, Paul Dash, Steve Herne, & Tara Page); and *Art, Equality and Learning: Pedagogies Against the State.* His new book entitled *Art Education, Pedagogy and Ethics: Beyond Knowledge, Without Criteria* will be published by Palgrave Macmillan in 2017.

John Baldacchino is currently Director of the Arts Institute and Professor of Arts Education at the University of Wisconsin-Madison. Before Madison, he served as Professorial Chair of Arts Education at the University of Dundee in Scotland. He served as faculty and held various senior roles in Falmouth University in England, Columbia University's Teachers College in New York, Gray's School of Art in Scotland, and the University of Warwick in England. He is the author of papers, articles, chapters and ten books on arts, philosophy and education. His books include *Post-Marxist Marxism: Questioning the Answer* (Ashgate 1996); *Easels of Utopia: Art's Fact Returned* (Ashgate 1998); *Avant-Nostalgia: An Excuse to Pause* (2002); *Education Beyond Education: Self and the Imaginary in Maxine Greene's Philosophy* (Peter Lang 2009); *Makings of the Sea: Journey, Doubt and Nostalgia* (Gorgias 2010); *Art's Way Out: Exit Pedagogy and the Cultural Condition* (Sense 2012); *Mediterranean Art Education* (With Raphael Vella, Sense 2013); *Democracy Without Confession* (with Kenneth Wain, Allied Publishers 2013); *John Dewey: Liberty and The Pedagogy of Disposition* (Springer 2014); and *My Teaching, My Philosophy. Kenneth Wain: A Lifelong Engagement with Education* (with Simone Galea and Duncan Mercieca, Peter Lang 2014). He is currently writing two monographs, on Ivan Illich (Peter Lang 2016) and Giambattista Vico (Springer 2016/17). He is also editor of the Histories and Philosophies volume of the Wiley Blackwell's *Encyclopedia of Art & Design Education.*

Jessie L. Beier is a teacher, artist, and independent scholar based in Edmonton, Alberta. Beier completed a Masters Degree in Curriculum Studies in 2014 with the thesis project "Schizophrenizing the Art Encounter: Towards a Politics of Dehabituation" and will be pursuing a Doctorate in Education (University of Alberta) beginning in the fall of 2016. Beier's interests in both visual and sonic ecologies have led to a research-creation practice that works to think pedagogy and learning, in its many forms, as a power for overturning cliché and dismantling common sense habits of interpretation. Beier has worked in a variety of settings as a researcher, educator and program developer, and currently teaches in the Department of Secondary Education at the University of Alberta. In addition to her scholarly work, Beier is also a practising artist, working mainly in video and sound installation. Beier has presented her research both locally and internationally, and has published writing in *Visual Arts Research* (University of Illinois Press), *The Journal of Curriculum and Pedagogy* (Taylor and Francis), and *The Alberta Journal of Educational Research* (University of Alberta).

Charles R. Garoian Professor of art education at Penn State University, received a B.A. in Art and an M.A. in Art from California State University, Fresno, and his Ph.D. in Education from Stanford University. He has performed, lectured and conducted workshops in festivals, galleries, museums and university campuses in the USA and internationally. Based on the critical strategies of performance art, his teaching focuses on exploratory, experimental and improvisational

art-making processes in visual art studio and art education courses. He was the principal organizer of the *Performance Art, Culture, Pedagogy Symposium* in November 1996. The first of its kind, the symposium program included 42 renowned performance artists, critics, historians, arts presenters and educators, who examined the historical, theoretical and experiential significance of performance art in order to distinguish its pedagogy as an emerging form of arts education. In October 2000, he co-organized *Performative Sites: Intersecting Art, Technology, and the Body*, an international symposium that examined the theoretical, experiential and pedagogical implications of performance artists' works that use mechanical and electronic technologies to critique the body and its identity. In addition to his scholarly articles featured in leading journals on art and education, Garoian is the author of *Performing Pedagogy: Toward an Art of Politics* (1999); co-author of *Spectacle Pedagogy: Art, Politics, and Visual Culture* (2008); and, *The Prosthetic Pedagogy of Art: Embodied Research and Practice* (2013); all three volumes published by The State University of New York Press. The several granting agencies and programs that have supported his cultural work include the Pennsylvania Council on the Arts, the Ford Foundation, the Rockefeller Foundations and the Getty Education Institute for the Arts.

jan jagodzinski is a professor in the Department of Secondary Education, University of Alberta in Edmonton, Alberta, Canada, where he teaches visual art and media education and curricular issues as they relate to postmodern concerns of gender politics, cultural studies and media (film and television). He is a founding member of the *Caucus on Social Theory in Art Education* (NAEA), past editor of *The Journal of Social Theory in Art Education* (JSTE), past president of SIG *Media, Culture and Curriculum*, Editorial Board Member for *Psychoanalysis, Culture & Society* (PCS) Advisory Board for *Journal of Lacanian Studies* (JLS), Review Board for *Studies in Art Education* (SAE), *Journal of Curriculum Theorizing* (JCT), *Journal of Cultural Research in Art Education* (JCRAE), *Visual Culture & Gender* and nine other journals; co-series editor with Mark Bracher, book series *Pedagogy, Psychoanalysis, Transformation* (Palgrave Press). Book credits: *The Anamorphic I/i* (1996 (Duval House Publishing Inc, 1996); *Postmodern Dilemmas: Outrageous Essays in Art&Art Education* (Lawrence Erlbaum, 1997); *Pun(k) Deconstruction: Experifigural Writings in Art&Art Education* (Lawrence Erlbaum, 1997); Editor of *Pedagogical Desire: Transference, Seduction and the Question of Ethics* (Bergin & Garvey, 2002); *Youth Fantasies: The Perverse Landscape of the Media* (Palgrave, 2004); *Musical Fantasies: A Lacanian Approach* (Palgrave, 2005); *Television and Youth: Televised Paranoia*, Palgrave, 2008); *The Deconstruction of the Oral Eye: Art and Its Education in an Era of Designer Capitalism* (Palgrave, 2010), *Misreading Postmodern Antigone: Marco Bellocchio's Devil in the Flesh (Diavolo in Corpo)* (Intellect Books, 2011) and *Psychoanalyzing Cinema: A Productive Encounter of Lacan, Deleuze, and*

Zizek (Palgrave, 2012); *Arts Based Research: A Critique and Proposal* (with Jason Wallin) (Sense, 2013); jagodzinski, jan ed., *The Precarious Future of Education* (Palgrave, 2017); jagodzinski, jan ed. *What is Art Education? After Deleuze and Guattari* (Palgrave, 2017).

Jack Richardson is an Associate Professor in the Department of Arts Administration, Education and Policy at The Ohio State University-Newark. His work explores the intersection between studio art practices, contemporary philosophy and art education. His current work continues his examination of the work of Gilles Deleuze and Felix Guattari and possibilities their work holds for reconsidering notions of thought and knowledge produced during art-making. Examinations of this topic have appeared in recent articles titled "Time Unhinged" (2013) and co-authored article, "Processing Process: The Event of Making Art" (2011).

Jason J. Wallin is an Associate Professor of Media and Youth Culture in Curriculum in the Faculty of Education at the University of Alberta, Canada, where he teaches courses in visual art, media studies and cultural curriculum theory. He is the author of "A Deleuzian Approach to Curriculum: Essays on a Pedagogical Life" (Palgrave Macmillan), co-author of "Arts-Based Research: A Critique and Proposal" (with jan jagodzinski, Sense Publishers), and co-editor of "Deleuze, Guattari, Politics and Education" (with Matt Carlin, Bloomsbury).

LIST OF FIGURES

A Critical Introduction to What Is Art Education?

jan jagodzinski

Let us begin from a quote taken from Deleuze and Guattari's *What is Philosophy?*, which sets the tone of this introduction: 'As the creation of thought, a problem has nothing to do with the question, which is only a suspended proposition, the bloodless double of an affirmative proposition that is supposed to serve as an answer' (139). It is the problem not the question, whose solution is all but suspended, which is at issue. *What is Art Education? After Deleuze and Guattari* draws its inspiration from the problematic raised by Deleuze and Guattari in their last book together, *What is Philosophy?*, which has been influential across many sectors of the academy due to the breadth of domains it addresses. Philosophy, science and art are each accounted for, and each discipline is attributed with its own distinct method, field of inquiry and orientation: succinctly put, philosophy is defined by its ability to create 'pure concepts'; science, on the other hand, is charged to discover knowledge via functions and domains of reference, or regions as specific states of affairs; and lastly art creates

j. jagodzinski (✉)
Department of Secondary Education, University of Alberta,
Edmonton, AB, Canada

© The Author(s) 2017
j. jagodzinski (ed.), *What Is Art Education?*,
DOI 10.1057/978-1-137-48127-6_1

1

new worlds of perception via blocs of affects and percepts. These three thought-forms *which stave off chaos* are not, however, pure disciplinary accounts; they do 'interfere' with one another, but no one form can be reduced to another. They come together through the medium of the brain, which should not be thought as a bodily 'organ,' but plane of immanence or A Life, a *junction—*not the unity—*of the three planes*' (WP, 208). The 'thought-brain' acts as a 'junction' for thought (thought not as opinion or recognition) through the processes of contraction and contemplation. In Rex Butler's (2016, 24) reading of WP, art, philosophy, science and logic provide the necessary sequence of thought: the movement from blocs of sensations to concepts (virtual Ideas), which are then actualized into represented generalized objects and subjects. Such a sequence, it appears, follows Charles Saunders Pierce's tripartite divisions of firstness, secondness, and thirdness. Each respective domain is a creative endeavor that leads from material chaos to transcendent virtual Ideas, on through to propositional consciousness, all three routes being interrelated yet independent.

Each of the disciplines, in its relation to chaos (or quantum field[2]), institutes its own unique way to shelter us against our complete deterritorialization. In this sense the brain acts as a screen or a sieve from the full intensity of chaos. Philosophy provides a consistent paradigm of interrelated concepts, all of which are subject to change; science searches for as yet unknown and undiscovered domains whose boundaries can become known via 'functives' (WP, 117). These are scientific propositions presented in discursive form. Art projects new worlds that are all possible, subject to the imagination, or more technically fabulation.[3] All three domains are under constant change. As such, this is not the truth of relativity, but the relativity of truth. In brief, the relation between truth and thought is always a non-relation, what Deleuze maintained as 'the powers of the false.'[4] All three domains are subject to change as they respond to a changing world that presents new problems. The impossible question—What is art education?—presents us with the contemporary challenge. This critical introduction attempts to situate the issues and problems of such a task by calling on the thesis of art in WP.

A LIFE AND THE LIVING

In the second part of their book (Chap. 7, 'Percept, Affect and Concept'), art is given its fullest and last treatment. Deleuze specialists such as Anne Sauvagnargues (2013) maintain that this work forms the last of what are four periods of meditation on art where creativity (genesis) is forwarded,

along with his single-authored cinema books.[5] This section of *What is Philosophy?* has received wide attention by many Deleuze|Guattarian scholars. Deleuze|Guattari conceptualize art as the expression of 'Life in the living or the Living in the lived' (WP, 172). A Life is a transcendental field, a pure plane of immanence. It is a plane of existence, of genesis, the clamour of becoming.[6] This *material vitalism* or A Life exists everywhere but it is covered over and hidden to ordinary conditioned perception, as the phenomenology of lived life. A Life and the living are in reciprocal pre-supposition with one another; that is, they presuppose and determine each other. Another way of putting this would be in terms of A life as zoë and bios engaged in a feedback loop of virtual and actual, where zoë (A Life) conditions bios (the living, nature and artifice), and then simultaneously bios (the living, nature and artifice) reciprocates itself into zoë (A Life), thereby changing the ontological and genetic condition in an endless process.[7] The bottom line has life and death in reciprocal presupposition with one another. The living is a world-*for-us*, it is what we ordinarily experience including the world grasped through our technologies, which is *in*human[8]; A Life is the world-*in-itself* or Earth—the *non*-human, whereas, following Thacker's (2010a) tripartite distinction, a world-*without-us*, what Thacker calls the Planet is chaos itself, which is absolutely *un*human, such as the mysteries of String theory, and Cosmology that alludes us all.

Chaos for Deleuze|Guattari consists of infinite speeds that constantly deterritorialize connections necessary for the emergence of individuated entities, whereas their term chaosmosis, as developed by Guattari (1995), is the groundless ground from which all 'subjectless subjectivities' arise. Chaosmosis is yet another synonym for A Life or the transcendental plane. Chaos cannot be thought in and of itself. It must be related to a rhythm or consistency. It cannot be thought outside A Life, but thought of in conjunction with chaos (hence chaosmos). It is Deleuze|Guattari's speculations on this last 'cosmological' view that this introduction in relation to art education will end on given that their stance is one characterized by *speculative aesthetics* and the cosmic artisan.

When taken seriously, this ontological and genetic condition of 'Life in the living or Living in the 'lived' can redefine what art and its education can become in relation to its current hegemonic understanding where aesthetics remain caught in the web of representation,[9] and art in many art educational circles continues to be taken up within hermeneutic and semiotic exegesis, engaged in what art means when embedded in various disciplines, be they literary, sociological, anthropological, or historical; whereas artistic practice, considered here as both art and design,[10] is then

framed most conservatively as being phenomenological, expressive of the subject (individual or as a team effort), or critical in its attempt to over-throw or intervene in the established representational discourses (racial, gendered, sexist, religious, ethnic, able bodied and so on) in the name of social equality and justice, or to overthrow established capitalist consum-erist design of the built environment for more equitable participation.[11]

The utilitarian aspects of art, be they therapeutic, pragmatic, or sym-bolic, put art and design in the service economy of 'doing' that is quite distinct from what art can 'do' in relation to Deleuze|Guattari's thought.[12] Deleuze's interest was not so much in 'images' (N, 137) as it was in per-cepts, affects and concepts, which are autonomous forces, the first two of which constitute blocs of sensations; they are prior to perceptions and affections or feelings. They belong to 'nonorganic Life,' or A Life (TP, 411–413). These forces are not in terms of power (*Macht*) to act, but to perceive and feel (*Lassen*) (WP, 130).[13] In this sense, an image is not a mental construct, but a *material reality*.[14] Concept, on the other hand, was a new synonym for virtual transcendental Ideas developed previously with Deleuze's engagement with Kantian philosophy.[15] In relation to artis-tic practice, Ideas (or concepts) are the nascent intuitions that an artist eventually actualizes through processes of 'arting.'[16] Ideas|concepts are neither objective, as in the sense of the Aristotelian hylomorphic tradition where the form (being or *ousia*) is already 'in' matter only to be released by the artist, nor subjective, where the Idea is clearly articulated by the art-ist, all that awaits is for it to be executed, that is, the figure needs only to be 'released' from the stone by the sculptor. Concepts in these two senses only lead to forms of imitation, repetitions, or most often clichés. Art becomes crowded with stereotypes, or what is often called 'school art style' as the proliferation of perceptual constants. Ideas or concepts are virtual, which Deleuze defined early in his exploration of Proust and signs as 'real without being actual, ideal without being abstract' (PS, 60, DR, 208). It is the constant back and forth between the virtual and the actual as the composition emerges through experimentation, rehearsal and repetition.

Any artistic process that produces the new is always faced with an unknown telos, subject to both breakthrough and breakdown, that is, failure. Things can be pushed just too far, as any number of artists, espe-cially actors, who have stared into the void too long, committing suicide or overdosed. The artist, for Deleuze, is someone who delves into the intensive chaotic presence of the flesh, into the 'wound' that defines his or her existence, experimenting with the force of the pure event, participat-

ing in it, thereby turning the physical event into a pure intensive becoming through a counteractualization. This takes a certain willingness, not in the sense of desiring per se, but a willingness to find something 'in' the sense-lessness of the wounds that are inflicted on us all. Such an artistic process requires an overcoming of existent clichés, a wrestling with the repetitive rehearsals that confront the chaos that surrounds the initial intuitions, creative destruction has to take place as experimental attempts have to be let go, what Deleuze calls the diagrammatic or deterritorializing moments, that then 'may' lead to a 'chaosmos,' an artistic style that is charged with blocs of sensations.

The artist through such a process 'drops out' as it were, becomes imperceptible, and the artwork becomes impersonal. It is an 'impersonified' reality that 'makes' the work of art. Hence, the work of art must *'stand up on its own'* (WP, 164, original emphasis). By standing up, Deleuze|Guattari are referring to art's ability to preserve blocs of sensations that can continually be encountered. The art 'outlives' the artist, who lives by 'dying' in it. Art is 'monumental' in this sense.[17] Yet, at the same time the aesthetic reality that is preserved in itself is dependent on 'support and materials' (WP, 163). But, then, even monuments break down, no matter how often they are propped up, if not physically, then psychically, for a point of exhaustion is reached where their address to a problematic no longer seems forceful. A new *Kunstwollen* becomes necessary. The most difficult task of the artist is to extract A Life or being of sensation from the lived as blocs of sensations that stand up.

Such creative play, as is well known, has been co-opted by the entertainment industries, play and work becoming indistinguishable as creative 'affective' immaterial labour becomes commodified. In this sense, artists do not escape the ethical and political forces of the problematic they are engaged in. There is a responsibility as to what they release into the world. Legend has it that a Chinese master potter would destroy and recycle thousands of pots before keeping one that was worthy of the standard sought. Seems rather quaint when compared to the contemporary antics of Jeff Koons' reproductions of banal objects or Damien Hirst diamond skull named, *For the Love of God* (2007). Art education for the most part becomes split between the entertainment industries and the entrepreneurship of the Contemporary Art Circuit within the globalized networked chain of galleries and museums as curators have now coveted the field of public art education.[18]

Deleuzian Education?

Deleuze and education is slowly becoming a crowded field.[19] An apprenticeship in 'signs' is how Deleuze sees '(art) education.' This has been the route many educators, inspired by Deleuze, have followed, as begun by the pioneering work of Kaustuv Roy (2003), which now has become standard fare as more and more work is published in education journals. Yet, as I argue in my own contribution to this collection, much of the work slips into phenomenology despite the parade of Deleuze|Guattarian terms, especially the emerging area called 'post-qualitative research.' The *radicality* of Deleuze|Guattari's aesthetic realism is seldom reached when it comes to extracting A Life, for this is the commitment that ought to be initiated, and each and every 'problem space' demands attention to the signs that are confronted 'in the relation between a sign and a response,' as Deleuze continues, in at least 'three ways' (DR, 22–23). The heterogeneity between sign and its object that bears them (as two separate registers); the heterogeneity between the sign and the Idea, that is, the problem space that this sign incarnates (the struggle on hand); and finally the relation between the sign and the response they elicit as an expansion of the sign with other signs to provide a 'plane of consistency.' The problem space as a plane of immanence (A Life) is inseparable from the creative process. 'It is signs which "cause problems" and are developed in a symbolic field' (DR, 164). *Signs produce desire*; they are intensities that are invested in, creating territories. Unlike the semiotics of Ferdinand de Saussure, the radicalness of this position presents arting as becoming-being, a transitivity without the mediation of a preposition, but part of the creative process of the becoming of the world. No separation exists between sign and meaning, and hence there is no separation between the world and the meaning attributed to the world. Arting as event becomes a site and a moment when change happens, a modulation takes place from one way of being to another.

Difference and Repetition has been picked clean for its references to learning. However, what is *not* often stressed is that the affect of such education is somewhat risky and violent. As Deleuze says, 'apprenticeship always gives rise to images of *death*, on the edges of the space it creates and with the help of the heterogeneity it engenders. Signs are *deadly* when they are lost in the distance, but also when they strike us with full force' (DR, 23, added emphasis). 'There is no more a method for learning than there is a method for finding treasures, but a *violent training*, a cul-

ture or *paideïa* which affects the entire individual' (DR, 165, 183, added emphasis). While Deleuze's example of 'swimming' in DR has become the central trope to explore learning by educators,[20] it seems that drowning is not given as much play, in short, not only the breakthrough, but also recognition for a breakdown. So, while learning is to take place by 'dosages,' risk cannot be discounted. Signs 'wound,' to echo Deleuze in his *Logic of Sense*. *A true encounter with a sign is an event*, an event of *sense* that then bridges or collapses the *nonsense* of virtual, from where the sign emerges, with the *common sense* of actual, the illusion of representation or opinion (*Urdoxa*), which is what worried Deleuze most. Signs penetrate one's 'being,' signifying 'real movement.' As such, Deleuze can say that such signs are 'spiritual' and have 'natural powers.' Such a description becomes somewhat more graspable in light of his later work where percepts and affects, as blocs of sensations, are what penetrate us as they are emitted from objects, from the Outside.[21] It is this *non-human* aspect of percepts and affects that I will return to, which is often missed.

Encounters are therefore 'shocking,' and *rare* than what most educators who embrace Deleuze are willing to admit. Educators writing with Deleuze in mind, all agree that schools and universities are not the places where such intense encounters can take place. Jacques Lacan's Discourse of the University (by university he does not mean 'just' the institution) succinctly articulates the exchange of knowledge as endeavours are made to domesticate, integrate and appropriate all the excesses that resist its demand for compliance. Apprenticeship becomes synonymous with learning but not as knowing, which already implies grasping of some pre-existing identity. It is not epistemology that is chased after in the last instance, but a becoming-other in relation to A Life itself. The time of such 'learning' is not chronological, but a transversal complexity of past-present-future times, which does not sit comfortably in the architecture of schooling or university that is so nicely ordered by bells, time slots, tests and hours of teaching (Williams 2013). Although a 'balance' between apprenticeship and knowledge is sought for, the aleatory points of change within a student are often imperceptible by the 'contractions,' and 'contemplations' that take place below the level of language.[22] As Deleuze writes, ' "learning" always takes place in and through the unconscious, thereby establishing the bond of a profound complicity between nature and mind' (DR, 165), it is also equally rare to have a teacher who, as Bogue (2013) puts it, is an 'emitter of signs,' someone who 'does not provide apprentices with answers, but guides them in the art of discovering problems, an art that

can only be mastered by practicing it' (31). Even then, such a teacher, as 'a master apprentice,' must create smooth spaces for this to happen, careful not to 'overdose' the students. *In the last instance it is the signs, which are the teachers.* This is perhaps why, as James Elkins (2001) provokingly argues, 'art cannot be taught,' or if one wishes a chuckle, Terry Zwigoff's film *Art School Confidential* (2006) will suffice.

Affective Problems?

The vast majority of art educators drawing on WP[23] have followed what has become known generally as the 'affective turn'[24] where virtual sensations as affects and percepts are given priority, problematizing the phenomenology of aesthetics with this level of non-conscious 'thought,' often referred to as a 'subjectless subject' (Bains 2002) or a pre-subjective realm, or more familiarly body without organs (BwO) that contemplates the part-objects of the material field (plane of immanence). In some circles the term *aisthesis* is used as the pre-Socratic term for the materiality of sense-perception.[25] Art educators who are aware of Deleuze|Gauattar's position have pretty much relied on Brian Massumi's (2002, 2015) interpretation of affect. Whether he has been carefully read or not forms another question as only a small minority of them acknowledge his political investment in this concept.[26] In the vast majority of cases, it seems Massumi's authority legitimates the mere mention of affect.

Massumi makes the distinction between affect and emotion. These two levels of image reception, while parallel, interfere with one another via their modulation in complex ways. The intensity or the effect of the image (*affectus*) and the content of the quality of the image in relations to its meaning (articulated as emotions) become entangled producing various effects. The question whether the difference between affect and emotions is one of degree or kind remains rather open since their heterogeneity, that is, their difference is not easily distinguished, neither in practice nor in the literature. Can affect be imperceptible, while emotion perceptible? Is the range between affect and emotion simply one of fully open at one end of the spectrum and completely closed on the other? Is this a misleading path of inquiry? Or, is this complex relationship yet another way of recognizing a synonymous complex relation: that is between life as zoë and life as bios? Affect being the line that 'unblocs' life, and this 'happens' in the time of Aion, a 'pure' line of flight, suggesting the contingency of an event of becoming is atemporal and incorporeal, a break in action and movement

occurs: 'something happens.' Hence, the significance of the 'autonomy' of affect is perhaps the most difficult issue to come to terms with in education, or art(s)-based research, since, the bottom line, there is *no method per se* making the generalization, 'affective pedagogy' (i.e., Hickey-Moody and Page 2016) appear as a misnomer when it comes to art education. In the fiercest language concerning affect in TP (395), '*Proposition VII. Nomad existence has for "affects" the weapons of a war machine*,' Deleuze|Guattari say that 'Affects are projectiles just like weapons; feelings are introceptive like tools' (400). Art and its education seldom reach this grasp of affect. 'Affective education' and 'affective research' end up being closer to what Deleuze|Guattari say feelings are: 'Feeling implies an evaluation of matter and its resistances' (400). Feelings are always displaced, resisting emotion and retarded. All this is not to say that war machines are necessary 'violent,' 'war is not its only object' (TP, 416), but some form of disruption (i.e., The Occupy Movement). Affects are meant to shock, a visceral reaction that is monitored and policed in public schools. All this saying that, taken at their word, affect falls along the side of risk, death and danger as mentioned previously.

There is, however, 'schizoanalysis,' to be sure, as the exploration of a material and a transcendental unconscious (A-O, 109), but this task is formidable as it is singular for any teacher: 'the task of schizoanalysis is that of learning what a subject's desiring machines are, how they work, with what synthesis, what bursts of energy in the machine, what constituent misfires, with what flows, what chains and what becomings in each case' (A-O, 338). This 'something happens,' is then actualized—from a static passive synthesis to a dynamic one. To be sure, artists committed to A Life need to extract affects and percepts, but this difficulty needs to be acknowledged.

Percepts and affects are part-objects that are apprehended by Deleuze's first passive synthesis, to be then bound and recorded as an affection-image, which presents us with an emotion or feeling that can lead to action where perception and affection are synthesized; change happens but it is repetitive. If, however, the sensor–motor link between affection and perception is broken, then either perception or affection is outstripped in its response to action: time as Aion and the unthought are confronted. But percepts are as difficult to pin down as affects. François Zourabichvili (1996) makes an effort to clarify such a difficulty. A percept, says Deleuze (CC), is 'a perception in becoming' (88). Such a perception that is 'becoming' refers to an elevation in vision, a potentiality of sight as to what it can 'do.' Precisely what is it that such sight can 'do'? Just as enigmatically

Deleuze says: when one sees what is invisible or imperceptible. Such a sight is more of a 'vision.' *What cannot be seen is perceived.*[27] But this is not a 'hidden world,' which is what we immediately think; rather, more complexly, it is the invisible *of* the visible itself: living (or nature) consists in what is ordinarily experienced *as* A Life. A Life is the experience of the transcendental field or plane of immanence *inside which we live.* Hence, such vision has potential to raise sight to the nth power, which then breaks with normative human perception. Its capacity refers to the 'being of the sensible,' A Life, grasping how a phenomenon is manifested, or has come about. This would be the ground or the fold of its existence, and this invisibility is immanent within the visible itself. Such would be an artistic 'eye' where the forces of the invisible within the visible are exposed.[28]

Deleuze|Guattar's interest is in the non-organic life, not life as phenomenologically lived, which often becomes accused of anthropomorphism: most commonly in their discussion of 'becoming animal.' The requirement of percept and affect, however, is not to claim any sort of true grasp of the animal's experiential world; rather, it amounts closer to a question of attunement to it, to resonate and attempt to grasp its 'world.' Such attunement targets a zone of indistinction or indiscernibility where a 'blurring' between nature and culture happens—something becomes transferred. Becoming is not simply the naive notion of change or a subject that is always in flux. Often the way becoming in art education is understood in this pedestrian way. A world-for-us is continually snuck in under a Deleuzian disguise. The artist who 'sees' does not re-emerge from the spectacle being identical to a former self. 'Art undoes the triple organization of perceptions, affections, and opinions in order to substitute a monument composed of percepts, affects, and blocs of sensation that take the place of language. It is about listening [WP, 170]. This is precisely the task of all art' [WP, 177].

Affect theory is very worrisome as it has taken on dimensions that simply feed 'affective capitalism' and move away from A Life art educators should address. It is worth exploring briefly here to differentiate what has been happening to art education under the Deleuzian banner in many circles where *the body has been brought back with vengeance to overcome mind.* Ruth Leys' (2011) critique of affect theory should be recognized as pointing out some of the problems of the slippages that happen when affect (and percept) are not understood in their autonomous sense as A Life. This position is forcefully an *aesthetic realism* where the autonomy of affect and percept as non-human phenomena comes up against affect

as emotion, the captured life of bios, and the reigning rule of capitalist neuromarketers: affective labour and affect become the latest commodity for capitalist expansion. The *absence of percept* in this affective paradigm should be the warning sign. The excesses of affect manifest themselves in the physicality of obesity and the symptomatology of attention deficit as the speeds of transfer within circuits of stimulation are without translation or delay. The hypertrophy of sensation by new media was already fore-shadowed by Deleuze|Guattari's discussion of control societies. Affect in control societies is mere stimulus to be felt as events are staged to be con-sumed immediately without delay. Perhaps the legalization of marijuana clinches the sale of affective addiction, just like refined sugars, tobacco and a Starbucks on every corner do. Which is why so many educators worry about the loss of reading abilities where sense matters as time is slowed down via attention to meaning. In capitalist forms of consumption and production, affects are always collapsing into affections, or *feelings of the lived body* all under the name of Deleuze and Guattari.[29] It is a performa-tive 'selfie' world of privatized individuated narcissists where artistic auto-biography can become a legitimate 'research' orientation.

Ruth Leys' critique of the turn to affect presents these difficulties, or should it be said, the misunderstandings that are made when affect is understood as an *embodied experience* rather than, as Deleuze|Guattari make the case in WP, that affects and percepts are outside the human, and beyond the organism. Embodied is a 'poor' word as blocs of sensations are not revealed *in* the flesh, but in both a deeper interior and a framing exterior. 'Embodied' seems to slip into unity rather than dwelling on its 'organs.' A Life (immanence) cannot be reduced to the lived human life, which is what continually happens when affect is treated as human emo-tion; or both terms become indistinguishable in theorizing the 'emotional brain' (Damasio 1995; LeDoux 1996).[30] Life as bios completely over-whelms zoë, there is no 'life' to be released.

Affective capitalism is obsessed with the felt world-for-us, which sup-ports the enactivism of the biological framework of Humberto Maturana and Francisco Varela (1980), whose philosophies are the basis for Marc Hansen's (2004a) *embodied* philosophy for a new media (more below). Deleuze|Guattari's *aesthetic realism* becomes one-sided with the slip-pages that continually take place between embodied human affects and emotions. This collapsing or rather the difficulty of any easy separation between intensity (affect) and the quality of emergence (emotion) as sub-jected to the living body of everyday affairs seems to go back to Brian

Massumi (1995) whose writing on the 'autonomy' of affect offers a (mis) appropriation of affects' status. As he writes,

'Both levels, qualification and intensity, are immediately em-bodied. Intensity is embodied in purely autonomic reactions most directly manifested in the skin-at the surface of the body, at the interface with things. Depth reactions belong more to the form/content (qualification) level, even though they also involve auto-nomic functions such as heartbeat and breathing. The reason may be that they are associated with expectation, which depends on consciously positing oneself in a line of narrative continuity' (85).

Embodied affect in this case is humanized. The relationship between intensity and qualification simply means that's its complexity has no direct causal link between thought and the modulation of affect, which reception cultural theorists have explored for some time. Neuromarketers and sentiment analysts, especially preying on 'empathy,' now try to manipulate via databases to create affective resonances in the voting or consuming public independent of content or meaning, what Delueze would identify not as thought but opinion. Affect 'trumps' rationality each and every time, as the current 'Trump for president' campaign clearly shows.

The turn to the *body's affects and brain patterns as indicators of emotional response* is not what Deleuze|Guattari had in mind in WP when it came to art and its education. It is the harnessing of asubjective intensities and preconscious, or non-conscious impulses (A Life, or zoë) *that do away with any interval of delay to action*, which should worry art educators under the name of 'affective art education.' What seems to be happening is that the non-conscious body of the autonomic nervous system is being equated or collapsed or confused with the autonomy of non-human percepts and affects in a great deal of affect literature. Or, this non-conscious body reaction is privileged above and beyond higher functioning consciousness when the ecology of the situation is far beyond such simplistic reductions.

Ruth Leys (2011) in her critique of affect reviews what she refers to as the 'Basic Emotions Paradigm' (439) as forwarded by neuroscientists such as Antonio Damasio and Joseph Ledoux, and followed by Silvan S. Tomkins and Eve Kosofsky Sedgwick to name the most cited in this area. She carefully shows the flaws in this claim to emotional universality without taking context into account. Deleuzians such as Massumi and William Connolly do not fare any better in Leys' account as they are taken to task for reinstating a dualism between the body and the brain. In a particularly important

footnote (62, 468), she lists no less than ten citations by Massumi within his *Parables of the Virtual* book that definitively claims that the virtual is located in the body-brain (as developed in WP), yet affects and percepts are non-human entities (A Life). This all adds to the confusion.

Art educators, as well as arts educators, have made the representation of emotions (affection rather than affect) the staple of their education, especially when affect, as emotion, presents facial expression to capture 'authentically' as to what is felt. The basic emotions—fear, anger, disgust, joy, sadness, surprise and so on—are said to be genetically hard-wired and universal. The broad accusation Leys levies against affect theorists would support 'affective capitalism' of today: namely affect is a realm that remains anti-intentional and postcomprehensional, one of 'feelings,' big data that 'speaks for itself,' and brain research which, in some cases, comes close to neo-phrenological causal research. Claims of tomographical brain mapping to be consonant with experienced emotions when watching projected images and films remain highly suspect. Such 'findings' have become marketing ploys with aspirations of achieving *Minority Report* status.[31] Art educators can no longer ignore media research as we live in a 'screen society' of mediated experiences. Visual cultural research has become a mainstay of art education.

Neuroaesthetics, Art and its Education

In the last section of WP, Deleuze|Guattari's discussion on the 'brain as a screen' has become particularly important to rethink digital media given that art and its education generally equates the 'new media' with having a digitalized technical component as part of its installation works. This is now known as the 'new aesthetics' (Berry et al. 2012). Video art in particular and algorithmic functions in general have become common fare. Art and science 'share a brain' of thinking in what will be discussed in the last section as 'art-sci,' not in the usual way that they come together, which is neuroaesthetics.[32] Neuroscience further complicates this issue of affect for art education. Neurologists Damasio (1995) and LeDoux (1996) introduce emotion and feelings in the mix, maintaining that emotions are prior to feeling, further confusing the semantic landscape. Emotions are said to be comparable to affect, as are feelings comparable to Massumi's emotions.[33] Then there is the microconsciousness of the image itself. The visual brain has separate areas where colour is perceived before motion, location is perceived before colour and colour is perceived before orienta-

tion. This generates a 'temporal hierarchy of microconsciousness' that is seamlessly integrated from various parcelled parts of the brain (Semir Zeki, in Hansen 2011, 87).

Perhaps more significantly is Patricia Pisters' (2012) discussion of 'mirror neurons' in relation to affect. Mirror neurons indicate a relation between observed action and its implication for simulated action as they rely on the same cortical network. Extrapolated further, this also means that the bond with others happens at an intersubjective subpersonal level, an unconscious process of motor simulation. On a neurological level, empathy is embodied via the similarity and simulation of the other. Now affect becomes equated with empathy. Is this then yet another conflation of affect with affection? Yet, empathy is said to happen below the level of consciousness as well. So, is this yet another phenomenological tenet? It seems so if we follow Gallese (2001). Given this direct power of images via mirror neurons, the complexity of the encounter with art is further enhanced. Gallese (2001, 45) in his 'shared manifold hypothesis' presents three layers of intersubjective communication through which mirror neurons can operate. The phenomenological level is equated with empathy itself; the functional level is characterized by an 'as if' process that enables the modelling of others; and lastly, the subpersonal level has both an expressive and a receptive mode of mirror neural circuits that are coupled with body states. 'We can "co-sense" in many variations and in relations both the emotions and feelings (or affects and emotions in Massumi's terms) of the characters, in addition to the aesthetic intensities and qualities of the images on our screens' (Pisters 2012: 119–120). But neuromarketers are quite aware of this as well. The question of art as a form of resistance that Deleuze (1998) supported seems to wane in these discussions, or at least it is not very clear how distinctions are to be made just how art 'resists' in a digital age.[34]

Microconscious Sensory Reality: From Light to Time

Affect seems to be a very imprecise term for what might be happening in the so-called art or media encounters. Massumi's explorations in his well-known *Parables of the Virtue* have been carefully questioned and explored by Leys, and the question of affective 'embodiment' remains in the balance as both affective capitalism and the Deleuzians who take digitalization as possibly advancing his commitment to A Life via artistic creation (which art education should take seriously) seem to cover the

same ground; however there is little to no talk of the sense event of A Life via art. This remains absent with affect theory in general. The absence of percepts that form a bloc of sensations, along with affects, also seems to vanish. The question of 'affective resistance' that emerges from this receptive complexity is given different explanations: for Paolo Virno (2008) it is language, which counterpowers mirror neurons, but for Norman Holland (2007), it seems that the dorsolateral prefrontal cortex is involved in executing or inhibiting actions.

Whatever the possible solutions are to disarticulate the confusion between affect and the emotions, the oeuvre of Mark Hansen (2011) offers yet more difficulties, especially when it comes to 'new media.' In his analysis of Semir Zeki's neuronal aesthetics, whose experiments show that colour is perceived a full 80 milliseconds before movement, provides insight that 'binding' as well as 'mis-binding' happen as a 'post-conscious' phenomenon. Colour and motion (direction and orientation) are processed without being conscious to the self or higher-order consciousness. They are microconscious and quasi-autonomous constituents of higher-order consciousness. Hansen emphasizes *the temporal processes of images.* Drawing on the ontological significance of video (as developed by Maurizio Lazzarato), which offers viewers a video screen that refreshes itself 30 times per second, a form that is synchronous with the time of human consciousness, the possibility emerges of a truly 'dynamic image.' The binding at the microconscious level can be manipulated to create crossmodal mental images as colour, motion, location and orientation become variables for experimentation, especially through digitalization. Would this be the first time that 'dynamic' images have been created, subject to digital manipulation? And, would such an understanding especially for art and its education mean new insights as to how A Life might free up the hardwired brain circuits via this inhuman technology to generate paths toward new subjectivities given the brain's plasticity? These are difficult questions that will be explored as screen technologies advance.

Hansen ends his exploration on the 'flux' of images by reviewing the work of Warren Neidich, an artist who has been involved in neuroaesthetics for some time. The significance of Neidich premises for art education should not be underestimated as what is called into question is the way 'natural vision' is continuously modified by the (optical) technologies and 'cognitive ergonomics' of our own invention, and just how these technologies change the human brain structure, for example, Julian Jayne's (1976) hypothesis of the 'bicameral mind': the modification of the brain

when writing was invented. Such technologies comprise an inhuman (to add to the usual non-human) agency in relation to culture.[35] The ontogenesis of our species in relation to inhuman and non-human agencies is part of Deleuze's 'post-anthropology' as explored by the oeuvre of Keith Ansell Pearson (1997, 1999) so as to think 'beyond the human condition.' I shall return to the signification of this in the last section of my introduction.

Neidich speaks of engineering 'phatic images,' which 'have been engineered with the human nervous system in mind' (Neidich 2003, 36). The point Hansen makes is that such cinematic/virtual images resonate with Zeki's account of the microsensory functional specialization of the visual cortex. Such images are able to resonate with the differentiated, quasi-autonomous microtemporalities of visual processing. Given this ability of electronic 'phatic images' to capture attention raises once again the complexity of affect in relation to emotion, as the structuring proceeds at the non-conscious level to grab our motion, or colour, or orientation at the microconscious level. Given that such images microtemporally address our brains 'directly' before the formation of the image-object as processed by higher cognition, is 'resistance' futile? What is required to break the ergonomic circuit that links image and motion or action? Again, capitalist affective marketers are already well onto this understanding. One visit to Affectiva's site (http://www.affectiva.com/) should be convincing enough.

Unlike Neidich, who maintains, like Virno and others, that it is discursive language that makes aesthetic resistance possible, Hansen calls on the plasticity of the brain (as forwarded by Catherine Malabou 2008) and the explorations of neuroaesthetics to offer another way to combat cognitive capitalism and its arsenal of 'phatic images.' Phatic images refer to Neidich's naming those images that are engineered by capitalism to impact the nervous system for attention and to prescriptive motor responses. Hansen credits Neidich for having moved toward the possibility of a different technification of perception that would address the hierarchy of the visual cortex by playing and intervening into the *concrete materiality* of the sensory flux. Rodolfo Llinás' (2002) experiments demonstrate that the oscillatory activity of the brain; that is the inherent (natural) temporality of the brain is privileged at the frequency rate of 40 Hz (cycles per second). This is when binding takes place within the visual cortex below the level of 'higher' consciousness. Cinema (at 24 frames per sec) and video (at 30 frames per second), as macrotemporal binding patterns, are then superimposed and coordinated with this microtemporal neural oscillation of

the visual cortex. Cinema and video 'capture' the brain's potentiality and structure it in a particular rhythm based on marketing research.[36] Hansen (2011) proposes a different technification of time that 'disarticulates the overcoding imposed by cinema in ways that can liberate neural flexibility (or placticity) from its all-too-seamless integration into contemporary capitalist networks of efficiency' (95). This challenge is yet to be taken up in art and its education; however, early childhood studies are already onto modifying infant brains via neuroplasticity (i.e., Gopnik et al. 1999).

To make his point, Hansen draws on several artists. According to him, James Coupe's public art installation, *Re-Collector*, is said to expand human perception beyond the human time frame that is germane to phenomenological consciousness. Algorithmic computation enables 'seeing' what is imperceptible; that is, perceiving nuances of movement at the microtemporal scale is made possible through surveillance cameras. A network of cameras around the city of Cambridge, England, is programed to recognize the 'cinematic behaviours' of the public that correspond to sequences in Michelangelo Antonioni's film, *Blow Up*. The captured footage is analysed by computer vision software, which then selectively reorganizes the information into a narrative sequence of images that is modified daily. The result is a continuously mutating story that disturbs the usual narrative sequencing we have become accustomed to: the idea being that these daily films, when projected back into Cambridge's city centre, become an interactive site with the public. Gradually Cambridge's city dwellers began to modify their behaviour to regain control of their image as the boundaries between performance and identity, subject and object, observer and the observed began to blur.

Hansen's claim is that a *sharing* took place, a symbiotic happening took place between the microconsciousness of human sensations and the analysis of microtemporal processes by machinic vision. There is no imposition on sensation from the outside as in cinema. *Re-collector* does not impose its framing on the spectator; rather, the microtemporal frames that are assembled into images address the microtemporal frames of human sensation, and their coincidence (as direct material contact) makes possible the altering of habit. Brushing the potential paranoia of such an installation aside (the feeling of always being observed), Hansen's point is such asubjective (machinic) vision belongs as much to the human as it does to the machine. To extend his insight, the interactive technology opens up an optical unconscious that is beyond human perception, but now available for modification.

Patricia Pisters (2012) makes the same point in her discussion of *Red Road*, a movie concerning surveillance where the protagonist Jackie, a surveillance attendant, spots Clyde, and is deeply affected by his surveillance image. It was Clyde who had run over and killed both her child and husband while drunk. The story proceeds as to how she is able to manufacture her revenge via the surveillance technology, and her redemption that follows. Pisters' point is that the technology of surveillance enables such a strong affective response that leads to her action. Here, the Deleuzian concept of the 'crystal image' is paradigmatic: the electronic media presents Jackie with an image that unites her historical past as recorded by the surveillance media, with the immediacy of her present viewing. The virtual image (of Clyde) and the actual image (by Jackie) are unified into this variation of the time-image. The virtual image exists in the past and is remembered (by Jackie), and is brought to life by the actual image, which is immediate and objective as viewed. We can say that Jackie is 'framed' by this image because of its affective impact on her. She experiences 'emotions' (affects?) of sexual arousal, fear, disgust and anger throughout the film's narrative via her surveillance images of Clyde as she stages her revenge scenario.

The time-image in film is not what Hansen is getting at via his examples. The idea of 'image' is being completely stripped of its representational residual that digitalization exposes. The question of what precisely is affect is further problematized when Bergson and Deleuze's appropriation of him are called into this question. Bergson postulates that matter, movement and 'image' seem to be all the same. 'Images,' are impersonal, not yet connected to a 'subject.' Further, Deleuze maintains that '*movement-image* and *flowing-matter* are strictly the same thing,' as a 'bloc of space-time' (C1, 59). He then further extends this equivalency to light: 'identity of the image and movement stems from the identity of matter and light' (60), marking a stark demarcation from phenomenology when it comes to *consciousness*. Acknowledging Bergson, the shift is from the intentionality *of* consciousness to a non-representational claim: 'Things are luminous by themselves without anything illuminating them: all consciousness is something, it is indistinguishable from the thing, that is from the *image of light*' (60, added emphasis). Deleuze concludes with, '[I]t is not consciousness which is light, it is the set of images, or the light, which is consciousness, immanent to matter' (61). In brief 'the plane of immanence or the plane of matter is: a set of movement-images; a collection of lines or figures of light; a series of blocs of space-time' (61). Artists in WP are charged with

extrapolating A Life to make, as Deleuze emphasized by Klee's succinct statement: 'not to render the invisible but to render the visible.' The being of sensation is figural as opposed to being representationally figured.

For perception to happen a 'doubling' takes place, *'a double regime of reference of images'* (62) is necessary. Taking his lead from Bergson, Deleuze maintains (against the luminosity of things as images or plane of matter, the usual spiritualism) perceptions as 'living images' form a 'black screen,' which consists of the second regime of images. Perception, in this view, is 'opaque'; it forms a necessary screen as the intensity of light may be too much. Perception only 'sees' so much that is of interest. What light gets through forms the object of reflection, and is, in this sense translucent. Bergson calls such images that are 'developed' as a 'black screen,' 'living images.' This happens when a gap or *'interval* appears' (61) on the plane of luminous matter, which for Deleuze forms a frame, a closed system or 'tableau.' Hence, perception is a subtractive process as other matter-images are ignored, or are of no interest as they form an Outside. Perception as a 'living image' is therefore a reflected image made possible by luminous matter, which enables the 'translucencies' of perception, as the Real can never be perceived. It is precisely this 'gap' or interval where a disidentification or a desubjectification can or might occur.[37]

Given that the interval is subject to *time,* the delay enables a new movement to take place; a reaction can emerge that is quite at odds with the previous action or habit. The brain as a 'living image' makes this possible, as it is the brain that initiates at the non-conscious level this interval. Because such a difference can occur between action and reaction due to a 'living image,' Deleuze, following Bergson, names 'living images as "centers of indetermination" ' (62) forming a black screen. Change is indeterminate and contingent. And, it is here that affect plays its part as it intervenes in the gap or interval between perception (or incoming action) and (outgoing) action. The intensity of affect as the link between received movement and executed movement means that perception has to be 'troubled' in some way, and the action has to have a moment of hesitation. So affect links object–subject couplet as a quality; this quality is linked to expression. Expression here is presented as 'pure affect' since the object through a close-up has been abstracted in such a way that its spatiotemporal co-ordinates fall away. It seems to exist in 'any-space-whatever' (C1, 109). Basically, in Charles Sanders Pierce's schema, a 'secondness' appears enabling a self-reflexion[38] to take place as a 'delay' occurs: the 'subject perceives itself, or rather experiences itself or feels

itself "from the inside"' (C1, 65). For Deleuze, this applies to any body or object whatever, not *just* the face. 'There is no close-up of the face. The close-up is the face' (C1, 99). *Any object can be extracted from its habitual spatial-temporal co-ordinates and take on the power of expression.* So affect now takes on a *non-human dimension* wherein affect is an entity, a being in-itself, independent, autonomous, singular. Treated in this way affect becomes totally opaque or abstracted. To call it embodied seems to miss the point, or present it as a half-truth.

Here we come up with a problem with Hansen's revised account of Deleuze's affect that clearly does not support Deleuze's *aesthetic realism.* Affect is incorporeal when it is extracted as in the famous *scream* of Francis Bacon's *Portrait of Pope Innocent X* as discussed in FB. The scream does not 'belong' to the Pope, but is a non-human entity that has been abstracted. It exists in no-place and everywhere. It is a virtual entity. The viewer is 'affected' by the scream, by its expressive qualities. The scream is a virtual phenomenon (A Life). It is this virtual realm of affects and percepts that provides a resistance to the market of exchange so that the affected viewer in that time interval generates thought that breaks with action or habit. It is precisely Deleuze's aesthetic realism that Hansen rejects so that affectivity is given *back to the body.* Rather than virtual, Hansen uses the term 'virtualization of the body' as in the ability of the artwork to evoke new sensations, or the ability of the viewer to feel new sensations. This seems to be only part of the story that has become the whole story. The complications of this misreading or misunderstanding might be thought in relation to the well-known Spinozian adage as to how bodies affect and are affected. Hansen seems to develop the reception side of this exchange, that is, to the responses to the new media that are engendered, so it appears as if Deleuze's cinematic theory has the spectator 'framed' by the cinema (rather than doing the framing). New digitalized media offer an interactive component that films lack. Affectivity is then a bodily production of excess enabling the body to break its previous boundaries via such interactive responses. Deleuze and Guattari in WP, on the other hand, present artworks as 'monuments' that preserve blocs of sensations, so as to expose A Life.

This tension is extremely complicated. The apotheosis of Hansen's argument regarding the 'virtualization of the body' is the video game that raises issues, not only of interactivity but also of interpassivity: just how much does the algorithms structure the player?[39] In terms of art and its education, and of its resistance, this route of digitalization and screen

technologies means developing the specificity of each and every interactive digital installation as to its capacity to virtualize a new body. Given Hansen's reception aesthetics, he presents a variation of phenomenology as the spectator's bodily affections must be virtualized so that the artwork comes into being, a *world-for-us*. By forwarding the affective body as a framed unity before the differentiation of the senses as the frame of being, it seems as though Hansen would dismiss Deleuze|Guattari's BwO, precisely where refiguration or desubjectification can take place.

David Cecchetto (2011) presents a rather extensive review of Hansen's 'deconstructing affect,' noting his misreading of Derrida as well, but, more significantly, in what would require much more unpacking than I can offer here, is Hansen's reliance on the enactivism of Francisco Varela's phenomenologically inflected autopoietic system. Making the shift from 'body image' to 'body schema' Hansen (2006) makes the claim that Merleau-Ponty's *'schema corporel'* was mistranslated as body image: the former term refers to the body as an external object via representation, while the latter is an autopoietic system that is in continuous exchange with its environment as it develops and changes. This is at odds with Deleuze|Guattari's account where it is the transformative event at the edge of chaos where there is a marked becoming, a dissipative ecology versus one that is modulated where there is a continuous exchange between the body and its environment as in Maturana and Varela's biologically inflected enactivism. A further question is whether body schema, in the way Hansen employs the concept, has any bearing on BwO, which is a purely intensive body. The BwO is A Life, the non-organic and intensive vitality that traverses the organism (not only the human). A BwO is the Life that a body 'is,' as well as the Life through which we sense.[40] Bodily schema can easily be read as part of lived life (bios), this being the organism with forms and functions that, for Deleuze and Guattari, 'imprison' life (WP, 171). Like chaos and A Life (chaosmosis), the BwO does not exist 'before' but *with* the organism, or 'adjacent to' the organism, and is continually in the process of becoming.

Can Deleuze|Guattari's extended idea of affection, and not 'simply' as affection-image, survive the assault of digitalization that is waged on it by new media theorists such as Hansen? In a nutshell, the charge here is that the body in Deleuze's account is too 'passive,' that 'embodiment'[41] is eventually done away with. Hansen wants to recover phenomenology 'his way,'[42] so to speak, by maintaining that Deleuze's grasp of the subjectivity is all too machinic, rather than being all too human. Hansen mistakenly equates Deleuze's affection-image, especially of the facial close-up,[43]

with affection in general, and claims that the passive synthesis that correlates images as being too reductive so that he may assert his own thesis. Hansen's overarching mistake is to claim that Deleuze accepts a distinction between perception and simulation, that is, between external and internal images that lead to action. This is not to dismiss the power of his work, but to question the write-off that he initiates toward Deleuze each and every time as his 'signature' move.

For art and its education, the question of the confused relationship between affect and percept and digital media is far from over. It is just beginning. Seung-Hoon Jeong's recent *Cinematic Interfaces: Film Theory after New Media* (2013) is perhaps a good example of this as any. It may well be that Deleuzian affect theory needs to be extended (more below). Taking up a Deleuze's account of affect, Katrine Dirckinck-Holmfeld (2015) makes the case that digitalization can be monumental in Deleuze|Guattari's sense of aesthetic realism despite its supposed loss of indexicality. Dirckinck-Holmfeld notes the distinction that Eve Sedgwick makes between texxture and texture: the extra 'x' denotes the felt historicity and patina and historical materiality of how an object came into being. Texxture, understood this way, is the foundation to art education as it is continually practiced, that is, as a 'painterly style' and so on. In contrast, texture without the extra 'x' is where history is erased. The image seems 'slick,' its history hidden, simply stored as ones and zeros. Texxture is lost in the digital image.

Dirckinck-Holmfeld queries this distinction in relation to Lebanese performance-artist Rabin Mroué's *Pixilated Revolution* (https://vimeo.com/44123255), which is an installation where an activist, who is then shot, captures his sniper on a handheld cellular phone. In the minute and a half video the images produced are 'poor,' as theorized by Hito Steyerl (2009; Pereira and Harcha 2014). In the context of Syrian uprising, the production of images in the midst of violent dislocation results in poor resolutions and erratic effects from being held by trembling body and hands. All of this adds to the documentation's 'authenticity.' The faces are grainy and pixillated. Many viewers to the exhibit react how 'touched' they are, and how the installation, which includes what look like blow-ups of single blurred pixillated images from the cell's video, bring out a structure of fear and death that is politically charged, like the stoning of women for adultery captured on video by Islamic State (ISIS) 'judges.' This is Deleuze|Guattari's affect working as a structured virtual entity as the faceless face of the perpetrator's individuation is annihilated and communication stopped, creating a 'probe head' (TP, 190) that disturbs perception.[44]

To conclude this question of affect is to raise yet one last concern regarding the difficulty of sorting out an art of resistance versus an art of entertainment. The affective turn can then take on two meaning, depending on whom one reads in this literature. There is always the seeming impossibility of separating affects from emotions, although the distinction is often recognized.[45] If the contextual specificity of art encounters and artistic processes are taken into account, then the singularity of the event is also in question as to both its effect and affect. The impact of any artistic work (performance) is variable, as is its production. What art can 'do' refers to the effects it produces, and these are, for the most part, unpredictable, although marketers try to change the percentages for success. Patricia Pisters (2012) makes a case for the neurological image that has emerged in the era of digitalization; the idea that, through special effects, it now becomes possible, so to speak, to enter the minds of characters, thereby mapping the emotional brain through cinema via the narrative. Pisters equates this image to Deleuze's third synthesis of time: the future where both past and present are explored in relation to it. Pisters is rather careful to discuss films she identifies as continuing a critical questioning, like *Red Road* that is discussed in her book and mentioned earlier. In other words, the exteriorization of non-human emotions, cut lose from characters is possible in certain films, made possible by the enhanced techniques of digitalization. However, another roadblock presents itself from such generalizations. On another occasion (Pisters 2016), when discussing the 'neurothriller' as she calls it, where the antecedent filmography of Hitchcock is discussed, there is no distinction made between Hitchcock's desire to manipulate his audience and the neuroscientists (Uri Hasson at the Princeton Neuroscience Institute) who simply confirm that this is possible, like any neuromarketer. There is no autonomy of created affects here as the audience is 'emotionally' manipulated through careful 'dynamic images.' Blockbusters such as *Avatar* and *Star Wars* make this very evident (Flaxman 2012).

Bodily Matters

For art educators who have embraced Deleuze|Guattari, it seems that often it is not evident what theory of 'affect' is being drawn on as the *body* is most often referred to as being the affective core in Deleuze|Guattari's work. The term 'embodiment' is dotted throughout these writings. In a recent collection of essays by Hickey-Moody and Page (2016) this is

precisely the case making the slippages into affection rather easy, bringing forth a neo-phenomenological view where the world-for-us is reconfirmed often via various biographical narratives, yet affect is said to play a prominent role in such 'becomings.' The Deleuzian 'event' is strangely undertheorized for it brings out the edge of chaos (death) in lived life that itself covers over A Life, which is the 'conditions of real experience' (DR, 68), and these 'conditions' are specific to the situation and cannot be uncovered by a methodology, making 'research' under the Deleuze|Guattari banner always suspect as specificity is lost.[46] The 'structure' of the virtual is uncovered as A Life. Such is affect understood as an aesthetic realism— the non-human. The radicality of becoming as non-organic Life (A Life) seems to be reduced to simply 'change' in most art education expositions claiming Deleuze|Guattari as their framework. Perhaps this is a way to continue critical theory, but then such slippages are subject to attacks like that of Slavoj Žižek (2004).[47]

Creativity (as genesis) is rarer than art educators seem to acknowledge, and counteractualization is rarely mentioned and explored for its potential.[48] The difference between human 'embodiment' and affects and percepts being 'embodied' via artwork is illustrated by Francis Bacon's works of art, or in literature when art gives 'body' to that which exceeds the lived (e.g., Kafkaesque, Dickensian, Lawrentian and Orwellian—all Deleuzian examples). Yet, if we follow Pisters' neurological digitalized cinematic images, there are many affects captured beyond the humanly lived. Perhaps this is why there is a marked absence of the 'other' aspect of a bloc of sensation, namely percepts in much of the art education writings. The plane of composition of art always involves the assemblages of affects and percepts. Percepts decentre the slippages into affection and are less likely to fall into a psychologizing Deleuze|Guattari for it points away from the human to Deleuze's transcendental conceptualized as a pure plane of immanence, as an Outside, a *world-without-us*. We then no longer deal with a simple empirical experience *of* A Life but an unruly empiricism that *is* A Life. Percepts address this Outside as well, a non-human landscape in which we are already immersed in, 'the impression of a fictive, foreign world, seen by other creatures, but also the presentment that this world is already ours, and those creatures, ourselves' (Deleuze 2001 PI, 35).

Percepts are closer to grasping the invisible forces that populate the universe and are hence *cosmological*, forcing forms of thought that enable us to think the Planet (a world-without-us) more so than the Earth as a world-in-itself (as does science). When Deleuze|Guattari say percepts

refer to man being 'absent but entirely within the landscape,' (WP, 169), following Cézanne, it is their poetic paradoxical way of acknowledge that 'Man' is simply another species on the Earth, part of the planetary cosmos: humans in the transcendental field and the transcendental field in us. As 'haecceities' the mode of individuation of life (not A Life), but life as we experience it for-us does not differ in kind from nature that we are part of. It is a 'rare' artist then who is able to capture the autonomy of per-cepts to a point where, mystically, 'We are not *in* the world, we become *with* the world' (WP, 169, added emphasis). This is 'more' than an empa-thetic gesture. With art, viewers have a vision of a non-human landscape of nature (percept) and undergo a non-human becoming of 'man' (affect), as the Life they have a vision of passes through them. Affect and percept are simultaneously enfolded[49] as viewers cross a 'threshold of consistency,' thereby dissolving the logical identity of the subject. Such an event hap-pens then at the edge of chaos. Educationally, such a disruption does not happen 'every day,' and it should be understood as what 'learning' is in Deleuze|Guattari's sense. Such an event is unpredictable, that is, aleatory at the point of excess. While such disruptions happen all the time, they are most often dismissed; the 'signs' are not answered their call due to habit.

Possible Universes

Art is the creation of *possible universes* that Deleuze|Guattari advocate in WP, another term they use is fabulation. Fabulation refers to visionary percepts and becomings of affect.[50] They are quite explicit in how art is differentiated from science; whereas art operates in co-creation with A Life, its consistency to chaos is through genesis; science does *not* operate as genesis, but references genesis as A Life that *is*. Art then opens itself up to infinity, whereas science as finitude is said to territorialize the infinitude that A Life is. The relation of science and art is crucial for art to go 'out-side' itself, a point I will return to in the final section of this introduction. Design, media and educational technology constitute inferences that cut across art and science respectively. There are historical reasons for their distinct separation,[51] but we now have their indistinctions taking place like 'designart' (Holt 2015) that do away with the ampersand between art & designs as interdisciplinarity has become more the fashion in research.

Design *education* in particular has been relatively silent in relation to the philosophy of Deleuze|Guattari. The exception is perhaps John R. Dakers (2011a, b, 2014) and Stephen Petrina (2014). Both are attempting to

introduce Deleuze|Guattari into the mainstream technological educa-
tion, but it all seems that it is in its beginning stages. The overwhelming
position in Europe and North American among art and design education
circles (NAEA in the USA, and their European equivalent, International
Journal of Art & Design Education, IJADE) courts the 'creative indus-
tries' of capitalism as agreed via the Bologna agreement trying to wedge
itself within the STEM (Science, Technology, Engineering, Math) move-
ment to place art as design under a new acronym STEAM, so as to further
advance the 'prosumer' mentality of global capitalism (Knott 2013). The
Design Interest Group (DIG) of the National Art Education Association
(USA), by and large, supports this STEAM direction to make 'artdesign'
more entrepreneurial.

An edited publication by Marenko & Brassett (2015), *Deleuze and
Design*, attempts to rethink the field of design '*with* Deleuze' (8); however,
their general thrust seems to be to claim that design is a process of change,
invention and speculation that is concerned with the future, rather than
any grounding in objects. 'Design thinking' as simply problem-solving
is being slowly replaced by an acknowledgment of non-human actors
(the objects in design practice), thereby decentring the designer as the
main agent in designing (Kimbell 2011, 2012). A 'fling' so to speak is
being staged with Graham Harman's object-orientated-ontology (OOO),
'thing' versus object (Kimbell 2013; Atzmon and Boradkar 2014;
Marenko 2014). Design concerns for 'co-creation, openness, nonlinearity
and experimentation' are taken to be points of connection to Deleuze's
thought (9), all of which, it should be said, fit nicely into global capitalist
design. Organizational theory under capitalism is questioned, as is the old
hylomorphic adage 'form follows function.' However, no general emerg-
ing problematic is discussed by its authors apart from perhaps Petra Hroch
(2015) who is sensitive to issues of sustainability given the advent of the
Anthropocene. Gilbert Simondon appears as the bridge between Deleuze
and design, which slips into questions related to technology, exploring
Deleuze's general claim that design is not imposed from without, but
emerges within matter (Kearnes 2006). Design and technology begin
to strongly overlap, along with art. However, recent biomimicry where
design and culture are overcome through integration with nature is not
mentioned.[52]

Possible Worlds: Beyond God, Man, World

The *Great Chain of Being* summarizes the ontology at it presented itself in Western thought during the fifteenth century wherein a spiritual hierarchy separated mind, soul and body through a transcendental God, whose idealization was venerated, controlled and reached only by a priestly class in leagues with an equally patriarchal royalty. The story is well known: royalty was eventually to pull itself away and subordinate the Church to its own ends, while a bourgeois class was to eventually do the same to royalty, where in a so-called democratic national state, royalty remained only figureheads, symbolic rallying points to further a semblance of a national identity. This ontological landscape was to change through colonialization and postcolonialization where the figurehead of God became replaced eventually by Man in the twentieth century, and by Global Corporate Capitalism in the twenty-first century. Postmodernism, as a conversation with modernism, and the posthuman as a conversation with the 'human' continue today. The point of this short summary is to raise art and its education in the context of what Deleuze developed in the Appendix section of his book on Foucault (F) called 'Towards a Formation of the Future' the idea of the three deaths—God, Man and World.[53]

The 'death of God' as initiated by Feuerbach (God essentially being the social projection of Man) with Nietzsche carrying out the 'execution,' the event of God's death simply passed on to the 'Man-form.' And, as is well known, Foucault tried to deterritorialize this Man-Form, which, given the state of global capitalist situation, remains steadfast as the hierarchy remains: issues of postcolonialism, feminism, the status of children and the commodification of 'Nature' prop up capitalist economic transcendence for profit. Beyond this, the World has now become 'thing theory,' the heterogeneity of the OOO crowd has established its market share in academia. Each of these 'deaths' has been recuperated. The transcendent God is far from 'dead.' One needs only turn look toward the 'barbarism' of ISIS (Roy 2014). Theology has become 'sexy' again as Spinoza is rethought and the new materialisms grappled with. There are now a number of 'Deleuzians' who are reworking Deleuze's rejection of transcendentalism.[54] Materialist vitalism is experiencing a boom.

Art educators who have formed a 'spiritual' SIG at the NAEA are not Deleuzian in their orientation, but follow what could be called a neo-Romantic tradition where the world-for-us is translated as a transcendental spirituality. Indigenous spirituality brushes up to these developments as

well making 'zoë-centric' and animistic thought reappear in discussions with panpsychism as an overarching concept.[55] As for Man, the gridlock between neo-liberalism and critical theory, left and right, makes sure that little to no 'progress' is made, however that may be interpreted and measured, takes place as the 'society of control' and assures that capitalism has its place. Deleuze|Guattari's minoritarian politics has received all sorts of attention. Yet, when inequalities are exposed not much happens as is so clear regarding the recent migrations of refugees fleeing war-torn cities, while dictatorships linger and the 'royals' in democratic countries celebrated.

As for the World, it is the era of the Anthropocene where Deleuze|Guattari's cosmological imagination gives art and its education its mandate: a commitment to A Life. As Deleuze writes in his preface to DR, 'We believe in a world in which individuations are impersonal, and singularities are pre-individual: the splendour of the pronoun "*one*"— whence the science-fiction aspect, which necessarily derives from [Samuel Butler's] *Erewhon*' (xxi, added emphasis). The splendour of 'one' that Deleuze addresses refers to the univocity of Being, where imperceptibility manifests itself, where subject, ego and self are dispersed into an anonymous 'one,' as such anonymity can accommodate unprecedented pluralism. The indefinite pronoun 'one' refers to multiplicity, and not to, as his detractors say, an opposition to the many, or subsuming the many, or even complexly counting them in some assemblage. The univocity of Being 'is said, in a single and same sense, *of* all of its individuating differences and intrinsic modalities' (DR, 36). It is a clarion call towards a planetary consciousness, or it can be so developed. '[I]t may be that believing in this world, in this life, has become our most difficult task, or the task of existence yet to be discovered on our plane of immanence today' (WP, 75). Given the theoretical flood of the 'dark universe,' it seems the stakes of Deleuze's plea and lament have become more urgent than ever.

In keeping with mandate that Deleuze|Guattari set out in WP, as well as Deleuze in his study of Leibnitz in *The Fold* (TF), art creates *possible universes* that are territorializations of chaos as actualized in the materiality of artworks to form possible consistencies as we enter a cosmic zone. Empiricism becomes transcendental 'only when we apprehend directly in the sensible [A Life] that which can only be sensed [via lived life], the very being of the sensible' (DR, 56–57). Deleuze invokes the notion of fabulation so as to think the unthinkable. If affect is a material change, the percept is the empirical experience implied by this becoming. It is 'creative

fabulation' (WP, 171), or, in relation to Deleuze's cinema, a 'hallucination' or 'vision.' Visions as percepts construct the non-human landscapes of nature, the cosmic forces. It is a perspective ('a kind of superior viewpoint,' WP, 172) that constructs a possible world.

Possible universes are not actual, nor are they opposed to the actual universe. 'These universes are neither virtual nor actual, they are possible, the possible as aesthetic category ("the possible or I shall suffocate"), the existence of the possible, whereas events are the reality of the virtual, forms of a thought-Nature that surveys every possible universe' (WP, 177–178). Thought-Nature is the actualized materiality of the universe said to be 'real.' The actual universe is a possible universe—one among an infinity—that has become 'real.' In brief, A Life is the ontological and genetic condition for every possible world that art creates. A possible world renders A Life sensory, as a being of sensation via its rendering of chaos to a consistency. These possible worlds are co-created with A Life, whereas an actual universe are the ordinary experiences we have of the chaosmos. The possible world through art is able to express what the actual universe cannot. It offers something completely different via *haptic vision*. It should be noted these possible worlds have nothing to do with alternate worlds. 'Perhaps the peculiarity of art is to pass through the finite in order to rediscover, to restore the infinite' (WP, 197). Hence, such a possible world through haptic vision is able to compose chaos in such a way that the quality of expression of A Life becomes visible.

These possible worlds of 'new media,' as developed and extended by contemporary digital technologies, face the same fate and confusion as argued above between affect and affection. Affect, to recall, is a *passive vitalism* in Colebrook's (2010, 115) terms, as the forces beyond the norms and boundaries and lived meanings of the organism, as well as beyond any idealized image, or alienating image imposed on the norm. While affection is the *active vitalism*, which evaluates images and the life of the living organism; all the forces and relations are referenced to the living being, evaluated according to a furthering or alienating the organism's individual sense of life.

Hansen (2000) once again reasserts what he sees as Deleuze's error of misreading Bergson on evolution, maintaining that Deleuze's 'creative involution' based on A Life (passive vitalism) is not agentic enough. Perhaps badly put, Bergson's 'creative evolution' provides an agentic 'drift' in terms of the future of the earth. Hansen places more emphases on the self-organizing autopoietic productivity of the organism itself (follow-

ing Varela), and on the specific effects by the assemblages that are created. Colebrook (2004) has on many occasions pointed out why Hansen's 'signature mistake' needs to be answered by Deleuzians. Deleuze|Guattari's philosophy is not based on biology; it is not biology that is used to explain other strata such as art, language and history. Biology becomes simply one way in which the power of life is manifested; the virtual power of Life is always propelled outside any representational designations, which is why the indeterminate article in *A* Life served Deleuze so well ('a smile, a gesture, a funny face'[56]) for these singularities detached themselves from any possession.

Why is this important for art and its education for those of us who are committed to further exploring the implications of Deleuze|Guattari's call for a New Earth and a 'people to come' (Carlin and Wallin 2014)? Contemporary art presents a challenge to Deleuze|Guattari to a certain extent given their 'modernism,' and there have been Deleuzians who have directly addressed this (Zepke and O'Sullivan 2010). It should be pointed out, however, that art as discussed in WP has little to do with the 'artword' as we know it; that is, in the usual way art functions in art education. Only in rare exceptions, otherwise Deleuze|Guattari do not speak of art in relations to movements, the hierarchy of arts, the usual canons of aesthetic judgement (e.g., formalism), nor the social history of art. Even when they single out artists such as Bacon, Cézanne and Matisse, it is not to periodize them.[57] Their concern is for the *possible worlds* art can fabricate, that is, art's engagement with the world as A Life. What is it that this 'possibility' of art is telling us?

The *possible* of art is often equated with the *imagination* by many Deleuzian inflected art educators (e.g., Hickey-Moody 2013b; Reinertsen 2016), but this is not the 'possible' of Deleuze|Guattari. The imaginary is too closely aligned with perception as attributed to the mind of an individual, and the dominant image of thought. It is closer to stylization and innovation.[58] The possible is fabulation as discussed above. Bogue (2006) has it right when he wrote: 'For Deleuze, the fabulative function is the function proper to art, which projects into the world images so intense that they take on a life of their own' (218). Fabulation in relation to contemporary art needs to be articulated given that the cosmological concerns within the Anthropocene are involved when it comes to this 'possible' for art and its education.

In a series of four carefully constructed lectures as first presented in 2013,[59] Suhail Malik presents a strong charge against contemporary art.

It speaks of the malaise of the contemporary in general where art is subsumed under the global network of galleries tied to corporate interests. 'Contemporary art substitutes the identity-lessness of the present with its own indeterminancy and posits its own meta-generic commonality for the non-unity of the present. It mistakes itself for contemporary art. Contemporary art is a fetish for the present. It replaces the present with an idealization of its unity as indeterminate. Contemporary art is thus not adequate to the present. Contemporary art is contemporary to itself. It configures its own horizon as indeterminate and mistakes the particularity of a specific mode of the now (art) for the non-totality of the now.'[60] The charge is that the historical process that 'defines' art is one of negation. Art continually negates itself (what it is not), which is, as he calls it, an 'anarcho-realist maxim' as the indeterminacy of the present. A dissensus is always required to provide its 'motor,' and the art industry (critics, historians, curators and so on) makes sure that its movement is sustained. Which is why the 'present' is fetishized. 'Contemporary art is a proliferation of differences via the judgment of dissensus [the relativity of democratic opinion]. Contemporary art is a post-negational art. This is why contemporary art cannot contest an injustice. If you contest the injustice you negate the injustice. When it confronts an injustice it produces another dissensus. Thus, it clings to greater indeterminacy.'[61]

I point to Malik's important thesis because art education is in many respects no different as it follows the trends that appear on art's horizon that are then worked into classroom use. The history of art education can easily be traced this way. Art education is caught in a vice, as school bureaucracies demand that assessment be on the top of the agenda. 'School arts' aside, there are all kinds of political reasons as to why the National Art Education Association (NAEA) in the USA has concentrated on setting up standards. This is rather distasteful for those art educators who embrace Deleuze's Artaud's inflected saying: 'to have done with the judgment of God.' Malik does not provide an 'exit' from contemporary art in his last lecture;[62] this may well be worked out in his forthcoming book with the same title as his talks. The 'exit' strategy I would suggest for art education in this age of the Anthropocene is to embrace Deleuze|Guattari's notion of the Cosmic Artisan, which does away with 'art' as it has become institutionalized, but stays true to art as developed in DW, an art that is committed to A Life that this critical introduction has explored. It is in this conceptualization where art, science and technology can come together. I believe this is already taking place in various biomimicry design projects

that work with the Earth, rather than against it (hylomorphism), which generate a possible planetary consciousness, where the public is involved as not only witnesses but also active participants (Benyus 2002).

The Cosmic 'Posthuman' Artisan

Art and Its Education in Anthropocentric Times

A 'dark Deleuze' has been proposed,[63] one where A Life becomes a dark ecology presenting the musings of a world-for-itself. It is a speculative realism where the OOO crowd in all its heterogeneity (Ray Brassier's cold scientism, Graham Harman's 'allure' of non-relational objects, Tim Morton's 'strange stranger,' Ian Hamilton Grant's 'nature after Schelling,' and Levi Bryant's 'machine-orientated ontology') come together to fabulate, not the light, but the dark, much as François Laruelle has done with his stance of non-philosophy.[64] One comes up against a 'planetary dysphoria,' as Apter (2013) 'aptly' characterizes it, a requiem for an 'our' dying planet as the Planet itself does not 'care' whether our species lives or dies.

Given the projections of the Anthropocene, the impending bio-horror on a planet where our extinction is probable preoccupies the dark Deleuzians. The challenge is laid out by Thacker (2010a): *'Can there exist today a mysticism of the unhuman, one that has as its focus the climatological, meterological, and geological world-in-itself, and, moreover, one that does not resort to either religion or science?'* (133, original emphasis). The closer the embryonic state, the more likelihood of 'pure and simple terror' (WP, 175), write Deleuze|Guattari as an uncanny possible world opens up. The possible world of a dark ecology fabulates a 'people-to-come' that may end in extinction. It is an end game with the realization that we are but a hick-up in terms of Earth's time, liable to disappear as many species have before us; there is nothing here to privilege the human except to explore the current species death drive made probable through continued capitalist exploitation. In his 'Preface to the Original Edition' of DR, Deleuze again refers to God, Man and World, but as a lament that the work was not 'apocalyptic' enough. 'What this book should therefore have made apparent is the advent of a coherence which is no more our own, that of mankind, than that of God or the world. In this sense, it should have been an *apocalyptic book* (the third time in the series of times)' (DR, xxi, added emphasis). The possible fabulated worlds of dark Deleuzians have begun to do just that.

Perhaps the work of Ian Bogost (2012) in his 'alien phenomenology'[65] (considered part of OOO) provides another way of articulating A Life wherein anthropocentrism is at least somewhat muted, although not 'entirely' erased as that is an impossibility. Yet the world-in-itself is speculatively explored through an extended phenomenology that exceeds the human. Bogost offers a return to things themselves rather than a phenomenological world-for-us; this becomes a world-of-a-thing, which is somewhat of a refinement along the same course of thought as Bruno Latour's actor network theory (ANT), which considers how objects emerge from the relationship between things. Yet, Bogost's possible world has a number of advantages that are appealing. It generates the wonder of things, not necessarily the psychological phenomenon of 'empathy,' although empathy and compassion are not ruled out, but wonder that takes us outside ourselves that requires a 'haptic eye' to fully articulate, a trait of the cosmic artisan. There is no exploitation in this but anthropological in its intent without the baggage of 'anthropos' (it is anthro-de-centric). The 'object' looks back, as it is now grasped in its own ecology, which has the artisan sensibility about it (as developed below). In this sense Bogost is following Jakob von Uexkull's ethology, as did Deleuze|Guattari. Bogost's alien phenomenology is reminiscent of the Deleuzian Paul A. Harris (2005, 2009) work as well, where wonder is evoked. The point is that no entity is reducible to perception. Haptic vision as an anthro-de-centric gesture is recognition that excess (the dark) is always there. Wonder points to the sublimity of the Cosmos, which is the great strength of Harris' Deleuzian 'research.'

Of the entire OOO crowd, Levy Bryant (2014) is closest to Deleuze|Guattari with his 'machine-orientated ontology' (MOO). His vital materialism provides touchstones to what a Cosmic posthuman ontology might become in the possible world that is engendered. The non-relational aspects of singular entities are developed by Levy Bryant's (2011) account of 'perturbation' to grasp how objects relate to one another and generate atmospheres. Bryant obverses Hansen's reliance on autopoiesis and addresses inorganic objects as being allopoietic objects, that is, objects that are 'selectively open to their environments' (167). Translating Spinoza, he calls this mode of selective relation 'perturbation.' It is the ability for aspects of one object to affect another in some basic way. A 'technical' object understood as a complex allopoietic form has the capacity to respond to these perturbations with perturbations of its own. This generates atmospheres in the sense that objects can perturb different

entities in ways that alter those entities and their capacities. So objects create atmospheres, 'affective atmospheres' more precisely, which shape the conduct of other objects within those atmospheres. Here the Deleuzian traces can be detected as affordances and affect belongs neither to the object nor to the subject but emerge from an encounter. These qualities of objects, it is maintained, are only partially selected or disclosed in an encounter. Excess always remains. What emerges is a duration and space (percept) in the specificity of the encounter.

Atmospheres, as they appear in Bryant's MOO, can be equated to Deleuzian haecceities.[66] Returning briefly to Hansen (2011) once again, in a section titled ' From Media Temporal Objects to Sensory Atmospherics,' we are in a better position to grasp how science, art and technology must come together without the annoyance of emphasizing one-sided human embodiment as correlationist interactions between subject|object when exploring today's condition of the Anthropocene via postconceptual art.[67] Hansen refers to the oeuvre of German artist Tobias Rehberger whose installations I would say are exemplary of atmospheres that generate haecceities (blocs of percepts and affects) that exemplify the being of sensation. Rehberger's installations are sensory-light-environments where images are treated as temporalizations of light, and hence 'images are not a function of light, but of time. Images arise only as a function of the brain's ability to contract and distribute temporal matter' (Bloom 2007, 104).[68]

Hansen makes the point that these sensory light installations, made possible via digitalized technology, present the duration of sensation as images that, in effect, coincide with the microtemporal sensory flux, which, following Zeki, comprises the materiality of human experience. Our brains assemble the elementary rhythms, patterns of light, colour and motion to generate images. In short, *prior to the image is time*. This is not chronological time, but time as non-time (Aion).[69] If this is the case we are into the dark or 'Hermetic Deleuze,' as Joshua Ramey (2012) maintains. Such transcendental processes happen to the subject. For Deleuze this is a passive process, embodied to be sure. However, the subject is then subjected to two further synthesis of time: that of memory and the eternal return of difference, opening up an unknown future. Hansen admits that Rehberger's work 'attests to a fundamental Being of the sensible that imperceptibly informs conscious perception' (103).

In this sense, Rehberger's installations follow the tracks of the light installations of James Turrell, which present a direction that dovetails into François Laruelle's non-philosophy of 'radical immanence.'[70] Oddly,

I would say, we are led to the meeting place of Deleuze|Guattari and the work of Francois Laruelle who is also fixated on the 'dark universe.' 'Vision is foundational when it abandons perception and sees-in-the-night.'[71] Such a vision I would equate with Deleuze|Guattari's haptic vision or the artist's commitment to A Life as the vocation that art educators should take. As Alexander Galloway (2014) comments on Laruelle's aesthetics: '[V]ision is never vision when the lights are ablaze. Vision is only vision when it looks avidly into the pitch black of night. Likewise art will never be art until it ceases to represent and begins to look into the Stygian monochrome, that blackness that has yet to be exposed to any living light' (136).

Light and Dark appear to cancel each other out in this view.[72] We are on another Planet in relation as to where art and education are today. Yet this is the proposal of this critical introduction. In the Anthropocene age, this is the work of the Cosmic 'postmodern artisan.' Deleuze's challenge was to develop a 'sci-ph'[73] (a cross between science and philosophy). It is no surprise that Laruelle also calls himself a science-fiction philosopher.[74] To complement 'sci-phi' is the 'art-sci' of the cosmic 'posthuman' artisan. Dark Deleuzians in this regard should not be dismissed but recognized for the 'utopian' project that Deleuze|Guattari call for in the possible words they fabulate and fabricate. As Ian Buchanan (2000) put it, 'the most deeply utopian texts are not those that propose or depict a better society, but those that carry out the most thoroughgoing destruction of the present society' (94) that call for total critique as total deterritorialization.

Art and its Education Yet-to-Come

The Cosmic artisan, as presented in TP, shifts the usual understanding of the artist as defined by the global institutions of art where the artists seeks to represent the world, or represent a nation, or to express themselves, but this is not to say that Cosmic artisans are not found in the art world per se; they exists as singularities.[75] Their commitment, as Deleuze|Guattari maintain in WP, is to '*summon forth a new earth, a new people*' (99, original emphasis), as such a people do not yet exist, but are about to come. This means a complete deterritorialization of the Earth for-us via a geo-philosophy; the 'future' Earth and people are then sites for reterritorialization. In this sense, Deleuze|Guattari present a 'utopian' discourse as they ask the artisan to engage with the negation of topos, the limits of current imagined spaces in the untimely present of the Anthropocene. And, as

Lambert (2005) reminds us: 'The earth [...] as Deleuze and Guattari have remarked many times, does not have a future, but only a 'becoming' (or many becomings)' (237).

The dark Deleuzians are as much Cosmic artisans as those of the Light as both draw on the forces of vitalism.[76] The Outside, after all is 'dark,' dark cosmic holes exist; light is both refracted and reflected—*Lux and Lumen*—transparency and opacity (Galloway 2014, 140). The Cosmic artisan, as Deleuze|Guattari develop this trajectory, follows the flow of cosmic forces and intensities. Both Joshua Ramey and Janae Sholtz (2015) have extensive discussions on the Cosmic artisan. The point to be made is that this is *not* an out-of-the-world practice; it is just the opposite: it is to reveal, expose and experiment to show that the cosmic is of this world. Given that this world-for-us is dominated by the screen and the precarity of human survival, which form the real conditions of the world-for-us, those artist-artisans who are both fabulating and fabricating possible worlds via technology, science and art within a postconceptual frame may be said to be nomadic in providing an 'exit' from contemporary art in Suhail Malik's terms, not one of escape, but a creative exit. The nomad in Deleuze|Guattari's conception happens in its place(s), it is not necessarily movement per se as traditionally thought, it is a specific movement in terms of occupying a 'smooth space' for as long as it remains creative (TP, 482). This is all the more important as technologies have been harnessed for capitalist ends.

The forces that are harnessed as a commitment to A Life, a New Earth, and a people-to-come require the coming together of technology, science and art. It is a question of deterritorializing this world-for-us to face the forces of the Earth that may do us in. Yet, in WP, Deleuze|Guattari place this 'force work' of deterritorialization in order that the generic ideas of 'the human' are imperceptibly transformed. Such artists are 'anomalous' as they create a Being of sensation that has not been released into the world-for-us. But here incompossible worlds are made possible, as opposed to the usual ability of art that allows us to understand the perspective of others: the emic view of anthropology via novels and the like. The anomality of the Cosmic artisan is charged with creating new arrangements of the virtual, a much more difficult task.[77]

The cosmic 'posthuman' artisan today for Janae Sholtz (2015), in what is a remarkable narrative of exploring a people-to-come, would be those artists who inherit the spirit of Fluxus.[78] She carefully articulates as to why Fluxus experimentation answers to Deleuze|Guattari's call for an art

form that introduced new affects into the world in such a robust way. Art education based on Fluxus at the time would have been impossible. But, now many of the Fluxus 'antics' have entered the arts curriculum as projects where their vitalism has been captured, and in many cases evaluated. Yet, I do agree with Sholtz's assessment, but to add that the inheritors of Fluxus are the postconceptualists today that can, as cosmic 'posthuman' artisans, address the dystopia we are in: the Anthropocene. My feeling that a new art and a people-to-come can only be carried out by 'an avant-garde without authority,'[79] a heterogeneous network of artists who address the Anthropocene,[80] each a singularity spread across the arts. Art, science and technology must come together to offer a postrepresentational or a postconceptual or non-representational logic to open up a gap within our habituated anthropocentric world to change human intensity so that a belief in the world can still emerge. I offer one brief example to illustrate. This is the oeuvre by Olafur Eliasson. However, I will only quickly dwell on his well-received, *The Weather Project*, and mention briefly how his other projects explore this non-representational multiplicity regarding climate change to give us a being of sensation.

The Weather Project was installed from 16 October 2003 to 21 March 2004, at the large Turbine Hall of the Tate Modern in London as part of their Unilever series that began in 2000. Eliasson called it a 'machine' or diagram in Deleuze|Guattari's terms, an abstract machine the entire space of the Turbine Hall (155-m long, 23-m wide and 35-m high). This space became doubled by the mirror ceiling that was part of the installation. On entering the Hall, the visitor faced a huge large setting sun at the far end that dominated the whole space. The installation's atmosphere gave visitors a feeling of tranquil wholeness and completeness. The calm of a setting sun created this cozy familiarity of a hazy late summer afternoon. However, the audience soon became aware of the construction of the experience, the space, the ambience, the warmth and the haze; they became aware of the construction of the *atmosphere*. Yet, it was not London's winter outside that *perturbed and de-framed* this illusion.

The indoor sun already revealed its technological construction: a screen and an array of orange mono-frequency sodium lamps that were positioned behind the screen, but not completely covered by it. The screen forming the 15-m solar circle was simply a translucent semicircle; its flat upper section was flushed against the ceiling mirrors, the reflection creating the top half of the circle. This uneven juxtaposition created a shimmer of a forever setting sun, as if time was arrested in the present. The ceiling

mirrors reflected the whole floor of the Hall, and those visitors who stood on it. The atmospheric haze was controlled by pumping water vapour into the Hall. This created a mist that dissipated periodically. All 16 nozzles, the piping, and the pumps were visible. There was no attempt made to conceal them. All the construction of this space was visible: steel, concrete, glass, electric wiring, artificial temperature and humidity, and so on to create this atmospheric experience.

The installation was an astounding success as more than two million visitors came. It became famous as images of the audience reacting to and interacting with the installation became available. Visitors basked in the sun by lying on the floor as if on a beach, which gave them contact with the ceiling mirrors seeing themselves from a new angle and so on. *The Weather Project* formed a representational inversion of the naturalized order of things. The 'natural word' went indoors. Bruno Latour at that time wrote that, like the reversal that the diagram of *The Weather Project* made evident, global warming had placed us in Nature's own indoors permanently, a similar reversal our species found itself facing.

The Weather Project questions our ideas of nature and its representation, and the way they are assembled by our perceptual selves, our institutions, museums, galleries, the media and society in general. It vivifies our anthropocentric biases as a world-for-us. The experience of the audience was not disconcerting; in fact, it was just the opposite, not a dissensus as is usually thought. Bathing in the sun, visitors experienced the exposed entrails of the artificiality of the natural. Eliasson constructs an abstract machine that, in the first moment, is phenomenologically pleasant and soothing. But, in the second moment, it reveals what sustains that experience—the visibility of the technical setup of the installation that makes the shift to the second moment inevitable, but reversible only to a limited extent. Conceptually, once this shift has occurred the second moment immediately interferes with the return to the first. It is not the same phenomenological space any longer. Returning to the first has now to be a conscious decision. In this way the multiplicity of layers of just what the installation is 'doing' is replicated in the viewer's mind.

Eliasson's diagram positions the viewer in this vibrating gap to stir up an event; notice that this event 'happens,' it is incorporeal, impassive and impersonal, enabling the phenomenon of 'seeing yourself seeing' as perceptual representation is disturbed and the unthought opens up through a machinic aesthetic that is able to deanthropomorphize experience by wedging itself between subject and object, a third person neutral position. Through this subjectification, a new subject is produced. Eliasson invites

the visitor to reflect on the perception of nature and on the nature of perception. But it is technology that inserts itself between object (unknown Nature) and subject (the visitor) staging an encounter, an event. While the technology here does not include digitalization, I would maintain, especially in film, this same gap to the Outside of thought can be opened up rather than the visitor being usurped into the frame. It is precisely in disturbing cause and effect, which allows the unthought to emerge. This thought is contingent but it presents a grasp as to what learning is in terms of a creative becoming according to Deleuze|Guattari. *Like Alice, the visitor becomes bigger than she was, yet smaller than she is now.*

Eliasson has developed many other machinic installations as examples of postrepresentational postconceptual assemblages (in this case human and inhuman assemblages) that explore this gap, of seeing yourself seeing in different ways, playing with different non-human times, all immanent in their exploration of questioning the world-for-us. He reiterates a Baroque complexity of vision by exploring the human perceptual system of subjective seeing via a machinic vision. *The Weather Project* is an exploration of upward reflexive vision, but this is one of many including downward vision, frozen vision, afterimage vision, perspectival shattered vision, hyperreal perspectival images, relative position image and so on, all investigated through a host of abstract machines of his invention. Thus science, art and technology come together in achieving this postconceptual aesthetic. Eliasson is an exemplary Cosmic 'posthuman' artisan in his creative endeavour, who like a great teacher, is an emitter of signs.

All this is to say that the essays in this collection address in their own way A Life.

* * *

The book is divided into three parts. The first part, 'Styles of Deleuzian Pedagogy' consists of six essays. Each essay is a singularity in the way Deleuze|Guattari's concepts are taken up in art education. Each author presents a style in his own right. To follow Flaxman (2011) here on Deleuze's style: 'Style is this supplest of lines, the one that passes through every series, that traverses the surface of concepts, and that draws together the philosophical plane, the plane of immanence, as a plane of *consistency*' (10, original emphasis). And, this consistency always harbours an inconsistency as style is never complete. Charles Garoian demonstrates what 'signs' are for Deleuze|Guattari, and how educators are able to respond to them and be affected by them. This is followed by Jack Richardson,

whose experimental class style clears a smooth space in his institutional setting so that his students are able to invent and create what appear to be outrageous disturbances in normative perception, reminiscent of Fluxus. It ends with Dennis Atkinson's exploration of what precisely is 'learning' if we take Deleuze|Guattari seriously, and what might education become if we do so. All three art educators have taught art in public school and higher education for many years. The depth of these essays shows their commitment to art education students as they embrace their learning environments.

The middle section is a long meditative essay by John Baldacchino. It performs an 'Intermezzo' in this collection, a link between the two sections. Not strictly directed at Deleuze or Guattari, Baldacchino's sweeping essay is an example of grappling with art and its education outside its current formulations; as such it is a performative exploration of the Outside as well, true to Deleuze|Guattari's spirit of a line of flight that tries to affect its readers to thought that is as yet unthought. It is a tour de force of such inquiry.

The last section 'Deleuzian Projections' has two essays: Jessie Beier and Jason Wallin and my own. Jessie Beier and Jason Wallin query the world-for-us that art and its education never cease to promote; together, they bring out the implications of what does it mean to think the world-without-us, and hence draw on aspects of what I have called the 'dark Deleuze' in this introduction. In my essay, I present a further 'betrayal' of the field in raising questions as to its current performances under the Deleuze|Guattarian banner by answering carefully two critics who have taken *Arts Based Research: A Critique and a Proposal* to task. I then question whether the postqualitative developments fare any better when drawing on Deleuze|Guattari, and end with a turn to the cosmic in Deleuze|Guattari, a projection that my introduction has explored.

We hope that these forays into Deleuze|Guattari and art education will open up new thoughts, irritate some, but in general promote a discussion on issues of art and its education in what are precarious times.

NOTES

1. Readers of WP include Elizabeth Grosz (2008), *Chaos, Territory, Art: Deleuze and the Framing of the Earth*; Rodolphe Gasché (2014), *Geophilosophy: On Gilles Deleuze and Félix Guattari's What is Philosophy*; Joe Hughes (2008), *Deleuze and the Genesis of*

Representation; Mathais Schönher (2013), 'The Creation of the Concept Through the Interaction of Philosophy and Science and Art'; Rex Butler (2016), *Deleuze and Guattari's What is Philosophy?*; and Jeffrey A. Bell (2016), *Deleuze and Guattari's What is Philosophy?: A Critical Introduction and Guide.*

2. See Arkady Plotnitsky (2006), "Chaosmologies: Quantum Field Theory, Chaos and Thought in Deleuze and Guattari's *What is Philosophy?*" Plotnitsky theorizes chaos in relation to quantum physics throughout his writings.

3. Fabulation and imagination appear synonymous; however, imagination and intuition already make things difficult as both can be psychologized. I prefer fabulation, a Deleuzian term which I explain further on in this introduction.

4. *C2*, Chap. 6, 126–155.

5. Her periodizating includes 1) the intensity of the sign, 2) sociopolitical interventions (with Guattari), 3) ethology of culture, and 4) creativity.

6. A Life, capitalized here with the indefinite article, serves as an index of the transcendental. See also Agamben's (1999) "Absolute Immanence" for one explanation of Deleuze's use of the indefinite article.

7. Claire Colebrook (2010) in *Deleuze and the Meaning of Life* makes the same distinction via an active vitalism (bios) and a passive vitalism (zoë). The terms zoë and bios have been popularized more by Rosi Braidotti (2013).

8. I make a distinction between *in*human technologies and the usual designation of *non*human to an organic life (or inorganic life). See also Leslie Dema (2007) for further clarifications.

9. In *DR*, Deleuze writes that "It is strange that aesthetics (as science of the sensible) could be found on what can be represented in the sensible [...] Empiricism truly becomes transcendental and aesthetics an apodictic discipline, only when we apprehend directly in the sensible that which can only be senses, the very being of the sensible: difference, potential difference and difference in intensity as the reason behind qualitative diversity" (57).

10. On the historical question of the "and" or ampersand (&) between them, see jagodzinski (2010a), *Visual Art and Education in an Era of Designer Capitalism*, 41–56.

11. For a review of this development, see jagodzinski (2010a).
12. Just to qualify my reference to "therapeutic": Deleuze and Guattari's proposal is therapeutic but in quite a different sense than in the ordinary sense of "art therapy." For them art is therapeutic in that it offers a way to counteractualize events in one's life. See Lorna Collins (2010).
13. I draw the German distinction between *Macht* and *Lassen* from Krzysztof Ziarek's (2004) *Force of Art*.
14. This will be clearer when I later discuss the recent developments of neuroaesthetics.
15. For an articulation of Deleuze's concept of Ideas, see especially Daniela Voss (2013), *Conditions of Thought: Deleuze and Transcendental Ideas*, especially Chap. 3, "Ideas as Problems" (143–202).
16. On "arting" as a process, see jagodzinski (2007).
17. Deleuze's inspiration comes from the writings of Maurice Blanchot, Erwin Straus, and Henri Maldiney (see Screel, 2014).
18. One begins to comprehend the range of this entrepreneurship by reading the responses to a questionnaire, "What is Contemporary Art" sent to the most influential voices in the art world by Hal Foster and the Editors of *October* (Fall, 2009). As for the hegemony of curatorship, see for instance Paul O'Neil and Mick Wilson (2010) eds., *Curating and the Educational Turn*.
19. In the course I teach on Deleuze and education called "The Pedagogy of Desire," the syllabus has more than 200 articles and more than 20 books on this topic as literature students can draw on that directly address this topic. Guattari's work has only begun to be taken up by educators. The extraordinary exploration and commentary on Guattari oeuvre has been through the efforts of Gary Genosko who has recently put his efforts toward education.
20. Bogue (2004, 2013) is best on this, but also Drohan (2009, 2013) has a good handle as to the function of signs in Deleuze's philosophy.
21. Outside is a difficult term since there is no "outside" per se. It is a convenient way to point to an impossible-Real, or better still to avoid this Lacanian inflection, pure chaos. Paradoxical terms such as "groundless ground" or "given without givenness" would be synonymous expressions.

22. By "contractions" and "contemplations" that are self-"preserved," I am referring to the so-called passive synthesis of sensations that take place in the first synthesis of time. There is an "enjoyment" by this "subject of *inject*" who contemplates. Deleuze and Guattari discuss this development in WP, 212–213.

23. Among the many, Barbara Bolt (2004) and Anna Hickey-Moody (2013a) stand out in the Australian context where affect plays a prominent role.

24. The most recent collections of essays include Clough and Halley, eds. (2007), *The Affective Turn*, and Gregg and Seigworth, eds. (2010), *The Affective Reader*.

25. For the distinction between aesthetics and aisthesis in relation to art education, see jagodzinski (2010b).

26. Massumi's political understanding of affect is presented via a number of interviews. See Brian Massumi (2015), *Politics of Affect*.

27. This has nothing to do with "visual literacy" as is often thought. Visual literacy (coming from the field of linguistics and signification) would be closer to how Deleuze and Guattari understand everyday perception.

28. Zourabichvili (1996, 191) clarifies the only "seeming" proximity with Merleau-Ponty's phenomenology, especially in the posthumous work *Visible and the Invisible* where invisibility also refers to life forces. The main difference is that, unlike Merleau-Ponty's 'flesh,' which deals with essences, Deleuze theorizes the wound (see Reynolds, 2007). Zourabichvili points out that the forces are relational in Deleuze's case; they are 'reversible,' subject to intensity and evaluation as to which life is manifested. In Merleau-Ponty's case there is no mention of relationality of forces; rather, a qualitative phenomenon is posited.

29. This is my claim what a/r/tography does in chapter 9 of thus collection. See also jagodzinski and Wallin (2013) for an in-depth review. I feel the same slippages into a humanist discourse in the collected essays by Reinertsen (2016). Perhaps this is unavoidable as it is difficult to think otherwise.

30. For a close examination of Damasio and LeDoux brain research in the context of resistance in education using a Lacanian and Wilfred Bion lens, see Marshall Alcorn, Jr. (2013).

31. I refer to the well-known development of 'premediation' by Richard Grusin (2010). Also the work of Mark Andrejevic (2013)

addresses many of these concerns raised in this section on affect and the brain (especially Chap. 6, 'Neuro Glut: Marketing the Brain').

32. Riffing on the five propositions on the brain by Gregg Lambert and Gregory Flaxman (2000-02) in the short-lived *Journal of Neuro-Aesthetic Theory*, the idea here is that the brain for Deleuze and Guattari is one manifestation of many. It is not theorized in 'human' terms but in relation to speeds and intensive states. It is no longer a topographical brain with spatiotemporal coordinates; rather, it is a virtual brain, a plane that provides the conditions for space and time, thereby actualizing the virtual. Its plasticity is shaped both by *in*human brains (i.e., cybernetic, technological and computer) and by nonhuman, nonorganic brains through involutionary and evolutionary processes.

33. This is Patricia Pisters claim (2012, 110–111). Feelings as discussed throughout TP are particularly viewed as psychological states.

34. 'What is the relation between the work of art and communication? None whatsoever. The work of art is not an instrument of communication. The work of art has nothing to do with communication. [...] To the contrary, there is a fundamental affinity between the work of art and the act of resistance. [...] It has something to do with information and communication as act of resistance' (Deleuze, 1998, 18).

35. There are new speculations as to how the plasticity of the brain is changing with the new technologies. For example, see Susan Greenfield (2008), *The Question for Meaning in the 21st Century*; Maryanne Wolf (2007), *Proust and the Squid*; and Nicholas Carr (2010), *The Shallows: What the Internet is Doing to Our Brains*. While these works are often speculative projections, such explorations are essential.

36. See Andrejevic's (2013) interesting study of neuromarketing the brain in *Infoglut* on a more superficial less technical level.

37. For all of Jacques Rancière's (2004) posturing and questioning Deleuzian aesthetics as a road to 'hysteria,' 'schizophrenia' and 'madness' as the artist seeks journey toward justice in undoing the world of figuration and doxa, such a journey is in accordance with his own dissensus, but the vocabulary changes (e.g., Deleuze's doxa and figuration could be synonymous with Rancière's Police

state); his well-known 'partition of the sensible' synonymous with a minority politics that undermines the Police state. Rancière does not seem to get that the allegorical use of the Deleuzian 'desert' is another name for the Outside wherein the forces of Life are made visible. The political question, however, remains unsolved between them. Minoritarian politics (fabulation) would have aesthetic particularity, changing or intervening in the political generality of the molar. Does Rancière's dissensus model follow? Or, is it confined to a logic where aesthetic generality that enables a political particularity (Police state) is only changed through yet another political generality (a meta-politics) that then distributes the sensible? Politics in the latter sense would not simply be a 'disagreement' but a revolutionary change.

38. Throughout my own work I have used this grapheme to distinguish this Deleuzian take of affect and percept from the naive notions of mirror doubling (reflection) and poststructuralist decentering of subjectivity (reflexion).

39. Interpassivity is developed by Austrian philosopher Robert Pfaller (2003) and put to good effect by the writings of Slavoj Žižek.

40. Deleuze's study on Bacon (FB) shows how his figures express and are BwOs. Art (painting in this case) has its figures, while philosophy has its "conceptual personae" and science its formulations. Figures (or haptic visions) express the indiscernibility between the sensed and the sensing, between the organism and the BwO. There is an infinity of levels and rhythms between the two that express the actions of force on the body, that is, the BwO. The figure in this case is an affect ('nonhuman becoming of man').

41. Embodiment for Hansen is understood from a neuroscience viewpoint, basically that of Francisco Valera 'as inseparable from the cognitive activity of the brain' (2004a, 2).

42. This has become more evident in his most recent work *Feed Forward* (2015) where he addresses the work of Alfred Whitehead, who has taken on so much recent academic energies (Isabelle Stengers, Steven Shaviro, Brian Massumi, Luciana Parisi and so on), dismissed of the usual Deleuzian appropriations, with phenomenology coming to the fore as Husserl's later work on time is reworked.

43. This misreading of Deleuze goes back to his dispute with Richard Rushton. The exchange is worth reading as Rushton does a mas-

terful analysis as to just how Hansen's take on Deleuze's affect as discussed in C1 benefits his own position. See Rushton (2004), Hansen's reply (2004b), and Rushton's (2008) summative counter.

44. The idea of probe-head is developed in TP, explored by Simon O'Sulivan (2006) in its capacity for subjectivity to become anomalous.

45. Patricia Pisters (2012) also admits to this difficulty in her discussion of the neuroimage throughout her second and third chapters.

46. No doubt because of grant(man)ship pressures, a number of books have now been published that present various 'methodologies' for research based on Deleuze and Guattari oeuvre (i.e., Coleman and Ringrose, 2013). The approaches are heterogeneous and diverse leaning closer to models of qualitative research, now being called postqualitative research. Hickey-Moody's (2013b) 'Affect as Method: Feeling, Aesthetics and Affective Pedagogy' is a good example of the collapse between incorporeal affect and embodied affection even though Spinoza is being called on to make distinctions. Yet, throughout the essay one reads many slippages. 'After Spinoza,' she writes, 'Deleuze believes the materiality of sensation is the part of our imagination g*rounded in our body*' (82, added emphasis). This is a half-truth only, for such claims simply 'phenomenologize' Deleuze and Guattari's machinic philosophy. The work is riddled with emotion as an embodiment, collapsed with feelings. For a questioning of such approaches, see jagodzinski, Chap. 9 in this collection.

47. In moments of his most vicious (and funny) attacks on Deleuze (make that Deleuzians), in what he claims to be an 'encounter' rather than a dialogue, Žižek makes fun of 'yuppies' reading many of the concepts in WP in such a way 'that [could easily] justify calling Deleuze the ideologist of late capitalism' (2004, 183–184). Žižek has a point when 'affect' slips easily into affection, which is precisely what neuromarketers have done: 'the *communication* of affective intensities beneath the level of meaning (183)' (my emphasis on (t)his word) turned into the algorithms of big data to target emotion, and so on. 'Communication' being the operant word, which is easily instrumentalized. This is not 'Deleuzian' articulation of affect. Sadly, one can find many articles now written

by academics housed in management and business schools who have appropriated Deleuze and Guattari's ideas, especially on creativity, to further entrepreneurship and even management efficiency through assemblage theory.

48. Perhaps an exception, Christian Beighton (2015) in his meditative study Deleuze and lifelong learning ends his book on the need for counteractualization in education. But, counteractualization is not just a human endeavour; animals counteractualize as well. They modify the salient features of their environments and themselves; for instance a population can modify its behaviour and discriminate a response to their predators thereby counteractualizing the virtuality of the predatory population.

49. Percepts and affects are 'completely complementary' (WP, 182). Percept constructs the virtual, chasomic plane of forces, which are 'expanded to infinity' (WP, 188). Percepts provide the plane of consistency composed by the forces of matter. Affect, therefore, simultaneously actualizes this plane, a material becoming through subjectivation.

50. Bogue's (2006) wonderful study of fabulation confirms or rather reiterates the important claim that percepts and affects are nonpersonal and nonhuman becomings. Only art preserves.... 'Percepts can be telescopic or microscopic, giving characters and landscapes giant dimensions as if they were swollen by a life *that no lived perception can attain*' (WP, 171, added emphasis).

51. The ampersand between art and design emerges in the nineteenth century. I explore this in jagodzinski (2010a). Research and development at the twentieth century separated pure science from applied technological sciences. These developments have now collapsed.

52. The literature is vast in this area. Biomimicry is championed by Janine Benyus (2002), who offers many examples of design that use Nature as a guide. She offers a redesigning of the world based on the designs of Nature. The Brute force of design (hylomorphism) is being replaced by biological design (bioengineering, bioenergy and so on).

53. These next two sections are inspired by Greg Flaxman's (2011) discussion in his Coda on the importance of fabulation (sci-phi). He is interested in the intersection of science and philosophy when it comes to science fiction; in this section, I am interested in the

intersection between science, art and technology in relation to the Anthropocene and the world-without-us as the future of art education. This section builds on two previous attempts of a 'cosmic Deleuze' (see jagodzinski 2014a, b). I am also indebted to Janae Sholtz for her own forays into this realm. See Sholtz (2015) and her recent presentation for the Anthropocene, Ecology and Pedagogy: The Future in Question (2016, YouTube posting in progress, https://www.youtube.com/channel/UCiYpb7adp3lvjdi-F8RktrQ)

54. To name the most prominent: F. LeRon Shults (2014), *Iconoclastic Theology*; F. LeRon Shults and Lindsay Powell-Jones (2016), *Deleuze and the Schizoanalyis of Religion*; Brent Adkins (2013), *Rethinking Philosophy and Theology with Deleuze: A New Cartography*; Kristien Justaert (2012), *Theology after Deleuze*; Patricia Haynes' (2014) *Immanent Transcendence: Reconfiguring Materialism in Continental Philosophy*; and Sam Mickey (2015), *Whole Earth Thinking and Planetary Coexistence: Ecological Wisdom at the Intersection of Religion, Ecology, and Philosophy*.

55. My own efforts at analysis of art and spiritualism can be found in jagodzinski (2012) and (2013).

56. 'The indefinite is the mark not of an empirical indetermination but of a determination by immanence or a transcendental determinability. The indefinite article is the indetermination of the person only because it is determination of the singular' (Deleuze, PI, 30).

57. 'In no way do we believe in the fine-arts system: we believe in very diverse problems whose solutions are found in heterogeneous arts' (TP, 300).

58. I say this despite Massumi's claim: 'Imagination is the mode of thought most precisely suited to the vagueness of the virtual' (Massumi, 2002: 134). In DR (71–72) Deleuze's discussion of imagination as a contractual phenomenon in relation to Hume provides him with his first passive synthesis of time as the repetition of habit. Imagination certainly creates a possible 'future,' but a future of repetition that needs to be immediately overcome via the second synthesis of time (that of the past, memory and the necessity of reflection). It is the third synthesis of time of the eternal return that presents the future proper and closer to fabulation than that of imagination, which remains psychologically subjective.

59. Available on YouTube. The book is scheduled to come out in 2016 by Urbanomic press. Malik presents 6 defining characteristics of contemporary art: 1. It asks probing questions without resolution; 2. Its addresses are nondeterminate and anonymous; 3. It has no criteria or universal standards (there can be an appeal to external authorities); 4. It is singular, that is, it operates per artwork; 5. It has a generic commonality in its determinacy; 6. It is a meta-genre without identity.

60. From Malik's first lecture: Exit not escape – On The Necessity of Art's Exist from Contemporary Art (4. Institution). *YouTube*, June 14, 2013.

61. Ibid., See also an earlier reiteration of some of his lectures themes in 'The Wrong of Contemporary Art' (2011) written with Andreas Phillips in a collection exploring the work of Rancière.

62. In the earlier work with Phillips the one example that is enthusiastically embraced was Hirschhorn's *Monuments*.

63. Explicitly so stated by Andrew Culp (2014) in his 'Anarchist Without Content' blog. As also explored by Ben Woodward (2013), Negarestrani (2008), Thacker's (2010b) 'dark pantheism' (as opposed to theological pantheism), and MacKay's (2012) 'geo-trauma.' For a review, see Apter's (2013) 'Planetary Dysphoria.'

64. There has been a boom of books translating Laruelle's philosophy into English, although his non-philosophy is almost impenetrable in the original. For a good readable overview, see Ian James (2012), *The New French Philosophy* (Chap. 7, 'François Laruelle: Beginning with One').

65. There are a number of philosophers reworking the phenomenological position. Tom Sparrow (2013) and David Roden's *Posthuman Life* (2014), which develops 'dark phenomenology' as speculative posthumanism. Thacker (2014) develops 'dark media' in *Excommunication*, a book co-authored with Alexander Galloway and MacKenzie Wark.

66. But again, all these OOO developments of "thing theory" are subject to capitalist exploitation. The geographer Ash (2013) develops the atmospherics of the iPhone 4, which is meant as an example to grasp how the complex technological devices shape the environments in which humans live. Such explorations become part of R&D in companies such as Apple and Google in the future so that

human and inhuman (as technologies) interactions will be better understood.

67. The reference is to Hansen's (2004a) forwarding the "virtualization of the body" by new media, which is the provenance of the phenomenological subject. I would see this as slippages into affection.

68. Hansen's discussion of Tobias Rehberger is indebted to Ina Bloom's (2007) *On the Style Site: Art, Society, and Media Culture.*

69. This should not be surprising. Time is also related to vibration and hence the metaphysics of String theory.

70. Laruelle's enthusiasm for James Turrell in relation to his own philosophy is briefly discussed by Galloway (2012).

71. Laruelle's (1991) discussion on the Black Universe is quite impenetrable, the irony of that statement should be apparent when you read: 'Man approaches the World only by way of this transcendental darkness, not which he never entered and from which he will never leave' (see Como 2013). I rely on Galloway (2014) for being able to grasp Laruelle's aesthetics. Laruelle's (1989) quote is found on p. 96 in 'Biographiie de l'oeil,' *La Décision Philosoque* 9: 93–104.

72. Deleuze speaks of the monochrome of the blank canvas as being the erasure of every image. Monochrome is the 'universe-cosmos' for Deleuze (DW, 180). 'And when painting wants to start again at zero, by constructing the percept as a minimum before the void, or by bringing it closer to the maximum of the concept, it works with *monochrome freed from any house or flesh*' (WP, 181, added emphasis). In this sense, the artist faces a black canvas, not a blank one. There is no trace of an image. Analogously, we can point to one of Hansen's (2011) discussed examples: Tobias Rehberger's *84 Year Film* (2002), which is a complete erasure of film, really a 'black' film—a monochrome. The digital film comprises images of all the 2.6 million colours of which the digital video projector is capable of generating over 84 years. 'The work begins with all pixels set to display a monochrome surface and subsequently changes each pixel to the next colour in the spectrum according to an algorithmic logic. What this affords the viewer is a paradoxical experience of change *without change*, a change that cannot be perceived but only sensed: thus, even as she senses very subtle, imperceptible changes in light output, the viewer remains unable to *perceive* a

distinct change in image' (100–101, original emphasis). In short, the viewer is watching a 'blank' or 'dark' film.

73. As discussed by Flaxman (2011) in his Coda.

74. This is developed in his *Struggle and Utopia at the End of Times of Philosophy*. Non-philosophy is connected with the utopian narrative in science fictions, where utopias do not refer to a past, regardless of the chronologies presented; rather, Laruelle is interested in developing a *parallelism* that is located in the here and now. I take this *parallelism* to be Deleuze and Guattari's equivalence of A Life, a non-place where conventional rules or 'standard' philosophy does not apply. This I believe is justified when Laruelle discusses the music-art drawings of August von Briesen that are, in my view, equivalences of James Turrelle and Rehberger's light installations as direct being of sensation (the 'utopian' non-world for-itself that is 'parallel' to our own world-for-us in Laruelle's thought). Laruelle maintains that August von Briesen drawings are directly *in* the realm of the music, which of course is durational as an event (time of Aion). Deleuze and Guattari discuss this aspect of Utopia in WP (100–110), which I take as the place (no-where, Butler's Erewhon) of potential for revolutionary transformation that artisans must 'uncover.' Also see Galloway (2014), 'Art and Utopia' (153–174) where August von Briesen is discussed.

75. Throughout my work I call such artisans 'an avant-garde without authority' (i.e., jagodzinski 2010a)

76. The obvious joke is this is an academic version of 'Star Wars.' Perhaps to add to the hilarity is a Vimeo video posted by Aaron Metté on Laruelle's Black Universe where his words are spoken in the voice of Darth Vadar. https://vimeo.com/40918311.

77. This is the problem of 'The Other person' as developed in DR in the final chapter, and then revisited in WP (17–19). It provides the insight as to why it is so difficult to escape representation. It is the problem of the 'interior' of the Other, which is always outside the powers of representation as manifest via a possible world that is the face, language or speech. With representation the Other is either reduced to another 'I' or simply dismissed as alien. The singularity of the Other person is already lost. With representation of the Other what always remains 'unthought' and 'outside' representation is the difference that is implicated and interiorized in the idea of another possible world that the Other expresses as a reality. In

terms of this section, one could say a 'dark' anthropology is needed, or again an 'alien' phenomenology where art expresses compossible worlds.

78. Sholtz (2015, 266–267) maps out 6 characteristics of Fluxus that are compatible with a Deleuze–Guattarian approach. In truncated form, they are: 1. The temporality of an event; 2. The heterogeneity of membership; 3. It is anti-art in its liberation of affects; 4. Its aesthetic is in-between art and life; 5. It is a decentering paradigm, a mobile and permeable group or community; and 6. Indeterminacy and contingency pervade its performances. She then fully articulates each of these characteristics in her text.

79. This concept is developed in jagodzinski (2010a, 2014a, b)

80. Literature on the art and the Anthropocene has exploded. For a representational sample, see Heather Davis and Etienne Turoin (2015), *Art in the Anthropocene.*

LIST OF ABBREVIATIONS

Works by Gilles Deleuze

C1	*Cinema 1: The Movement-Image*
C2	*Cinema 2: The Time-Image*
CC	*Essays Critical and Clinical*
DR	*Difference and Repetition*
F	*Foucault*
FB	*Francis Bacon*
PI	*Pure Immanence*
LS	*Logic of Sense*
N	*Negotiations*
PS	*Proust and Signs*
TF	*The Fold*

Works by Gilles Deleuze and Fèlix Guattari

A-O	*Anti-Oedipus*
TP	*Thousand Plateaus*
WP	*What is Philosophy?*

References

Adkins, B. (2013). *Rethinking philosophy and theology with Deleuze: A new cartography.* London/New York: Bloomsbury.

Agamben, G. (1999). Absolute immanence. In G. Agambem (Ed.), *Potentialities* (pp. 220–242). Stanford: Stanford University Press.

Alcorn, M., R. (2013). *Resistance to learning: Overcoming desire not to know in classroom teaching.* New York/London: Palgrave Macmillan.

Andrejevic, M. (2013). *Infoglut: How too much information is changing the way we thin and know.* London/New York: Routledge.

Ansell-Pearson, K. (1997). *Viroid: Perspectives on Nietzsche and the Transhuman condition.* London/New York: Routledge.

Ansell-Pearson, K. (1999). *Germinal life: The difference and repetition in Deleuze.* London/New York: Routledge.

Apter, E. (2013). Planetary dysphoria. *Third Text, 27*(1), 131–140.

Chaosmologies: Quantum field theory, chaos and thought in Deleuze and Guattari's What is Philosophy? *Paragraph, 29*(2), 40–56.

Ash, J. (2013). Rethinking affective atmospheres: Technology, perturbation and space times of the non-human. *Geoforum, 49*, 20–28.

Atzmon, L., & Boradkar, P. (2014). Introduction: A design encounter with thing theory. *Design and Culture: The Journal of Design Studies Forum, 6*(2), 141–152.

Bains, P. (2002). Subjectless subjectivities. In B. Massumi (Ed.), *A shock to thought: Expression after Deleuze and Guattari* (pp. 101–116). London/New York: Routledge.

Beighton, C. (2015). *Deleuze and lifelong learning: Creativity, events, ethics.* New York/London: Palgrave Macmillan.

Bell, J. A. (2016). *Deleuze and Guattari's what is philosophy?: A critical introduction and guide.* Edinburgh: Edinburgh University Press.

Benyus, J. (2002). *Biomimicry: Innovation inspired by nature.* New York: William Morrow.

Berry, D. M., Dartel, M. v., Dieter, M., Kasprzak, M. Muller, N., O'Reilly, R., Vicente, J. L. (2012). *New aesthetic, new anxieties,* Amsterdam: V2. Accessed 25 Mar 2015. http://www.v2.nl/publishing/new-aesthetic-new-anxieties

Bloom, I. (2007). *On the style site: Art, society, and media culture.* Berlin/New York: Sternberg Press.

Bogost, I. (2012). *Alien phenomenology, or what it's like to be a thing.* Minneapolis: University of Minnesota Press.

Bogue, R. (2004). Search, swim and see: Deleuze's apprenticeship in signs and pedagogy of images. *Educational Philosophy and Theory, 36*(3), 327–342.

Bogue, R. (2006). Fabulation, narration, and the people to come. In C. V. Boundas (Ed.), *Deleuze and philosophy* (pp. 202–226). Edinburgh: Edinburg University Press.

Bogue, R. (2013). Master apprentice. In I. Semetsky & D. Masny (Eds.), *Deleuze and education* (pp. 21–36). Edinburgh: Edinburgh University Press.

Bolt, B. (2004). *Art beyond representation: The performative power of the image.* London: I.B. Tauris & Co. Ltd.

Braidotti, R. (2013). *The Posthuman.* Cambridge: Polity Press.

Bryant, L. (2011). *The democracy of objects.* Ann Arbor: Open Humanities Press.

Bryant, L. (2014). *Onto-Cartography: An ontology of machines and media.* Edinburgh: Edinburgh University Press.

Buchanan, I. (2000). *Deleuzism: A metacommentary.* London/Durham: Duke University Press.

Butler, R. (2016). *Deleuze and Guattari's what is philosophy?* London/New Delhi/New York/Sydney: Bloomsbury Academic.

Carlin, M., & Wallin, J. (Eds.). (2014). *Deleuze and Guattari, politics and education: For a people-yet-to-come.* London/Oxford/New York/New Delhi/Syndney: Bloomsbury Publishing.

Carr, N. (2010). *The shallows: What the Internet is doing to our brains.* London/New York: W.W. Norton.

Cecchetto, D. (2011). Deconstructing affect: Posthumanism and Mark Hansen's media theory. *Theory Culture & Society, 28*(5), 3–33.

Clough, P., & Halley, J. (Eds.). (2007). *The affective reader: Theorizing the social.* London/Durham: Duke University Press.

Colebrook, C. (2004). The sense of space: On the specificity of affect in Deleuze and Guattari. *Postmodern Culture, 15*(1). Available at http://pmc.iath.virginia.edu/text-only/issue.904/15.1colebrook.txt

Colebrook, C. (2010). *Deleuze and the meaning of life.* London: Continuum.

Coleman, R., & Ringrose, J. (Eds.). (2013). *Deleuze and research methodologies.* Edinburgh: Edinburgh University Press.

Collins, L. (2010). Making restorative sense with Deleuzian morality, art brut and the schizophrenic. *Deleuze Studies, 4*(2), 234–255.

Como, V. (2013). The black singularity. *Drain, 8*(1). Available at: http://drain-mag.com/the-black-singularity/

Culp, R. (2014). Dark Deleuze project abstract. Available at https://anarchist-withoutcontent.wordpress.com/2014/04/09/dark-deleuze-project-abstract/

Dakers, J. R. (2011a). Blurring the boundaries between human and world. In M. J. de Vries (Ed.), *Positioning technology education in the curriculum* (pp. 41–52). Rotterdam/Boston/Taipei: Sense Publishers.

Dakers, J. R. (2011b). Defining technological literacy by exploring the liminal space between technological disruptions. *Vimeo* (vimeo.com/49101331).

Dakers, J. R. (2014). Technological literacy as a creative process of becoming other. In J. R. Dakers (Ed.), *New frontiers in technological literacy: Breaking with the past* (pp. 9–27). New York/London: Palgrave Macmillan.

Damasio, A. (1995). *Descartes' error: Emotion, reason, and the human brain.* New York: Harper Perennial.

Davis, H., & Turoin, E. (2015). *Art in the anthopocene: Encounters amongst aesthetics, politics, environments and epistemologies.* Ann Arbor: Open Humanities Press.

Deleuze, G. (1986). *Cinema 1: The movement-image* (H. Tomlinson & B. Habberjam, Trans.). Minneapolis: University of Minnesota Press (C1).

Deleuze, G. (1989). *Cinema 2: The time-image* (H. Tomlinson & R. Galeta, Trans.). Minneapolis: University of Minnesota Press (C2).

Deleuze, G. (1990). *The logic of sense* (M. Lester Trans. with C. Stivale, edited by C.V. Boudas). New York: Columbia University Press (LS).

Deleuze, G. (1992). *The fold: Leibniz and the Baroque* (T. Conley, Trans.). Minneapolis: University of Minnesota Press (TF).

Deleuze, G. (1994). *Difference and repetition* (P. Patton, Trans.). New York: Columbia University Press (D).

Deleuze, G. (1997a). *Essays critical and clinical* (D. W. Smith & M. A. Greco, Trans.). Minneapolis: University of Minnesota Press (CC).

Deleuze, G. (1997b). *Negotiations 1972–1990.* New York: Columbia University Press (N).

Deleuze, G. (1998). Having an idea in cinema (on the cinema of Straub-Huillet) (E. Kaufman, Trans.). In E. Kaufman & K. J. Heller (Eds.) *Deleuze and Guattari: New mappings in politics, philosophy, and culture* (pp. 14–19). London/Minneapolis: University of Minnesota Press.

Deleuze, G. (2000). *Proust and signs: The complete text* (R. Howard, Trans.). Minneapolis: University of Minnesota Press (PS).

Deleuze, G. (2001). *Pure immanence: Essays on a life* (A. Boyman, Trans.). New York: Zone Books (PI).

Deleuze, G. (2003). *Francis Bacon: The logic of sensation* (Trans. and Introduced: D. W. Smith). Minneapolis: University of Minnesota Press (FB).

Deleuze, G. (2006). *Foucault* (S. Hand, Trans. and Ed.). London/New York: Continuum (F).

Deleuze, G., & Guattari, F. (1983). *Anti-Oedipus: Capitalism and schizophrenia* (R. Hurley, M. Seem & H. R. Lane, Trans.). Minneapolis: University of Minnesota Press (A-O).

Deleuze, G., & Guattari, F. (1987). *Thousand plateaus: Capitalism and schizophrenia* (B. Massumi, Trans.). Minneapolis: University of Minnesota Press, (TP).

Deleuze, G., & Guattari, F. (1996). *What is philosophy?* New York: Columbia University Press (WP).

Dema, L. (2007). 'Inorganic, Yet Alive': How Deleuze and Guattari deal with the accusation of vitalism?. *rhizomes* 15 (Winter). Available at http://www.rhizomes.net/issue15/dema.html

Dirckinck-Holmfeld, K. (2015). Affect image, touch image. In D. Sharma & F. Tygstrup (Eds.), *Structures of feeling: Affectivity and the study of culture* (pp. 50–57). Berlin/Munich/Boston: Walter de Gruyter GmbH.

Drohan, C. M. (2009). *Deleuze and the sign.* New York: Atropos Press.

Drohan, C. M. (2013). Deleuze and the virtual classroom. In I. Semetsky & D. Masny (Eds.), *Deleuze and education* (pp. 112–133). Edinburgh: Edinburgh University Press.

Elkins, J. (2001). *Why art cannot be taught: A handbook for students.* Urbana/Chicago: University of Illinois Press.

Flaxman, G. (2011). *Gilles Deleuze and the fabulation of philosophy: Volume powers of the false.* Minneapolis: University of Minnesota Press.

Flaxman, G. (2012). Out of Field. *Angelaki: Journal of the Theoretical Humanities, 17*(4), 119–137.

Foster, H. (2009). Questionaire on 'The Contemporary'. *October, 130,* 3–124.

Gallese, V. (2001). The 'Shard Manifold' hypothesis. *Journal of Consciousness Studies, 8*(5-7), 33–50.

Galloway, A. R. (2012). Laruelle and art. *Continent, 2*(4), 230–236.

Galloway, A. R. (2014). *Laruelle: Against the digital.* Minneapolis/London: University of Minnesota Press.

Galloway, A., Thacker, E., & Wark, M. K. (2014). *Excommunication: Three inquires into media and mediation.* Chicago: Chicago University Press.

Gasché, R. (2014). *Geophilosophy: On Gilles Deleuze and Félix Guattari's what is philosophy?* Evanston: Northwestern University Press.

Gopnik, A., Meltzoff, A., & Kuhl, P. (1999). *The scientist in the crib: What early learning tells us about the mind.* New York: HarperCollins Publishers.

Gregg, M., & Seigworth, G. J. (Eds.). (2010). *The affective reader.* London/Durham: Duke University Press.

Greenfield, S. (2008). *The question for meaning in the 21st century.* London: Sceptre.

Grosz, E. (2008). *Chaos, territory, art: Deleuze and the framing of the Earth.* New York: Columbia University Press.

Grusin, R. (2010). *Remediation: Affect and mediality after 9/11.* London/New York: Palgrave Macmillan.

Guattari, F. (1995). Chaosmosis: An ethico-aesthetic paradigm (P. Bains & J. Pefanis, Trans.). Bloomington: Indiana University Press.

Hansen, M. (2000). Becoming as creative involution? Contextualizing Deleuze and Guattari's biophilosophy. *Postmodern Culture*, *11*(1). Available at: http://pmc.iath.virginia.edu/text-only/issue.900/11.1hansen.txt

Hansen, M. (2004a). *New philosophy for new media*. Cambridge, MA: MIT Press.

Hansen, M. (2004b). Communication as interface or information exchange? A reply to Richard Rushton. *Journal of Visual Culture*, *3*(3), 359–366.

Hansen, M. (2006). *Bodies in code*. New York/London: Routledge.

Hansen, M. (2011). From fixed to fluid: Material-mental images between neural synchronization and computational mediation. In J. Khalip & R. Mitchell (Eds.), *Releasing the image: From literature to the new media* (pp. 83–111). Stanford: Stanford University Press.

Hansen, M. (2015). *Feed-forward: On the future of twenty-first century media*. Chicago: Chicago University Press.

Harris, P. A. (2005). To see with the mind and think through the eye, Deleuze Folding architecture and Simon Rodia's Watts tower. In I. Buchanan & G. Lambert (Eds.), *Deleuze and space* (pp. 36–60). Edinburgh: Edinburgh University Press.

Harris, P. A. (2009). Deleuze as Wunderkind: Spirit, wonder, and the empiricist conversion experiment. In H. Berressem & L. Haferkamp (Eds.), *Deleuzian events: Writing\history* (pp. 254–268). Berlin: Lit Verlag.

Haynes, P. (2014). *Immanent transcendence: Reconfiguring materialism in continental philosophy*. New York/London: Bloomsbury.

Hickey-Moody, A. (2013a). *Youth, arts, education: Reassembling subjectivity through affect*. London/New York: Routledge.

Hickey-Moody, A. (2013b). Affect as method: feelings, aesthetics and affective pedagogy. In R. Coleman & J. Ringrose (Eds.), *Deleuze and research methodologies* (pp. 79–95). Edinburgh: Edinburgh University Press.

Hickey-Moody, A., & Page, T. (Eds.). (2016). *Arts, pedagogy and cultural resistance: New materialisms*. London/New York: Rowman & Littlefield International.

Holland, E. (2007). The neuroscience of metafilm. *Projections,* *1*(1), 59–74.

Holt, M. (2015). Transformation of the aesthetic: Art as participatory design. *Design and Culture: The Journal of the Design Studies Forum,* *7*(2), 143–165.

Hroch, P. (2015). Sustainable design activism: Affirmative politics and fruitful futures. In J. Brassett & B. Marenko (Eds.), *Deleuze and design* (pp. 219–245). Edinburgh: Edinburgh University Press.

Hughes, J. (2008). *Deleuze and the genesis of representation*. London/New York: Continuum.

jagodzinski, j. (2007). Without Title: On the impossibility of art education: Art as becoming-posthuman (Gaitskell Address, Nov. 24, 2006). *Canadian Journal of Education Through Art*, *5*(2), 6–15.

jagodzinski, j. (2010a). *Visual art and education in an era of designer capitalism.* London/New York: Palgrave Macmillan.

jagodzinski, j. (2010b). Between aisthetics and aesthetics: The challenges to aesthetic education in designer capitalism. In Tracie Constantino and Boyd White, Eds. Essays on aesthetic education for the twenty-first century (29-42). Rotterdam/Boston/Taipei: Sense Publishers.

jagodzinski, j. (2012). Immanent spirituality: Art|education in an era of digitalization. *Visual Arts Forum: [Taiwan Journal], 7,* 2–29.

jagodzinski, j. (2013). Commentary: Concerning the spiritual in arts and its education: Postmodern-romanticism and its discontents. *Studies in Art Education: A Journal of Issues and Research, 54*(3), 277–280.

jagodzinski, J. (2014a). Chapter 11, An avant-garde 'without Authority': Towards a future Oekoumene—If there is a future? In H. Felder, F. Vighi, & S. Žižek (Eds.), *States of crisis and post-capitalist scenarios* (pp. 219–239). Farnham: Ashgate Press.

jagodzinski, j. (2014b). 1780 and 1985: An avant-garde without authority, addressing the anthropocene. In I. Buchanan & L. Collins (Eds.), *Deleuze and schizoanalysis of visual art* (pp. 149–171). London/New York/New Delhi/Sydney: Bloomsbury.

jagodzinski, j., & Wallin, J. (2013). *Arts based research: A critique and proposal.* Rotterdam/Boston/Taipei: Sense Publishers.

James, I. (2012). *The new French philosophy.* Cambridge, UK/Malden: Polity Press.

Jaynes, J. (1976). *The origin of consciousness in the breakdown of the Bicaeral Mind.* Boston: Houghton Mifflin.

Jeong, S.-H. (2013). *Cinematic interfaces: Film theory after new media.* New York/London: Routledge.

Justaert, K. (2012). *Theology after Deleuze.* New York: Continuum.

Kearnes, M. (2006). Chaos and control: Nanotechnology and the politics of emergence. *Paragraph, 29*(2), 57–80.

Kimbell, L. (2013). The object fights back: An interview with Graham Harman. *Design and Culture: The Journal of Design Studies Forum, 5*(1), 103–117.

Kimbell, L. (2011). Rethinking design thinking: Part 1. *Design and Culture: The Journal of Design Studies Forum, 3*(3), 285–306.

Kimbell, L. (2012). Rethinking design thinking: Part 2. *Design and Culture: The Journal of Design Studies Forum, 4*(2), 129–148.

Knott, S. (2013). Design in the age of presumption: The craft of design after the object. *Design and Culture: The Journal of Design Studies Forum, 5*(1), 45–67.

Lambert, G. (2005). What the Earth thinks. In I. Buchanan & G. Lambert (Eds.), *Deleuze and space* (pp. 220–239). Toronto/Buffalo: University of Toronto Press.

Lambert, G., & Flaxman G. (2000–2002). Five propositions on the brain. *Artbrain.org: Journal of Neuro-Aesthetic Theory.* Available at http://www.artbrain.org/five-propositions-on-the-brain/

Laruelle, F. (1989). Biographiie de l'oeil. *La Décision Philosoque, 9,* 93–104.

Laruelle, F. (1991). On the black universe in the human foundations of color (M. Abreu, Trans.). In *Hyun soo choi: Seven large-scale paintings* (pp. 2–4). New York: Thread Waxing Space.

LeDoux, J. (1996). *The emotional brain: The mysterious underpinnings of emotional life.* New York: Touchstone Books.

Leys, R. (2011). The turn to affect: A critique. *Critical Inquiry, 37*(3), 434–472.

Llinás, R. (2002). *I of the vortex: From neurons to self.* Cambridge, MA/London: MIT Press.

Malik, S. (2013). On the necessity of art's exit form contemporary art, Lectures series, 1–4: Friday, May 3 – Friday, June 14, 2013. Available on *YouTube,* http://artistsspace.org/programs/on-the-necessity-of-arts-exit-from-contemporary-art

Malik, S., & Phillips, A. (2011). The wrong of contemporary art. In P. Bowman & R. Stamp (Eds.), *Reading Rancière: Critical Dissensus* (pp. 111–128). London/Oxford/New York/New Delhi/Syndney: Bloomsbury Publishing.

Mackay, R. (2012). A brief history of Geotrauma. In E. Keller et al. (Eds.), *Leper creativity: Cyclonopedia symposium.* Brooklyn: Punctum Books.

Malabou, C. (2008). *What should we do with our brain?* (S. Rand, Trans.). New York: Fordham University Press.

Marenko, B. (2014). Neo-animism and design: A new paradigm in object theory. *Design and Culture: The Journal of Design Studies Forum, 6*(2), 219–241.

Marenko, B., & Brassett, J. (2015). *Deleuze and design.* Edinburgh: Edinburgh University Press.

Massumi, B. (1995). The autonomy of affect. *Cultural Critique, 31,* 83–109.

Massumi, B. (2002). *Parables for the virtual: Movement, affect, sensation.* Durham/London: Duke University Press.

Massumi, B. (2015). *Politics of affect.* Cambridge, UK: Polity Press.

Maturana, H., & Varela, F. (1980). *Autopoesis and cognition: The realization of the living.* Dordrecht/Holland/London/Boston: D. Reidel Publishing Company.

Mickey, S. (2015). *Whole earth thinking and planetary coexistence: Ecological wisdom at the intersection of religion, ecology, and philosophy.* London and New York: Routledge.

Negarestani, R. (2008). *Cyclonopedia: Complicity with anonymous materials.* Melbourne: re:press.

Neidich, W. (2003). *Blow-up: Photography, cinema and the brain.* New York: Distributed Art Publishers.

O'Neil, P., & Wilson, M. (Eds.). (2010). *Curating and the educational turn.* London: Open Editions.

O'Sullivan, S. (2006). Pragmatics for the production of subjectivity: Time for probe-heads. *Journal for Cultural Research, 10*(4), 309–322.

Pereira, P. C., & Harcha, J. Z. (2014). Revolutions of resolution: About the fluxes of poor images in visual capitalism. *tripeC, 12*(1), 315–327.

Petrina, S. (2014). Postliterate machineries. In J. R. Dakers (Ed.), *New frontiers in technological literacy: breaking with the past* (pp. 29–43). New York/London: Palgrave Macmillan.

Pfaller, R. (2003). *Illusionen der Anderen*. Frankfurt: Suhrkamp.

Pisters, P. (2012). *The neuro-image: A Deleuzian film-philosophy of digital screen culture*. Stanford: Stanford University Press.

Pisters, P. (2016). Neurothriller. *Aeon*. Available at: https://aeon.co/essays/horror-films-are-far-scarier-than-in-the-past-here-s-how

Plotnitsky, A. (2006). Chaosmologies: Quantum field theory, Chaos and thought in Deleuze and Guattari's what is philosophy? *Paragraph, 29*(2), 40–56.

Ramey, J. (2012). *The hermetic Deleuze: Philosophy and the spiritual ordeal*. Durham/London: Duke University Press.

Rancière, J. (2004). Is there a Deleuzian aesthetics? *Qui Parle, 14*(2), 1–14.

Reinertsen, A. B. (Ed.). (2016). *Becoming Earth: A post human turn in educational discourse collapsing nature/culture divide*. Rotterdam/Boston/Taipei: Sense Publishers.

Reynolds, J. (2007). Wounds and scars: Deleuze on the time and ethics of the event. *Deleuze Studies, 1*(2), 144–164.

Roden, D. (2014). *Posthuman life: Philosophy at the edge of the human*. London/New York: Routledge.

Roy, K. (2003). *Teachers in nomadic spaces: Deleuze and curriculum*. New York: Peter Lang.

Roy, Olivier (2014). *Holy ignorance: When religion and culture part ways* (R. Schwartz, Trans.). Oxford University Press.

Rushton, R. (2004). Response to Mark B.N. Hansen's 'Affect as Medium', or the 'Digital-Facial-Image'. *Journal of Visual Culture, 3*(3), 353–357.

Rushton, R. (2008). Passions and actions: Deleuze's cinematographic *Cogito*. *Deleuze Studies, 2*(2), 121–139.

Sauvagnargues, A. (2013). *Deleuze and art* (S. Bankston, Trans.). London/Oxford/New York/New Delhi/Syndney: Bloomsbury Publishing.

Schönher, M. (2013). The creation of the concept through the interaction of philosophy and science and art. *Deleuze Studies, 7*(1), 26–52.

Screel, L. (2014). The work of art as monument: Deleuze and the (after-) life of art. *Footprint: Asignifying semiotics: Or, How to Paint Pink on Pink* (Spring): 97–108.

Sholtz, J. (2015). *The invention of a people: Heidegger and Deleuze and the political*. Edinburgh: Edinburgh University Press.

Shults, F. L. R. (2014). *Iconoclastic theology: Gilles Deleuze and the secretion of atheism*. Edinburgh: Edinburgh University Press.

Shults, F. L. R., & Powell-Jones, L. (2016). *Deleuze and the Schizoanalysis of religion*. London: Bloomington Academic.

Sparrow, T. (2013). *Levinas unhinged*. New York: Zero Books.

Steyerl, H. (2009). In defence of the poor image. *e-flux, 10*. Available at http://www.e-flux.com/journal/in-defense-of-the-poor-image/

Thacker, E. (2010a). *In the dust of this planet, Horror of philosophy* (Vol. 1). Alresford: Zero Books.

Thacker, E. (2010b). *After life*. Chicago: University of Chicago Press.

Virno, P. (2008). Mirror neurons, linguistic egation, reciprocal recognition. In *Multitude: Between innovation and negation* (pp. 175–190) (I. Bertoletti, J. Cascaito & A. Cassson, Trans.). Los Angeles: Semiotex(e).

Voss, D. (2013). *Conditions of thought: Deleuze and transcendental ideas*. Edinburgh: Edinburgh University Press.

Williams, J. (2013). Time and education in the philosophy of Gilles Deleuze. In I. Semetsky & D. Masny (Eds.), *Deleuze and education* (pp. 235–251). Edinburgh: Edinburgh University Press.

Wolf, M. (2007). *Proust and the squid*. New York/London/Toronto/Sydney/New Delhi/Auckland: Harper Perennial.

Woodward, B. (2013). *On an ungrounded Earth: Towards a new geophilosophy*. New York: Punctum Books.

Zepke, S., & O'Sullivan, S. (Eds.). (2010). *Deleuze and contemporary art*. Edinburgh: Edinburgh University Press.

Ziarek, K. Z. (2004). *Force of art*. Stanford: Stanford University Press.

Žižek, S. (2004). *Organs without bodies: On Deleuze and consequences*. New York/London: Routledge.

Zourabichvili, F. (1996). Six notes on the percept (On the relation between the critical and the clinical). In P. Patton (Ed.), *Deleuze: A critical reader* (pp. 188–216). Oxford/Cambridge, MA: Blackwell.

Styles of Deleuzian Pedagogy

Learning by Swimming in Signs

Charles R. Garoian

How Fortuitous!

While reading about agglomerations[1] of learning as Deleuzian swimming in signs, I received a phone call from our daughter Stephanie to inform us that Lilit, our two-year-old granddaughter, was about to begin swimming lessons, which I immediately associated with Lilit's favorite animated film *Nemo* about a toddler Clownfish whose mother is devoured by a Barracuda, and whose protective father, for fear of also losing his son, sends him off to sea-school apprehensively, warning him not to wander off beyond the Great Barrier Reef into the expansive unknown that is the ocean; in responding to Stephanie's news about Lilit's swimming lessons, I blurted "Wow, having birthed from her amniotic aquarium, she is now swimming with *Nemo* in an aquatic immensity of asignifying signs, and will, perhaps one day, swim with *Moby Dick* in Melville's, and other literary oceans yet to be experienced"....

...signs, multiple signs, their multiple lines of flight, their machinic zigging and zagging, cutting and cross-cutting, enfolding and unfolding their differences, their multiple encounters and alliances picking up

C.R. Garoian (✉)
Penn State University, State College, PA, USA

© The Author(s) 2017
j. jagodzinski (ed.), *What Is Art Education?*,
DOI 10.1057/978-1-137-48127-6_2

Deleuze|Guattari speed, constituting a logic of sensation; such simultaneity and complexity with no beginning and no end enabling multiple ways of seeing and thinking differently...my reading Deleuze about swimming in signs, the phone call announcing Lilit's swimming lessons, the animated film about *Nemo*, and my tongue-in-cheek remark about *Moby Dick*; then, then, amid the ebb and flow of my thoughts, and with this writing, a swimming also, signs and other signs continued to emerge; commencement was occurring at the university where I teach, a significant marker in the life of our students about which a colleague felt compelled to share the following parable that author David Foster Wallace invoked in his 2005 commencement address at Kenyon College:

> There are these two young fish swimming along and they happen to meet an older fish swimming the other way, who nods at them and says 'Morning, boys. How's the water?' And the two young fish swim on for a bit, and then eventually one of them looks over at the other and goes, 'What the hell is water' (Wallace 2005)?

While the older fish's question "How's the water?" seems perfunctory, it is nonetheless posed while in the flow of a greeting, a morning swim, and perhaps the drifting wisdom of age. By contrast, the young fish's surprised response "What the hell is water?" is a question that ruptures complacency that once exposed rouses their sudden encounter with what Wallace describes as "the most obvious, ubiquitous, important realities [that] are often the ones that are the hardest to see and talk about" (Wallace 2005). Nevertheless, as the young fish desperately seek an answer to resolve their conundrum about the ontology, the *being* of water, their swimming comes to an abrupt standstill and in doing so water's immanent *becomings*, its movable and moving force that disarticulates sedentary and habituated cultural representations as an asignifying regime of signs,[2] pass by them still unnoticed.

Consider H_2O as an asignifying event: on the one hand, its agglomeration of two hydrogen atoms and one oxygen atom; and, on the other hand, mutability, its dematerializing processes of evaporation, condensation, and precipitation. Then consider the asignifying sonic utterances of *echolocation* that dolphins, whales, and bats use to establish proximity, communication, and navigation between and among other members of their species, their food sources, and other creatures and objects in the darkness of sea and air. These animals actually and virtually swim or fly

according to the acoustic and aquatic signs and signals that they produce to constitute incorporeal, diagrammatic[3] networks. Accordingly, Wallace's fish story suggests that learning to see and think differently constitutes *becoming-water*, not to mention *becoming-fish* or *becoming-bat*, incorporeal and incompatible bodies that are defined by zones of proximity and intensity. It is by way of asignifying sensations, affects, and movements that such alterity emerges as swimming in signs (Deleuze and Guattari 1987, p. 274). As nuclei of differentiation, signs are immaterial, and they have no bodily structure; as bodies without organs (BwO),[4] they elude ontology, and always already in a state of becoming-other. This elusion of ontological representations, according to Deleuze (2000), requires that "one must be endowed for the signs, ready to encounter them, one must open oneself to their violence. The intelligence always comes after; it is good when it comes after; it is good only when it comes after" (p. 101). Hence, "coming after" suggests that *intelligence* is constituted by signification and subjectification, while encountering a turbulence of signs constitutes *learning* as an immanent event.

The "becoming-water" is not to suggest that the body is reproducing and pretending to be water, nor being fish-like or bat-like, but constituting fortuitous flows and intensities of signs referring to signs, referring to other signs, to a multiplicity of signs.... In doing so, "becoming is a rhizome, not a classificatory or genealogical tree...[but] a verb with a consistency all its own: it does not reduce to, or lead back to, 'appearing,' 'being,' 'equaling,' or 'producing' " (Deleuze and Guattari 1987, p. 239). Such heterogeneous encounters and alliances between and among signs are consonant with the physics of swimming insofar as its hydraulics is constituted as a processual transaction between the potential energy of water and its transformation into kinetic energy by the swimmer's movements, and the transformation of the swimmer's potential energy into kinetic energy by the movement of water. As such, this chapter explores Wallace's fish parable in terms of Deleuze's notion that *real*[5] learning occurs by swimming in a domain of perpetual difference.

The fluidity and flow of swimming is for Deleuze a powerful metaphor that suggests learning occurs through a multiplicity of unanticipated ideational movements that disrupt and disarticulate sedentary representations thus casting socially and historically constructed knowledge and intelligence into a predicament, an anomalous sea of complex and contradictory signs. Deleuze (1994) argues, "Learning takes place not in the relations between representation and an action (reproduction of the same) but in

the relation between a sign and a response (encounter [and doing] with the [unanticipated] Other)" (p. 22). As such, Deleuze is arguing for a pragmatics of learning rather than semiotics inasmuch as the former is about what signs "do" to bodies through sensation as compared with the latter having to do with what signs "represent" through signification and subjectification. He ascribes the pragmatics of signs, their doing, to swimming insofar as its fluid movements and responses do not reproduce signs but repeat them differently, repeatedly.

> The movement of the swimmer does not resemble that of the wave, in particular, the movements of the swimming instructor which we reproduce on the sand bear no relation to the movements of the wave, which we learn to deal with only by grasping the former [the instructor's movements] in practice as signs...We learn nothing from those who say: 'Do as I do'. Our only teachers are those who tell us to 'do with me,' and are able to emit signs to be developed in heterogeneity rather than proposed gestures for us to reproduce. (Deleuze 1994, p. 23)

According to Deleuze, the swimmer learns how to swim by swimming, not by following a swimming manual, or the "do as I do" directives of a swimming instructor. Learning to swim by swimming, the swimmer responds to the emergent problematic conditions of signs emitted and merited by the flow of the wave.

Unlike swimming according to the directives of an instructor, the swimmer learns to swim by swimming symbiotically with the wave, by *becoming-wave* rather than reproducing the manual and replicating the instructor. Becoming-wave is becoming rhizomatic assemblage, the multiplicities that constitute the wave.

> When a body combines some of its own distinctive points with those of a wave, it espouses the principle of a repetition which is no longer that of the Same, but involves the Other—involves difference, from one wave and one gesture to another, and carries that difference through the repetitive space thereby constituted. To learn is indeed to constitute this space of an encounter with signs, in which the distinctive points renew themselves in each other, and repetition takes shape while disguising itself. (Deleuze 1994, p. 23)

Within Deleuze's space of learning, the repetition of difference occurs by dint of abrupt, disjunctive encounters and alliances between and among

the distinctive, asignifying sensations emitted by the body swimming in processual rhythm *with* the asignifying modulations of a wave, thus enabling renewal autopoietically.[6] The signs' discharge of multiplicity, their transversal lines of movement where "every sign refers to another sign, and only to another sign, ad infinitum" (Deleuze and Guattari 1987, p. 112), constitutes the space of learning as a virtual,[7] problematic field of sensation[8] within which the swimmer must immerse and learn *to navigate* without yielding to representations of swimming according to the navigational determinations of a semiotic compass. Transversal trajectories are diagrammatic inasmuch as they "function as vectoring tools that probe meaning by testing or suggesting connections" (Knoespel 2005, p. 152). The issue with semiosis is that its signifying and subjectifying formulations impede transversal exploration, experimentation, and improvisation between and among signs, thereby shutting down the immanent events of creative thought and action from occurring. In other words, once signs are assigned meanings, their associational playing ends in intellectual closure.

Navigating the heterogeneous modulations of a wave constitutes a double problematic of the *swimmer learning to swim by swimming with the wave*, which accords with Deleuze insofar as

> to learn to swim is to conjugate [to coexist and coextend with] the distinctive points of our bodies with the singular points of the objective Idea [the wave] in order to form a problematic field. This conjugation determines for us a threshold of consciousness at which our real acts are adjusted to our perceptions of the real relations, thereby providing a solution to the problem. (1994, p. 165)

By perceptions of real relations, Deleuze is referring to our awareness, accommodation, and address of incipient problems that compel real acts, experimental approaches to solutions that the problems merit rather than pre-determined, normative modes of address. Considering swimming's threshold of perpetual difference, the problems and solutions of swimming remain unresolved, endlessly redistributed, and contingent on what the emergent conjugations between the swimmer and the wave necessitate.[9]

Hence, in becoming-wave, the swimmer does not reproduce the wave by "doing as it does," or reproduce the didactic "do as I do" directives of a manual or instructor. On the contrary, in becoming-wave, the swimmer learns to swim by entering into an immersive encounter with the anomalous, problematic field of the wave. In *doing with*, the multiplicity

of asignifying sensations that ally diagrammatically as swimming in signs is what Félix Guattari (2006) refers to as *machinic assemblage*: "a precarious undertaking, of a continual creation, which does not have the benefit of any pre-established theoretical support" (p. 71). Indeed, the precarious functioning of the diagrammatic, its unpredictable doing, constitutes the machinic assemblage of the abstract machine (Deleuze and Guattari 1987, p. 142); that is, its non-representational, non-foundational multiplicity of swimming in signs. Deleuze and Guattari's use of *machine* and *machinic* is not to be confused with mechanical or electronic devices and technologies but as a "multitude of modalities of alterity...that deterritorialize [signification and] subjectivity" (Guattari 2006, pp. 96–97; Deleuze and Guattari 1987, p. 333), an agglomeration of intermingling enunciations that constitute the experience of learning as an immanent event.

Navigating the uncharted waters of signs is the abstract machine's *diagrammatic* functioning that constitutes learning through immanence. Such an event of learning, yet to emerge, is precarious insofar as it enables seeing and thinking differently by addressing the contingent peculiarities and problems of experiences according to their own merits in deciding what can be done rather than what cannot be done according to social and historical determinations. Deleuze (2000) writes, "what forces us to think is the sign. The sign is the object of an encounter, but it is precisely the contingency of the encounter that guarantees the necessity of what it leads us to think" (p. 97). This diagrammatic vectoring of the abstract machine that enables precarious modalities of thinking to emerge constitutes the immanent creativity of art research and practice. Characterizing this abstract machinic functionality of art learning, Stephen Zepke writes,

> An abstract machine determines the real conditions of experience, conditions neither subjective nor objective (they have become abstract), and that can only be experienced in the work of art (in a machine). A work entirely experimental, inasmuch as art is a permanent research on its own conditions, and is always constructing new machines. Feedback loop. (Zepke 2005, p. 4)

Traces of diagrammatic functioning in historical works of art can be found in the falling figures of Michelangelo's *The Last Judgment* (1536–1541); the civic guards' movements of indecision in Rembrandt's *Company of Captain Frans Banning Cocq and Lieutenant Willem van Ruytenhurch* (aka *The Night Watch*, 1642); and the figural turbulence in Gericault's

Raft of the Medusa (1818–1819). While the directional forces (explicit and implicit lines of movement) in these artists' compositions are constituted by transversal, diagrammatic criss-cossings, they are nevertheless overshadowed by emphases on verisimilitude, spectacle, and visual signification.

Focused attention on art's machinic production of sensation, its diagrammatic force, emerged from the prolific experimentations of post-impressionists such as Cézanne, Seurat, Van Gogh, and Rodin, and its momentum increased in such works as *Girl With a Mandolin* (1910), Picasso's multi-planar cubism, the figural forces in Boccioni's futurist painting *States of Mind: The Farewells* (1911), and his sculpture *Unique Forms of Continuity in Space* (1913). Zepke contends, "sensations must be created, as any artist knows, for the [abstract] machine [of art] to work" (2005, p. 8). However, it was not until Marcel Duchamp's questioning of functionality that art took a radical conceptual turn from signification and subjectification. Duchamp asked, "Can one make works which are not works of 'art'? Can one make something that has no function, that performs no work, that is not beholden to a purpose, even that of art?" (Duchamp in Molesworth 1998, p. 57). These questions that Duchamp raised in 1913 compelled him to divert attention from what he referred to as "retinal" representations in art by turning from conventional art materials and modalities to experiment with found, *readymade* objects consisting of industrial products: a kitchen stool, bicycle wheel, urinal, snow shovel, bottle rack, coat rack, and others.

Duchamp's questioning process consisted of displacing these objects from their familiar environments, then replacing them in unfamiliar ones. To push the question of functionality further, he modified the objects' positioning: consider the conceptual machinations of *Bicycle Wheel* (1913) inverted and affixed to a stool; *Fountain* (1917), an inverted urinal, mounted on a pedestal in an art gallery and signed R. Mutt, a pseudonym; and, a snow shovel, its handle tied with string, suspended from a ceiling, with wall text that reads *In Advance of a Broken Art* (1915), not a naming or title of the installation but yet another "object" of radical juxtaposition to delay and avert historical associations and significations. Each of the readymades, wild and restless experiments in conceptual bipolarity, requires "permanent research on its own conditions…[and in doing so] always constructing new [abstract] machines" (Zepke 2005, p. 4). The multiple articulations of the readymades create a wave of disjunctive encounters and alliances that constitute art research and practice as swimming in and among asignifying signs and sensations. Such diagrammatic

wave movement, in deterritorializing and reterritorializing representational structures, constitutes learning as swimming in perpetual difference.

More recently, artists directly and indirectly influenced by Duchamp have adopted his experimental ethos in their research and practice of conceptual, process, installation, and performance art. Richard Serra's *Verb List* (1968–1969) that later served as proposals for his process art works such as *Throwing Lead in Leo Castelli's Gallery* (1968); Robert Smithson's *Spiral Jetty* (1970) in the Great Salt Lake to reveal the transformational processes of geological time through the event of entropy; Rachel Whiteread's *House* (1993) in which she filled its rooms with concrete, removed its structural walls, paradoxically transforming its immaterial architectural space into an ontologically solid, material form, thus enabling seeing its inside from the outside; and Mona Hatoum's *Measures of Distance* (Hatoum 1988, [Online]) that the Tate Gallery describes in the following way:

> *Measures of Distance* is a video work comprising several layered elements. Letters written by Hatoum's mother in Beirut to her daughter in London appear as Arabic text moving over the screen and are read aloud in English by Hatoum. The background images are slides of Hatoum's mother in the shower, taken by the artist during a visit to Lebanon. Taped conversations in Arabic between mother and daughter, in which her mother speaks openly about her feelings, her sexuality and her husband's objections to Hatoum's intimate observation of her mother's naked body are intercut with Hatoum's voice in English reading the letters. (Tate Gallery [Online]).

Experiencing the diagrammatic simultaneity in the video constitutes swimming in signs as a palimpsestic event. The video begins with a silent, still image of an indistinguishable woman, Hatoum's mother, veiled by a blur, veiled in black, and veiled again by an overlaid, separate and simultaneous video track of her Arabic handwriting...and while the hazy images of her mother's body slowly fade from one to the next, the voices of two women, Hatoum and her mother, overheard in a simultaneous audio track, are engaged in a jovial conversation in Arabic against distant sounds of cars and trucks in the street, and a faint radio...and while images of her mother's body stances continue to fade in and out, a second simultaneous audio track begins....

My dear Mona, the apple of my eyes, how I miss you and long to feast my eyes on your beautiful face...I enjoyed very much those conversations we had about women's things...you and I had never talked this way before... You asked...if you can use my pictures in your work...use them but don't mention a thing about it to your father...remember how he caught us taking pictures in the shower...I suppose he was embarrassed to find us both standing there stark naked...he was seriously angry...I felt that we were like sisters...nothing to hide... (Excerpted from Hatoum 1988, [Online])

...it is with those lines delivered in a measured, overlaid voice that Hatoum begins her reading, slowly and purposefully, reading her mother's letters written in Arabic, reading while translating them to English, as if reading to herself aloud, lines from her mother's letters , one, one line at a time...this, this against the continuing, lively Arabic exchange in the background...against, against the continuing stream of images that begin to show her mother unveiling, undressing, while veiled behind the Arabic calligraphy of her letters, as the conversation and noises in the background continue, and as Hatoum continues calmly reading her mother's letters....

My dear Mona...I'm surprised that you still remember every word I said... twenty years ago...I was only trying to console...you were very upset at the sight of the blood...I was only trying to cheer you up, make you feel good about being a woman... (Excerpted from Hatoum 1988, [Online])

...successive images of her mother showering intimate the movements of her naked body...anomalous gestures that suggest washing her face, washing her hair, her shoulders, arms, breasts, abdomen, and other parts of her torso; these are bodily signs that in proximity to and distance from the ongoing happy discussion between mother and daughter in the background are heard from Hatoum's demure reading of her mother's letters in the foreground....

My dear Mona...Tis not fair that this bloody war should take all my daughters away from me to the four corners of the world...your questions although they are sometimes weird and too probing...they make me think about myself in a way that I hadn't looked at before...they take my mind way [sic] from this terrible war...When you asked me questions about my sexuality, your father said, "what's all this nonsense she is occupying her mind with"... (Excerpted from Hatoum 1988, [Online])

...that, and Hatoum's mother's anomalous gestures providing visual evidence that she, her body is actually there in the shower, while not being there, not there, but contemplating a virtual elsewhere, a different kind of time and place...the fading in and out of naked images, from one to the next, veiled, veiled by Arabic script, veiled by the din of conversation, and Hatoum's English reading and translation,

> My dear Mona...You say you can't remember that I was around when you were a child...before we ended up in Lebanon, we were living on our own land, in a village with all our friends and family...So if I seemed to be irritable and impatient it's because life was very hard when we first left Palestine...I personally felt as if I'd been stripped naked of my very soul... so when you talk about a feeling of fragmentation and not knowing where you really belong, well this has been the painful reality for all our people... (Excerpted from Hatoum 1988, [Online])

...with that, the diagrammatic lines of flight between and among the calligraphy, voices, and images constitute a tangled, agglomeration of signs that is Hatoum's video, *Measures of Distance*; a processual rhythm of veiling and unveiling a complex and contradictory relationship between a Palestinian mother and her artist daughter, the former exiled in Lebanon, the latter exiled in London, both émigrés from one another, from other family members, friends, neighbors, from their homeland, all of whom scattered in and among the fragmented communities of the Palestinian diaspora. The displaced fragments in Hatoum's disjunctive video are in measured proximity with the disjunctive fragments of her displaced life and the lives of her people. Such proximity and fragmentation are not about being Palestinian or pretending to be Palestinian, but *becoming-Palestinian* insofar as it is constituted by the intensities and flows of displacement. Paradoxically, Hatoum's video reveals and emancipates what is otherwise concealed and suppressed by social and historical assumptions and representations of her cultural identity, and especially those of her family. *Measures of distance,* whether the video's naming or yet another of Hatoum's anomalous signs, suggests taking action, "taking measures into one's hands" and "measures" of proximity to the extent of one's closeness, juxtaposition, and contiguity with an Other.

Hatoum's object as an artist is neither signification nor subjectification, neither the making of meaning nor the reproduction of herself, but the making of signs entangling with multiple other signs, signs upon signs,

interminably. By resisting reactionary representations, her video enables "getting away" from one's culture, one's self, as Duchamp (1962, p. 82) suggested, getting away from one's history, to linger on the juxtapositions between and among signs. Multiple modalities of difference are what constitute *Measures of Distance* as an abstract machine of art, a precarious domain of perpetual research and learning based on its own existential conditions of exile, sexuality, identity, gender, trust, love, war, life, and death. If "learning is essentially concerned with signs" as Deleuze (2000, p. 4) contends, then the emission of problematic signs in Hatoum's *Measures of Distance* affects a wave of sensations that enables seeing and thinking differently about how families are constituted regardless of their differing and ever-changing cultural histories. It is by way of proximity to the veiling and unveiling form and content in *Measures of Distance*, that learning occurs differently from social and historical representations of cultural identity that teach moralizing assumptions, biases, and stereotypes that disenfranchise and marginalize the Other.

The immersion and swimming in signs constituted by the multiple lines of flight, and the encounters, and alliances in Hatoum's machinic assemblage, while *autopoietic* in their perpetual research and renewal, also have an *allopoietic* characteristic. Maturana and Varela (1980) conceptualize autopoiesis as living, self-producing machines, and feedback loops that initiate changes to compensate for external perturbations. "Such machines are homeostatic machines and all feedback is internal to them" (Maturana and Varela 1980, p. 78). Allopoietic systems by comparison are not self-producing but "have as the product of their functioning something different from themselves" (Maturana and Varela 1980, p. 80). While Maturana and Varela address machines in terms of their mechanical efficiency, Guattari (2006) argues that autopoiesis ought to be reconsidered in terms of open, machinic systems of alterity rather than the closed homeostatic systems that they are. "In such a case, institutions and technical machines appear to be allopoietic, but when one considers them in the context of the machinic assemblages they constitute with human beings, they become ipso facto autopoietic" (p. 40).

While the self-renewal of Hatoum's *Measures of Distance* is autopoietic, it nonetheless functions allopoietically insofar as it produces something other than itself. That production, multiple lines of flight, their transversal movements unimpeded, speeding toward other signs, and agglomerating constellations of abstract machines, ad infinitum, constitute the repetitive, noncyclical logic of the AND, never identical, never becoming the same,

always becoming-other (Deleuze 1994, p. 241). This machinic alterity is not movement or escape from *Measures of Distance*, but the production of incorporeal universes by "measures of distance," according to Guattari (2006, p. 45), agglomerations of referential signs that enable experiencing Hatoum's video both in terms of its autopoietic self-renewal and in terms of its allopoietic renewal within the constellation.

The sensations, affects, and movements that I experienced from the multiplicity of signs in *Measures of Distance* touched a cord and evoked personal memory and history. I am the first-born son of Armenian parents who narrowly escaped the long forgotten Genocide of Armenians perpetrated by the Turkish government during the first two decades of the twentieth century; atrocities that have been continually denied by subsequent regimes in Turkey to this day. As children my parents witnessed the horrors of mass killings and mass deportations of friends and family members sanctioned by that government. As refugees finding sanctuary in Marseille, their lives were forever dislocated, the culture they once knew obliterated. Then, after several years in France, they immigrated to the USA settling in Fresno, California, where they started their lives all over again according to the contingent circumstances of living and learning in America. Theirs was the plight of the Armenian diaspora to this date dispersed worldwide. Born after my parents resettled and married in the USA, mine, and those of my brother and sisters, was a received history of the Genocide experienced through their experiences, their recollections intermingled with remaking their lives in yet another foreign land. Our experience of what had happened to our parents was through sensation and affect, an emission of signs upon signs of pain, alienation, fragmentation, fears, and anxieties coupled with their relentless pursuits and accomplishments, no matter how insignificant, to overcome what seemed virtually impossible.

It is through the multiplicity of signs emitted by Hatoum's video that measures of distance emerged with the particularities and peculiarities of my growing up with emigrant parents, experiencing the veilings and unveilings of their trauma, the emotional complexities of their relationship, fears and anxieties from the past, passed on to us, their children growing up in the new world, their frustrations with the new language and culture, their survivors guilt, their lamentations for past sufferings, their need to recapture past losses by continually talking about them while working our vineyard, their new Armenia, where we sun dried grapes, Thompson Seedless, into raisins, to eke out a living, to make

the impossible possible...it was in Fresno where going to school was imperative to learning, learning in becoming-American, while, at home, learning to maintain and transmit cultural heritage the imperative to becoming-Armenian...no, no bifurcation, not a dualism, but complex dislocations in proximity, measures of distance to one another, multiple encounters and alliances among and between signs, with no beginning and no end, always in the middle of things, not *or*, but *and*, Armenian *and* American, a liminal identity, always contingent on the unexpected,[10] always becoming-other than what we were, what I was...living life not according to what it was in the past, but what living does and can become as an immanent force, not on what we could not do, but what we could learn, and what could be done...ours was a contingent economy of living a contingent life, on how we might live rather than how we should live, evoking the Nietzschean ethos of "inventing new possibilities of life. Existing not as a subject but as a work of art" (Deleuze 1995, p. 95; Garoian 2015).

The afore-mentioned, disjunctive characterization about the diasporic experiences of my Armenian family life emerged from Hatoum's video according to what Deleuze (2000) refers to as an exploration of *involuntary memory*. As yet another permutation of measured proximity, involuntary memory "intervenes only in terms of a sign of a very special type: the sensuous signs. We apprehend a sensuous quality as a sign; we feel an imperative that forces us to seek its meaning" (p. 53). The imperative of sensuous signs in Hatoum's video is referential insofar as the qualities of experience it emits "no longer appears [sic] as a property of the object [her video] that now possesses it, but as the sign of an *altogether different* object [my history] that we must try to decipher, at the cost of an effort that always risks failure" (Deleuze, p. 11). The risk that Deleuze is referring to is the indeterminate, precarious undertaking of swimming in perpetual difference, which, according to Guattari, "does not have the benefit of any pre-established theoretical support" (Guattari 2006, p. 71). The complexity of *what, what I saw and heard*, and *how, how I saw and heard* that complexity in Hatoum's *Measures of Distance*, was constituted by the video's emission of sensuous signs, signs upon signs, agglomeration of signs; their qualities of visual and auditory experience rousing proximity with and transversal exploration of my Armenian diasporic history through involuntary memory.

As compared with the nostalgic reminiscing of *voluntary memory* that "proceeds from an actual [experience in the] present to a present that

'has been,' to something that was present and is so no longer" (Deleuze 2000, p. 57), involuntary memory extends prosthetically between and through two simultaneous moments of sensation that resemble each other. Something seen, heard, touched, tasted, and/or smelled: sensuous, asignifying signs experienced in the present in Hatoum's video that evoked encounters and alliances with the particularities and peculiarities of my past experiences. Given the proximity between a past memory and a present moment, involuntary memory is doubly articulated: "the difference in the past moment, the repetition in the present one" (p. 61). In other words, whereas voluntary memory repeats experiences the *same* as they were in the past, involuntary memory repeats the past *differently* in the present, and in doing so constitutes what Michel Foucault (1995) describes as a *history of the present* (pp. 30–31).

Such history is paradoxical insofar as it is not anchored in the past or the present, and precarious insofar as the multiplicity of encounters and alliances between the past and the present destabilize and resist any such anchoring. Instead, in-between what is anchored in the past, and what is anchored in the present, history emerges as an immanent event, a happening: an imperceptible history in the process of becoming that is inferred virtually as an absence. Given its immanent, living force, the event of history constitutes becoming-intense and becoming-other than merely what happened in the past or is going on in the present. This unbinding of historical ontologies disrupts and disarticulates stratified dualistic assumptions about past and present knowledge, and in doing so constitutes historical knowledge as an immanent political force. Hence, Foucault's notion of history of the present is contiguous with *knowledge of the present*, not being anchored by pre-existing knowledge, or by what is merely occurring and learned in the present, knowledge is an immanent political force that is constituted by unexpected, unknown, and unmeasured occurrences of signs that enable seeing and thinking differently.

Notwithstanding their importance in constituting learning through involuntary memory, sensuous signs are "signs of life, not of Art," according to Deleuze. "They represent only the effort of life to prepare us for art and for the final revelation of art...we must regard art as a more profound means of exploring involuntary memory. We must regard involuntary memory as a stage, which is not even the most important stage, in the apprenticeship to art" (Deleuze 2000, p. 65). While the transversal and diagrammatic meanderings of signs are staged in involuntary memory, it is through art research and practice that their asignifying fragments

detour and resist totalization; those intellectual closures of signification and subjectification. In doing so, the encounters and alliances of signs, in their differing speeds, sweep and agglomerate multiplicities of fragments "each one of which refers to a different whole, to no whole at all, or to no other whole than that of style" (p. 115); that is, "style" as a mode of addressing the contingent circumstances of unanticipated event encounters as a multiplicity.

It is in art's precarious, machinic chaos that the determinations of signification and subjectification collapse to constitute learning as a live, immanent event. This is what art does. How it functions as an abstract learning machine. How it releases representations from their determining conditions and creating resonances to reincarnate them according to its contingent flows and intensities (p. 156). And, that is how the diagrammatic movements in Hatoum's *Measures of Distance* affected me. As its machinic operations roused involuntary memory, it enabled me to see and think about my parents' diasporic history differently; in ways that were conditioned by the entangled, diasporic displacements of her video; conditions that enabled me to get away from myself, to resist the trappings of self-absorption, nostalgia, and sympathetic associations and representations of memory volunteering the Armenian Genocide. Instead, the sensations, affects, and movements stirred by Hatoum's compelling video enabled me to see and think differently, to becoming-other than a mere victim of history; to experience history as that of the present; and, to acquire knowledge as that of the present through its flows and intensities, its *Measures of Distance*; in other words, to live life as permanent research, to live it as a work of art.

NOTES

1. "Agglomeration" constitutes a dynamic clustering of particles, signs, or concepts that resists coherence as a universal signifier.
2. "Asignifying regimes of signs" rupture and dismantle signifying and subjectifying organizational structures.
3. The "diagrammatic," according to Deleuze and Guattari (1987), is an incorporeal, deterritorializing machine, a virtual, abstract machine that "operates by matter [unformed and mutable events], not by substance; by function, not by form" (p. 141). Eluding signification, the diagrammatic is a vectoring of exploratory, experi-

mental, improvisational navigation in a virtual sea of asignifying signs.

4. The body without organs is "opposed to the organism, the organic organization of the organs" (Deleuze and Guattari, p. 158). What Deleuze and Guattari are referring to is a space where organizational structures have not yet taken hold.

5. According to Deleuze and Guattari (1987), "real" learning does not function as signification, subjectification, or pre-existing knowledge, but learning that is yet to come that emerges from swimming in signs (p. 142).

6. Autopoiesis is a process by which a system in breakdown renews itself; a feedback loop.

7. Learning by swimming in signs is "constituted through immanence; an imperceptible way of seeing and know that is yet to happen, and inferred virtually as an absence" (Garoian 2013, p. 29).

8. Deleuzoguattarian scholar Brian Massumi (2002) characterizes "sensation" as the "direct registering of potential...an extremity of perception...[and] a state in which action, perception, and thought are so intensely, performatively mixed that their in-mixing falls out of itself...[and] extend[s] into the nonfactual...the virtual" (pp. 97–98).

9. Deleuze and Guattari scholar Ronald Bogue (2004) writes that "one must immerse oneself in a problem, with its system of differential relations ('the universal of the relations which constitute the Idea' [Deleuze 1994, p. 165]) and their corresponding singular points" (p. 336).

10. About ontology, philosopher Giorgio Agamben (1999) writes, "a being that can both be and not be is said to be contingent" (p. 261).

REFERENCES

Agamben, G. (1999). *Potentialities: Collected essays in philosophy* (D. Heller-Roazen, Ed. & Trans.). Stanford: Stanford University.

Bogue, R. (2004). Search, swim and see: Deleuze's apprenticeship in signs and pedagogy of images. *Educational Philosophy and Theory, 36*(3), 327–342.

Deleuze, G. (1994). *Difference & repetition* (P. Patton, Trans.). New York: Columbia University.

Deleuze, G. (1995). *Negotiations: 1972–1990*. New York: Columbia University.

Deleuze, G. (2000). *Proust & signs: The complete text* (R. Howard, Trans.). Minneapolis: University of Minnesota.

Deleuze, G., & Guattari, F. (1987). *A thousand plateaus: Capitalism and schizophrenia* (B. Massumi, Trans.). Minneapolis: University of Minnesota.

Duchamp in conversation with Katherine Kuh. (1962). In K. Kuh (Ed.), *Artist's voice: Talks with seventeen artists* (p. 82). New York: Harper & Row.

Foucault, M. (1995). *Discipline & punish: The birth of the prison.* (A. Sheridan, Trans.). New York: Vintage.

Garoian, C. R. (2013). In the event that art occurs. *Visual Arts Research, 39*(1), 18–34.

Garoian, C. R. (2014). In the event that art and teaching encounter. *Studies in Art Education: A Journal of Issues and Research in Art Education, 56*(1), 384–396.

Guattari, F. (2006). *Chaosmosis: An ethico-aesthetic paradigm* (P. Bains & J. Pefanis, Trans.). Sydney: Power Publications, University of Sydney.

Hatoum, M. (1988). Measures of distance. Retrieved from http://www.youtube.com/watch?v=ZMAU2SfkXD0

Knoespel, K. J. (2005). Diagrams as piloting devices in the philosophy of Gilles. *Théorie, Littérature, Enseignement, 19,* 145–165. Saint-Denis: Universitaires de Vincennes.

Massumi, B. (2002). *Parables for the virtual: Movement, affect, sensation.* Durham: Duke University.

Maturana, H. R., & Varela, F. J. (1980). *Autopoiesis and cognition: The realization of living.* Boston: D. Reidel.

Molesworth, H. (1998). Work avoidance: The everyday life of Marcel Duchamp's readymades. *Art Journal, 57*(4), 50–61.

Wallace, D.F. (2005). *Transcription of the 2005 Kenyon Commencement Address.* Retrieved from http://web.ics.purdue.edu/~drkelly/DFWKenyonAddress Z2005.pdf

Zepke, S. (2005). *Art as abstract machine: Ontology and aesthetics in Deleuze and Guattari.* New York: Routledge.

Performing *The Refrain* of Art Research and Practice

Charles R. Garoian

Drill, baby, drill! It was on October 2, 2008, during her vice presidential debate with Senator Joe Biden, Democrat from New Jersey, that Alaska's Republican Governor Sarah Palin's vociferous pronouncement, *Drill, baby, drill!* gathered pungency, went viral, and was established as the quintessential refrain of the 2008 Republican National Convention. A lightning rod of the political Right, Palin's pugnacious bluster was intentional: to strike a nerve and spark anxiety in American voters for the purpose of convincing them that the Republicans and their corporate sponsors, unlike the Democrats' weak "socialist" leanings, were resolute on ending US dependency on oil from the Middle East. After nearly a decade of two wars in the region that virtually depleted the Nation's coffers, exhausted its military force, and disillusioned citizens about their government, *Drill, baby, drill!* pledged increasing offshore and onshore drilling in the USA and its neighbors. While the Republicans lost the 2008 elections to the Democrats, the fear tactics of Palin, the Tea Party, and other extremists of their ilk were successful in swinging political power from the Center to

C.R. Garoian (✉)
Penn State University, State College, PA, USA

© The Author(s) 2017
j. jagodzinski (ed.), *What Is Art Education?*,
DOI 10.1057/978-1-137-48127-6_3

the Right in subsequent midterm elections driven by an urgency to re-establish US isolationism on the one hand while promoting the so-called US global "exceptionalism" on the other.

With the Supreme Court's ruling on *Citizens United v. Federal Election Commission* and *Speechnow.org v. Federal Election Commission* of 2010, to allow Super Political Action Committees' unlimited contributions to political campaigns, the power of big business to buy elections was legitimized. In recent elections, coal and oil barons like the Koch Brothers have managed to get conservative majorities elected and, in overtaking both houses of Congress, the membership is certain to pass legislation that undermines scientific evidence that the health of the planet is in jeopardy due to the emission of greenhouse gases. In denying the science on global warming, and discrediting the necessity for alternative energy sources, neo-liberal, laissez faire capitalists vehemently oppose environmental restrictions arguing instead that greater petroleum exploration and extraction, as in shale oil in South Texas, tar sands in Alberta, deep water sites in Brazil, and offshore wells in the Arctic, is best for Americans' economic future.

Now, you might be wondering why I have begun this paper on art education with *Drill, baby, drill!* the refrain of neo-liberalism that espouses unrestricted access to natural resources based on historical determinations of environmental economics and politics. Those of us who have experienced unrestricted educational standardizations and assessments first hand certainly know such "drilling" all too well. Within the terrain of schooling, we have clearly learned and continue to understand the drill as *Test, baby, test!* In other words, the drilling down of standardized "high-stakes testing" in today's schools points to a systemic problem within the social, political, and economic ecology of American culture obsessed with neo-liberal and neo-conservative values and ambitions to entrench American exceptionalism, which is an ironic, hollow compulsion considering that it comes at the expense of the Nation's public schools.[1]

What I am suggesting is that within the current political climate in the USA where *Drill, baby, drill!* and *Test, baby, test!* are correlative and ideologically homologous, there exists a growing dependence on educational standards and assessments as the definitive "resource" for bolstering, if not supplanting, what are perceived as underachieving, if not failing, public schools by diverting public monies to privatized forms of education. In one example, Scott Walker, the Governor of Wisconsin, among his many offenses against public education, has offered "virtually no significant increase in public school funding while increasing voucher support for private and religious schools at taxpayers' expense" (Editorial Board

2015). This is an example of free market thinking, which is coincidently at the detriment of freethinking in schools. Unfortunately, such extreme resistance to funding public schools is not isolated to Wisconsin, but has become a nation-wide trend among those in power.

In characterizing the reductionist ethos of high-stakes testing to what she refers to as "real learning," progressive educator and activist Diane Ravitch (n.d.) writes: "As early as the first grade, American schoolchildren are practicing test-taking skills, learning how to fill in the right bubble on reading and math exams. And teachers across the nation are demoralized, compelled to teach what is tested, nothing more" (On-line). As Ravitch contends, teaching to the test is pernicious insofar as it purports serving students' best interests while limiting their learning to reified and rarified understandings. In other words, at issue with *Drill, baby, drill!* and *Test, baby, test!* is that such bullish thinking perpetuates ecological homogeneity and sameness, thus conforming thought and action to what is ideologically driven, and refraining from learning alternatives that are peculiar, complex, and contradictory. My use of "ecology" here is in reference to manifold ways of thinking that Gregory Bateson and Linda Hutcheon neologize as "trans-contextual." For Bateson (1972), trans-contextuality constitutes an enriched, differential way of thinking across contexts (p. 272). For Hutcheon (1985), it is the self-reflexive process of parody that "defines a particular form of historical consciousness, whereby form is created to interrogate itself against significant [socially and historically constructed] precedents" (p. 101).

Consequently, my compulsion in this brief paper is "to drill" as Palin's refrain urges, but to do so differently; to "drill," that is, to "drill down" the blame of diminishing test scores on teachers' inability to teach; a presumptuous way of thinking that denies their expertise, their differential pedagogies, and their bargaining rights, and assumes that politicians, and their big-business backers, are better positioned to fix what they assume is the "learning deficit" in today's public schools. Refuting such assumptions, Paul Krugman (2015) contends that politicizing alleged problems with education is a red herring inasmuch as it attempts to evade and divert our national discourse from the specter of inequality. "Drilling down," insofar as I am characterizing it, constitutes parody; that is, a trans-contextual inflection, an unfolding to expose reductive hierarchies, taxonomies, and standardizations in schools to examination and deconstruction. In other words, reductive reasonings like *Drill, baby, drill!* and *Test, baby, test!* trivialize and impede potentially new and different understandings that can be

mined from standardized formulations. For such critique and transformation to occur, however, it requires not educational entrenchment, but the multifarious and differential movements and entanglements that constitute the emancipatory refrains of art research and practice.

My argument is not to throw the proverbial "baby" of educational standardization and assessment "out with the bathwater," but *to perform its refrain differently*. No, my argument with standardized education and its testing is that it neglects exploratory and experimental impulses that enable thinking creatively and performing differently in classrooms—to enable the "real learning" that Ravitch talks about (n.d., On-line). The "real" to which she refers constitutes pragmatic learning that occurs in the making. It is an incipient learning that emerges experientially through doing and making with images, ideas, and materials that John Dewey so eloquently expounded in *Art as Experience* (Dewey 1934). Such emergent learning by doing occurs through exploration, experimentation, and improvisation as in the creative processes of art making.

Conversely, learning that is confined to standardized testing relies exclusively on pre-existing, pre-determined understandings—knowledge that stands on ceremony more than it does on substance, more about semiotics than pragmatics, focused on reproducing existing meanings at the exclusion of those that can potentially emerge differently.[2] Regrettably, art education has often been duplicitous of such redundancy when it has advocated for creative experience while in the same breath promoting representationalism. About this matter, Donal O'Donoghue (2015) asks an important question: "Isn't it fair to say that, for decades, many students in art education classes have been invited to represent an experience already had, which is an act that occurs independently of that experience and, for the most part, demands representational capacities that have little to do with it" (p. 104). O'Donoghue's question suggests that the teaching of art has a tendency to adapt and adopt the culture of standardized representations in schools, which neglects and takes away from art's experiential potentiality.

Consider the following example of excessive standardization and assessment in schools. On a recent field trip to a major American city with my art education colleagues and our undergraduate pre-service art teachers, we visited a secondary school where one of our seniors was student teaching. The purpose of our visit was to observe the student teacher's performance teaching alongside the cooperating teacher of the art classroom. After entering the front doors of the school, and passing through a

mandatory metal detector where we were checked for weapons, we were escorted down a long corridor toward the art classroom where the student teacher was conducting class.

During our walk, we noticed a poster (Fig. 3.1) that was posted in strategic locations along the corridor, and later we found many others posted throughout the school. Their message repeated the following refrain: "DATA NON-NEGOTIABLES," followed by a list of five admonitions: "1. Know your data; 2. Organize your data; 3. Use your data to support instruction; 4. Make sure students know their data and what they need to do to improve; and 5. Display your data." While these admonitions were clearly aimed at teachers, given their ubiquity, the posters' advisory was conspicuously intended for every student in the school. Similar to Ravitch's point about practicing test-taking skills, the school's teachers and students were being continually prodded to attain and maintain the school's expectations for high test scores, and its state and national rankings.

In addition to the data non-negotiable posters, we also found several swaths of large bright-colored butcher paper taped to each other in abstract, irregular patterns on the corridor walls (Figs. 3.2 and 3.3). Their oddly shaped, blank empty surfaces roused our curiosity and suggested several possibilities: perhaps they were preparations for students' large-scale mural projects; perhaps they were students' minimalist collage projects; perhaps students were emulating the early works of Christo; or, perhaps they were the late abstractions of Robert Motherwell. Whatever their purpose, those butcher paper postings affected a sense of excitement and musings about what the students were doing, perhaps exploring and experimenting with images, ideas, and materialities that are imperceptible

Fig. 3.1 DATA NON-NEGOTIABLES Poster (Courtesy of Charles Garoian)

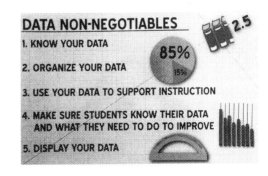

Fig. 3.2 Large bright-colored butcher paper taped on corridor wall (Courtesy of Charles Garoian)

Fig. 3.3 Large bright-colored butcher paper taped on corridor wall (Courtesy of Charles Garoian)

and about to emerge, about to happen. Wow! What counterpoint to the data-driven non-negotiable postings, we thought.

Our enthusiasm was short lived, however, when the Principal of the school, when asked, informed us that the explicit purpose of the butcher paper was to cover up students' artworks (Fig. 3.4). As art educators advocating for the creative and intellectual significance of art in the schools, we were taken aback by the Principal's rationale. Unlike Christo's double-coded, paradoxical concealments enabling revelations of seeing and thinking differently, during testing days and testing weeks, all artworks were covered up to refrain students from being visually distracted and any possibility of finding clues to answers on the standardized tests. This restriction, of course, also applied to the covers and spines of all books

Fig. 3.4 Large bright-colored butcher paper covering student artwork (Courtesy of Charles Garoian)

and magazines, any reading materials, in the testing rooms. Yes, *Drill baby drill! Test baby test!* Upon further inquiry, the Principal informed us that a hefty fine of 3000 dollars would be levied against the school by the private testing agency whose services had been contracted by the school district if such testing restrictions were not followed.

Considering that the refrain as I've conceptualized thus far constitutes repetition that holds back, constrains, and keeps on doing and thinking the same as before, raises the question as to what art research and practice does and can do that can possibly make a difference given the perpetual recurrence of standardization. So the question remains, how does one go about performing the refrain of standardized forms differently through art? In response, I turn to the three aspects that constitute the dynamics of The Refrain as conceptualized by Deleuze and Guattari (1987, pp. 311–312): *infra*-assemblage, *intra*-assemblage, and *inter*-assemblage. Infra-assemblage is that movement of The Refrain that occurs when an ideational encounter short circuits thought yet inspires curiosity and further inquiry and exploration. Intra-assemblage occurs as disparate elements within the unexpected and unfamiliar event are extracted and brought together into a convergence. And, inter-assemblage is that aspect of The Refrain that occurs as the unfolding and launching of transversal lines of flight that hazard improvisational encounters and alliances in-between standardized formulations.

Instead of *refraining from*, these three aspects constitute The Refrain as *riffing-on*, a transversal, performative process, not to be confused with being "RIFed," which is the downsizing "reduction-in-force" of teach-

ers and school personnel for reasons that are unrelated to their perfor-
mance, an example of which is the estimated 13,000 layoffs in the State
of Illinois this year. The Refrain's riffing-on, according to Deleuze and
Guattari, is not a violent movement against standardized understandings,
but an eagerness to be affected and *played by* them as the basis for experi-
mentation and improvisations; that is, *playing with* and inflecting stan-
dardizations in order to create new and different ways of thinking. About
inflecting standards in this experimental way, Herbert Kohl (2006) writes:
"The notion of riffing on the standards implies developing an interesting
or powerful idea or theme and then tying it to a learning standard. For me
it implies creating curriculum that embodies one of more standards but
is not designed because of the standards but because of the power of the
idea" ([On-line], p. 8).

To elaborate on The Refrain's destabilizing process, *infra-assemblage*
constitutes underground movement, an anxious curiosity and impulse to
explore monolithic forms *from beneath* their rarified images, ideas, and
materialities. Consider how artists and other creative practitioners explore
constraining monolithic social and historical representations through anx-
ious and impulsive curiosity. Might such impulses and eagerness among
teachers and students to explore standardized forms through playful
research generate a multiplicity of experiential encounters? If so, such
experiences would enable thinking standardized forms in manifold ways to
constitute *intra-assemblage*; an *assured curiosity* and eagerness to experi-
ment *from within* their closed systems by extracting and tinkering with
their fragments, and reassembling new and different alignments to consti-
tute alternative ways of thinking to those of given standardizations.

With regard to *intra-assemblage*, consider how art researchers and prac-
titioners eagerly approach standardized representations through playful
experimentations disassembling their monolithic forms and reassembling
them in new and differing ways. Doing so constitutes a subversive pro-
cess through which standardized assumptions can disarticulate and trans-
form into new and different possibilities from within their closed systems
of thought. And, consider how teachers and students might extract and
tinker with pre-existing cultural images, ideas, and materialities to create
unknown, alternative ways of thinking. In doing so, the *en*folding con-
vergence of intra-assemblage constitutes potentiality for the *un*folding,
transversal divergence of *inter-assemblage*, a thinking that is constituted
through *confident curiosity* and daring to risk improvising trans-contextual

associations *between* the reassembled, new images, ideas, and materialities, and *among* those of disparate others.

Hence, The Refrain of art research and practice constitutes a riffing process of being *played by* and *playing with* standardized iterations differently rather than perpetuating their sameness. As art educators, let us not assume that creativity occurs without being played by and playing with resistance. Resistance to what? Riffing on what? Exploring, experimenting, and improvising with what? Manifold ways of thinking that emerge through art research and practice do so not by running away from standardized images, ideas, and materialities, but by running toward them to explore, experiment, and improvise from beneath, within, and in-between their monolithic forms. In doing so, restrictive refrains such as *Drill baby drill!* and *Test baby test!* disarticulate and repeat differently through the riffing refrains of art research and practice.

In ending, I return to the curiosity that the large butcher paper tapings on the walls of the school roused in my colleagues, our students, and me (Fig. 3.5). Our musings about their purpose for mural art, as minimalist collage, or even emulating Christo or Motherwell, while seemingly inconsequential at the time, constituted *infra-, intra-, inter-assemblage*, our riffing-on and reconstituting their ubiquitous, imposing refrains. Little did I realize then how germane was our petite riffing-on their refraining blank purpose, their evasion of student art to instead divert attention to "non-negotiable data". It is that, the non-negotiable illusion of high-stakes testing and standardization that calls for the riffing logic and performativity of art research and practice again, and again.

Fig. 3.5 Large bright-colored butcher paper covering student artwork (Courtesy of Charles Garoian)

NOTES

1. Educator W. James Popham (1999, p. 10) contends, "employing standardized achievement tests to ascertain educational quality is like measuring temperature with a tablespoon."
2. The confinement of educational research and practice to standardized formulations is homologous with Deleuze|Guattari (1994, p. 83) argument that, "nothing positive is done, nothing at all, in the domains of either criticism or history, when we are content to brandish ready-made old concepts like skeletons intended to intimidate any creation..."

REFERENCES

Bateson, G. (1972). *Steps to an ecology of mind*. New York: Ballantine.

Deleuze, G. & Guattari, F. (1987). *A thousand plateaus: Capitalism and schizophrenia* (B. Massumi, Trans.). Minneapolis: University of Minnesota.

Deleuze, G., & Guattari, F. (1994). *What is philosophy* (H. Tomlinson & G. Burchell, Trans.). New York: Columbia University.

Dewey, J. (1934). *Art as experience*. New York: Putnam.

Editorial Board. (2015, February 6). Gov Walker's 'drafting error'. *The New York Times*. Retrieved from http://www.nytimes.com/2015/02/07/opinion/gov-scott-walkers-drafting-error.html?_r=0

Hutcheon, L. (1985). *A theory of Parody: The teachings of twentieth-century artforms*. New York: Methuen.

Kohl, H. (2006). Love supreme—riffing on the standards: Placing ideas at the center of high stakes schooling. *Multicultural Education, 14*(2), 4–9 Retrieved from http://files.eric.ed.gov/fulltext/EJ759645.pdf

Krugman, P. (2015, February 23). Knowledge isn't power. *The New York Times*. Retrieved from http://www.nytimes.com/2015/02/23/opinion/paul-krugman-isnt-power.html

O'Donoghue, D. (2015). The turn to experience in contemporary art: A potentiality for thinking art education differently. *Studies in Art Education, 56*(2), 103–113.

Popham, W. J. (1999). Why standardized tests don't measure educational quality. *Educational Leadership, 56*(6), 8–15.

Ravitch, D. (n.d.). High-stakes testing. *Washington Post*. Retrieved from: http://www.washingtonpost.com/wp-srv/special/opinions/outlook/spring-cleaning/high-stakes-tests.html

Folding Pedagogy: Thinking Between Spaces

Jack Richardson

He stands at the edge of the pool located in the large university aquatic complex. He stretches his arms and legs in preparation for his swim. He is fully clothed wearing his employee uniform, still wearing his glasses, and the university-issued identification tag. Deliberately and without hesitation, he jumps feet first into the pool and pushes off the wall. Stopping only briefly to take a few sips of energy drink, he continues to swim with a smooth and obviously practiced stroke. Back and forth, back and forth. The weight of his saturated clothing seems to affect his stroke only slightly. Once the swim is completed, he exits the pool, clothing clinging and drenched. He grabs his towel off of the starting block on the edge of the pool. He is finished.

The work described above represents a site-based art project carried out by a student who had been enrolled in a course titled *Artmaking as Encounter* that a colleague and I taught as a weeklong summer seminar in the department of art education. We had designed the course as a

J. Richardson (✉)
Department of Secondary Education/Department of Arts Administration, Education and Policy, The Ohio State University, Newark, OH, USA

© The Author(s) 2017
j. jagodzinski (ed.), *What Is Art Education?*,
DOI 10.1057/978-1-137-48127-6_4

93

studio-based exploration of the work and ideas of Gilles Deleuze and Felix Guattari. At the conclusion of the course, we marveled at the strength and uniqueness of the projects done by the students. We rarely see this level of work in many of the courses that we have taught, and we are often somewhat at odds to explain the success. Indeed, as a brief summer seminar, there is the opportunity to approach the course structure in a more experimental manner. Anecdotally, we can look at how we had presented the material. For instance, we had only provided very brief quoted sections, literally cut from multiple sources pertaining to the topic for the day, and had given them to the students as a collection in a small envelope. Additionally, the material was not structured sequentially but thematically, and given the time constraints of the course, these themes quickly blended and overlapped in the projects, discussions, and presentations. Finally, there was no expectation of prior knowledge either in terms of making art, or a familiarity with the topics associated with Deleuze and Guattari. Yet, while we can look back at our week and see where and in some cases why things seemed to work, it is clear that this class did not resemble others we have taught.

This chapter is an effort to provide a tentative description of a pedagogical approach that corresponds appropriately to the unusual structure of the course, to the ideas and concepts presented in Deleuze's work, and serves as an effective lens through which to examine and discuss student work. Whereas each of the course titles was derived from Deleuze and Guattari's work (*Artmaking as Difference, Artmaking as Encounter*, and *Art as Encounter*), I will be using another term central to much of Deleuze's late work to articulate a pedagogical approach used in each course, and use the term *folding* pedagogy. While it will be the philosophy of Deleuze that will support a rethinking of pedagogy, the chapter will also examine these concepts in recent architectural theory as a means through which to develop a metaphorical reference around which to structure these ideas.

The chapter will outline Deleuzian concepts as they pertain to pedagogy. In light of Deleuze's concept of both art and philosophy, conventional pedagogical approaches must be altered to align with his ideas. This is not in an effort to simply overlay his ideas onto more common approaches to learning, but rather to see what is produced when such an alternate conception of learning is introduced. At a fundamental level, Deleuze's ideas are not included as an additive component to the social and cultural landscape, but rather as an event that "extracts new harmo-

nies" (Deleuze and Guattari 1994, p. 176) from the environment, both real and virtual, that surrounds us. As such, art becomes less an endeavor of memory, skill, and/or representation and more one of immediacy and experimentation. Art "does not commemorate or celebrate something that happened but confides to the ear of the future the persistent sensations that embody the event" (p. 176). It is not a way of explaining the world; it is a way of coming to know the world, more specifically, *a world that does not yet exist*. It follows a conception of novelty and originality that does not simply present something we have not *seen*, but rather a novelty that opens us to something we have not yet *thought*. How do you teach, learn, or respond to something that is not yet, but is only to come?

BACKGROUND

On three different occasions, I have co-taught a one-week graduate seminar for university students focusing on artmaking and the work of Gilles Deleuze and Felix Guattari. The reason for using their philosophy as a foundation for the course was not arbitrary. It grew out of our acknowledgment that while much contemporary art had expanded far beyond both the literal and figurative walls of the institution, art education as a component of broader general education had largely remained within its boundaries. Additionally, our approach followed Deleuze's comment regarding teaching that "you give courses on what you're investigating, not on what you know" (Deleuze 1995, p. 139), and the complex idiosyncratic nature of Deleuze and Guattari's work, by their own admission, is not intended to be fully known. It is my contention that it is not simply the historical precedents of art and education that have guided art educational practice, but the very building itself, and what it stands for, has produced a pedagogical approach to learning that is implicit in all disciplines. And until the practice of art education can be articulated from the *outside*, a term taken up later in this chapter, it will continue to replicate itself. Simply taking the art production outside the classroom to mirror some contemporary art practices does not alter the very principles associated with the pedagogy that is in place. As such, acceptance of art as a necessary and unique component of contemporary education is perpetually at risk. It would be unrealistic to argue that a simple change in pedagogical approach could rescue art from its frequently tenuous status; however, if we cannot explain the unique pedagogical capabilities of art that stand

apart from all other disciplines, then I believe its position at the margins of learning will continue.

I would not, and could not, begin to know or be able to fairly explain the great diversity of teaching pedagogies that are used across the field of art education. However, I can say with some degree of certainty that at their core, they are informed by some seemingly inviolable presumptions. For instance, it is perhaps fair to say that each discipline has some core principles and basic content that is simply accepted as such. History, for instance, presumes an analysis of things and events from the past, and of these, some are more significant than others. Its content is understood to have existed prior to our study of it, and it is toward this past that we direct our attention. Basic arithmetic and algorithms are necessary for achievement in math and must be accepted in order that learning can be replicated. Reading and literature presume at minimum a basic knowledge of language and syntax, which must be more or less universally acknowledged. In all cases, there is the presumption that there is a body of knowledge and a set of skills to be learned and furthermore this knowledge can be taught.

Perhaps one of the deepest and most intractable presumptions about teaching pedagogy in any field is the presumption that there is a subject (student and teacher) who thinks as being separate from knowledge (ideas, events, objects, and so on) to be thought about. It is this very separation that Gilles Deleuze's concept of the *fold* serves to disrupt. As a result, a pedagogy based on this concept will necessarily be fundamentally different from others. In fact, it is this construction of subject and object dichotomy that produces the proposition "I think" that lies at the heart of Deleuze's critique of much Western philosophy. His fundamental question is what comes before thought that constitutes the subject presumed to be at the center of thinking? Philosophers such as Plato, Descartes, and Heidegger have each privileged the centrality of the thinking subject as a given in their various articulations of the nature of thought. Similarly, it is the very buildings within which we teach, and the consistent designs of classrooms that predispose this assumption. The basic principle that learning occurs when a subject is taught is so profoundly entrenched in our understanding of knowledge and so fully reinforced within both the physical and cultural structures of the school that teachers become unwitting advocates of this accepted ideal. Friedrich Nietzsche, a philosopher admired by Deleuze, suggests this condition in his provocative critique of the philosophers of his time. "They are all advocates who do not want to be seen as such;

for the most part, in fact, they are sly spokesmen for prejudices that they christen as 'truths'" (Nietzsche 2002, p. 8). It is within Deleuze's concept of the fold that this separation between subject and object is no longer presupposed, and it is out of this concept that I will endeavor to articulate an alternative foundation for pedagogy.

There are various theoretical and philosophical foundations for articulating pedagogy and its relation to learning approaches. Such as didactic, dialectic, Socratic, and so on, yet each, though different in their procedures, presumes a definition of knowledge that is understood to exist prior to learning and toward which each of the approaches will guide students. In short, knowledge is obtained through an accumulation of learning over time. By contrast, underpinning pedagogy with Deleuzian ideas suggests a manner of learning that presupposes no particular knowledge, no particular skills, and no particular outcomes. Rather, a "folding pedagogy" would presuppose only that there is a world and there are students, and somewhere at the point of contact thought occurs. Nietzsche remarks "that a thought comes when 'it' wants, and not when 'I' want" (Nietzsche 2002, p. 17), suggesting that thought does not emanate from the subject, but rather has a force all its own. This is a thought neither directed toward future understanding, nor reflecting upon prior knowledge, but rather represents a reconciliation of the immediate moment of contact with difference.

The type of knowledge produced would be understood as synchronic or pertaining to the here and now, to the in-between that forms the boundary of the past (with its own knowledge) and the future (a knowledge yet to come). This is in contrast to diachronic knowledge suggesting a sort of accumulation of thought producing knowledge achieved over time. In terms relating to Deleuze's concept of the fold, learning occurs at a crease in a space where one's particular experience produces a particular knowledge for a particular subject that itself did not exist prior to that experience. If, as Deleuze suggests, the world is an undifferentiated collection of things of which we as humans are a part, then not only does making art serve to connect, and thus reveal objects and images, and their connections, it also reveals the subject simultaneously. This is the "experience of knowledge in the making [and] also the experience of our selves in the making... there is no self who preexists a learning experience" (Ellsworth 2005, p. 2).

One of the most basic and perhaps most radical changes that must be made when considering a pedagogical approach to an art education based

on the Deleuzian principle of the fold is a turn away from the object of art (both its production and the processes necessary for its production) toward the production of thought. This is not to discount or diminish the role of artmaking as a component of art education. Rather, it is an effort to move learning through art away from the sometimes explicit and frequently implicit attention given to the art object toward a focus on what artmaking *does* during its production. Conventional art educational processes variously involve attention to materials, content, skills, appreciation, and interpretation. As such, a pedagogical approach to learning with and through these elements looks little different from similar approaches in other disciplines. That is, there is a presumed body of knowledge, a theoretical foundation, and a set of skills that precede learning. And while self-guided and experimental inquiry is frequently a component of good pedagogical practices, the assumption is that these exploratory practices are largely a means to an end. That end may be making art, interpreting art, or even understanding ideas and content only tangentially related to art. However, in all cases, the educational process is developed around and guided toward a qualifiable or quantifiable outcome, which itself must presuppose an identifiable, if not particular, outcome.

A FOLDED AND EVENTFUL WORLD

It is perhaps an understatement to acknowledge the difficulty of developing and applying a pedagogical approach to learning through art that purports to yield a type of knowledge that begins with neither content nor a subject for its production. Yet this is the basis upon which I would like to make a case for a radical rethinking of the purpose, form, and value of art production in the context of art education that begins with a substantive reconsideration of what constitutes *thinking*. This is not to suggest that there is no material to teach and there is no student to learn, rather these two elements are constituted as a consequence of a folding pedagogy. In other words, it is not simply that a subject as learner thinks a thought. Rather, *learning occurs as thought thinks and produces a subject*. It is only at the point of subjectivation, or the emergence of the subject, that thought becomes conscious.

One element of our course that was consistent in each of its presentations is the use of some building or location within the university as the site of much of the artwork produced by the students, such as the University Library or Students' Union. We had chosen to use public sites

in order that the ideas presented could be explored in places that included a level of both familiarity and unpredictability. To further articulate a folding pedagogy, it is useful to articulate these spaces as folded sites. Indeed, Deleuze, following Leibniz, suggests that all experience, and the subjects and objects of that experience can be understood in terms of a folded world.

On the first page of his book, *The Fold: Leibniz and the Baroque*, Deleuze (1993) crystallizes his perception of the fold. "The multiple is not only what has many parts but also what is folded in many ways" (p. 3). That is, the space of the world is not an endless collection of distinct objects coexisting in measurable space referred to as extensive space. Rather all objects and forms constitute an intensive or internal force that makes possible endless fluid connections. Deleuze characterizes this combinatory potential as elasticity, and writes that each "elastic body still has cohering parts that form a fold, such that they are not separated into parts of parts but are rather divided to infinity in smaller and smaller folds that always retain a certain cohesion" (p. 6). Organic bodies within a folded world are not simply distinct forms that maintain their prior integrity that makes contact with other organic and inorganic forms only to separate and continue as the same form. Rather, "[f]olding-unfolding no longer simply means tension-release, contraction-dilation, but enveloping-developing, involution-evolution" (p. 8). Folding is an ontogenetic process.

Deleuze reconsiders the work of seventeenth century philosopher Gottfried Wilhelm von Leibniz in his constitution of the fold. For Leibniz, there exist unique, distinct, non-reproducible, and indestructible entities he calls monads, which exist even prior to the constitution of the subject. The world that we inhabit is thus composed of endless harmonious series of these simple substances that come to harmonious organization from a source outside their existence, such as God. What Deleuze brings to this equation is the idea that the coordinating force that Leibniz identified as outside the internal structure of the monad was to be found within the singular form. Knowing the world for Liebniz could then be understood as the coming to form of the individual as a collection of the unified monads in an organized and harmonious manner. "We say that the individual is a 'concrescence' of elements. This is something other than a connection or a conjunction" (Deleuze 1993, p. 78). By contrast, Deleuze suggests that the element of unity is contained within both the monad (intensive) and the world (extensive). The subject "becomes" within the folds of matter. Thus, as changes occur in both the world and the subject, there is not a

separation, but rather there is an unfolding. It is within this sequence of folding and unfolding that a world and its inhabitants take form.

The folds and pleats that emerge are a consequence of what Deleuze refers to as prehensions, or more simply pre-apprehensions. Apprehension presumes an already-formed subject, whereas prehensions represent forces within and running through all elements. Prehensions occur unconsciously and represent the limits of difference between multiple elements. That is, when differentiating between objects or forms, we can identify representational differences; however, as we reduce these differential points further, we reach a point where difference is no longer maintained. At the level of prehension, there is not a perceptible force, but rather intensive forces such as vibrations and luminosity. It is the point of convergence of these forces that constitute the event "where the relation among limits establish a conjunction" (Deleuze 1993, p. 77). The event produces prehension that "moves from the world to the subject, from the prehended datum to the prehending one (a 'superject'); thus the data of a prehension are *public* elements, while the subject is the intimate or *private* element that expresses immediacy, individuality, and novelty" (p. 78). The event is thus the conscious perception of the fold coming to form as prehension moves into perception. "We can say that 'echoes, reflections, traces, prismatic deformations, perspective, thresholds, folds' are prehensions that somehow anticipate psychic life" (p. 78).

This articulation of the composition of the world is not merely a novel way of conceiving its interrelatedness. It also provides a foundation for Deleuze's notion of thought as understood through the fold. Thinking is not what emanates from the subject because, as has been stated above, the subject and perceiver is a consequence of the fold and not the other way around. For example, in a world understood as a multiplicity of distinct objects, differences in the application of thought are negative, which is to say that difference is identifiable as *that* which is not *this*, and out of which clarity or "truth" is established. By contrast, for Deleuze, it is the fold that draws out clarity in the form of perception. "Inconspicuous perceptions constitute the obscure dust of the world, the dark depths every monad contains" (Deleuze 1993, p. 90). Inconspicuous perceptions here can be understood as prehensions, the integration of which constitutes a fold, which brings forth and provides a ground for thought. "This ground is in continuation with that which is distinct from it, because the distinct arises out of the obscure ground" (Kaiser 2010, p. 213).

ART PRACTICE AS EVENT: MONUMENTAL SINGULARITIES

If we are to begin to develop a pedagogical approach to teaching and learning within a folded and folding world as conceived in Deleuze's thought, then we must also reconsider what it means to make art within this construction. It becomes less important to focus on what is made, and emphasize when and where making occurs. In correspondence with this understanding, most of the artwork done by our students was done in public spaces throughout the campus. Site-based work allows for the maximum number of prehensions to perhaps take hold and emerge as perceptions. The event represents time and proximity within a series of passive syntheses of experience representing the contraction and expansion of prehensions. This is not to be understood as a linear sequence of experience, but rather as the nexus of an infinite field of forces within which we are always immersed. As we move through the world, we are always updating our experience based on this process of ongoing synthesis. At the convergence of series are singularities. These are "turning points and points of inflection; bottlenecks, knots, foyers, and centers; points of fusion, condensation, and boiling; points of tears and joy, sickness and health, hope and anxiety, 'sensitive' points" (Deleuze 1990, p. 52). This is not understood as a moment that can be sensed by an individual, but rather, "[i]t is essentially pre-individual, non-personal, and a-conceptual" (p. 52). At the point of intersection of a series, the individual and the art emerge simultaneously through this singular coincidence.

The world of series, singularities, and prehensions is the virtual and differential world that represents the predicate of all subject formation, and I would argue in the context of artmaking the production of art. In other words, a folding pedagogy does not and cannot presume a particular artistic form or object as this is merely the visual representation of the resolution of the singularity performed by the newly formed identity. Prior to representation in this process is experimentation. "Only by destabilizing our thinking, disrupting our faculties and freeing our senses from established tendencies might we uncover the difference evident in the lived world, and realize the uniqueness of each moment and thing" (Stagoll 2005, pp. 75–76). At the level of prehensions and singularities, the world operates in the realm of percepts, whereas at the level of consciousness, we perceive the world through perceptions. The process of percepts coalescing creates what Deleuze and Guattari call "blocs" (Deleuze and Guattari 1994, p. 164). "The artist creates blocs of percepts and affects,

but the only law of creation is that the compound must stand up on its own" (p. 164). This bloc of sensations is what Deleuze and Guattari call a "monument."

As stated in the previous section, the event is marked by the convergence of singularities that produce a fold out of which a subject emerges. The incompatibility of difference within the fold is then rectified as an event that brings forth simultaneously a subject and the concepts through which sense can be attained. "Awareness of such specific circumstances means that the notion of some 'thing in general' can be set aside in favour of one's experience of *this* thing, here and now" (Stagoll 2005, p. 76). The specificity of concept production is what makes thought itself specific to discrete circumstances rather than producing a concept that will make sense of subsequent experiences. "With its concepts, philosophy brings forth events. Art erects monuments with its sensations" (Deleuze and Guattari 1994, p. 199). Though monuments are conventionally understood as commemorative of something past, here Deleuze and Guattari are referring to a "bloc of present sensations that owe their preservation only to themselves and that provide the event with the compound that celebrates it... The monument's action is not memory but fabulation" (pp. 167–168).

It is in fabulation or experimentation within the monument that a folding pedagogy finds its unique capacity to produce new thought. In the erection of monuments, artists are both active and passive producers of new awareness, of novel ways of seeing, responding to, and understanding the world. The activity and passivity of the event of the fold is not simultaneous, rather it is the moment that difference has compressed to the point of vibration where the virtual and the real achieve contact. "Art undoes the triple organization of perceptions, affections, and opinions in order to substitute a monument composed of percepts, affects, and blocs of sensations that take the place of language" (Deleuze and Guattari 1994, p. 176). Learning through art understood as monument construction shifts attention away from knowledge that can be represented "as a thing already made" (Ellsworth 2005, p. 27) toward an understanding of learning as knowledge in the making. Indeed art in this process is not predetermined or predictable. A folding pedagogy precipitates a becoming-art with art understood as an experimental intervention that produces new thought and new perspectives of the world.

Indeed the 'I' and 'we' don't come before such a 'becoming-art,' but on the contrary form part of its invention, its experimentation. An 'artistic voli- tion' thus starts with no given public, obeys no established 'intersubjective norms' of judgment, reduces to no sociological or institutional definition, and can be contained or directed by no avant-garde with its pope-master— such is precisely its force and its promise. (Rajchman 2000, p. 121)

Having established the basis for a folding pedagogy, the following section will examine in more depth some of the work done by the students in the summer seminar read through some of these ideas. As most of the work in the course was done in public sites and buildings throughout the campus, I will first articulate some of the manifestations of the concept of the fold and various Deleuzian ideas as they have been taken up in architecture. The work of Bernard Cache, a French furniture designer and architect, is particularly useful as the philosophical ideas presented in Deleuze's work form a foundation upon which Cache reconsidered architectural form and purpose. Indeed, Cache followed closely and even attended some of Deleuze's seminars at the University of Paris (Cache and Speaks 1995, p. vii). Also, Deleuze directly references Cache's ideas in his book *The Fold: Leibniz and the Baroque*. The more concrete, albeit still largely theoretical, exploration of these ideas in the context of architecture perhaps provides a more accessible articulation of the fold as it pertains to lived spaces, and as they are experienced by the students in our course.

THE ARTIST BECOMING OTHER

In 1929, Georges Bataille commented that "[a]rchitecture is the expres- sion of the very being of societies, in the same way that human physiog- nomy is the expression of the being of individuals" (as cited in Leach 1997, p. 19). As such, architecture represents a physical structure that mitigates against social transgression. Architectural form rises "up like dams, pitting the logic of majesty and authority against all the shady elements: it is in the form of cathedrals and palaces that Church and State speak and impose silence on the multitudes" (as cited in Leach 1997, p. 20). It is the strict dichotomy produced by architectural compositions between inside and outside that brought about Bataille's critical stance and formed the critical foundation for Bernard Cache's rethinking of architecture.

In Cache's work, he uses the word "inflection" as a corollary to the "fold." Inflection for Cache constitutes an image. Yet, this is an image

that does not simply refer to a facile visual document or form. Rather, it is an image that corresponds to all visible phenomena, which include architectural forms, the site of those forms, communities, individuals, geologic formations, and so on. All these images as such are in constant fluid and dynamic relationships. It is architecture that provides the frame that can isolate but not arrest this dynamism. Just as the fold represents the pre-subjective constitution of sensation and affect, inflection precedes human presence in architecture. The fold unfolds and refolds. Like the fold, inflection, or the perpetual interaction of images of architecture, cannot be permanently fixed and will always unframe as it frames. "Together they draw a diagram of an unlimited deframable space of possible inflection prior to the delimited space of fixed objects and images" (Boyman 1995, p. xi).

Cache's frame isolates but does not determine the identity of a site or individual within that site. That is, though it represents the most basic attribute of architecture, the frame is not the identity of architecture. Rather, it is what allows the isolation of the interval as a site of probability. It does this by first providing a provisional separation between inside and outside. Yet this is a separation perforated by openings like the lower floor of the Baroque house described by Deleuze (1993), referencing Leibniz, as "a great Baroque montage that moves between the lower floor, pierced with windows, and the upper floor, blind and closed, but on the other hand resonating as if it were a musical salon translating the visible movements below into sounds up above" (p. 4). Whereas the Baroque house of Deleuze and the architectural frame of Cache both impose a separation, they both assume a permeable barrier that marks the interval between cause and effect, between outside and inside, and between rational and irrational. Cache remarks that philosophically and architecturally "no value has been attributed to the interval that separates the cause from the realization of its effect... One never knows how the interval will be filled" (Cache and Speaks 1995, p. 23).

The interval, like Deleuze's virtual, is activated by inflection to produce a zone of neither predictability nor chaos but of probability. "The wall delimits dark rooms; the window lets the sun shine in; what is still needed is a surface that stretches its screen to the variable play of shadows formed by the light" (Cache and Speaks 1995, p. 25). This interchange or inflection that occurs as the outside intermingles with the inside represents the "actualization of the virtual the becoming other of something that, though real, has not yet been" (Speaks 1995, p. xv). "Becoming other" refers not

just to the space affected by the inflection, but also to the individual who produces and/or occupies that space. As such, art and artmaking become the form and act of becoming along with the becoming-other of the artist. This is the space of a folding pedagogy within the built environment of the university; it is the space toward which we guided our students to occupy the interval. "Life alone creates such zones where living beings whirl around, and only art can reach and penetrate them in its enterprise of co-creation" (Deleuze and Guattari 1994, p. 173).

STUDENT PROJECTS

In this section, I will recount student artworks done in our courses read through a folding pedagogy. While I can describe the form of the work, such as the description that introduced this chapter, I will endeavor to reflect upon what I think was happening as the students carried out their projects, again focusing primarily on what the art *does* rather than what it is. Indeed, I can only speculate on what was actually occurring in the thoughts and experiences of the students as they operated in the fold of their own making. While each of the works was predicated on a prompt that we provided and shared with the class as a completed form as a video or slide show, it could not be said that the actions of the students within the process of enacting the space had a clear beginning or end. It is within this inflected space, the space of the virtual, that the becoming-other of the artist occurs, and where learning unfolds within the fold. Elizabeth Ellsworth (2005) articulates this process well when she describes Herbert Muschamp's, the architectural critic for the *New York Times*, learning experience in the Lois and Richard Rosenthal Center for Contemporary Art in Cincinnati.

> For him, this building modulates the compression and expansion of space in a way that offers a material correlate for the experience of the learning self as in the making. It does so by powerfully synchronizing his body's movements with the propulsion of his curious mind toward a particular understanding of the present time. (p. 20)

Swimming

Returning to the work presented at the beginning of this chapter, we can see the multiple forms and practices that individually have a rational cor-

respondence to the student's life, yet their coalescences within this piece represent a fold at the intersection of their functional, social, physical, and personal forms. Likewise the building, the pool, and the water each represent forms that contribute to the folding and folded experiences of the work. Each of these elements has a continuity prior to the students' actions representing what Deleuze would call the "plane of consistency" that establishes "the outside of all multiplicities" (Deleuze and Guattari 1987, p. 9) or a rational order whose counterpart is understood as the virtual or potential contained within that order. Swimming fully clothed and wearing glasses disrupts this plane, producing a fold within which rational order is disturbed, yet is not replaced by chaos. The artwork constitutes an interval in the plane, a fold with a particular duration after which the elements of the action, including but not limited to the building, the pool, the student, and the clothing may or may not return to their prior consistency. Upon completion of the work, the world created Upon completion of the work, the world created by the event, unfolds by the event, unfolds. The work itself represents, not a midpoint in a linear sequence of events, but rather a hub in the center of a multiplicity of forms. Art and learning as such are not conceived as endpoints or beginnings, but rather as sort of a fulcrum dividing what is known from what is possible.

Breathing

Another student work involved three students and took place in the university's library. The central feature of the building is the six-story main book collection open to visitors to view through a wall of glass exposing all of the contents contained within. It is this glass that provided the central feature of the students' artwork. Dressed in white lab coats, the students approached each pane of glass. One student then used her breath to produce a small circle of condensation on the glass wall. Another student then measured the height and width of the moisture, while a third dutifully recorded the measurements on a form held on a clipboard. This process proceeded at a deliberate and constant pace across one floor of windows, returning on the next floor above to continue their repetitive action until they reached the top of the enclosed glass structure. As in the swimming piece, there is a multiplicity of elements that come together through this action. Some forms, such as the glass, breath, books, students, and the library itself, are within the library structure, whereas other forms—medical or scientific practices, absurdity, and humor—represent outside forms

and forces. Just as each of these elements has a continuity prior to this action, and may return to that continuity following their intervention, their actions provoke a convergence that represents a fold or an event of experimentation that produces the previously unthought. "To think is to fold, to double the outside with a coextensive inside" (Deleuze 1988, p. 118).

FOLDING PEDAGOGY: TEACHING THE INTERVAL

There is a paradoxical basis for a folding pedagogy: while the fold presumes an endlessly connected plane of experience suggesting an immediacy associated with an immersive experience of the world, it also suggests a gap that is always present within the immediacy associated with that contact. It is this gap that represents the dynamism, the unpredictability, and chance that is always a part of life and our general experience, yet it is the portion of this experience that is most often ignored. Ignoring this in-between space may have multiple explanations, but in the context of pedagogy, it is its very ineffable and often quixotic quality that makes its integration within pedagogical structures seem at best complicated and at worst misleading. If there is one thing that can be agreed upon regarding learning and the pedagogical foundations of teaching, it is that, at its very least, it should not mislead. However, I propose that it is the very uncertainty of this gap and its potential to mislead that make it ideally suited for developing a pedagogical approach to teaching and learning through the production of art. This is a pedagogy designed not with the intention of producing things, but with the object of producing *new thought*.

Within a folding pedagogy, thought and subsequent knowledge must correspond to the potential rather than the actuality of the environment within which it is produced. It cannot be conceptualized before the event of its becoming. Both terms must possess a flexibility that allows for variations. Within this fluid composition, thought and knowledge can achieve a particularly supple form that has an internal logic, yet is always open to the *outside*. Lynn (1998) characterizes this sort of logic in his account of folded architecture. Postmodern architectural forms are characterized as discontinuous and intermingling but maintain a distinct and consistent structure within a logic of contradiction. By comparison, folded architectural forms, what Lynn refers to as "pliant" forms, cohere and maintain a consistency through unpredictable and chance alliances that produce new structures. "Connections by vicissitude develop identity through the

exploitation of local adjacencies and their affiliations with external forces. In this sense, vicissitudinous mixtures become cohesive through a logic of viscosity" (p. 113). The nature of folded architecture is thus an aleatory amalgamation of various forces and forms whose composition maintains an internal connective logic while also retaining a pliancy that renders this mixture sticky yet mutable. "Forms of viscosity and pliability cannot be examined outside of the viscissitudinous connections and forces with which their deformation is intensively involved. The nature of pliant forms is that they are sticky and flexible" (p. 114). The move from this account of a folded architecture toward an account of folded pedagogy is a direct one. Just as a folded architecture is a construction within which the probable and unexpected hold sway over the exact and the predictable, a folding pedagogy is a construction that possesses the same potential for thought, experience, and learning.

With each iteration of the courses that we taught pertaining to the work of Deleuze and Guattari, and the practice of artmaking, we endeavored to situate our students within the complex structures of the university. This was done not to familiarize them with the spaces of their experiences, but rather to acquaint them with the potential of truly novel thought through the process of defamiliarizing their prior experiences within the spaces of the university. Our objective, though not spoken explicitly, was to create what Ellsworth (2005) termed an "anomalous space of learning." We adopted a pedagogical approach that did not define this space and did not presume its existence. Rather we framed opportunities for students to create folds or hinges from which concepts could emerge through the creation of new forms of participation. In this process, artforms emerged that produced new thought that could account for these unique forms and produce a foundation for thoughts yet to come, and for knowledge yet to be formed. Though speaking specifically of architectural spaces designed to be places of learning for those who enter their structures, Ellsworth (2005) suggests: "Architecture becomes pedagogical, pedagogy becomes architectural when together they create a fluid, moving pivot place that puts inside and outside, self and other, personal and social into relation" (p. 38). In the end, a folding pedagogy can be effective only if we, as instructors, situate ourselves on the same plane of consistency that we conceive our students. As such, we too are subjects yet-to-come who do not possess knowledge but play within the interval between what is and what might be, within the pleats and creases along with our students, to affect and be affected by the folds that emerge only to prompt new folds that will affect all subsequent pedagogical forms and dispositions.

REFERENCES

Boyman, A. (1995). Translator's preface. In M. Speaks (Ed.), *Earth moves: The furnishing of territories* (pp. viii–vixi). Cambridge, MA: MIT Press.

Cache, B., & Speaks, M. (1995). *Earth moves: The furnishing of territories.* Cambridge, MA: MIT Press.

Deleuze, G. (1988). *Foucault.* Minneapolis: University of Minnesota Press.

Deleuze, G. (1990). *The logic of sense* (M. L. w. C. Stivale, Trans.). New York: Columbia University Press.

Deleuze, G. (1993). *The fold: Leibniz and the baroque.* Minneapolis: University of Minnesota Press.

Deleuze, G. (1995). *Negotiations, 1972–1990.* New York: Columbia University Press.

Deleuze, G., & Guattari, F. (1987). *A thousand plateaus: Capitalism and schizophrenia.* Minneapolis: University of Minnesota Press.

Deleuze, G., & Guattari, F. (1994). *What is philosophy?* New York: Columbia University Press.

Ellsworth, E. A. (2005). *Places of learning: Media, architecture, pedagogy.* New York: Routledge Falmer.

Kaiser, B. M. (2010). Two floors of thinking. In S. V. Tuinen & N. McDonnell (Eds.), *Deleuze and the fold: A critical reader* (pp. 203–224). Basingstoke/New York: Palgrave Macmillan.

Leach, N. (1997). *Rethinking architecture: A reader in cultural theory.* New York: Routledge.

Lynn, G. (1998). *Folds, bodies & blobs: Collected essays.* Bruxelles: La Lettre volée.

Nietzsche, F. W. (2002). *Beyond good and evil: Prelude to a philosophy of the future.* Cambridge/New York: Cambridge University Press.

Rajchman, J. (2000). *The Deleuze connections.* Cambridge, MA: MIT Press.

Speaks, M. (1995). Folding toward a new architecture. In M. Speaks (Ed.), *Earth moves: The furnishing of territories* (pp. xiii–xixx). Cambridge, MA: MIT Press.

Stagoll, C. (2005). Difference. In A. Parr (Ed.), *The Deleuze dictionary* (pp. 74–76). New York: Columbia University Press.

What Art Thinks

Jack Richardson

The status of art within broader discussions of general education has always been tenuous. Frequently, educational success is represented anecdotally (what I learn and know I can express in various contexts), instrumentally (gainful employment is a consequence of good education), and quantitatively (testing scores). In each case, educational viability is assessed in relation to its application in the world and is an important consideration for student success. However, in each instance, there is little attention paid to the actual moment of learning, the pre-subjective, inexpressible, unmeasurable, and unrepeatable point at which our mind is compelled to think. Indeed in the more traditional areas of learning—math, science, language arts, and social sciences—attention to such a fleeting moment is relatively unnecessary as each discipline has a particular set of knowledge and predictable applications. In this chapter, I will argue that artmaking as a mode of learning among these areas is not necessarily burdened by the necessity of intrinsic and rational application and, as such, lends itself well to the exploration of those transitory and transitional moments of learning.

J. Richardson (✉)
Department of Arts Administration, Education and Policy, The Ohio State University, Newark, OH, USA

© The Author(s) 2017
j. jagodzinski (ed.), *What Is Art Education?*,
DOI 10.1057/978-1-137-48127-6_5

111

There is arguably a body of knowledge relating to art and artmaking; however, this material is not inherently necessary for success in art or otherwise, yet relying on this knowledge as the basis for the production of art merely replicates the type of learning that occurs in other disciplines. By focusing more on the art's capacity to *provoke thought* without particular objectives, artmaking offers insight into the very root of the learning process, the moment when we are confronted with something truly novel compelling us to think anew without the expectation of application. Learning in artmaking also occurs at the level of application; however, unencumbered by specific objectives, it offers the ideal context within which to explore learning at the level of contact with the world, exposed to the unknown prior to its becoming known. Learning as such represents a moment where Elizabeth Ellsworth (2005) suggests we are in the midst "of being radically in relation to one's self, to others, and to the world" (p. 2). It is artmaking and the openness of its practice that can illuminate the very process of learning in all its peculiar, unpredictable, idiosyncratic anomalies that occur at the moment of making in the eruption of processes "as yet unmade, that provoke us to think or imagine new things in new ways" (Rajchman 2000, p. 15). The difference between what is made and what is "in the making," as explained by Rajchman, suggests that "there is nothing in the making unless what is already there is unsettled, mixed up, and mixed together anew, without prior program, encompassing plan, or single fixed end" (p. 15).

When arguing for art's inclusion in broader education and learning, the question often posed is "What does art do for us (or our students)?" Some of the diverse claims made for art's benefits are a variation on this basic question. For instance, art expands student opportunities for personal expression, art can extend student learning in other subject areas, and art can reinforce social and cultural values. Each of these functions is legitimate, yet art's worth is still largely coupled to its ability to reinforce and support the more established learning objectives associated with core subjects such as science, math, language arts, and social sciences. As such, support for and defense of art as a significant component of the learning process is conditioned by its relative usefulness for accepted core subjects, leaving its status within schools frequently insubstantial.

In this chapter, I intend to ask and respond to a question other than what art can do *for* us, asking rather, "What does art do *to* us?" It is art's unique capacity to provoke thought in the process of its *production* rather than *reflection* that positions it as a special contributor to learning. Others

have certainly asked a similar question about art's capacity to *do* something. Indeed, those who value art's status as a unique subject compared to other core subjects would undoubtedly support this position by suggesting that it also *does* something for the students in terms of their capacity to learn, and as such is valuable on its own terms. However, no matter how expansive one's argument about the learning benefits of art may be, it seems that its status as a necessary and permanent part of general education is always under debate in ways that other subjects are not. We do not generally hear discussions about the advantages for reading offered by studying math. Nor do we hear about large research studies that show how studying science will support understanding of history (though it could be argued that it does). Rather each of these core subjects is beneficial based apparently on its intrinsic merits specifically pertaining to the students' capacity for success in the world and lifelong learning.

THINKING THOUGHT DIFFERENTLY

I propose that art should indeed be considered an essential element of learning not based on its ability to reinforce established notions of what it means to learn, but rather on its capacity to challenge what it means to think. In other words, I am suggesting that art produces a particular type of thinking unique to its practice. A type of thinking more akin to Gilles Deleuze's (1994) definition of philosophical thought, which occurs prior to the presumption of either a subject or an object.

> There is a great difference between writing history of philosophy and writing philosophy. In the one case, we study the arrows or the tools of a great thinking, the trophies and the prey, the continents discovered. In the other case, we trim our own arrows, or gather those which seem to us the finest in order to try to send them in other directions, even if the distance covered is not astronomical but relatively small. (p. xv)

This statement is the core of Deleuze's notion of what it means to *study* philosophy as opposed to *doing* philosophy. The former presupposes not only a subject from and within whom thinking materializes, but also presumes objects toward which thinking is directed. This construction represents what Deleuze refers to as a dogmatic or traditional image of thought. All thinking, Deleuze suggests, is premised on an image of what it means to think. It is an image "in which subject and object and being

and beings are already assigned their proper place and relation one to the other" (Dronsfield 2012, p. 404). "By this I mean not only that we think according to a given method, but also that there is a more or less implicit, tacit or presupposed image of thought which determines our goals when we try to think" (Deleuze 1994, xvi). Deleuze's work puts this very construction in disarray. Operating within a "prison of thought" (p. xvii) that implies a thinking subject suggests that thought can occur only at the level of recognition. That is, thought is the domain of the subject, and the capacity to recognize objects in the world is a projection of his/her own subjectivity. Thus, it could be argued that nothing new could be learned if the origin of thought is predicated on the ability of the subject to recognize the object of his/her thought. This would suggest that there is no new knowledge since the subject produces knowledge in its own image. Thus, "thought is left with no means of grasping that which cannot be recognized" (Dronsfield 2012, p. 405).

Opposing this traditional image of thought, which arguably runs through much understanding of conventional notions of learning and teaching, Deleuze proposes a new image of thought. It is an image that decenters and delays subject formation in the process of thinking and places greater emphasis on the very moment of contact with the world, specifically an encounter with difference that cannot be incorporated within subjective claims. It is something that is *sensed* as opposed to something recognized (Dronsfield 2012, p. 407). It is in this moment that thought occurs, which is very different from saying this is where we begin to think. Thought is not the privilege of the subject. It is the effect of encountering an opening in established order that requires new thinking for its reconciliation. Something violent from outside ourselves "shocks" us and sets us adrift, producing a gap between the content of the encounter and our expression of that content. Our subjective perception cannot reconcile its place within this unfamiliar experience. It is at the pre-subjective level of sensation, provoked by the difference inherent to the encounter that initiates thought, not our own confusion, as this event occurs prior to our capacity to think it. As this sensation moves through our various bodily faculties (memory, touch, smell, and emotion), thinking occurs independently as a consequence of the shock, not as a result of our conscious decision to think. As such a truly new thought is produced that could not have occurred within the traditional image of thought as described by Deleuze. "The violence of that which forces thought develops from the *sentiendum* to the *cogitandum*. Each faculty is unhinged...[e]ach one,

in its own order and on its own account" (Deleuze 1994, p. 141 [no emphasis, removed italics on "its" other italics are language difference, not emphasis]).

It is only within an expanded notion of both artmaking practices and learning that Deleuze's "new image of thought" might productively be addressed and its distinctive capacity for novel understanding be embraced. For Deleuze, thought is not something we apply to an inert world, nor does it proceed in accordance with an "image" that we as thinkers carry within our minds. It is something that occurs through our "encounter" with an active world of sensations and intensities. It is in this capacity that artmaking practices, specifically those which position the artist/student in physical proximity to the world outside the classroom, possess a singular ability to address and explore the very root of thought and the creation of new thinking.

In order that art achieves its unique capacity to teach that which cannot be taught through other subject areas, its teaching must be founded on an alternative understanding of what it means to think, and consequently what it means to learn within the framework of a "new image of thought." What follows is a deeper analysis of Deleuze's ideas within the educational context through his unconventional articulation of the "diagram" as a component of his philosophy. Following this discussion, the artwork of Francis Alÿs will be presented as an artistic form/practice that corresponds well with Deleuze's concepts. Finally, the chapter will conclude with some general implications regarding art educational practices, embracing this rethinking of thought as a foundational component of teaching art. Indeed, the suggestion that thought occurs prior to the formation of the subject also suggests a more provocative question to ask, which might be: "*What does art think?*"

Artmaking as Philosophy: Constructing a Diagram

"But the poet learns that what is essential is outside of thought, in what forces us to think." (Deleuze 2000, p. 61)

In his assessment of Deleuze's new image of thought, Jonathan Dronsfield (2012) makes the provocative claim that not only are art and philosophy compatible, but also they are mutually necessary, yet always distinct. It is perhaps misleading to refer to Deleuze's challenge to thinking as a new image of thought since this suggests that there may be a recogniz-

able image that is different from the dogmatic image of thought. It is its very recognizability that warrants the term dogmatic. Perhaps it is more accurate, and this was Deleuze's initial objective, to say that he was trying to remove image from thought to set thought apart from the thinking subject. However, Deleuze determined that thought needs an image. The image conceived by Deleuze is the plane of immanence, which can be understood not as a recognizable image but as a sort of cohesive chaos.

> The plane of immanence is like a section of chaos and acts like a sieve... Chaos makes chaotic and undoes every consistency in the infinite. The problem of philosophy [or thought] is to acquire a consistency without losing the infinite into which thought plunges. (Deleuze and Guattari 1994, p. 42)

Thought, like philosophy, produces concepts that can be employed by the thinking subject. However, thought cannot generate concepts if it remains chaotic; if an outside order is imposed, new thought cannot emerge. Therefore, paradoxically, thought needs to produce its own image for itself.

> The plane of immanence is not a concept that is or can be thought but rather the image of thought, the image thought gives itself of what it means to think, to make use of thought, to find one's bearings in thought. (Deleuze and Guattari 1994, p. 37)

Ultimately, thought needs an image and it is art that can provide that image. Once thought has an image, it can produce concepts that can provide consistency on a new plane. The elements of the plane include not only objects but also intensities or the forces that bind elements and hold chaos in abeyance. Art presents not the objects, but the forces between them suggesting a kind of immanent diagram conveying a sort of provisional order. "But in reality, elements of the plane are diagrammatic features, whereas concepts are intensive features... The former are *intuitions*, and the latter *intensions*" (Deleuze and Guattari 1994, pp. 39–40).

Philosophical inquiry is often taken to be a series of questions posed to the world of things, values, and objects with the ultimate goal being the production of some kind of repeatable framework within which one can determine some of the most profound questions of the universe: What is life? What is good? As such, philosophy reiterates a model of Deleuze's dogmatic or traditional image of thought. The questions are directed

outward from the thinking mind as problems to be resolved, or at least explored, with a conscious mind. Once determined, a philosophical order or structure can be overlaid onto the world as a sort of map or diagram for knowledge. Deleuze writes, "In this sense conceptual philosophical thought has as its implicit presupposition a pre-philosophical and natural Image of thought, borrowed from the pure element of common sense" (Deleuze 1994, p. 131). Knowledge derived from this framework perhaps represents more clearly the structure itself rather than greater insight into the world as seen through its forms. As such, learning acquired through traditional philosophy is largely reflective as the thinker applies thought to a problem in order to propose a solution or explication. Such an image of thought is considered to be dogmatic to the extent "that it holds in principle, this image presupposes a certain distribution of the empirical and the transcendental, and it is this distribution or transcendental model implied by the image that must be judged" (Deleuze 1994, p. 133). When Deleuze and Guattari (1994) state that "philosophy is the art of forming, inventing, and fabricating concepts" (p. 131), they are challenging the very status of philosophy as a fixed set of propositions. Using the gerund form –*ing*, they are stating clearly that thought does not pre-exist thinking, and concepts as such cannot come before experience but are always in the process of becoming known.

The notion of common sense figures largely in Deleuze's thought. For Deleuze, there is nothing common about sense. This would suggest that there is a sort of universal notion of thinking that is part of all sentient experience. Deleuze is in fact questioning the very foundation of what it means to think, suggesting that historically the foundation for thought was often relegated to the subject doing the thinking. For example, Descartes' *cogito* assumed the role of the pure subject; it was the ground upon which thought emerges. Descartes' designation of the cogito as a sort of universal subjectivity is necessary for his "image of thought" in that "it provides a philosophical concept for the presupposition of a common sense" (Deleuze 1994, p. 133). Stated more clearly, the suggestion is that when anyone is confronted with an object (an idea or an actual form), thought proceeds by virtue of recognition of that object, a recognition that can be confirmed by the common sense of the universal cogito.

What troubles Deleuze is the presumption that the world and all of its elements are static. It is only through the mind of the human subject that its meaning can be judged or determined. Such a position can effectively overlook or obscure the vitality of the objects in the world,

producing a gap between what is and what we think is. In other words, what we experience, provided we can describe it, can be communicated in another form such as language. However, the "truth" or accuracy of this description is based on a form of expression, namely language, which is already once removed from the encounter itself. As such, there is a gap that exists between percepts at the level of sensation and their expression that remains hidden but essential. This is the consequence of an approach to thought that positions the subject at its center. Deleuze seeks to decentralize the subject as the arbiter of "truth" in the world and as the sole producer of thought and knowledge derived from thinking. Deleuze suggests "that this subjective presupposition [is] itself a form of prejudice" (Deleuze and Guattari 1994, p. 2). As such, "the philosopher sets off in search of something that is already presumed to be in agreement with his foreknowledge of it, something that is already accorded a nature that is disposable to being discovered or revealed" (p. 37).

In order to position artmaking within the context of philosophical thinking, we need to address a few terms that Delueze uses unconventionally to identify philosophical inquiry: theory, practice, and diagrams. Regarding the terms theory and practice, Deleuze does not differentiate between them. That is, theory does not precede practice. Additionally, theory is not a set of concepts that can be applied to the chaos of the world as a means to explain its complexity. In a conversation with Michel Foucault, Deleuze states,

> The relationships between theory and practice are far more partial and fragmentary. On one side, a theory is always local and related to a limited field, and it is applied in another sphere, more or less distant from it. The relationship which holds in the application of theory is never one of resemblance. (Lambert 2012, p. 37)

Foucault (1977) responds with a more succinct notion of theory: "In this sense theory does not express, translate, or serve to apply practice: it is practice" (p. 208). In other words, philosophical inquiry is neither a project of relating concepts to life as theory, nor is it a practice that engages in the application of concepts to matters of living. "A theory does not totalize; it is an instrument for multiplication and it also multiplies itself" (p. 208). Philosophy is neither theory nor practice; it is both at the same time. It is a constructive and ontogenetic means of inquiry that occurs at

the intersection of the subject and the world, arising at their confluence, neither wholly from the world nor fully through the subject. It is the capacity of this in-between to generate thought and produce concepts that might, in the moment of contact/inquiry, provide novel insight into this particular encounter. For Deleuze, it is at the intersection, the moment of contact with difference, that a diagram, or map, is created, which functions as a creative, generative, and constructive process of thought. "[I]t is entirely oriented towards an experimentation in contact with the real. The map does not reproduce an unconscious closed in upon itself... It fosters connections between fields" (Deleuze and Guattari 1987, p. 13). It is at the generative point of contact in the process of philosophical inquiry that art can play a role as a sort of "diagram" of thought.

The diagram in Deleuze's thought takes on a purpose and form radically different from its typical understandings. It is neither a schematic form that exists prior to its realization as a structure such as a blueprint for a building, nor is it an abstract rendering of a structure meant to simplify its purpose or meaning such as a flow chart representing a bureaucratic structure. Rather, it is an intrinsic structure that two forms share, which serves to link them at a pre-subjective level. Deleuze offers an example from Michel Foucault's *Discipline and Punish: The Birth of the Prison* (1979). From this text, Deleuze shows how Foucault reconciles an inherent incongruity between two forms: the prison and penal law. While it is superficially apparent that these two things are related, the nature of that connection is that neither the physical form of the prison nor the discursive form of the law signifies the other. In order to make this connection, Deleuze identifies both forms not as things, but as systems. That is, both forms are grounded on a network of systems.

> The prison environment is not defined by its materiality: stone walls and prison bars. It is defined by its function: seeing without being seen. For its part, the penal law is defined by what can be articulated in language... In-between these two heterogeneities, there is an intermingling. (Deleuze quoted in Zdebik 2012, p. 12)

It is in this intermingling that a diagram is produced irreducible to any particular visual or linguistic form. The "diagram is highly unstable or fluid, continually churning up matter and functions in a way likely to create change...[E]very diagram is intersocial and constantly evolving"

(Zdebik 2012, p. 3). The diagram does not represent order in a chaotic world; rather it generates a fully novel account of that world.

In its capacity as a diagram, artmaking functions not as a model *for* thought, but as a diagram *of* thought. When viewed in this way, art ceases to be a mode of expression, reflection, or idiosyncratic abstraction. Rather, art becomes the very force of philosophical inquiry or thought, though it is in a form that has no predicate (i.e., language, elements of design, compositional strategies, art historical precedence, material skills, and so on) and no particular culminating objective. "Art cannot create concepts, philosophy cannot think images. If thought needs an image to think then this will be created by art and given back to thought" (Deleuze 1988, p. 35). In this construction, art education must ask a lot more of art itself and less of the maker. This is a fundamental shift in both art education specifically and education generally. This raises some elemental questions. How can learning be founded on something other than the thinking of the student? And if it is art that produces thinking, where does one begin in terms of teaching artmaking processes? The following sections will address these questions through an articulation of how Deleuzian learning would work, and what it might look like through an examination of the artwork of Francis Alÿs. The conclusion will offer some ideas regarding what Deleuzian teaching might look like.

Learning the Impossible

A creator who isn't grabbed around the throat by a set of impossibilities is no creator. A creator's someone who creates their own impossibilities, and thereby creates possibilities. (Deleuze 1995, p. 133)

Deleuze argued that education focused on the acquisition of known facts and data both linguistically and perceptually limits its potential to think new ideas. Its narrow attention to data attained through conscious perceptions is limiting in terms of acquiring and producing knowledge. Learning is not a body of information, but "a dynamic process of inquiry as an experimental and practical art embedded in experience" (Dronsfield 2012, p. 212). Within such a process, both the object of inquiry and the inquiring subject are not yet formed. Indeed, Deleuze argues that thinking itself is not a conscious faculty rather it is an "a-subjective and pre-personal" (Semetsky 2009, p. 443) autonomous force that occurs when one encounters difference that has no predetermined concept through

which to make sense of that experience. "Something in the world forces us to think. This something is an object not of recognition but of a fundamental *encounter*" (Deleuze 1994, p. 139, emphasis original). An encounter necessarily leads to inquiry into the "as-yet-unknown" (Semetsky 2009, p. 444)—that is, a pre-subjective encounter with affect, or that which is beneath or beyond conscious perceptions, a percept. Yet it is that thing within the encounter that we cannot know because it cannot be thought with pre-given concepts that provoke thinking and the production of new concepts. Thought is an active force and not a contemplative procedure that builds upon prior knowledge. It produces the very concepts necessary for knowledge pertaining to a particular circumstance.

Deleuze rejected the notion of the progressive building up of knowledge. In describing his own teaching experience at Vincennes, Deleuze (1995) remarked, "Indeed there's nothing in principle to stop courses being a bit like a rock concert" (p. 139). Which is to say, a primarily sensate experience, the meaning of which is particular to the very moment of that experience. Describing a concert can never do justice to the experience of being there. You must go to the experience to have the experience. Similarly, Deleuze suggested, "you give courses on what you're investigating, not on what you know" (p. 139). Conventional notions of learning and subsequent knowledge presuppose a set of ideas, concepts, or truths "out there" to be discovered through recollection and application. The teacher is assumed to know these and transmit them to the student. If they do not, it is understood that someone does know. However, in Deleuze's conception of knowledge and the concepts needed to achieve knowledge are born of experimentation with the unknown that produces truly novel concepts. It is a process that represents the becoming of both knowledge and the subject simultaneously. Ideas are neither something that is transmitted from the teacher to the student, nor do they relate to a pre-existing mind as in Descartes *cogito*; rather ideas are related to "the fractured I of a dissolved Cogito; in other words, to the universal *ungrounding* which characterizes thought as a faculty in its transcendental exercise" (Deleuze 1994, p. 194, original emphasis). Learning, as such, becomes

an object of an encounter, as a here-and-now...from which emerge inexhaustibly ever new, differently distributed 'heres' and 'nows'.... I make, remake and unmake my concepts along a moving horizon, from an always decentered center, from an always displaced periphery which repeats and differentiates them. (Deleuze quoted in Semetsky 2009, p, 444)

FRANCIS ALŸS: WALKING/MAKING DIAGRAMS

Before concluding this chapter with some reflections and implications relating to teaching art in the context of the ideas expressed above, I would like to examine two works by Belgian artist Francis Alÿs called *Paradox of Praxis 1 (Sometimes Doing Something Leads to Nothing)* (1997) and *The Green Line (Sometimes doing something poetic leads to something political and sometimes something political leads to something poetic)* (2004). I believe that these works offer a visual/performative counterpart to Deleuze's notion of the provocation of thought as a consequence of an encounter with difference.

A body, suggest Deleuze and Guattari, is not defined by its form as a collection of organs or by its functions. On a plane of immanence, also understood as a plane of consistency, "*a body is defined only by a longitude and a latitude*: in other words the sum total of the material elements belonging to it under given relations of movement and rest, speed and slowness (longitude)" (Deleuze and Guattari 1987, p. 260, emphasis original). As such, the constant movement and the relationships with the elements of the plane of immanence that coalesce around and with it define a body or a subject. A body or subject is not a predicate to thought, nor is it a culmination of a collection of forces and forms; a body is "[n]othing but affects and local movements" (p. 260). It is the in-between composed entirely of relationships born of external forces coming together to form a provisional consistency. It is what Deleuze and Guattari call a *haecceity* and offer the notion that "Taking a walk is a haecceity" (Deleuze and Guattari 1987, p. 263).

To fulfill a commitment to the Belgian army, Alÿs went to southern Mexico in 1986. Subsequently, Alÿs stayed and moved to Mexico City. Though he had been in Mexico a few years, this move offered a kind of cultural shock that was both discomforting and exciting for Alÿs, which became the foundation of much of his artistic activity (Ferguson 2007, p. 8). The piece, *Paradox of Praxis 1*, consisted of Alÿs pushing a large block of ice with his bare hands around the streets in Mexico City for nine hours, ending only when the block had almost completely melted. He was forced to kick the tiny cube along the street until it disappeared. "I think the artist can intervene by provoking a situation in which you suddenly step out of everyday life and start looking at things again from a different perspective – even if it is just for an instant" (Alÿs quoted in Dezeuze 2009, p. 4). It is in this statement that Alÿs relates his work to Deleuze's

ideas associated with thought and philosophy. The notion to push a large block of ice through the streets was indeed an active thought; the knowledge, effects, concepts, and affects produced by the event were largely imperceptible and unpredictable. The action forces an encounter with difference within a familiar environment. The sensation of muscles that were likely feeling the effects of the constant exertion, the sounds of the ice against the ground, the chill of the ice on his ungloved hands, the voices of the observers, and the cacophony of everyday life all comingled in the becoming of both the subject and the experience. Alÿs' walked a *haecceity*.

In another piece titled *The Green Line*, Alÿs traversed the city of Jerusalem while dripping a continuous line of green paint from a can he carried with him. He traced a path that ostensibly divides the city between Palestinian and Israeli control. This piece was conceived as a reiteration of a similar work, *The Leak* (1995), done in Sao Paulo nine years earlier. "By re-enacting the same action but now performing it in a completely different context, I was questioning the pertinence of an artistic intervention in a context of political, religious and military crisis" (Alÿs quoted in Ferguson 2007, p. 39). Like *Paradox of Praxis I, The Green Line* stood out in its environment as an absurdity in an otherwise rational environment. This is not to say that the social and political setting of the work is rational by conventional terms; it operates within an order, albeit a complex one, that maintains its elements within a plane of consistency. Alÿs' intervention infiltrates the connections that exist, prying them apart momentarily and subsequently reconstituting them in a new amalgamation of sense that comes to form only within the context of his walk. "The action had to be borderline ridiculous for people to start talking beyond stereotypical discourses on the left or on the right, whether Palestinian or Israeli" (Alÿs quoted in Dezeuze 2009, p. 4). The various components that comprise the complexity that is Jerusalem including its politics, its geography, its culture, and its people had been kept in a temporary order prior to Alÿs' disruption, perhaps what could be called a dogmatic image. Along with his presence and actions came a new image of thought that sought its own reconciliation in new *haecceities,* engendering new relationships, new concepts, and new ways of seeing the conditions of the site.

The meaning of the works cannot be understood entirely in hindsight and cannot be explained completely as both the subject that thinks. The experience that produces thought was always "in the making" (Ellsworth 2005). Rather than speak of the event as an artwork or even a performance, perhaps we can more accurately speak of its form as a diagram

in the manner described above. It is not a form that resembles a prior abstract form, nor is it an abstract form that implies a future construction. It is what Deleuze and Guattari (1987) would call an "abstract machine." "An abstract machine in itself is not physical or corporeal, any more than it is semiotic; it is diagrammatic... The abstract machine is pure Matter-Function – a diagram independent of the forms and substances, expressions and contents it will distribute" (p. 141). As in the description above, the diagram is a dynamic process occurring between multiple systems. "[I]t describes the flexible, elastic, incorporeal functions before they settle into a definitive form" (Zdebik 2012, p. 1). A diagram functions as a generative and organizational force that "allows a glimpse of the state that comes before the formation of an object, and of what goes into its formation" (p. 2).

The various systems in play in Alÿs' pieces take two specific forms: discursive (the economic, political, and social structures of the areas in the city traversed by Alÿs) and non-discursive (the street, the ice, sounds, people, paint, and shoes). These heterogeneous systems are related, yet they are not inherently merged. Yet with the introduction of the "shock" of Alÿs' performance, a "relationship emerges from the shift both [discursive and non-discursive] systems incurred at a particular point in time" (Zdebik 2012, p. 3). The works are neither discursive nor non-discursive as both of these forms present themselves only within representational thought. The diagram, or art, emerges at the point of intermingling of systems, where their incongruities are resolved by "abstracting them to the level of their function" (p. 4). More succinctly, Alÿs' actions were so sufficiently decontextualized within the environment of Mexico City and Jerusalem that representational thought corresponding to his efforts were inadequate to account for his movements, thus opening him up to the affective forces virtually present in the environment. Ultimately, neither *Paradox of Praxis 1 (Sometimes Doing Something Leads to Nothing)* nor *The Green Line (Sometimes doing something political leads to something political and sometimes something political leads to something poetic)* resolves problems the way that conventional understandings of diagrams do; rather they pose one. "It is only through skillful problem-posing that we can begin to think diagrammatically" (p. 1). In this previous statement, we can begin to imagine a framework for rethinking the role and purpose of teaching and making art in the context of general schooling.

CONCLUSION: DIAGRAMMING SYNCHRONIC THOUGHT

Most conceptualizations of learning and schooling involve a sequential building of knowledge. This would be understood as diachronic learning suggesting a progression of awareness and an evolution of understanding based on various principles existing prior to the education of the student. Ideas such as developmental stages often guide education generally, and art education in particular by presupposing particular intellectual and physical capabilities. More egregious applications of diachronic thinking in schooling can be witnessed in the emphasis on standards that presume universal subjects that learn the same way as every other student despite the great variety of contexts within which this learning occurs. In both these educational scenarios, the assumption regarding knowledge is that it presupposes a subject as the learner where thinking assumes a dogmatic image of thought. There remains an unaccounted for gap between the content and the student where the indistinct and ineffable process of thought occurs. While many subject areas might benefit from a model of learning based on a dogmatic image of thought, art has no reason to abide by this structure. It is art in all its various forms that can fit comfortably in that gap where experience and learning are synchronous. A formless space outside and prior to thought, a space containing the unthought, which is not to say unthinkable, but simply thought yet to come. There is no structure and no repeatable diagram that can account for this space educationally without excessive abstraction. Art as the experience of a *haecceity* is a practice that extracts affects from this gap and produces tentative diagrams of synchronic thought.

Following from Deleuze's ideas and reflecting on Alÿs' practice, we become aware that it is not the thinking subject that initiates thought, but rather thoughts' origins can be located in the ontogenetic conditions of experience. This change in our understanding of thought suggests a radical rethinking of the process of teaching. Perhaps we could take a page from Deleuze's own reflections on teaching, which he suggests is "like a research laboratory: you give courses on what you're investigating, not on what you know" (Deleuze 1995, p. 139). Artmaking within art education thus assumes a process of simultaneous teaching and learning whereby knowledge and its accuracy are immanent to, rather than prior to, thought. Consequently, it is the art that thinks producing simultaneously the thought that gives form and sense to the world and the experience of the thinking subject. If art education can effectively fill this gap, I

would argue that its status within broader notions of learning is less tenable, and indeed more necessary as its existence relies only on the worlds it produces. Art functions not as a tangent to other school subject areas but as a diagram upon which their content can be thought anew.

REFERENCES

Deleuze, G. (1988). *Foucault*. Minneapolis: University of Minnesota Press.
Deleuze, G. (1994). *Difference and repetition*. New York: Columbia University Press.
Deleuze, G. (1995). *Negotiations, 1972–1990*. New York: Columbia University Press.
Deleuze, G. (2000). *Proust and signs: The complete text*. Minneapolis: University of Minnesota Press.
Deleuze, G., & Guattari, F. (1987). *A thousand plateaus: Capitalism and schizophrenia*. Minneapolis: University of Minnesota Press.
Deleuze, G., & Guattari, F. (1994). *What is philosophy?* New York: Columbia University Press.
Dezeuze, A. (2009). Walking the line. *Art Monthly*, 1–6.
Dronsfield, J. (2012). Deleuze and the image of thought. *Philosophy Today, 56*(4), 404–414.
Ellsworth, E. A. (2005). *Places of learning: Media, architecture, pedagogy*. New York: Routledge Falmer.
Ferguson, R. (2007). Interview. In C. Medina, F. Alÿs, R. Ferguson, & J. Fisher (Eds.), *Francis Alÿs*. London: Phaidon Press.
Foucault, M. (1977). *Language, counter-memory, practice: Selected essays and interviews*. Ithaca, N.Y: Cornell University Press.
Foucault, M. (1979). *Discipline and punish: The birth of the prison* (A. Sheridan, Trans.). New York: Vintage Books.
Lambert, G. (2012). *In search of a new image of thought: Gilles Deleuze and philosophical expressionism*. Minneapolis: University of Minnesota Press.
Rajchman, J. (2000). General introduction. In J. Ockman (Ed.), *The pragmatist imagination: Thinking about "things in the making"* (1st ed., p. 277). New York: Princeton Architectural Press.
Semetsky, I. (2009). Deleuze as a philosopher of education: Affective knowledge/ effective learning. *The European Legacy, 14*(4), 443–456.
Zdebik, J. (2012). *Deleuze and the diagram: Aesthetic threads in visual organization*. New York: Continuum.

Some Thoughts on the Finitude and Infinitude of Learning and Teaching in the Context of Art in Education

Dennis Atkinson

In an essay entitled *Something To Write Home About*, the Irish poet Seamus Heaney (2002) reflects upon his childhood days walking between Castledawson and Ballaghy. He remembers crossing a ford on the river Moyola and has vivid memories of standing on the stepping stones, feeling giddy at the thought of falling in but standing stock-still as he took in the vastness of the sky above. 'Nowadays', he remarks, "when I think of that child rooted to the spot midstream, I see a little version of the Roman God Terminus, the God of boundaries." There was an image of Terminus in the Temple of Jupiter on Capitol Hill and the interesting thing, Heaney comments, is that the ceiling above the image was an open cupola, suggesting that although Terminus is the God of earthly boundaries, it is as if by means of the open cupola he requires access to the boundlessness of the sky above. Heaney writes:

D. Atkinson (✉)
Department of Educational Studies, Goldsmiths University of London,
London, UK

© The Author(s) 2017
j. jagodzinski (ed.), *What Is Art Education?*,
DOI 10.1057/978-1-137-48127-6_6

> As if to say that all boundaries are necessary evils and that the truly desirable condition is the feeling of being unbounded, of being king of infinite space. And it is that double capacity that we possess as human beings – the capacity to be attracted at one and the same time to the security of what is intimately known and the challenges and entrancements of what is beyond us (Heaney 2002: 48)

The contrary ideas of boundaries and boundlessness can be expressed in different terms: finitude and infinitude.

Heaney's words seem to me to be deeply resonant with the adventure of learning and the adventure of pedagogy, which constitute a teacher's mode of learning. The stepping stones that constitute his boyhood experiences invite him to change the terms and boundaries of his understanding; they "do not ask you to take your feet off the ground but they refresh your vision by keeping your head in the air and bring you alive to the open sky of possibility that is within you (Heaney 2002:58)."

When I reflect on these words in relation to processes of human learning, they seem to point towards finite moments of understanding in learning experiences but also to the 'immanence of infinitude' in these finite moments, which involves the potential of new ideas, new practices, new ways of seeing, new values and so on. It is as if, when thinking about learning in the context of art practice, the importance for the learner is not only the finite occasions of practice: the drawing, the painting, the video, the construction, the performance, but perhaps of more significance is the immanence of infinitude within each of these moments and the potential for what Alfred North Whitehead termed 'the creative advance into novelty'. A key aspect of learning therefore is the importance beyond itself of a learner's expression. We might rephrase this as 'the importance to learning of the not-yet-known.' This suggests that in our work with learners, we are *concerned* with the notion of learners-yet-to come and correlatively with an appeal for appropriate, relevant and commensurate pedagogical strategies... teachers-yet-to-come. We are dealing with the finitude and infinitude of learning and teaching.

I am using the term 'concern' in the Quaker sense of relation, where it refers to a 'weight on the spirit' (Shaviro 2014). When something concerns me, I can't ignore it; it affects my being and forces me to respond. This denotes the experience of being affected by others and opens me towards them. This Quaker expression of concern is employed by Whitehead (1929) when describing what he calls 'actual occasions' or events whereby

each occasion is *concerned* through processes of affect and cognition with things or beings that lie beyond it. He employs the term *prehension* to refer to the relational process in which things take account of or have a concern for each other. The flower takes account of or has a concern for the bee and vice versa. Concern is therefore immanent to an encounter, and it introduces relational unity or cohesion. A painting is an expression of the concern between each element: brush, paint, paper, body, affects, thoughts and so on; each phase of the painting is more than the collection of elements; it is the expression of their concern. On the human level, writes Massumi (2015, p. 198,), "care is the way in which relational unities eventually emerge that recursively give the diversity of contributing elements a concern for each other that they don't have in themselves." Concern therefore is not something that pre-exists events or encounters; it emerges in them. It seems to me that this notion of concern is important for considering the dynamics of pedagogical work and relations, where a disjunctive synthesis of difference (classroom) and the diversity of elements (teacher, learners and all that constitutes these and their relations) develop a concern that does not pre-exist their becoming.

We know in our hearts that there is nothing average about individual expression and its potential, but increasing institutional pressures upon teaching and learning, such as assessment structured according to norms and standards, often create situations in which the dominance of norms leads to a fading or marginalising of expression in its infinite diversity. This affects both learning and teaching. This situation can lead to a totalising of teaching and learning that produces a desire for preordained pedagogised subjects held in place by controlled curriculums, assessment and inspection regimes. It invokes planned routes for teaching and learning that determine educational success or failure.

If we can look beyond the perspective of these current prescriptive systems of pedagogical control, which are deeply embedded in my country and elsewhere, we might be able to conceive pedagogical practices differently, so that rather than being subject to prescription, teaching and learning are conceived as processes of adventure.

In the creative processes of learning, the plural character of the world within and without become one through the creative decision and expression of a learner; in Whitehead's (1929) aphorism, "the many (world) become one and are increased by one." A child's creative expression through a painting or a drawing can be viewed as a gift to the world, an event of difference. And the teacher's question "What is expected of

me here?" denotes a crucial pedagogic moment as she recognises the need to respond, even though sometimes the form of the child's expression is beyond the limits of her intelligibility. For me, such situations denote part of the adventure of pedagogy.

What in the past I have called 'real learning' (Atkinson 2011) signifying a transition into new or modified epistemological and ontological phases involves finite occasions of practice and their particular *concerns* but also an immanence of infinitude of potential. This process therefore combines a transcendence of expression through which a world (idea, practice and new way of seeing) is conceived and an immanence of potential for future becomings. The notion of real learning also applies to the practice of teaching, which is constituted through finite occasions and their particular *concerns* and an infinitude of potential. So both learners and teachers (who must also be conceived as learners) exist, in Heaney's terms, within the security of the known but also the entrancements and challenges that lie beyond. The *concern* of teaching and learning is both finite and infinite.

Pedagogic relations consist of highly complex spatio-temporal events in which contrasts between established boundaries that constitute forms of knowledge and practice, and challenges or encounters with the not-known proliferate. The coming together of learners and teachers in specific pedagogic relations constitutes a series of singularities in which the nature of coipseity, or 'being-with', functions on many levels: affective, cognitive, ideological, social and political.

If we consider the temporalities of learning spaces such as classrooms or studios, the contemporaneity of coipseity is not simply a case of learners and teachers coming together in the same time. More specifically, it is the coming together of the different times (and their diverse ontological structures) of human lives that rub up against each other in a particular time and space of living: a disjunctive unity between contemporaries. How something matters for a learner in a particular learning encounter will be influenced by his or her previous experiences, the current context of learning with its diverse social and psychic dimensions and future potentials. In this disjunctive unity, the relations of finitude and infinitude, when applied to each learner's social as well as cognitive and affective experiences, suggest a highly complex matrix. These disjunctive temporalities and spaces have deep implications for the politics and ethics of pedagogical practices.

One thing is evident and this is that, in what I have termed a pedagogy of adventure, the identity of the learner, or the teacher, is not so clear cut

as in more prescribed pedagogical practices. It has to be assumed from the beginning therefore that pedagogical work sometimes means that teachers become undone when their modes of address and frameworks of recognition become fractured by a leaner's response 'that does not fit'. Judith Butler (2005) puts her finger on the ethical problematics of such moments:

> Perhaps most importantly, we must recognize that ethics requires us to risk ourselves precisely at moments of unknowingness, when what forms us diverges from what lies before us, when our willingness to become undone in relation to others constitutes our chance of becoming human. To become undone by another is a primary necessity, an anguish to be sure, but also a chance – to be addressed, claimed, bound to what is not me, but also to be moved, to be prompted to act, to address myself elsewhere, and so to vacate the self-sufficient "I" as a kind of possession. If we speak and try to give an account from this place, we will not be irresponsible, or, if we are, we will surely be forgiven (p. 136.).

This ethical risk-taking involving encounters with the unknown on the part of the teacher involves an interrogation of the logic of place that maintains people (learners and teachers) in their place and it bleeds into the question of politics. Such risk-taking and an openness to that which might appear strange to what has formed us suggest the possibility of extending our grasp of what it is to be human in the particular contexts in which we work.

I am not suggesting here that we abandon what we call traditional skills and knowledge in art practice, but rather that we remain as open as we can to the diversity of forms of expression and their immanent potential; this is what extends our grasp of what art can be and therefore what it is to be human. The adventure of pedagogy is driven by a passionate state of wonder about that which undoes our frameworks of understanding, not a closing down to the latter. In such adventures, a crucial point is that it is not necessarily a case of learning new facts but, as Shotter (2011) posits, "of learning new ways of relating ourselves to the others and othernesses in the world around us."

In the essay already mentioned, Seamus Heaney extends the idea of the boundaries of his childhood to those that demarcate political and cultural identities in Northern Ireland. He refers to a particularly emotive tradition fused with identity politics...the marching season. To march in

this tradition is to perpetuate division and confrontation, sometimes with violent repercussions. But in the countryside where Heaney grew up, it was the land that marched. 'To march' meant to 'meet at the boundary, to be bordered by, to be matched up to and yet marked off from; one farm marched another farm; one field marched another field;' and what divided the fields was a narrow water channel called the march drain, or the march hedge. The march drain is a fluid and mutable space, a kind of vital lubrication. So to march in this context means to be close, to live alongside; it acknowledges difference but also a sense of becoming with. For Heaney, the symbol of the march drain as a fluid medium that supports 'becoming with' is a far better one for contemplating than the marching season, which is closely associated with division and confrontation.

The policing of identities in institutional contexts of teaching and learning, manifested in my country by rigid government inspection regimes and the publication of school league tables, the relentless assessment of teaching according to prescribed teaching methodologies and their corresponding 'view' of what constitutes learning, the marginalising of art and its modes of learning...and so on, though not subject to forces of confrontation of which Heaney speaks, has created a form of identity politics in the context of education. Teacher and learner identities are now conceived according to a series of teaching standards that prescribe subject knowledge, teaching method and assessment method, and this impacts directly upon how learning is conceived. Though not entirely the case, this suggests a highly prescriptive approach to both learning and teaching according to finite means and ends where potentials are only recognised within prescribed boundaries of teaching and learning.

It seems to me that we need something like the march drain, the fluid mutable space of co-becoming, to which Heaney refers, in contexts of teaching and learning; the facility to draw alongside, to respond effectively to difference without the rigorous imposition of prescription. Where assessment is concerned, is it possible to soften the transcendence of established criteria so that assessment becomes more open to each learner's creative advance or to a teacher's novel approach to learners? In such fluid processes of assessment, there is the potential to expand our grasp of what teaching and learning can become.

THE FORCE OF ART

The immanence of a learner's practice denotes *how something matters* for a learner in his or her experience of a learning encounter and trying to ascertain how something matters for a learner constitutes, as I have said, a pedagogical adventure for the teacher. This notion of 'mattering' in the context of art practice and learning cannot be separated from the *force of art* which is the motive force for learning and which expands our understanding of what learning and 'art' can become. Thus it is not a case of coming to understand art through established knowledge and practice (e.g., assessment criteria) but the force of art challenging us to think. The force of art, or art's event, can be conceived therefore as a process with a potential for the individuation of new worlds or to see that other worlds might be possible: finitude and infinitude. Teachers are often challenged by the outcome of students' art practice.

Thus the force of art is a deeply affective force, particular to art's event, which precipitates ontogenetic potentials for evolving what it is to be human in its various relationalities. This force, it seems to me, is prior to its capture or application by various perspectives, motives or agendas, such as pronouncements of the purpose of art or curriculum innovations that precipitate new directions for art practice. Though these may initiate and propel art practice, they do not prescribe or control its vital force, which has the potential to pass beyond them and open up worlds that become possible as the work unfolds but which, beforehand, were 'unknown'. Perhaps this vital force of art, within its ambits and morphologies of practice, can be paralleled with the process of real learning, where learning is viewed as an ontosemantic event through which a learner emerges into new or reconfigured ontological and epistemological phases or, put another way, into new lived relations in the world.

Something of this vital force can be gleaned from those 'experiencings' of making or witnessing by, for example, a learner engaged in art practice or a teacher who encounters it. The ontology of this force is not located within art objects in whatever form but in the process of a relational ontogenesis, the process of becoming of art's event. Such events seem to me to be characterised by what I call a *poietic materiality* which I see as being fundamental to the affective engagement with art. In Chap. 8 of *The Man Without Content,* Agamben (1999) states that the Greek term *poiesis* refers to a process of appearing, a coming into presence, a movement from non-being into being, from concealment into full view. The essential nature

of poiesis is not concerned with productive or instrumental action, action which is preconceived by a particular will towards specific ends characteristic of *praxis*, but with the emergence of a truth as an unveiling (*alethia*). It is in the event of practice that something new appears, unexpectedly, unanticipated, something immanent to practice; this is poiesis (Agamben 1999, pp. 68–69).

A *poietic materialism* therefore is constituted through a series of encounters, it denotes a coming into being that is an amalgam of *intra-actions* between human and non-human actants, a coming into being that precipitates new relationalities and potentialities, and in the context of this chapter, for learning and its ontogenesis. The term intra-action is taken from Karen Barad (2007). While inter-action is a process which presupposes a reality of pre-existing entities which come together to interact, intra-action by contrast places fundamental emphasis upon the reality of relation from which entities emerge. It is an extension of the radical empiricism of William James for whom relation was a distinct reality more important than the reality of individual entities. The force of art as an appearing… as *poiesis*…is not *subjective* or *objective* but *intra-active* involving human and non-human actants…(affects, feeling, thoughts, memories, materials such as paint, paper, metal, wood, digital technologies and so on), and the pedagogical imperative of a *poeitic materialism* is to extend our grasp and potential of what it is to be human…put in the words of Spinoza…to extend our compass of what a body can do and what thoughts are capable of thinking.

I believe these intra-actions involving human and non-human actants can be conceived as *prehensions,* a term employed by Alfred North Whitehead (1929) to denote the process of 'taking account of', in the sense of entities taking account of other entities. Such processes can be conceived as *prehensive events.* The process of painting, for example, involves a series of prehensive relations, involving paint, brush, body movements, affect, memories, reflecting, anticipating, disappointments, frustrations and so on, in other words a series of prehensive relations between inorganic and organic entities in complex layers of intra-action. I don't think we know very much about the complexity of such prehensive events and relations but they are central to the process of, in this case, painting and learning, and they constitute how these processes matter. Whitehead does not limit prehensions to human activity but applies the term more broadly to refer to organic and inorganic phenomena, from atoms and molecules, plants, animals, humans, mountains, oceans and planets.

Whereas *praxis* is teleological, initially predicated upon a determinate idea towards specific outcomes, the process of *poietic materialism* involves a kind of paradox...a knowingness of the unknowing of practice which involves an affirmation of becoming as well as a carrying forward of the unknown and its potentialities, ...what might be termed poietic attractors or allures. Poietic materialism liberates praxis from the already known or possible-real linkages so provoking a not-known future dimension of becoming.

A poietic materiality defines an *event* of becoming, an event of learning as it happens within the different temporalities of experiencing. The emphasis therefore is not upon a predetermined pathway for learning but upon singularities (*thisnesses*) that enable invention into existence. In a strange, also paradoxical sense, one *becomes* a learner without *being* a learner, that is to say without those established *constructions* of being a learner which define (represent, theorise) and at the same time constrain what a learner is. The same goes for teaching. This illustrates the creative and mutable dynamic of *poiesis* that has the potential to disrupt and reconfigure existing comprehensions of learning that become inscribed upon pedagogical bodies and practices.

The poietic force of art practice precipitates an appearing, a letting go of normalised relations and practices as these are manifested in forms and practices that hold us... it is an assemblage of intra-actings, not a determined space but what the Greeks term a space of *aphesis* (letting go, release), a becoming which cannot be predicted, not a space of power but a space of enabling and affirmation. The trick is not to allow the outcomes of this aphetic space to turn into precious objects or practices, which in turn territorialise and control.

It's not that difficult to witness the poietic force of art in children's drawing or painting practices before these become subjected to the influences of aesthetic production and commodification that emerge in institutional practices. Such practices invent new worlds and possibilities; they are often events whose materiality involves desires, thoughts, speech, memories, affects, paper, crayons, paints, lines, marks, shapes, body movements and more...a *poietic assemblage* of intra-actions in which human and non-human actants become entangled.

Equally we might consider the poietic materialism of the force of art in some contemporary art practices such as Maria Abramovich's *The Artist is Present* (2010), which explores the contingent relations between artist and audience. Spectators were invited to sit opposite the artist who sat

motionless and in silence for seven days a week over three months. These encounters provoked unexpected intensities of affect that led to a variety of emotional responses including tears as they created a series of intense temporalities in which new existential territories could emerge, spaces in which these social intra-relatings precipitate new experiential domains. Such encounters can force us to think what art is and can become; they force a subject-yet-to-come. The position that I am advocating here is that in the context of art education in schools, the intensity of learning encounters with and through art practice has the potential to force us to expand our conceptions of art practice and learning. In Heaney's words, the force of art can take us beyond "the security of what is intimately known" and confront us with the "challenges and entrancements of what is beyond us."

IMMANENCE AND MORPHOGENESIS OF LOCAL PRACTICES OF LEARNING

The last point has direct implications for the immanent morphogenesis of local learning encounters in art practice in contrast to the morphogenesis of art education programmes and their specific pedagogical aims. Morphogenesis (Thom 1983) refers to processes of the growth of form, becoming and change. The aims or ambitions of particular art education programmes—for example, to acquire proficiency in a range of skills and techniques, to develop a critical awareness and understanding of art practice and other visual forms of practice, to explore social and cultural aspects of art practice—can be viewed as a series of transcendent pedagogical schemes characterised by a teleology of purposes and objectives. I am using the term transcendent here to denote that according to which something is interpreted or known, for example, a body of established knowledge or practice, a series of criteria or a set of norms. In contrast, the diverse actualities of local learning encounters that occur within such schemes, where the emphasis is placed upon *how* the content of such schemes matters for a learner, are likely to be more unpredictable. In such local spaces of practice, the outcomes of learning encounters take the form of local forms of transcendence emerging not from external epistemological frameworks but from the *intrinsic relations* of how something matters for a learner in a particular learning encounter. Although a particular (external) transcendent framing of art education may be desirable,

for example, to initiate work in a particular genre, the pedagogical task, I would argue, is not to allow established associated forms of practice totalise learners' practices but to anticipate the difference and immanence of local learning processes and try to grasp the morphology and meaning of their local transcendent actualisations for a learner.

What I am proposing then is to relax prescribed categories of and propositions about art education, subdue their ideological/transcendent framing and try to view the processes of practice in which learners engage as 'acategorical' events (which of course is another ideological framing), that is to say as 'evental' practices whose singularity cannot be categorised in any terms but their own. I am using the term singularity to refer to that which is singular, that which differs from the regular. So the aim is not to view these singular events according to already-established criteria, though this is difficult to avoid, but to try to approach them *without criteria*. This suggests that the 'thisness' of art practice, its internal resonance, is a coherent 'as-it-is' event that has the potential to extend how we conceive art and learning, a singular event that has universal implications.

The pedagogical approach I take does not anticipate an already-prescribed learner or teacher, but one that is oriented to the future and to novelty, to a subject-yet-to-come; it has the potential to expand our understanding of practice and learning. Each learner's decision in the *thisness* of practice is singular to that practice; no *definitive* rules guide it, although there will be influences from previous experiences of practice. So if we focus, for example, on the actual processes and practices of painting as performed by learners, each of these can be viewed as an extension of practice and carries a potential to transform practice. Put another way, we can understand the *thisness* or the immanence of learning in terms of the relation between what Whitehead (1929) calls the actual and the potential, which is similar but not quite the same as the actual and the virtual, discussed by Deleuze (2004).

This does not mean that we abandon or avoid assimilated practices and their respective traditions as though we were able to stand in a completely ideologically neutral, de-historicised space. This is impossible. It means that we try to relax the transcendence of tradition and transcendental ideological framing in order to catch (if this is possible) the local coherence of events of learning and their potential for novelty. Here the force of tradition, a particular programme or curriculum of art practice, for example, is softened in order to grasp local events of learning through art's *event* of becoming. Whereas the historical materialisations of programmes of

practice discussed earlier suggest an element of *prescription* in setting out their particular pedagogising aims and agendas, which, to some extent, anticipate particular teacher and learner subjectivities, the focus upon immanence concerns local stabilisations of practice and subjects; these are *constituted simultaneously* and they cohere together in 'this way' and not that.

The notion of the immanence of the event of practice relates to what Whitehead (1929) terms 'presentational immediacy' or what I call 'this-ness'; it relates to what Massumi (2011, Chap. 2,) calls the 'thinking-feeling' aspect of experience which is often backgrounded in favour of instrumental action or concerns. When trying to consider the immanence of a learner's practice, we are challenged to explore the ways in which a learner engages with a learning encounter: how is the learner capacitated or 'relationally activated' (Massumi) in such encounters? Such questions relate not only to what might be finitely actualised in a learning encounter but also to a pool of potential. A learning encounter is fringed by a thinking-feeling of potential that can move in a number of directions. So the pedagogical task is to stand outside of those normalising dream states and their regular affordances or apparatuses, those pedagogising technologies that govern teaching and learning in order to try to grasp the immanence of a learner's lived relation in a learning encounter. It is also important to acknowledge that the presentational immediacy (thisness) of a learning encounter can never be 'explained away' but is always subject to revision. This is an important point to make when experience reaches a limit, that is to say when modes of thought break down in the face of experience, and there is a need to develop new forms of thinking and understanding that contrast with, but do not dismiss, established forms.

Relevance

In pedagogical practice, all teachers operate from particular epistemological programmes and agendas either enforced or voluntary and they will want to help learners to become more effective learners. By placing emphasis upon the local immanence and morphogenesis of learning in order to advocate pedagogies that attempt to ascertain *how* a learning encounter *matters* for a learner, my intention is to propose that such an approach to pedagogical work may lead to an expanded understanding of learning, art practice and teaching. A pedagogy of immanence is rooted in the idea of the not-known in that it tries, however difficult, to approach

the learning situation without criteria whereas pedagogies driven by established knowledge and practice, what we might term transcendent pedagogies, tend to work from established criteria. We might say that pedagogies of immanence assume a process of becoming but without a clear predetermined 'subject', whereas pedagogies of transcendence anticipate preconceived subjects and objects in that particular kinds of learners and teachers as well as pedagogised objects are presumed by their prescribed curriculum agendas. Transcendent pedagogies might be viewed as constituting the boundaries and conditions of understanding that Heaney mentions above, whilst pedagogies of immanence relate to the 'open sky of possibility' within each learning encounter.

The issue of how a learning encounter matters for a learner introduces the notion of relevance. Consequent pedagogical questions concern what might be required, intellectually, ethically and politically, for pedagogical practices to respond to the issue of relevance in relation to the local modes of practice adopted by each learner in specific learning encounters—modes that involve ideas, feelings, materials, actions and so on. An important pedagogical tactic therefore is to ask how it is in this particular learning situation that something matters for a learner without predicating this question upon preconceived criteria that delimit what it is that matters or foreclosing the horizon or boundaries of the situation.

Pedagogical negotiations can therefore be conceived as risky situations when attempting to comprehend the relevance of how something matters for a learner—his or her modes of understanding, states of affect and so on. Pedagogical strategies leading to effective negotiations may require a holding back of the teacher's transcendent knowledge whilst trying to engage with the immanence of a learner's experience. The morphology of such negotiations, the negotiation of relevance, consists of a complex interweaving of modes of existence. A teacher's questions stemming from his or her comprehension of the learning task may act as a constraint upon the relevance of a learning encounter for a learner. The assumptions behind such questions may need to be placed at risk.

I have already mentioned the ethical dimension of this risk-taking when, for example, a teacher is confronted with a learner's practice and forms of expression which are puzzling and do not fit with the teacher's expectations that are grounded in his or her pedagogical praxis. In such situations, the relaxing of transcendent frameworks that structure pedagogic work seems important. Such frameworks establish ontological and epistemological parameters that maintain the viability and legitimacy of

learners and teachers. Such parameters denote degrees of participation: who is able to participate effectively and who is not within existing curriculum and examination formats? These questions raise the issue of politics within pedagogical work to which I now turn.

THE POLITICAL AND PEDAGOGY

I am not using the term politics to refer to the macro politics of government agendas for education policies that effect curriculum content and control. Rather I am concerned with a notion of politics, or perhaps more accurately, the political, that is much more local, relating to the immanence of learning, participation and enabling. For Rancière (2004) democracy is not a specific political regime but what he terms the institution of the political which is asserted at a democratic moment, initiated by the idea of equality, when someone is in a particular social setting where he or she has no part gains recognition or legitimation. The political therefore is a process driven by an idea of equality whereby those who are unable to participate in particular social spaces and their existing regulatory frameworks gain legitimation and as a consequence the structure of the social space becomes reconstituted. Established spaces of teaching and learning involve pedagogising technologies that create and regulate the pedagogical identities of teachers and learners. These technologies constitute the transcendent frameworks I have been discussing in relation to the immanence of local learning processes.

Democratic politics for Ranciere denotes an aesthetic process whereby those who have been marginalised or excluded within established orders bring about new forms of appearance that become legitimised and valued. This is the democratic space of encounter, the democratic event, and it has deep implications for pedagogical relations in terms of who is recognised and who is not. And the democratic event in which there is an encounter within a particular social context with something that is heterogeneous to it, a form of practice, for example, is termed by Ranciere the process of *dissensus*. (Rancière 2004: 226). Dissensus leads to a process of *subjectification* by which a way of acting or speaking which was previously occluded in particular fields of experience comes into the light of legitimation. Subjectification thus denotes the appearance of a subject and this appearance issues in a reconfigured field of the sensible. This contrast between established orders of practice and those forms that struggle for recognition can be conceived in the relations between transcendence and

immanence that I have discussed. We might consider the political enactment of equality in pedagogical relations then as a disavowal of established relations in which some forms of learning go unrecognised. The political within pedagogical relations emerges from those immanent learning processes that are excluded by established orders of recognition that constitute the pedagogical space.

In practical terms, it is dependent upon the teacher to relax his or her interpellatory parameters when confronting a learner's practice that appears strange; such situations are similar to what Ranciere terms the convergence of two worlds heterogeneous to each other. The teacher in such situations needs to recognise the possibility that a learner *is* 'speaking' but from a world and in ways the former does not yet comprehend. The teacher has to negotiate the political potential of such moments and try to bring about the viability of that which had no voice. This denotes the adventure of pedagogy.

One of the problems that Ranciere identifies in relation to modern conceptions of politics is the evacuation of the political through the idea of consensus (Ranciere 2010:188). Consensus for Ranciere does not denote agreement between parties over key interests or giving priority to discussion and negotiation to resolve conflicts. Consensus "defines a mode of symbolic structuration of the community that evacuates the political core constituting it, namely dissensus (Ibid, p.188)." A political community is structurally divided not according to conflicting interest groups but rather 'in relation to itself'. The political refers to that which is supplementary to any count of a population; it refers to a litigious relation between that which is supplementary to the group or community. Consensus reduces the group or the community to a state in which everyone is counted according to established forms and codes of representation.

Current educational programmes driven by economic ambition rely upon this idea of consensus in which everyone has a place according to established orders of representation and practice. Those that differ may be viewed as deficient or lacking and in need of a remedial programme of readjustment. In such instances, the political character of a community, that is to say the presence and potential of supplementary forms of existence, is transformed into an ethical issue, where ethics is viewed in terms of a moral programme built around normalised forms of practice and thought.

Applying these ideas of the political and consensus to pedagogical prac-
tices opens a problematic space, which will be the focus of my second
chapter.

REFERENCES

Agamben, G. (1999). *The man without content*. Stanford: Stanford University
Press.
Atkinson, D. (2011). *Art, equality and learning: Pedagogies against the state*.
Rotterdam/Boston/Tapei: Sense Publishers.
Barad, K. (2007). *Meeting the universe halfway: quantum physics and the entangle-
ment of matter and meaning*. Duke University Press.
Butler, J. (2005). *Giving an account of oneself*. New York: Fordham University
Press.
Deleuze, G. (2004). *Difference and repetition*. London/New York: Continuum.
Heaney, S. (2002). *Finders keepers, selected prose 1971–2001*. London: Faber and
Faber.
Massumi, B. (2011). *Semblance and event: activist philosophy and the occurrent arts*.
London/Cambridge MA: MIT Press.
Massumi, B. (2015). *Politics of affect*. Cambridge/Malden: Polity Press.
Ranciere, J. (2004). *The politics of aesthetics*. New York/London: Continuum.
Ranciere, J. (2010). *Dissensus: On politics and aesthetics*. London/New York:
Continuum.
Shaviro, S. (2014). *The universe of things: on speculative realism*. Minneapolis,
London: University of Minnesota Press.
Shotter, J. (2011). *Reflections on sociomateriality and dialogicality in organization
studies: from 'inter-' to 'intra-thinking.'... in performing practices*. Paper for
submission to the book series perspectives on process organization studies
(P-PROS), Vol. 3, Proceedings of Third International Symposium on Process
Organization Studies in Corfu, 16–18 June, http://www.johnshotter.com/
mypapers/Intra-thinking.pdf
Thom, R. (1983). *Mathematical models of morphogenesis*. Chichester: Ellis
Horwood.
Whitehead, A. N. (1929/1978). *Process and reality: An essay in cosmology*.
New York: The Free Press.

CHAPTER 7

What Is Art Education, What Might It Become?

Dennis Atkinson

Introduction

The question 'what is art education?' is open to disagreement. Some would argue that the very notion of 'art education' is untenable, that it is not possible to teach art because the process of art practice is contingent, driven by accidents, mistakes, revisions and outcomes that are unimagined. Others, to the contrary, would say that it is necessary to teach a body of skills and knowledge, which allow students to develop their practice. The latter position has tended to dominate school art education if we consider the different forms this curriculum subject has adopted historically. Examples are the focus upon traditional skills such as observational drawing, painting, ceramics, printmaking, collage and more contemporary skills using digital media—the programmes of Discipline-Based Art Education (DBAE) in the USA focussing upon art history, art criticism, art practice and aesthetics; visual culture art education; multi-cultural or inter-cultural art education; critical and contextual art education; and oth-

D. Atkinson (✉)
Department of Educational Studies, Goldsmiths University of London,
London, UK

© The Author(s) 2017
j. jagodzinski (ed.), *What Is Art Education?*,
DOI 10.1057/978-1-137-48127-6_7

ers. Each of these programmes developed particular approaches to teaching and learning in relation to their specific content and they expanded the meaning of the term art education.

The aim of this chapter is to consider the opening question from a rather different position. One intention is to argue that art practice as a form of learning is future oriented, that is to say it is not 'tied' to predictable, prescribed or known worlds but precipitates the possibility for new or modified ways of thinking, feeling, seeing and doing. It is concerned with processes of becoming and growth, and in order to be commensurate with such processes, it demands compatible pedagogical work that can respond effectively to learners and teachers-yet-to-come. To be commensurate with that-which-is-not-yet, such pedagogical work has to relax the totalising power of established forms of practice, skills and techniques and their established horizons of *aesthesis*. I am using this term *aesthesis*, taken from Rancière (Ranciere 2010; Ranciere 2013), to denote the process of affect in relation to bodily perception and the impression of that which is perceived leaves. In conjunction with the notion of that-which-is-not-yet, aesthesis points towards an expansion of perception and affect. This future-oriented view necessitates a consideration of practice from the notions of *process, relationality* and *disjunctive events*. I argue that art practice and educational practice both imply a process of *real learning* (Atkinson 2011). This notion draws upon the Lacanian *Real* in the sense that real learning involves a disruption of established epistemological, expressive or representational orders, and a projection into a new or modified orders; it precipitates a shift into new or modified epistemological and ontological worlds. For Lacan, the Real introduces a gap in the symbolic order, a disruption of established frameworks of understanding.

I will examine some of Rancière's writings on art and politics, which he views as dissensual processes. This commentary acts as a template for a discussion of the terms art and learning, and the implications for pedagogical work in the field we know as art education. I will consider the point that pedagogical work often involves situations that are political and aesthetic in the sense in which Rancière uses these terms. For Rancière, aesthetics is not concerned with the ways in which we experience art but with the ways in which we experience the world (Barbour 2010, p. 261; Ranciere 2005, p.15; Ranciere 2010, p. 176). Both processes involve a breaking of new ground or, put another way, the fracturing of established ground and the opening of new potential. A learning event is an aesthetic event in the sense that it involves a disruption of established patterns of experience and

the opening of new ways of experiencing. This process of breaking new ground suggests that the notion of encounter and its affective horizons (*aesthesis*) seems important—an encounter between an established mode of practice, way of thinking and doing, and that which is heterogeneous to these, so that existing forms of practice are reconfigured along new or modifies lines.

The future-oriented view of art education in which we are not concerned with learners (teachers) or practices that already exist but with those that are yet-to-come leads to a further issue: precarity. I am using this term specifically in relation to art practice and processes of learning. In the wider social context, precarity for many has come to define the rapid increase in conditions of existence that lack the traditional security (though this was never in any way total) of regular employment bringing with it an extension of low pay, periods of unemployment, migration, depression and more. For others, precarity introduces labour flexibility and opportunity. In the context of contemporary art practice, the notion of precarity may be used to describe the precarious nature of art objects and practices in terms of their status as art. This has implications for the contexts of art education that are grounded upon traditions that define the nature and content of art practice. If we adopt a precarious aesthetic, then what are the consequences for how we understand art education? How do we understand skills, knowledge and values in a world of precarity? How do we understand the notion of subjectivity? Here the notion of precarity can be equated with the idea of the suddenly possible (Buck-Morss 2013, p. 64).

This issue will be illustrated by considering the art project *Rogue Game* (2007-ongoing) developed by Can Altay, Sophie Warren, Jonathan Mosley and Emily Pethick. This project raises the problematics of boundaries and divisions, architectures or cartographies of space and their transgressions or ruptures, and the issues of cohabitation. I argue that to some extent, *Rogue Game* illustrates the dynamic of dissensus that Rancière posits as the driving force of art and politics in that as an art project it encourages a critical attitude towards established social divisions and boundaries, which in turn renews our capacity for exploring what we are able to think, feel, see and do.

These issues will then be considered in relation to pedagogical contexts of learning and art practice that are viewed in terms of a disjunctive synthesis. A school studio is a place of homonymy where practices deal with the 'same' learning encounter, where one draws a face and another

draws a face. Where one interprets a performance and another interprets a performance, but where each drawing or interpretation is constituted by a different *encounter* as it forms in the experiential relations that involve each student. In order to draw alongside these different spaces and temporalities of encounter and their particular ways of thinking, feeling, seeing and making, we may have to relax the parameters according to which practice is conceived. This, in turn, may allow an expansion in our understanding of practice and an expansion in our horizons of affect. Pedagogical work lies at a convergence of different discourses, ways of making and seeing and different kinds of reasoning as well as different processes of aesthesis; this convergence can be conceived as a disjunctive synthesis.

The first section provides a brief commentary on Rancière's work on politics and art.

POLITICS, CONSENSUS AND DISSENSUS

Rancière employs the phrase 'the distribution of the sensible' to describe the constitution and division of social organisation that establishes particular forms and ways of practice, forms of discourse and representation. Such organisation produces a series of norms and their associated regulatory practices. He uses the term *consensus* to describe this structuring and normalising of the social, whereby the 'proper' is identified against the 'improper', where certain forms of speaking are accepted and others are ignored, where there is a division between what is visible and what is not, where some people have rights and others do not. Consensus, according to Rancière (42), nullifies that which does not accord with this distribution of ways of speaking, thinking, seeing and doing. Consensus is not concerned with negotiating agreement through discussion and debate. Consensus reduces and regulates the social organisation to what Rancière calls the police order; consensus implies the police which 'structures perceptual space in terms of places, functions, aptitudes etc., to the exclusion of any supplement (92).'

> The police is, essentially, the law, which, generally implicit, defines a party's share or lack of it. But to define this, one must first define the configuration of the perceptible in which one or the other is inscribed. The police is thus first an order of bodies that defines the allocation of ways of doing, ways of being, and ways of saying, and sees that those bodies are assigned by name to a particular place and task; it is an order of the visible and the sayable that

sees that a particular activity is visible and another is not, that this speech is understood as discourse and another is noise (Ranciere 1999, p. 29).

It is not difficult to apply these notions of consensus and police order to the organisation of teaching and learning in institutions such as schools, colleges, universities and other sites. Here bodies and hierarchies of knowledge and practice are organised and disseminated, and particular responses, forms of practice and discourse are anticipated and policed through systems of assessment and examination. In the context of school, art education practices such as drawing, painting, printmaking and ceramics are assessed according to a series of criteria that accord with established and valued forms of preparation, representation and making. The mapping of the outcomes of a student's art practice according to established forms of representation and their respective set of skills and techniques also involves a correspondence between ways of making and an *aesthesis*, or 'horizon of affects (2)'. A seamless identity is already established between ways of perceiving, forms of making and particular aesthetic affects.

The notion of dissensus employed by Rancière fits closely alongside his notion of politics. Dissensus involves a gap in the representational order that occurs when a way of making sense, a way of acting, does not fit with the consensual order. A supplement appears in a social situation that intervenes in the order of the social space. Politics is the name given to this intervention into the established social order of social organisation and identity, ways of acting, speaking and doing. The motive force driving political process for Rancière is equality, and the idea of an equality of intelligences. Equality is not a goal to be achieved but something to be verified continually in the social spaces of practice. While consensus reduces politics to the police, to the established order or distribution of the sensible, dissensus is the essence of politics, which invokes an intervention and the appearance of subjects who were once unapparent and a reconfigured social space. Political dissensus is not a dispute between established participants or established objects of dispute, but it relies upon an individual or a body of people in dispute and their 'cause' being recognised by those who do not usually see *them* and *their* argument. It is the recognition by those who are being addressed and who are usually unaware, of an *ethos*, that is to say 'a dwelling and a way of being that corresponds to this dwelling (184)'. As Rancière states, 'A political demonstration is therefore always of the moment and its subjects are always precarious (39)'.

> Politics can be defined [...] as the activity that breaks with the order of the police by inventing new subjects. Politics invents new forms of collective enunciation; it re-frames the given by inventing new ways of making sense of the sensible, new configurations between the visible and the invisible, and between the audible and the inaudible, new distributions of space and time – in short, new bodily capacities (139).

The connection between art and politics for Rancière is manifested in the process of dissensus.

> Art and politics each define a form of dissensus, a dissensual re-configuration of the common experience of the sensible. If there is such a thing as an 'aesthetics of politics', it lies in a re-configuration of the distribution of the common through political processes of subjectivation. Correspondingly, if there is a politics of aesthetics, it lies in the practices and modes of visibility of art that re-configure the fabric of sensory experience (140).

Political dissensus involves the appearance of subjects who were present but unapparent in a particular social space, whose appearance reconfigures this space. Aesthetic dissensus in relation to art practice involves the creation and apprehension of forms of expression that reconfigure 'the fabric of sensory experience'; in other words, it precipitates new modes of visual practice that expand and reconfigure art practice and in doing so expands our horizons of affect.

THE AESTHETIC REGIME AND THE POLITICS OF AESTHETICS

The question 'What is Art?' has been tackled by Rancière in a number of publications dealing with aesthetics and politics. For the purpose of this chapter, I will concentrate on his notion of the aesthetic regime of art that he contrasts with the ethical and representational regimes. Briefly, the ethical regime refers to a relation of truth between a representation and its object such as in early religious iconography. The representational regime relates to what might be termed rules of representation as manifested, for example, in the hierarchy of genre painting and established systems of meaning that imposed a specific structuring of sensory experience. The aesthetic regime of art, which Rancière argues only emerged at the end of the eighteenth century, relates to 'the idea of a specific form of sensory

experience, disconnected from the normal forms of sensory experience (173)'. It involves an exception to established forms of experience, an undoing of established ways of seeing and making. At the heart of the aesthetic regime of art is the process of dissensus and the rupturing of boundaries and divisions of practice. In the aesthetic regime perhaps we might say that 'art is art to the extent that it is something else than art (118)', it pushes the boundary of what is considered art, it invokes a supplement to existing modes of practice and in doing so expands the horizon of affect (*aesthesis*).

Rancière reformulates Schiller's words on the importance of play (*Spieltrieb*) for 'the art of the beautiful and the still more difficult art of living', by stating:

> There exists a specific sensory experience that holds the promise of both a new world of Art <u>and</u> a new life for individuals and the community, namely *the aesthetic* (115, my underline).

For Rancière, 'the entire question of the politics of aesthetics' or 'the aesthetic regime of art' revolves around the conjunction 'and' in the previous quotation. The aesthetic experience is 'effective inasmuch as it is the experience of that "and"' whereby art practice and its reception has the potential to reconfigure ways of thinking, feeling, seeing and doing.

Rancière posits the aesthetic regime of art as a process of undoing the authority of existing practices and forms of representation so as to expose the latter to the egalitarian axiom. In politics, this would entail 'the assumption of equality between any and every speaking being and by the concern to test this equality – that is the staging of a 'we' that separates the community from itself (16)'. In aesthetic practice, this results in an open approach to the difference of forms of practice and expression, and the assumption of the equality of all subject matter. It also involves an open approach to the construction of meaning when viewing art: an infinite *aesthesis* (the affect of art). This in turn complicates the relation of art and non-art; art practice becomes more precarious since there are no pre-defined structures enforcing what and how things can be said or visualised in order to enfold experience. There are no pre-defined relations between forms of practice and their affects. Art practice in the aesthetic regime of art is an autonomous 'form of life' (118) that has the potential to reconfigure experience, a form of 'self-education' (119), and also to reconfigure art.

Pausing for a moment: the notion of experience I am using is not concerned with an essentialist position suggesting a 'person who experiences'. Rather it assumes a spatio-temporal process of relation, which is perhaps better comprehended through the idea of 'folding' so that experience is a process of ongoing foldings of bodies and other entities. Painting is a process of folding that involves body, mind, vision, affect, paint, surface, brush and so on. This suggests a dissolution of boundaries between subjects and objects, between beings and their milieu, replaced by a dynamic process of enfolding.

This opening up of the relation between practice and *aesthesis* has important implications for art education, a practice that involves the assessment of work, which in turn implies a hierarchy of relation between work and assessment criteria. The opening up of expression and representation, the exploding of any predication of art by established forms and practices, suggests, as already mentioned, that art becomes art by not being art. Art in the aesthetic regime is a practice that is constantly rupturing the boundaries that distinguish art from what is not art. Again there are implications for art education concerning this process of rupture for extending how we think, feel, see and do in this domain of practice. When such issues are transferred to pedagogical work there are implications: what constitutes an aesthetics and politics of pedagogy? There is a nudge towards an anarchic pedagogy, a pedagogy against the state (Atkinson 2011) that has to remain open to the instabilities of passing beyond its boundaries.

In the next section, I will discuss the art project *Rogue Game,* which I believe is trying to raise these issues of division and boundaries alongside a critical reflection whose aim is towards an expansion of thought and practice.

Rogue Game and the Not-Known

Earlier I argued for a relaxing of established parameters of practice and their respective skills in order to respond effectively to ways of making, and their outcomes that do not fit such parameters. Pedagogical work therefore needs to be able to respond to the 'not-known'. This is not an easy task in that such work is generally conceived as being concerned with a known world of knowledge and practice administered in schools by controlled curriculums, assessment and inspection programmes—a pervasive culture of audit that presupposes or anticipates known and desired pedagogical subjects and objects (learners, teachers, knowledge and skills).

Processes of dissensus, as described above, also involve the 'not-known' in that established boundaries and divisions are interrupted by that which is heterogeneous to them, so that the social space is reconfigured. If we take on board this notion of the not-known, then rather than predicating pedagogical work on established identities of teacher, learner and knowledge, it may be more effective to consider such work as a series of relations of becoming through which teachers and learners emerge, though their identities as such and the world in which they function are more precarious. If we acknowledge the importance of the idea of teachers and learners-yet-to-come, and of trying to respond effectively to the different ways in which students learn without overly predicating this process on prescribed ideas of practice and knowledge, then it may be possible in turn to expand our understanding of pedagogical work. Encounters with the not-known may lead to a reappraisal of pedagogical work, of what teaching or learning can become, and, in the contexts of art practice and art education, what art and art education can become.

The Turkish artist Can Altay, in collaboration with Sophie Warren, Jonathan Moseley and Emily Pethick from the UK, developed an art project entitled *Rogue Game,* which involved four iterations in London, Bristol and Utrecht. The work takes place in a sports centre, outside area or a gallery, where the markings that designate different games such as badminton, basketball or five-a-side soccer overlap. Participants for three or four games are asked to play their respective game simultaneously on the overlapping game areas. They have to negotiate playing their game while trying to manage interruptions and interventions from the other games that inevitably invade their territory; this management of disruption constitutes the *Rogue Game.*

Each game abides by its code or rules of practice through which player identities are constituted. Each game is prescribed by a designated playing area that regulates the space of play. In the *Rogue Game,* however, players also need to respond to the intermittent disruptions from other games. Thus in the *Rogue Game,* players' identities are less well defined; there are no rules or conventions. Players' identities become reconfigured according to the new relationalities and strategies that emerge as the *Rogue Game* develops. The *Rogue Game* forces constant reterritorialisings of practice; it involves collisions and negotiations of space and rules, whereby the games interweave. It is as though new rhythms of play emerge and reconfigure, and this makes it possible to view the playing area according to new horizons of playing together. As Can Altay states, '*Rogue Game* posits the

struggle of a 'social body' within a set of boundaries that are being challenged (Altay 2015, p. 208)'.

Because the *Rogue Game* has no rules that pre-constitute relations between players, we are encouraged to consider the 'thisness' of such relations and their potential outcomes. Such relations are therefore viewed as intra-active (Barad 2007), a process whereby bodies and strategies become constituted in the *thisness* of relation in contrast to pre-established identities or codes. Here *intra-action* contrasts with *inter-action* in that the latter involves preconstituted entities that come together to inter-act. The intra-active nature of *Rogue Game* draws our attention to the continual presence of a functioning disequilibrium or metastability. In chemistry and physics, the notion of metastability refers to a physical state of stability that can be destabilised by small changes or disturbances. In general terms, metastability relates to states of tension that, given the right kind of push or disturbance, can unleash potential energy that creates a transformation. So we can think of individuals in terms of relational processes existing in their particular milieus as metastable states containing potential energies that may be discharged given the right kind of push or disturbance.

Because there are no established tactics informing practice in the *Rogue Game*, its manoeuvres are informed by relations-in-transition and a thinking-in-action that denotes a knowing-how and a knowing-when. In the *Rogue Game*, the players have to continue to play, to individuate constantly within their social milieu, which also constantly individuates. Thus to be a player in the milieu of the *Rogue Game* is to learn how to become in a rather uncertain world of becoming, where individual (psychic) and social becomings are entwined, where the relations between 'I' and 'we' are precarious and constantly being renegotiated, but also where the horizons of cohabitation are expanded.

DISJUNCTIVE SYNTHESES

Rogue Game illustrates the tensionalities between practices of the known and the not-known. I am using it to draw analogies with such tensionalities in practices of teaching and learning where established forms of address, forms of knowledge, rituals of practice and theories of learning constitute pedagogical 'knowns', and where unexpected responses from learners, misalignments between a teacher's expectations and what actually happens, the thisness or singularities of learning, and their explosive ontogenetic character constitute the 'not-known', where practice runs counter to

received wisdom, where practice is in Nietzsche's terms 'untimely', travelling on a path with no clear destination.

The pedagogical aspect of *Rogue Game* concerning its dissensual dynamics, whereby heterogeneous games collide in the same space, encourages us to reflect upon the architectures, divisions, regulations and boundaries of pedagogical spaces, to consider the 'rules and relations of existence' that regulate and legitimate particular epistemologies and ontologies. In education, the 'games' of subject discourses and practices, and their specific organisation of knowledge can be contrasted with the collection of heterogeneous ontological worlds of students and their respective ways of thinking, feeling, seeing and doing. The homogeneous organisation of knowledge and curriculum content can be contrasted with the heterogeneity of the living realities of students. The coming together of this heterogeneity in a learning space such as a classroom or studio can be viewed in terms of a disjunctive synthesis. The temporality of communities of teaching and learning such as art studios in schools or colleges tends to be viewed in terms of teachers and learners coming together in the same time. But more appropriately, it refers to the coming together of the different times of human lives within the same time of living; in this sense, the temporality of such communities constitutes a disjunctive synthesis, but it tends to be perceived according to a fictional unity of co-presentness, administered according to an assumption of discrete blocks of knowledge. The complexity of these disjunctive spaces can perhaps be conceived when we consider situations such as when a teacher's introduction to a learning encounter travels towards the different times of the lives of students formed by their different cognitive and affective horizons, or when the art practices emanating from such horizons meet the judgement of normative assessment criteria.

The force of *Rogue Game* interrupts the space of prescription and identity, and allows us to contemplate new potentials for becoming: from prescribed to contingent communities. It provides a momentum for critique coupled with invention, a space reminiscent of what the Greek word *kairos* suggests, a temporal point of invention and innovation, an opportune moment, where being is endlessly constructed. Susan Buck-Morss (2013, p. 64) discusses *the pragmatics of the suddenly possible,* which I like to think as arising through social intra-relations. This phrase seems to embrace the ontogenetic dimension of *Rogue Game* as well as the nature of pedagogical work with which I am concerned.

Taking a lead from Buck-Morss and linking it to Rancière's notion of dissensus, we might state that the foregoing discussions of pedagogical work, processes of learning and art practice are, in a nutshell, concerned with *the politics, ethics and aesthetics of the suddenly possible* that arise through dissensual relations. How might we consider this idea in relation to pedagogical work and learning? What might a pedagogy of the suddenly possible look like? Is this a pedagogy of precarity?

PEDAGOGICAL WORK AND LEARNING

The Politics of Affect, Ethics and Aesthetics of the suddenly Possible

As we have seen, politics and art for Rancière are both dissensual processes; equally I argue that real learning, as described above, is also a dissensual process that is both political and aesthetic. Allow me to expand this point, particularly in relation to the futurity of art education. Real learning denotes a transition into new ontological and epistemological phases that also involve an expansion of the horizons of affect. Put in terms used earlier, it is a new enfolding of self and world. In this sense, real learning is an aesthetic process in that new forms of relation and sensibility emerge. Thinking of real learning as a political process as defined by Rancière is more difficult. For Rancière, politics is driven by a notion of equality when there is a clash between two worlds in one world so that a new subject appears, or does not. Equality is not a target to be achieved, but a constant process of verification. It is constant because of the heterogeneous and evolving composition of social worlds in which differences collide. How then might real learning *be* political, or learning *be* a political act? Perhaps it might be possible to see such learning as a process in which there is a sense of two (or more) worlds colliding, a world of established practice, ways of thinking, valuing, feeling, seeing and doing, and an encounter with a new world in which such processes become disrupted and reconfigured, but where there is a need to constantly verify these new enfoldings of self and world. Real learning is therefore a process in constant need of verification of relations between self and world. Perhaps this is stretching Rancière's notion of the political, but it goes some way to embrace the idea of real learning as grounded in heterogeneity and verification, and the appearance of a new subject, or more precisely a new subjectivation. Put in other terms, real learning is a precarious process of an enfolding self and world in constant need of verification. It may not

be driven by equality, as Rancière's politics, but it is driven by a desire for verification, a constant testing out of relations composed of self and world whereby a new subject appears.

Interlude I am making a painting consisting of some inter-linked areas of colour, lines and marks stemming from reflections about a walk on the coastline. It is going well for some time and I am fully immersed in the work, but then the enfoldings of action, coupled with excitement and forces of affect, are halted; I stand back to look at the work and to think about how to proceed. A distance or separation emerges. It becomes a struggle. I cannot see a way forward. Days pass by and I spend periods of time in front of the painting trying to find an opening but feeling detached from it. One day I am looking, mulling things over, rejecting them, when the idea of making a specific mark emerges along with a feeling of potential. I paint the mark, a yellow X, and there is an immediate flood of positive vibes and an enthusiasm to continue. (The idea of vibration is crucial to the process of art practice and is explored by Deleuze and Guattari and Elizabeth Grosz. Vibration is synonymous with sensation; the compounding of vibrations between entities, human and non-human, creates the possibilities for new sensations). Making the mark opens up new possibilities, it is a new or reconfigured painting now and 'we' have a new relation. This new relation is difficult to capture in words but central to it is the force of affect generated by making the new mark, which opens up new possibilities and sensibilities.

Some days later another blockage arises, more frustration, the painting remains unresolved.

An encounter offers potential for the suddenly possible to happen and this expands (or does not) the power and horizon of affect, ways of thinking and doing.

Brian Massumi (2015) links the notions of affect and politics to the idea of dissensus. His comments have direct implications for the disjunctive synthesis of learning spaces and pedagogical work. In *The Politics of Affect*, he helps us consider how acts of creativity and invention, or in my terminology, real learning, are political. Massumi writes:

> Affective politics, understood as aesthetic politics, is dissensual, in the sense that it holds contrasting alternatives together without immediately demanding that one alternative eventuate and the others evaporate (68).

Massumi is referring to group situations in this quote, but I am concerned with pedagogical work that is concerned with two dissensual conditions: one that precipitates the suddenly possible in individual processes of real learning, as described in the interlude above, and one that concerns the dissensus involved in the heterogeneous collection of a learning space such as a studio or classroom. Isabelle Stengers refers to the latter as an 'ecology of practices' and the political question, according to Massumi, is how to work effectively with the 'proliferation of differentiation' (68). On the one hand, there are the relationalities and intensities (affects) that constitute individual practices of learning in which new potentials 'collide' with established forms of practice; on the other, there is a space in which a heterogeneous collection of these individual processes 'live together'. Both these local and communal spaces are dissensual and require supportive pedagogical work. Furthermore, that which becomes suddenly possible in local spaces of practice (a local learning event or real learning) is echoed by that which becomes suddenly possible which emerges from the living together of heterogeneity. The complexity of both these dissensual processes, the local and the communal, would be the starting point for a pedagogical politics which tries to preserve the intensity of local processes of real learning as well as the communal intensity of the working together of difference. Trying to tend this complexity involves a pedagogy of adventure.

Massumi develops his thinking about the relation between politics, ethics, aesthetics and affect in a number of texts and in a series of interviews that make up *The Politics of Affect*. I cannot present a detailed discussion of this material in the space I have left, and so I will concentrate on some passages that are relevant to my interest in learning and pedagogical work. Several philosophers, notably Spinoza, Bergson, Whitehead Deleuze, Guattari, Stengers and others as well as numerous artists, influence his work on affect, and he cites as his starting point Spinoza's notion of 'an ability to affect and be affected'. The importance of this simple statement is that to affect and be affected introduces *the centrality of the process of relation and the dissolution of a separation between subject and object*. Relation is considered as an *event* in which a becoming emerges, so that in the act of painting, drawing, constructing, collaging and so on, the

traditional separation between maker, material and artwork is collapsed and replaced by the idea of a becoming together that involves human, more-than-human and non-human actants. It is an unfolding of becoming initiated by forces of affect between actants, which involves a lived past. The temporality of this unfolding is therefore transversal whereby a reconfiguring of the past is enfolded in a becoming towards a future, and where previous capacitations (ways of thinking, making and seeing) are enfolded into new or modified ones.

Massumi argues that what gives rise to an event is the affect of 'micro-shocks', or in other terms, the process of 'microperception' (53). Such shocks occur frequently such as a glance towards a sudden movement, a strange sound, something touching our body. Each change in attention involves an interruption of our flow of experiencing, which may not be noticed but which later affects conscious awareness; 'something that is felt without registering consciously. It registers only its affects (53)'. Microperception is thus concerned with events of affective transition a little like those alluded to in the interlude above. Some may produce an increased capacity to perceive or to act while others remain unactualised. A communal learning space will consist of a galaxy of microperceptions as the relationalities that form each student consist of different capacities and affective differences towards the 'same' learning encounter. The political aspect of pedagogies of microperception thus requires an open approach to such differences, and *how they matter and unfold* for each learner, remembering that such unfoldings of affect frequently involve a relational process between human and non-human actants, as mentioned above, affecting and being affected.

Another way of thinking about the heterogeneity of this collection of experiencings, and which has some resonance with the notion of dissensus, is through the term 'contrasts' as used by Whitehead (1929/1978, p. 115). He uses this term to describe different processes of becoming in a context, different actualities that are mutually exclusive, but in existing together create a kind of 'creative tension' (66). Isabelle Stengers (2002) writing on Whitehead's thoughts about oppositional views being turned into contrasts argues that what is involved is not the aim of a unity beyond difference, which would actually reduce difference, but an ecology of 'interlocking asymmetrical and always partial graspings (248–9)'. In his book *Adventures of Ideas*, Whitehead (1933, 1967) provides a final part on the idea of civilisation, which is a rather impaired term today, but as Massumi (2015, 99) suggests, Whitehead is not concerned with

celebrating any notion or form of cultural identity, but with contrast and the idea of holding contrasts together. Where cohabitation is seen positively as a cohabitation of difference, and where the intensity of such cohabitation has a potential to lead to new relations of living. Massumi writes:

> Whitehead's proposition to make a fundamental value of the mutual inclusion of differences makes the invaluable point that the goal of politics need not be the overcoming of differences, or even their reconciling. Instead, the goal can be their rendering compossible, *as* different, with all the intensity that can be had in their eventful in-between (100).

This returns us to the political/pedagogical question of how we attend to such ecologies in spaces of learning. In answer, it seems that the complexity of this heterogeneity should be the starting point for pedagogy. What we require then are pedagogies grounded in a dissensual politics and ethics that can work with the contrasts, the heterogeneous collection of local learning processes that can hold the contrasts and their respective intensities without any being marginalised.

The implications for practices of assessment whose criteria tend to be grounded in a consensual aesthetics that induce a 'power over' and standardise outcomes are profound. In Massumi's terms (115–121), how can we maintain and support the *differential attunement* of a learning space without reducing individual attunements to a standardised form? He is using the term attunement to refer to the 'direct capture of attention and energies by the event (115)' or in my terms the way in which something matters for each learner *in* a learning encounter. Differential relates to the process that learners are engaged in a learning encounter differently and follow their respective trajectories. How do we orchestrate these differential spaces so that learners are able to cohabit them inventively without diluting or disabling individual attunements?

Can we consider the attunement of learning and the practice of art action without the imposition of identity? This question calls for an art education that relaxes the force of identity or pedagogised identities in the form, for example, of predetermined categories of skill, technique or representation. It suggests a pedagogical spirit of adventure rather than capture, though the latter is always imminent—an adventure whose task is an attunement to the different attunements of learners. For learners and their different attunements to a learning encounter, the task is not one

where 'anything goes', but one that proceeds with a mixture of engagement, enthusiasm and responsibility.

One of Whitehead's eternal questions was, 'Why is there always something new?' From a pedagogical viewpoint, this question seems ever more apposite today. There is an infinity of ways of learning and teaching; there is an infinity of modes of art action. What we require therefore are pedagogies that value established knowledge and forms of practice, but which are equally able to respond effectively and sensitively to events of real learning, and their novel outcomes that lie beyond established parameters of thought and practice. Put in other terms resonant with the words of Spinoza, we do not know what learning and teaching are capable of, and therefore pedagogies of encounter necessitate an open and inventive perspective towards what becomes suddenly possible.

Throughout this chapter, I have argued that both real learning and art practice are dissensual practices through which new or modified ways of feeling, seeing, thinking and doing emerge, where new relationalities involving self and world are unfolded. The kind of pedagogies required to support and extend such processes cannot relinquish established modes of practice but neither can they allow such modes to totalise practice. Thus the question 'what is art education?' cannot only be retrospective but more importantly it must adopt an attitude of adventure, an attitude that pushes beyond knowledge and without criteria.

REFERENCES

Altay, C. (2015). Rogue Game: an architecture of transgression. In L. Rice & D. Littlefield (Eds.), *Transgression: towards an expanded field of architecture*. London: Routledge.

Atkinson, D. (2011). *Art, equality and learning: Pedagogies against the state*. Rotterdam/Boston/Tapei: Sense Publishers.

Barad, K. (2007). *Meeting the universe halfway: Quantum physics and the entanglement of matter and meaning*. Durham: Duke University Press.

Barbour, C. A. (2010). Militants of truth, communities of equality: Badiou and the ignorant schoolmaster. *Educational philosophy and theory, 42*(2), 251–263.

Buck-Morss, S. (2013). A commonist ethics. In S. Zizek (Ed.), *The idea of communism 2* (pp. 57–75). London/New York: Verso.

Deleuze, G. (1995). *Negotiations: 1972–1990*. Trans. Martin Joughin. New York: Columbia University Press.

Ellsworth, E. (2005). *Places of learning: Media, architecture, pedagogy*. New York/London: Routledge.

Massumi, B. (1992). *A user's guide to capitalism and schizophrenia: Deviations from Deleuze and Guattari*. Cambridge, MA/London: MIT Press.

Massumi, B. (2015). *The politics of affect*. Cambridge, UK/Malden: Polity.

Ranciere, J. (1999). *Disagreement: Politics and Philosophy*. Minneapolis: University of Minnesota Press.

Ranciere, J. (2005). From politics to aesthetics? *Paragraph, 28*(2), 12–25.

Ranciere, J. (2010). *Dissensus: On politics and aesthetics*. London/New York: Continuum.

Ranciere, J. (2013). *Aisthesis: Scenes from the aesthetic regime of art*. London/New York: Verso.

Stengers, I. (2002). Beyond conversation: the risks of peace. In K. Keller & A. Danielle (Eds.), *Process and difference: Between cosmological and poststructuralist postmodernisms* (pp. 235–255). Albany: SUNY Press.

Whitehead, A. N. (1929, 1978). *Process and reality: An essay in cosmology*. New York: Free Press.

Whitehead, A. N. (1933/1967). *The adventures of ideas*. New York: The Free Press.

Intermezzo

CHAPTER 8

Art's Ped(ago)gies

John Baldacchino

When we consider the value of art in our life, Hippocrates's first aphorism reveals the inherent aporia of death, which is the relationship between art and life. "Life is short, and art [τέχνη] long," he says. Then he adds: "the crisis fleeting; experience perilous, and decision difficult" (Hippocrates, nd). As we find ourselves pondering why should the aporia of death influence or even articulate what we mean by life's "long art"—indeed its "long *technē*"—we find less consolation in Derrida when he cites Diderot's treatment of the aporia of death as prompted by Seneca's *De Brevitate Vitae*. The same insufficiency of explanation, embodied in the impossible direction of an aporia, is cited by Derrida (1994, p. 10) as having to do with the identity of a language that "can only affirm itself as identity to itself by opening itself to the hospitality of a difference from itself or of a difference with itself." This prompts a vision of a condition—that of the self. "[S]uch a difference *from* and *with* itself," says Derrida,

J. Baldacchino (✉)
Arts Institute, University of Wisconsin-Madison, USA.

© The Author(s) 2017
j. jagodzinski (ed.), *What Is Art Education?*,
DOI 10.1057/978-1-137-48127-6_8

163

"would then be its very thing, the *pragma* of its pragmatics: the stranger at home, the invited or the one who is called." (1994, p. 10).

I. Art education's viability comes from the specificity of art and the singularity of education as autonomous spheres of human endeavour, and as phenomena of human freedom and intelligence.

As art never died, we never stop talking about it. This is no consolation because in talking *about* art one finds an inevitable paradox that is only matched by trying to make sense of death, knowing that only the dead could talk about it if they could speak. Just as to speak of death is to speak of the brevity of life, to speak of art is to talk about the boundaries beyond which we begin to define it.

Ernst Gombrich famously opens his *Story of Art* stating that really there is no such thing as art, only artists (1978, p. 4). To stop there, Gombrich's statement would become a cliché. Not unlike death, art is always peculiar, which is why everyone has something to say about it. But here is a caveat: While everyone has something to say about death, only a few have the stoic stamina of a Seneca and the artfulness of a Diderot—as Derrida (1994) has shown—to put something across that begins to make sense. Likewise, while many have a lot to say about art, and may well continue to say it, what really makes sense is what we *do not say* about art while we invariably continue to *talk* about it.

Gombrich is not exactly being ironic in his opening statement. A couple of pages later, he goes on to explain that his story "illustrates the harm that may be done by those who dislike and criticize works of art for the wrong reasons." (1978, p. 12). Could one say the same for the "right reasons?" Are there any right or wrong reasons for loving or hating art? Gombrich gives the impression that he wants to say everything by denying, from the start, that the story of art deals with other than what we often call "art" for the wrong reasons. Perhaps there is a reason for this, in that ultimately just as death is what happens to people whose life comes to an end, art is something that artists make when they go about living. In the peculiarity and special place that we attribute to art and death, we forget that they form an integral part of life that is what it is, and by which we confront the dilemma of its *speciality*.

Faced with this dilemma, we offer each other the possibility of being *educated* into art, just as we do when suffering bereavement and seek

professional help. Just as death is schooled in religion, social work or psychology, schooled notions of art are born from the need to talk about it. However, we need to keep in mind that while many art educators are too quick to argue otherwise, art has no actual bearing on the education that acts as its surrogate parent. In contrast, for art and education to make sense for us, they need to be kept separate. No degree of "help" is forthcoming in schooling art because art is neither a process of mourning, nor is it a tool of learning. In art, the *learning* bit comes later, and it is attributed to art for many reasons whose justification (or rejection) lies elsewhere. Those who insist that art is there to heal or teach, and should therefore find itself ensconced in a schooled educational edifice, are attempting to "rescue" what is not in danger.

This chapter is written in two parts, yet its ten sections follow each other, each headed by a theme or axiom which sums up each section's theme, and where all the themes are reproduced at the end by way of providing a summative conclusion. In this chapter, I want to draw a clear distinction between art and education by examining the illusive notion of *pedagogy*. Though it is tempting to argue that when I present two statements like "Education is not art" and "Art is not education," I am seeking an excuse, or trying to set up some language-game by which I want to say the same thing, and imply the same action, or draw a parallel distinction in mirror image, the case is the very opposite.

To argue that two opposite directions produce two different distinctions is to assert that such a differentiation must eliminate the confusion that is often drawn from an argument about art and education's *autonomous* claims. There is no mutual inherence in art and education, even when both spheres, in their different ways, entertain their formative and aesthetic attributes through a unitary discipline like art education. As I have argued elsewhere, to make art and education mutually inhere into each other would immediately eliminate them as such, and make them into something else, which is neither artistic nor educational, but which approximates a ventriloquist's soliloquy (Baldacchino 2015a). For human beings to claim a sense of autonomy through their artistic and educational *actions*, art and education must remain distinct and therefore autonomous even when they work together as when art education becomes necessary.

Autonomy needs contexts, and many of them. In the diverse practices and assumptions by which we premise our educational and artistic actions,

we need to assert how they also identify their sense of freedom, by which we as intelligent beings assert ourselves in the world. The autonomy of our actions does not present an argument for relativism. As we sustain the spheres of art and education as necessities in the contingent relationships that emerge between individual and society, we alert each other to a series of *political* and *aesthetic* questions that, in their singularity, take very different trajectories. It is through such trajectories that humans express meaning in how they unfold infinite ways of thinking and being, by means of what we identify as forms of doing and making.

Presenting a discussion of art and education from political and aesthetic perspectives, this dual chapter embarks on what Ernesto Laclau (1993) identifies as a "process of arguing" that finds its origins in diverse, often conflicting intentions that confirm humanity's recognition of its historical contingency. They are marked by inevitable points of conflict as well as convergence. These perspectives also explain how art and education continue to be *acted* and *enacted* as autonomous moments of universal singularities, as forms of desire, even as moments of obsession, and as other than what art and education are expected to portend. More so, in their autonomy, art and education could well regain their place in what is often threatened by institutionalised practices that took over the commons and whose vernacular *origins* we once held and spoke. These are the same commons that women and men need time and again to aim to re-appropriate and re-construct, destroy and demolish, in equal measure.

By the same token, just as we speak of political and aesthetic perspectives, contrary to the conventional expectations of art educational discourse, this chapter seeks ways by which art and education could claim their autonomist immanence beyond any form of aesthetic or political legitimation by which a schooled notion of art supposedly takes its place in society.

PART 1. EDUCATION IS NOT ART

In a discussion with Lucien Goldmann, on the value of description, understanding and explanation, Adorno makes a case and builds a defence for the dialectic: "A rigorous dialectical thinker should not in fact speak of method, for the simple reason—which today has almost entirely disappeared from view—that the method should be a function of the object, not the inverse." (Adorno and Goldmann 1977, p. 129). The case built

by Adorno is not simply theoretical, but brings us back to the very meaning of *theoria* as that art of our contemplative life by which we equip ourselves to look at the world and at each other in eye, and without any hesitation denounce what inhibits our liberty. It is in this concrete struggle that Maxine Greene confronts freedom in all its dialectical force and reveals that which inhibits and controls our freedom: "There are conference and commission reports, not barbed wire fences in the way," she says, referring to an educational system that has become the hub of operational oppression (Greene 1988, p. 15). "There are assured, helpful, bureaucratic faces, not glowering antagonists to growth and freedom and an enlarged sense of being in the world." Indeed the case Greene makes is not simply one that splits the then world of a communist and capitalist globe. Rather Greene sees liberty suffocated everywhere, which is also where the urgency of an art that conspires with dialectical struggle becomes inevitable and necessary: "The 'weight' is only dimly felt; yet, for many it is accepted by what Milan Kundera describes: It *must* be; *es muss sein.*" (Greene 1988, p. 15).

II. A possible rejection of schooled art is sought in the variegated distinctions that emerge from art's facticity and autonomy where the dialectic takes precedence over method.

There are things we call "works of art" in that someone made them and subsequently taught others how to make their own. How or why they are regarded as works of art is always disputed, and our explanations are closer to alchemy than science or art. We also choose to reserve other meanings for art, which we do not attribute to any other object or work. These are also constructs into which we seek to school others and ourselves, as we do with almost everything else in the expectation of socialising art into a world by which we seek to assert art as a matter mostly concerned with the *self and its realisation.* This comes from an expectation—often deemed *natural*—where art becomes an instrument or a condition of consensus that is then reinvested in the constructive appropriation of the world's commons.

Once art is schooled, we begin to believe in the myth of our aesthetic identity as a realisation of an exclusive truth. As a *learnt* prospect, identity warrants that art is synonymous with education. It is easy to see how this comes from the assumption that art is a form of learning; that we can edu-

cate *through* art; that art denotes what is *appropriately appropriated*, as if it was never within our reach before we could turn it into a form of knowledge, and even a special kind of *intelligence*. Many would rejoice that art enjoys this recognition while others even insist that the State should always do so, hardly realising the risks that this would imply. However, once art is seen as *another* (and an *other*) form of intelligence, it also means that art could be taken to market not just as a work of art, or an object that we make, but also as a competence, or an identifiable skill that could be sold.

Once at market, art also makes a good tool, or a machine, that far from simply allowing us to do something with it, we expect it to do something for us. Illich makes no bones about this: "it turns out that machines do not 'work' and that people cannot be schooled for a life at the service of machines." (Illich 2009a, p. 10). This expectation is at the root of our failure to live convivially. Rather, we seem to be all too ready to barter our freedom with instrumentalised reason in the forms of schooled learning and creativity while we stand to lose our autonomy:

> The crisis can be solved only if we learn to invert the present deep structure of tools; if we give people tools that guarantee their right to work with high, independent efficiency, thus simultaneously eliminating the need for either slaves or masters and enhancing each person's range of freedom. *People need new tools to work with rather than tools that 'work' for them.* They need technology to make the most of the energy and imagination each has, rather than more well-programmed energy slaves. (Illich 2009a, p. 10, emphasis added)

As art becomes a tool for learning—or indeed as art *is seen* as an identifiable tool that supposedly facilitates creativity—confusion often comes in between instrumentalism, and instrumental thinking and doing where art becomes a tool that "works" for us. This reduces us to spectators. We glorify art but only insofar as we can get something out of it—as it attracts consensus, prestige or fame and money, or a sense of peace and wellbeing.

Illich's distinction between what we make of tools and what tools do for us is too quickly dismissed from both ends of the spectrum. There are those who see tools as instruments that would approximate the idea of a means by which we can gain autonomy, where as Dewey contends, instrumentalism is "thoroughly realistic as to the objective or fulfilling conditions of knowledge [and where] [s]tates of consciousness, sensations and ideas as cognitive, exist as tools, bridges, cues, functions—whatever

one pleases—to affect a realistic presentation of things, in which there are no intervening states of consciousness as veils, or representatives." (Dewey 1905, p. 325). Indeed, Illich argues that, not unlike Dewey:

> Individuals need tools to move and to dwell. They need remedies for their diseases and means to communicate with one another. People cannot make all these things for themselves. They depend on being supplied with objects and services that vary from culture to culture. Some people depend on the supply of food and others on the supply of ball bearings. (Illich 2009a, p. 11)

On the other hand, instrumentalism raises the issue of control and manipulation where those tools that are meant "to 'work' for" us, as Illich put it, begin to sustain a state of instrumentalism, where, as Horkheimer argues, "the more ideas become automatic, instrumentalized, the less does anybody see in them thoughts with a meaning of their own." (Horkheimer 1974, pp. 21–22). Here, we begin to critique the expectation of instruments by which humans forfeit their autonomy. This is echoed by Illich when he states, "Present institutional purposes, which hallow industrial productivity at the expense of convivial effectiveness, are a major factor in the amorphousness and meaninglessness that plague contemporary society." (Illich 2009a, p. 11).

Without going off at tangents and enter into Illich's discussion of how the estrangement of humans from tools and the proscription of conviviality come about in the first place by a scarcity where the sense of instrumentalism (as identified by Dewey) finds itself institutionalised, it is important to accentuate Illich's view of an alternative state of affairs:

> As an alternative to technocratic disaster, I propose the vision of a convivial society. A convivial society would be the result of social arrangements that *guarantee for each member the most ample and free access to the tools of the community* and *limit this freedom only in favor of another member's equal freedom*. At present people tend to relinquish the task of envisaging the future to a professional élite. They transfer power to politicians who promise to build up the machinery to deliver this future. They accept a growing range of power levels in society when inequality is needed to maintain high outputs. Political institutions themselves become *draft mechanisms to press people into complicity with output goals*. *What is right comes to be subordinated to what is good for institutions*. Justice is debased to mean the equal distribution of institutional wares. (Illich 2009a, p. 12, emphases added)

Instrumentalised as a tool for education, or health, or any form of care or wellbeing, art begins to do what is good for institutions. It gradually enters a sphere of "needs" that are made scarce and given a price, and thereby identified with investment and profit. Art's price gains enough interest that the faculties by which humans are engaged with art leave the realm that Kant (1974 §2) reserved for the faculty of disinterested taste. For some, this means that art is no longer detached from practice and human reality. Yet this constitutes the very opposite, because as Kant has amply shown, in the realm of *interestedness*, there is no place for autonomy, let alone for a sense of "purpose without purposiveness." (Kant 1974 §11).

Those who claim to emancipate art from some elitist sphere, wrongly denounce non-purposiveness as exclusivist, which actually means that either they cannot understand art's need for autonomy, or they understand art so well that they also know that the only way to kill art's power of distinction is to make art "democratic." Again, just as instrumentalism takes on a dual meaning (which are best represented by Dewey and Horkheimer's respective positions), the notion of a speciality in art (the defenders of which are often misconstrued as *elitists*) is confused with what Illich calls the relinquishing of a vision and leadership "to a professional élite," which in this case would want art to enter the realm of interestedness and scarcity as this would command a high price of socio-economic privilege.

Those who preserve art as a scarce instrument of education, care, health and wellbeing would be the first to claim that they are putting art within the democratic sphere—just as they do with education, health, social work, care and wellbeing. In this democratic condition, art has no choice but to survive insofar as it becomes a form of socialised knowledge that is aimed at limiting the degree to which we could partake of it. Like education, health and other spheres of human activity that have been democratised, art becomes equivalent to a practice of normality where the speciality of the aesthetic (which is one of those abilities by which human beings, even when enslaved, could reclaim a sense of autonomy) is proscribed.

This is where those who decry Horkheimer and Adorno's critique of instrumentalism as being "elitist" mistake the idea of democracy with that of a service, or an instrumental sphere that would absorb all forms of human activity into a notion of growth and progress. In terms of art, and to many extents education, the democratisation of art is not that different from the Stalinist commissar and the Corporatist entrepreneur's shared

assumption that art's speciality is a bourgeois concept that must be sub-sumed and socialised, respectively.

With democracy understood as a well-calibrated machine that is expected to compute, weigh and yield rights and justice, to democratise art is to make it scarce enough to reserve, control and sell, just as we do with schooled education whose constructs of inclusion begin to draw the boundaries within which the polis is clearly enclosed. And let us not delude ourselves: This political machine is up and running, often justified on the pretext of electoral and juridical mechanisms that see the most autocratic governments being elected to exercise their "right" to suppress any notion of autonomy, and doing so in the name of liberty and social justice.

With the rise of neo-liberalism and that of top-down systems of gov-ernance that claim to be legally elected by confirmed majorities, democ-racy has moved beyond sociocratic notions of conviviality, or liberal forms of associated living dreamt by Illich and Dewey, respectively. For several decades, we have seen it coming. We are now witnessing democracies of sorts, reserved to those who are allowed to speak and make tools of exclu-sion out of art, culture, education, health and wellbeing. For many democ-racies, anyone else is just a barbarian refugee coming into our homes to take our privileges, to enjoy our health, education and wellbeing. Even political parties that remain ideologically pitted against social welfare are now crying out without any shame or decency that the welfare state is not open to all.

The sacred alliance by which these democrats are once again align-ing themselves with anti-immigrant fascists is all too prepared to appear philanthropic insofar as it keeps a reserved kind of political, educational and artistic ascendancy intact. Even when they speak of multiculturalism and bicker with their racist counterparts, these latter-day proponents of democracy actually mean assimilation, as if it were better to culturally breed an aboriginal race out of existence than murder gays, Roma, Jews, Armenians and Slavs in subsequent genocides.

The tragedy is that we seem to be all too happy to confuse elitism with the comfortable finesse by which expertly connoisseurs of whatever social standing perpetrate their existence in museums and art collections, in theatres and galleries, in shrines for beauty. In such delectation, violence and hatred are quickly tenderised by what Maxine Greene (1988, p. 15) calls the odourless "gas chamber of everyday life"—which often includes the arts and education, particularly when in being sold as scarce, they are turned into a unified instrument called *art education*.

III. Art seeks to unlearn the grammar of an ideational prototype. As unlearning, art thereby confirms our contingency. By asserting their own vernacular understanding of the world, women and men reaffirm freedom and intelligence on whose horizons art regains autonomy.

Socrates and the Sheikh

Who is this old man who leaves his home each morning to walk about, getting as much experience as he can? He is the Sheikh, the teacher of Arabic, who was retired more than twenty years ago. Whenever he feels tired he sits down on the pavement, or on the stone wall of the garden of a house, leaning on his stick and drying his sweat with the end of his flowing *gallabiya*. The quarter knows him and the people love him; but seldom does anyone greet him, because of his weak memory and senses. He has forgotten relatives and neighbors, students and the rules of grammar. (Mahfouz 1998, p. 6)

[Socrates] heard me out, and then said with that ironical simplicity of his, My dear Alchibiades, I've no doubt there's a lot in what you say, if you're right in thinking that I have some kind of power that would make a better man of you, because in that case you must find me so extraordinarily beautiful that your own attractions must be quite eclipsed. And if you're trying to barter your own beauty for the beauty you have found in me, you're driving a very hard bargain, let me tell you. You're trying to exchange the semblance of beauty for the thing itself (…) But you know, my dear fellow, you really must be careful. Suppose you're making a mistake, and I'm not worth anything at all. The mind's eye begins to see clearly when the outer eyes grow dim—and I fancy yours are still pretty keen. (Plato 1989, p. 570)

With all his zest for irony, Socrates knew well that his quest for knowledge was a lifelong attempt to recover from the predicaments of life. The old philosopher was tireless. His answers loathed a quick fix. His argument looked more like a haggling match in a flea market than a ponderous fit of academic drama. He drifted from one set of questions to another. He sought answers by the same viciousness with which an obsessed pervert would stalk his victims. The old philosopher's scorn was violent. He waited for the moment when his opponent would falter and botch logic with opinion. In his dialogues with young men, Socrates knew that his

love for youth went beyond carnal attraction. His eyes were set elsewhere: on an eternal kind of knowledge that a soul without "us" must have enjoyed before we were born. He constantly yearned for the mansions of perfection where the soul was said to be free from the limits of the body.

Unlike the philosopher, the Sheikh lost no sleep on the tricks of memory and logic. He was oblivious of the past. Thanks to his amnesia, he was free from any worries about the future. He turned out to be a good unlearner. His forgetfulness may have been caused by senility, but there were moments in which he took advantage of this liberation and wilfully forgot what happened around him. He stuck to what mattered, and he wizened up to what he chose to remember. Unlike Socrates, the Sheikh forgot and unlearned his grammar and stood beyond the old Greek's ruminations about the mind. During the walks which he took, aimlessly and without any destination, the old Alexandrian got rid of grammar. He bettered himself by what the old philosopher would have deemed useless. For the Sheikh, it seems that leisure took over the need for grammar and logic.

Here is a clear case for art's unlearning. Plato and Mahfouz both wrote with poetic enjoyment. Yet while the latter saw himself as an artist, despite his poetic abilities the former saw himself as art's opponent. The difference between art and philosophy in the Platonic tradition has been discussed in millions of pages, but a missed point is that Plato's argument for education as anamnesis, as a form of recollection, begins to articulate an interesting theory of unlearning by default. If learning is through and through a form of remembering, which goes in the same direction as that of philosophy, mathematics and logic, art goes the other direction, as it seeks to distance the soul's knowledge from its ideal origins through mimesis and the emotions. In this respect, one could well agree and argue that art's pedagogy is a form of forgetting, a form of unlearning—which is where Mahfouz's Sheikh becomes exemplary.

Memory, Grammar ... and Forgetfulness

Let us imagine a dialogue between Socrates and the Sheikh. In their chatter, they would share their wisdom over the recollection and forgetfulness of all those cherished words, their friendships and teaching and (of course!) their engagement with grammar. Socrates would perhaps understand the Sheikh's predicament, insisting—for once without irony—that

he also led a life of negotiation between forgetting what one knows and knowing what to forget. Socrates would delay his logic and sit down with the Sheikh, who in turn might just toy with his *gallabiya* while reminiscing about yesterday's walk in the dusty streets of old Alexandria as it would have happened in his youth.

This is a dialogue between memory, knowledge and grammar. It describes a moment where *beginning to remember* could also mean *beginning to understand what needs to be known, by what must be forgotten and unlearned*. We know that what we learn is more than a glimpse or a moment of recollection. What we know sets the limit to what we await to know. The Sheikh forgot his relatives and neighbours by forgetting the rules of grammar. The moment of grammar is so important that we hardly realise that we have lived it, and have been its protagonists for a long time. In every life, as in every step in the construction of our individuality, the moment of grammar has its brief yet intense glory. We know all this and we say it even when we keep it to ourselves because our aim to live is primarily an act of self-preservation. Each moment of our life is a victory over the limits of life itself. Aware of the certainty of death, we extend our lease of knowledge into the *beyond*, which implies a risky guess that we often consign to the mechanisms of faith, rather than grammar.

The Sheikh forgot his grammar and regained a kind of happiness that Socrates would deem impossible. Yet Socrates and the Sheikh shared the centrality of grammar: the latter grew out of it, unlearnt it; the former would never let go and stalked it until it killed him. Both knew (at some point) that they had their encounter with the love that bore them the child of wisdom. One wonders whether in his blissful walks, the Sheikh's love of wisdom glowed with a brilliance that would have outshone the grammatical arrogance of the dialogic teacher.

Lego and Scrabble

Whether the Sheikh's intended forgetfulness would ever win the day is beyond the point of this argument. What is at stake is the *sense* one makes of the memory by which we *construct* knowledge (as *epistémè*, as accrued knowledge), as distinct from the ways we *live* knowledge (as *gnosis*, as knowing to be). Everyone expec ts a result, especially when taking the trouble to reflect upon one's life. Everyone wants to make sense of the

plural moments of personal encounters that are in turn expressed by one's opinions, intentions and day-to-day living. This is because opinion, intention and living form an integral part of what we expect from the rules of grammar by which we try to express ourselves. Yet it is also true that when the Sheikh forgot the rules of grammar, there was a willed form of freedom, as it began to unlearn and undo what was imposed upon us by grammar's schooled forms of life by which, Illich (2009b, pp. 72–74) reminds us, we lost the vernacular possibilities and with them the plural universe of singularities. Upon unlearning his grammar, the Sheikh enjoyed his life as he regained his appreciation for a vernacular world that was less troubled by the logic by which Socrates was afflicted.

Contentions over life and happiness, rules and grammars, expectations and duties do not spare us from equivocation. Here, it may be worth considering Quine's attention to the drift with which the rules of grammar seem to influence our continuous attempt to establish some meaning for our talking:

> Language is perpetually in flux. Each of us in learning his own language depends heavily on analogy, interpreting or fabricating further phrases by analogy with phrases we have learned before; and this same force of analogy reacts upon the language itself over the years, leveling exceptions and forcing odd forms into a more common mold. *Swelled* supplants *swole*, and *thrived throve*, because inflection by suffix is more usual in English than inflection by change of vowel. (...) Language is always under the pressure for regimentation, what the Nazis called *Gleichschaltung* [*bringing into line, making the same*]. Granted the trend is sporadic; we can continue to treasure *mice, lice, dice, geese, men, women* and *children*. (Quine 1987, p. 110)

The regimentation by which grammar encroaches our language is found in words whose shape and sound yield a diversity of meanings. But before one gets excited over a presumed infinity of supplemental possibilities, diversity is wrenched by standards of intelligibility as assumed by power. Albeit plural, semantic diversity is only afforded up to a point: as long as it serves as an instrument—the same instrument by which during the last decade of the fifteenth century, the grammarian Elio Antonio de Nebrija, author of *Gramatica Castellana*, formalised and used the Castilian language as an instrument of accrued power for the court of Queen Isabella, thus imposing a universal construct on the plural dialects of daily life across the whole of Spain.[1]

Quoting the Bishop of Avila, Nebrija's justification of his grammar does not seem that distanced from the Nazi's concept of *Gleichschaltung*, intended to bring *in line*—and indeed *streamline*, to use modern managerial speak—everything and everyone:

> Soon Your Majesty will have placed her yoke upon many barbarians who speak outlandish tongues. By this, your victory, these people shall stand in a new need; the need for the laws the victor owes to the vanquished, and the need for the language we shall bring with us. (Cited in Illich 2009b, p. 49)

Words and agreed meaning are like a *Lego* set. A child's game, Lego also works for adults presented with a complex structure by which they must build a number of objects. Here, *Bildung* is killed off. Bereft of its dialectic, *Bildung* is no more. This is a structure built from a simple mechanism where all shapes are meant to fit in any "creative" way a child, or indeed a manager, banker or teacher on some corporate training session, wants to. Yet this diversity is regimented by the necessity of connectivity, which, in turn, offers a world that must be learnt, a world that regards paradox as mistake, as nonsense.

It is a given that Lego bricks must all fit, even when their shapes and colours are different. The condition of a Lego brick is *a priori* universal. Lego blocks that do not fit are not Lego bricks. Before any proof or any conclusive confirmation, the Lego brick is assumed as universal. There is no choice: it is either universal prior to being assembled with other Lego bricks, or it will never be a legitimate Lego brick if having tried to use it, one finds it does not work.[2]

In his book *Kierkegaard The Indirect Communication*, Roger Poole (1993, p. 53) remarks that "Lego is omni-usable, omni-adaptable." "Thus, in any specific context, the game of locking brick onto brick, of defining an old term in a new context, or a new context in old terms, is easily carried out," explains Pool. "Objective and subjective, positive and negative, can be fitted into any Lego context whatsoever." (Poole 1993, p. 52).[3]

The way words seem to be streamlined or regimented irrespective of their shape, sound or meaning strikes me as similar to the *a priori* condition of a Lego brick. It could be a question of play; of making do with other speakers in society; of having to operate with each other. It may have to do with the playfulness of poetic reconstruction where sounds are instruments of meaning, albeit uttered as words. Whether these words

pertain to the brain of a humanity of makers, a political animal, a thoughtful person or a playful being, the human uttering of words is an act of universality that is assumed prior to any use or experience. In this respect, the regimentation of words sets the context for a meaning that "awaits" our intentions.[4]

This state of affairs gives another function to regimentation, where words (and how they are uttered) make a case for the world as a meeting place of recollections. The world is a grander and wider depository of all those memories by which we could piece one word with another. It is where we could interpret, as well as fabricate, "further phrases by analogy with phrases we have learned before." (Quine 1987, p. 110). Such is the simplicity of the mechanism of words, their meaning and their context, in their universal character, that power is easily used to wrench grammars onto a vernacular world.

Universality is also a practice of words that are recollected and reconnected as we do in a composite building of *Scrabble* pieces. Like *Lego*, *Scrabble* is another game that mimics the way we order the world universally, by creatively adhering to presumed grammars that suppress any deviation. Like the monad, words and Lego bricks are intelligent substances. They are "a simple substance which enters into compounds: *simple* that is to say, without parts." (Leibniz 1995, §1, p. 179). Words and Lego blocks are universal by force of their simplicity. Their rule is clear: *simplicity = universality*. The minimum is the total. The smallest quantity is the largest possible quality. Likewise, their modality is simple and universal: it is exchangeable because it is equitable and appears to belong to a presumed *common sense*. In this relational context, one can see how the grammatical nature of our words makes the construction of truth in any way possible, thereby conditioning the same truth by its presumed possibility.

Dialects of Unlearning

Communities in which monolingual people prevail are rare except in three kinds of settings: tribal communities that have not really experienced the late neolithic, communities that for a long time lived through exceptional forms of discrimination, and among the citizens of nation states that, for several generations, have enjoyed the benefits of compulsory schooling. To take it for granted that most people are monolingual is typical of the members of the middle class. Admiration for the vernacular polyglot unfailingly exposes the social climber. (Illich 2009b, p. 67)

Social constructivist arguments for education have become more and more vulnerable upon finding themselves being thrown right against those notions of equity and diversity in support of which social constructivism originally emerged. The tautological nature of this state of affairs is so obvious that some take it as a sign of truth. Many teachers and artists alike would not accept the argument that to universalise art and education is to make it vulnerable. Many socially committed artists and educators fail to accept the danger by which the socialisation of art and education actually proscribes (rather than enables) children and adults from participating in art and education's power of consciousness. In schooling, this is a pervasive danger, and it remains present even in pedagogical systems that predominantly accentuate the use of criticality, play, learner-centredness and the like.

This happens when discussions of social consciousness through education and art fail to include a caveat, stating that when one speaks of art and education as autonomous spheres of action and meaning there must also be an appreciation of how, in their autonomous sense of immanence, both art and education have been able to articulate those respective dialectical logics by which women and men could regain and enjoy their vernacular understanding of the world.

Many seem to forget, or ignore the fact that in this age of standardisation, to resort to social assumptions of art and education may well reinforce the universalist suppression of the vernacular world of meaning and living from where art and our claims for education have emerged in the first place. Liberal, progressive and critical teachers and artists often forget that in a schooled society, one's effort to emancipate others is turned on its head and finds itself contributing to a massive loss of communication across almost all aspects of living. Before anyone else, in the 1930s, Dewey (2000) was already anticipating this state of affairs in his book *Liberalism and Social Action*, where he shows how while many claimed freedom and emancipation as their liberal duty, it turned out that their actions caused more oppression than ever before. Dewey called this "pseudo-liberalism". While some would call this an anticipation of neo-liberalism, I would be inclined to regard it as the manipulated degeneration of the dialectic of democracy that follows from the elimination of the vernacular imagination.

The vernacular world is that very same creative world which we seem to think—in our arrogance—that we could outwit, given that we have schooled the arts and language to such heights that we could empirically measure every aspect that it throws at us. As we look again at the vernacu-

lar spheres of living, we realise how education could revalue and recognise the *dialects* by which we could consciously unlearn the grammars that have suppressed our knowledge of life trans-subjectively, and through the lenses of particularity.

Dialects come before they become dialectical or dialogical. A dialect is localised in the context by which our words are formed. It holds onto its turf. It is aggressive and pugilistic. This is where we pack our historical baggage and hope that we find the joy of the *caminar* by which poets like Antonio Machado and Konstantin Kavafis urge us to keep the destination in our heart, and locate the sense of living in that of travelling by which we speak and talk about *walking*.

The land of ultimate understanding is always present in the wishful thinking of our own understanding of the world. Where we go, we learn how to speak other than one dialect. Again and again, we pack and go, with Socrates and the Sheikh, around Alexandria and beyond, and visit old friends, neighbours, lovers and students whose reluctant infancy has turned their joyful play into a wondering urge to win a game of *Scrabble*.

IV. Art reveals how pedagogy moves beyond mere technical procedure. By dint of education's singularity, *pedagogy* provides an agôn, an opportunity for argument that stems from the recurrent moments of human expression in the moments of *information* and *infatuation*. Being coextensive and never deterministic, information and infatuation broadly explain how by its intimacy with knowledge and desire, pedagogy takes an immanent form.

Agnes and the Radio

An early-morning news programme comes on, but I am hardly able to make out the individual words and once again I fall asleep, so that the announcer's sentences merge into my dreams. It is the most beautiful part of sleep, the most delightful moment of the day: thanks to the radio I can savour drowsing and waking, that marvellous swinging between wakefulness and sleep which in itself is enough to keep us from regretting our birth. (Kundera 1991, p. 5)

One would assume that rather than morning languor, what keeps us from regretting our birth is the wakefulness of reason. At least when it comes to defining reality, we often take it for granted that our hopes are found in those moments of absolute clarity when we could say with some certainty that we could distinguish dream from reality.

Yet, in Kundera's story, this seems to be the reverse. Any solace from the limits of mortality has to come from a blurred feeling of suspension between dream and reality. In essaying on immortality, Kundera defers any temptation to resolve this feeling. In his enigmatic love towards a person who appears to be neither real nor fictitious, he refuses to set strict benchmarks for what may be a truth or simply a fallacious figment of the imagination: "And then the word Agnes entered my mind. Agnes. I had never known a woman by that name." (Kundera 1991, p. 4).

Agnes came to him by chance when he saw a middle-aged woman whose girlish gesture triggered in him the memory of someone who meant a lot to him. His mind came across meaning as an experience of the present. This presence was constantly prompted, if not haunted, by an unknown past. Although the contents of that past remain unknown, he knew they belonged to the past and not the present. The past was expressed by gestures made in the present. The gestures took the form of a particular smile and a specific signal expressed by the lady in a swimsuit. These acts of the present suspended Kundera's memory between the knowledge of someone's smile, and a human gesture that belonged to a 20-year-old woman.

At some stage, Kundera utters the name "Agnes." "Agnes" gives him the means by which he could participate once more in the wakefulness of reason. However, this wakefulness is peculiar to the radio and how the sounds it makes extend the suspended moment between dream and wakefulness. The radio may well have been transmitting the news, but this is irrelevant to the person who is waking up. The sounds of the radio signal the moment between reality and the dream, even when dream and reality are indistinguishable from mere sounds.

At this particular point, the idea of time (expressed by the news as well as the radio doubling as an alarm clock) is omitted from the normal perception of reality. Time seems to be suspended, and so are the limits set between birth and death. In this respect, our sense of mortality conjures a contradiction as if it were to borrow extra time in an imagined timeless zone. This is swiftly adjusted by the rational ways of our brain. However, it is easy to see why this suspension provides us with what Kundera (1991, p. 5) regards as a "marvellous swinging between wakefulness and sleep which in itself is enough to keep us from regretting our birth."

We may recall the ambiguity of a similar "swinging" sense in Thomas Nagel's claim that: "observed from without, human beings obviously have a natural lifespan and cannot live much longer than a hundred years. A man's sense of his own experience, on the other hand, does not embody

this idea of a natural limit. His existence defines for him an essentially open-ended possible future, containing the usual mixture of goods and evils that he has found so tolerable in the past," says Nagel.

> Having been gratuitously introduced to the world by a collection of natural, historical, and social accidents, he finds himself the subject of a *life*, with an indeterminate and not essentially limited future. (Nagel 1991, pp. 9–10)

Existence and Reality

Kundera takes advantage of this open-ended possible future. Actually, this possibility is not limited to the future, but has a lot to do with the experience that shapes the past. What is even more daring is that the suspension between wakefulness and sleep would suggest a way of defining the present—often regarded as a split-second trapped between the past and the future.

By taking advantage of the open-ended possibility of our own mortality, we seek to eliminate the distinction between *existence* and *reality*. If, for the sake of argument, one regards existence and reality as terms by which we could define a ground that stands "between" mortality and immortality, then to cover this ground—to travel *within* it—would also imply an ability to eliminate this distinction.

It is reasonable to expect that at some point in life one could get over the distinctions between one's immediate experience of life and the point where one gains a larger sense and understanding of the world. After all, if life is partly expressed by our own understanding of what the world throws at us in the form of a collection of natural, historical and social accidents, then why should we remain suspended between a sense of finitude and an ambition to universality? Even when we know that what informs our experience is only partial to what we know of *reality*, it is not outrageous to argue that we can go beyond our first-person experience of the world. In this way, we could assume a set of meanings that would transcend the subject-object divide.[5] While *existence* may well represent the starting point from where we constantly attempt to travel beyond the limits of space and time, reality represents the point where we know that humans could still imagine a world beyond their spatio-temporal *dialects*.

Rather than a constant drive of progress from the known to the unknown, this transit is more of a toing and froing. Far from an accident, this open-ended possibility provides us with a meeting place—and indeed

a ground—for learning. The movement from the *wished-for* to the *possible* and onto the *impossible* is an act of *pedagogy* where what we learn is not simply given to us by a body of knowledge, but it comes from the "accidental" ways by which we relate existence to reality.

Kundera's story could well provide us with a closer view of this meeting place. Here we find two senses to this movement: (a) the knowledge that comes from experience; and (b) the sense of self as it reacts to memory. In the first sense (a), the name Agnes stands for "a sense of being." One could term this sense as that of Agnes as *ontological information*. In the second instance (b), the individual discovers that memory defines the self by accidental moments such as a smile or a face. Though the incident is casual, the feeling is intense, and to that effect, it takes over one's line of reasoning. Here, the name Agnes becomes a moment of *pedagogical infatuation*.

Information and Infatuation

At face value, the link between ontological information and pedagogical infatuation could be dismissed as merely playful. With information dealing with knowledge and infatuation with a feeling verging on obsession, it seems more sensible to speak about pedagogical information than ontological infatuation. However, the suggestion of an infatuation that pertains to learning and information as a fact of being has to do with a link that could only be thinkable in the contexts that are initially presented to us by Kundera's story. But I would hasten to add that once we remember that these are not separate states of affairs, this *initial* connection does not fail to come into effect in our day-to-day contexts of learning and being—this time from outside a literary context like Kundera's.

In the *Concise Oxford Dictionary*, the fourth meaning given to the word "inform" is "impart its quality, to permeate." Given we do not have a word in English that integrates a rational assimilation of information with the rather sensual feeling of infatuation, the fourth meaning of *inform* begs a context that is other than that of attributing meaning to an object or situation. Here I am looking for a word that links *inform* with a quality that would transport an act (in this context, we are talking of a smile and a gesture) into the realms of the senses by other than reason. By itself, this *fact*—or better, this *act*—is neither tangible nor audible. It is a bit like a fragmentary moment of awareness. In Kundera's story, it is a moment represented by a vague recollection of a smile. The smile leads to a moment

of intense feeling. The smile informs the senses through a complex set of memories which, though vague, have an effect on one's entire being.

This kind of information is an ontological affair. The effect it has—what it *leads* to—is pedagogical. Admittedly, the notion of *pedagogical infatuation* is rather odd, but it does suggest something other than the common meanings of infatuation and pedagogy. When a passionate memory of a gesture and smile *leads* to a sense of being where meaning is just a hint of the double meaning of a name (Agnes), there is more than a story to be told. This information is *pedagogical* because it has to do with what the ancient Greeks meant by the word *ágo*, from where we get the word *pedagogy*. Amongst the variety of meanings of *ágo*, we have "to lead away, towards" and 'to conduct, convey, to take along'. *Ágo* also implies an act of directing. This is where pedagogy becomes an act of directing the youth—as *paedeia*. This notion of direction is also intended in terms of moving, passing and even marching.[6]

Kundera's encounter with immortality takes place in the past. Its truth is of a passionate kind. In this way, the encounter tries to outsmart time and takes on a concept of space that has nothing to do with actuality. This does not mean that his truth has no presence. To the contrary, Kundera liberates time from chronology and transforms it into *number*.

Here the sense of *number* needs qualification. It has a plural meaning in that it is both a sequential sense of "events" and also implies an incremental sense of the same "occurrences." *Event* and *occurrence* are often conflated in their different meaning(s) by the diversity of senses that *number* takes. However, it is also qualified in that what could have happened (in reality or in the mind, as a semblance or a desired effect) is either a cause for conjecture, or it gives way to an opportunity to play between what is real in the mind and what is existent out there—that is, real in the sense of it happening as a significant event (significant, that is, to the observer—Kundera), whereas it could only be mere existence in terms of its occurrence (which may or may not have any significance to the person being observed—Agnes).

One could imagine a notion of time that is not read in a sequential and numeric manner, where, as Bergson suggests, it is considered as duration. But Kundera does the opposite. He invests number with another kind of information. Numeric time becomes *infatuated*—more than *informed*—by a timeless sense of suspension. This invests number with the *a priori* mechanism of words (as we have seen in the analogies of *Lego* and *Scrabble*). Just as one could read number as words, one could rephrase

time in a sequence of words. This allows for the idea of time to become a movement that drifts between those conventions by which we understand the actual notion of time.

Pedagogy as Performance and Intention

John Searle argues that:

> In the ontological sense, 'objective' and 'subjective' are predicates of entities and types of entities, and they ascribe modes of existence. In their onto-logical sense, pains are subjective entities, because their mode of existence depends on being felt by subjects. But mountains, for example, in contrast to pains, are ontologically objective because their mode of existence is inde-pendent of any perceiver or any mental state. (Searle 1995, p. 8)

As a moment of ontological *information*, Agnes is the object. As peda-gogical *infatuation*, Agnes is the subject. As a pedagogic memory, Agnes is an awareness that is felt by subjects. As an objective moment, Agnes's objective being is informed subjectively (as information). If the relation-ship between subject and object were between two distinct states of affairs, the ontological condition of immortality (*qua* memory) would result in nonsense. This would also mean that knowledge and being would be sepa-rate moments, experienced by the person who has to relate to an exter-nalised (objective) process of learning where the person and the process of learning become separated. Also, memory would become schizophrenic, disconnecting possibility from truth.

This connectivity between dream and wakefulness, infatuation and information is by no means a given. The moment of Agnes in its two roles of being and knowledge emerges from a negotiation—and by no means a smooth transition—between truth and possibility. At the moment when the individual becomes conscious of both the radio and the act of wake-fulness, the weights of mortality and immortality reach full balance. If there was such an instrument which could gauge the equilibrium between mortality and immortality, where life is and is not real at the same time, we would be able to gauge learning at its fullest. We know, however, that this is impossible because one could never separate the person from the learn-ing experience, unless of course, we begin to understand how education is also characterised by the need to unlearn. This is what some theories

of knowledge and assessment fail to understand when they separate the person prior to learning and after the supposed moment of learning takes place. More so, in their obsession with learning as a unidirectional process, many fail to recognise that unlearning requires that we restore and regain the vernacular tools of conviviality.

As unlearning is consistently overruled by the need for measured and accountable grammars of learning, we have no such instrument. Thus we could only balance the objective with the subjective in the sense by which Searle explains our construction of reality. As in the relationship between information and infatuation, learning is an act where nothing in its objectivity could be possible unless it functions as subjectivity, and where conversely, no subjectivity could be true unless it were objectively placed. This is the basic nature of both knowledge and being, and unless learning is infatuated by knowledge and information permeated by being, there will be no way out of what would be later identified as the anomalous nature of education. This is another way to say that unless the pedagogy also includes those dialects of unlearning by which infatuation becomes a vehicle of information, then the dualism remains, and our education keeps missing its vernacular roots.

In the balance between drowsing and waking, Kundera's truth bears the name of Agnes. In Agnes the object-subject construct is expressed by a set of words whose form and meaning regard any distinction between reality and existence as irrelevant. The only way to immortality is found in the methods of mortality, by which pedagogy has nothing to lose but those misconceptions propagated by idealists and positivists alike.

One could even read this statement as a legitimisation of pedagogy, where the direction of life (as information-infatuation) constitutes the same immortal moment by which Socrates sought his death, and by which the Sheikh enjoyed a happy life in his amnesiac retirement.

To Socrates, the moment of learning is the moment of recollecting a body of knowledge invested in the soul before it was supposedly overwhelmed by the limited existence of the body. In this way, Socrates found a way out of the predicaments of mortality by regaling the soul with immortality while despising the body for its alleged misery. But unlike Socrates, we are not privileged by the certainty of theory. If we go by Kundera, memory gives us a sense of preservation: "enough to keep us from regretting our birth." (Kundera 1991, p. 5). The dream is an act of delectation, and we know its limits when we negotiate our ambitions

within the parameters of truth. A bit more like the Sheikh we have come to the conclusion that happiness pertains to the moment when we unlearn and direct ourselves to an objective world inter-subjectively. We also prefer to seek those moments by which we could entertain the idea of memory as a facilitator of truth as well as beauty.

This is where pedagogy starts to look like an activity that takes on two roles: *intentionality* and *performance*. We have seen how experiential knowledge and the memorial sense of self direct us to the mutual validation of information and infatuation. But this is not possible unless we frame learning in its two roles of performance and intention. As a pedagogical act, performance indicates a series of actions that are seen, understood and valued within specific contexts and conventions. As intention, pedagogy is a structure of conscious representations by which we construct reality in full engagement with the limits and contradictions of our mortal existence.

In its forms of representation, pedagogy as intention and performance extends the original ground of knowledge to open-ended possibilities. This positions learning and unlearning in a context of time that is similar to what we considered above: where we consciously play with the conventions of possibility while we remain objectively aware of the actual understanding of time and space. The open-ended nature of performance is related to that of learning as intentionality. Performance is itself intentional, and in this respect, it constructs reality by a conscious relationship with the limits that are set for us by mortality: "When I wake up, at almost half-past eight, I try to picture Agnes. She is lying, like myself, in a wide bed." (Kundera 1991, p. 7)

V. While as agôn pedagogy ties desire to knowledge, by its transitory nature, it moves into a third moment: that of the political. A split between *citizenhood* and *citizenship* challenges pedagogy as a political affair. As a schooled moment, *citizenhood* is set within a history of standardised monoliths. As we think of a counteroffensive, we await the praxis of citizenship, which is potentially realised through the singularity of education and the autonomy of art.

Promised: A Butcher's Apron

The drumming started in the cool of the evening, as if the dome of air were lightly hailed on. The drumming murmured from beneath the

drum. The drumming didn't murmur, rather hammered. Soundsmiths found a rhythm gradually. On the far bench of the hills tuns and ingots were being beaten thin. The hills were a bellied sound-box resonating, a low dyke against diurnal roar, a tidal wave that stayed, that still might open. Through red seas of July the Orange drummers led a chosen people through their dream. Dilations and engorgings, contrapuntal; slashers in shirt-sleeves, collared in the sunset, policemen flanking them like anthracite. The air grew dark, cloud-barred, a butcher's apron. The night hushed like a white-mothed reach of water, miles downstream from the battle, a skein of blood still lazing in the channel. ('July', in *Stations*, Heaney 1998, p. 84)

Here pedagogy confronts us by the harsh grit of its practice and definition. This reveals a third role for pedagogy—that of the *ágo* as an intransitive verb meaning 'to march, to move, to pass.' I choose to name the march as a pedagogic structure because it is no less different from the curricular march where the "chosen" are led to a meeting place where performance and intention engage with knowledge as a tool that *informs* and *infatuates*. In this context, information and infatuation move away from a personalised relationship between mortality and memory. As a third role of pedagogy, the march pertains to a meeting place by which we come to assert where we belong. In this respect, learning, performance and intention come to terms with belonging as a ground of citizenship where personal identity is defined by *the many*.

In the third role of pedagogy, performance and intention face up to the *polis*, the city that gives us our methods of governance. In this respect, pedagogy also stands for a polity that is prone to the myth of a "chosen" group whose job is to frame learning in a system of education with a specific objective: *citizenhood*. This starts to suggest education as an anomalous construct where belonging as an inclusion of identity is also an exclusion of those who are "not chosen." While in the avenues that run between information and infatuation, learning was allowed to negotiate fact and dream, it is not the case in the third moment of pedagogy. Here learning stumbles into a number of constraints. It has to face up to the responsibility of what could only be defined as a political struggle. In this state of affairs, negotiation is not a given, and more often than not, Agnes is no more because the radio and its drift between sleep and wakefulness are shattered by the drumming call to blind certainty.

In its third role, pedagogy takes two instances: the moment of the School, which then becomes the moment of the March. In the first instance, *citizenhood* (rather than *citizenship*) is an edifice where rights are set within a history of monoliths carved after phraseologies of "achievement," "standards" and "economic viability." This instance of educational citizenhood is no less a praxis of citizenship than a community of subjects willed to the monoliths of a political history that has hammered down the will to freedom into a certain rhythm, which Heaney tells us, beats ingots thin.

Learning as Dispute

Pedagogy presumes its ground as that of *agôn*.[7] *Agôn* is a meeting place (a form of inclusion) that brings together a number of actions pertaining to dispute (a form of exclusion) in terms of legality, struggle and (perhaps more importantly) argument.[8] It is interesting to note how the *agôn*, as a ground for argument and dispute, becomes a sign of education where another practice—that of the *curriculum*—recalls an arena of contest.[9] As a derivative of *curro*—a race—the word *curriculum* highlights the central polity of citizenship.

The marcher and the learner are the same individual who participates in the polity's edifice. This edifice highlights another side of education—that of the School, where the universality of knowledge is often measured against ideologies of merit rather than opportunity. I hasten to say that this reality is not something to be dismissed as some form of hegemony bequeathed by an established social class as a result of some political conspiracy. If the critique of education were to be limited to views of this kind, it would result in the same subjectivist assumptions by which learner-centred education became a surrogate of other ideological forms where a distorted, patronising view of opportunity wiped off any notion of merit. Merit and opportunity have to be alternative parts, and to that effect the anomalous reality of the third role of pedagogy must be seen in its legitimate contexts *where* and *how* citizens belong.

Citizens that belong have rights for themselves, as well as duties to other citizens, as well as non-citizens. This is where the Lego blocks of language—and of learning—are also contingent to the perusal of their effects. In the moment of citizenship, intention and performance are accountable to answer why immortality is an accident of a manufactured

universe. In the pedagogical construct of citizenhood, Kundera's dream is substituted by Heaney's nightmare, while Socrates and the Sheikh are visited by the grammar of finitude, where logic and memory are forced to abdicate from their immortal solace. Now learning dances with the method of drumming to a contrapuntal rhythm by which we construct our right to negotiate our everyday life in the knowledge that this is not as straight forward as we have been led to believe. Here the dialects of unlearning, by which citizens and non-citizens seek to belong beyond the claims of exclusive citizenhood, find themselves confronted by the grammars of learning that promise citizenhood to those who want to be included by excluding others.[10]

Passwords and Verbs

Back to the prospect of death, we know that like the quest for happiness, mortal finitude constantly reinvents the journey of life and its ever-changing end-objective (*telos*). But as an object of pedagogy, mortality is inversely constructed—as the *avoidance* of an end. Happiness reflects an ethics of avoidance where the construction of everyday life seeks the continuous avoidance of sorrow. The avoidance of sorrow reflects an understanding of being where possibility is not simply found or recognised—but continuously constructed.

Drumming the way for a "chosen" people also means the drumming away of the accidental situation that originally prompted the justification of aggression as a form of protection; arrogance as an attitude of philanthropy; and oppression as a justification of democracy. On this dialectical ground, we could assert our opposite world-outlooks as uttered in their diverse dialects. Like education, this dialectic has to balance performance and intention with the duties and rights of belonging. Education is not simply right or righteous. It emerges from the dispute between dialects and grammatical outlooks. The apparent righteousness by which education has been assumed as a *received* and easily *apprehended* universality is shown to be fallacious when one takes a closer look at the ethical and ontological spaces where individuals locate their notions of possibility. Whether possibility takes the form of power, happiness, knowledge, allegiance or any other teleological project, it remains an object of dispute, and to that effect, it is never given by some divine right or teleological certainty.

What beats ingots thin is not the violent and fearsome rhythm of the drummers, but their joyful ascendancy to a promise of happiness (without reminding us of the ethics of avoidance). This dilemma is characterised by Heaney's *Stations* where the harsh imperatives of belonging present us with a picture of happiness (as eudaimonic fulfilment), and where the marcher's certainty is invested in the butcher's apron. Far from a poetic turn of phrase, this depicts the inherent contradictions of belonging. In Heaney's example, we have the harsh demarcation of belonging which, in Northern Ireland, is more than an externalised political dispute.

Before the advent of unlearning (that was inaugurated by the 1994 Peace Process) enabled Republicans and Unionists to govern together a devolved Ulster, the learner-marcher had to wander in and out of the edifices of belonging. To the learner-marcher, belonging is externalised (by its periphery—figured as a wall), but at the same time it is internalised (by its enclosed spaces—illustrated by the analogy of the cloister). This is where the learner achieves the skills of the word, uttered in the form of passwords:

> I lodged with 'the enemies of Ulster', the scullions outside the walls. An adept at banter, I crossed the lines with carefully enunciated passwords, manned every speech with checkpoints and reported back to nobody. ('England's Difficulty', in Heaney 1998, p. 85)

The word is also written in verbs:

> In the study hall my hand was cold as a scribe's in winter. The supervisor rustled past, sibilant, vapouring into his breviary, his welted brogues unexpectedly secular under the soutane. Now I bisected the line AB, now found my foothold in a main verb in Livy. From my dormer after lights out I revisited the constellations and in the mourning broke the ice on an enamelled water-jug with exhilarated self-regard. ('Cloistered', in Heaney 1998, p. 89)

The borders of the agôn could never forestall the anomalies of belonging. In the same way, the agôn cannot turn the harsh reality of human dispute into a utopian vision of innate goodness or unforced freedom. As a third role of pedagogy, citizenship (away from the School's monolithic citizenhood) proves that intention and performance are not restricted to

closed and certain parameters. In Heaney's image of the polity, we are alerted to education's anomalous nature—where learning is a moment of citizenhood and unlearning begins to inaugurate that of citizenship. The learner-marchers may well form part of the serene teleology of Ulster's fundamentalist individualism. Likewise, they could be the rightful recipients of the Cloister's scholastic theocracy. But ultimately, the choices that are given to the learner-marchers inform the performance and intentions by which they are spared from regretting their being born into the very burgh by which they claim citizenship.

By passwords and verbs, the learner-marcher adopts the three roles of pedagogy as forms of life where one can imagine the positivist at dawn becoming the marcher at dusk, and where the scribe at Matins is a pagan at Compline. Here, the student of Livy becomes a mixture of a Protestant Orangeman and a Catholic Republican, whose secret life as a scribe vows a peculiar loyalty to the majesty of the inclusive-yet-exclusive walls, where Pope and Monarch are equal symbols of an outlook in constant struggle. These anomalies cannot be spared. Neither are they gratuitous.

PART 2. ART IS NOT EDUCATION

Hegel (1975, p. 9) confirms how "the work of art brings before us the eternal powers that govern history without [the] appendage of the immediate sensuous present and its unstable appearance." The case he makes for it is real inasmuch as this reality reflects and constructs a dialectical logic that augurs a degree of hope, over and beyond the contingency by which human beings do art, in its historical recognition of their limitations. Unless this is seen from the historicity by which art helps us articulate our plural contexts, the following will remain a case of metaphysical verbiage: "The hard shell of nature and the ordinary world make it more difficult for the spirit to penetrate through them to the Idea, than works of art do." (Hegel 1975, p. 9). Yet far from being simply an idealist, Hegel here values art beyond any other human action.

Marcuse further attests this when he states that "in various forms of mask and silence, the artistic universe is organized by the images of a life without fear—in mask and silence because art is without power to bring about this life, and even without power to represent it adequately." As a good student of Hegel, Marcuse knows that the reality by which we make

art is far more potent than the limitations by which we delineate philosophy or its linguistic limitations: "The more blatantly irrational the society becomes, the greater the rationality of the artistic universe." (Marcuse 2002, p. 243)

VI. As art's autonomy reveals its paradoxical nature, the fallacy of *education as a system of coherent necessities* is confirmed. Rather than invalidating education, this restores its singularity. Education cannot be gambled within the interstices of learning and unlearning. If, on the other hand, we were to regard education as that which counters the normalisation and desublimation of the world, then what emerges from the interstices of learning and unlearning is yet to be defined.

Like any teleological projection, education is countered by a number of what appear to be anomalies. This becomes acute in the relationship between art and education. In this relationship—with art as a form of unlearning—education oscillates in and out of a self-reflective process where it comes to the conclusion that it has none but one certainty: that art pedagogy is essentially a paradox.

Here I suggest that we take a closer look at art and how *it* speaks *about* (and *to*) the world. To do this effectively, we need to trace several arguments that emerge from aesthetics while following art's take, particularly in its distinction from those grounds where aesthetics would invariably be played. Just as art and education remain distinct, philosophy—being that by which we *do* aesthetics—should retain its own immanent autonomy.

In aesthetics, we come to terms with a state of affairs where the *grounds* of education are rendered irrelevant by an anomalous relationship between art as an autonomous construct and education as a formative device. This philosophical intervention continues to facilitate the approach where education as a *device* is seen for what it is in its instrumentality. At the same time, a philosophical approach allows us to make reference to the (often prevalent) idea of education as a teleological project, where formation is framed between an assumed point of departure or origin (*arkhé*) and a projected end (*telos*). Rather than turning philosophy into a mediational tool between art and education, here we have an opportunity to begin to map the convivial ways by which an argument

for art would not exclude an argument for education, while at the same time dismiss the argument that one should beget the other as if these human activities must be coextensive.

In this second part of this chapter, I am proposing that we get to the heart of this state of affairs by (a) establishing whether the relationship between art and education in effect portends a necessary anomaly and (b) showing that the only way education and art could be effective as autonomous states of affairs would be for them to act in recognition of this anomaly, while being regarded as separate domains.

Philosophy has taught us that *contingency* is not an arbitrary game. The accidental is not (as common parlance would put it) a particular state of affairs left to the mercy of chance. As necessity's *other*, the accidental pertains to particularity. By particularity, we also imply a singular set of events that have a bearing on the ways by which we universalise our experience of the world, and how we justify and explain it.

In line with how, in the first part of this chapter, we examined the fallacy of the subject-object divide, it is worth reiterating that what we tend to *explain* is not a mutually exclusive relation between an objective world and how we subjectively experience it. If explanations are meant to exhaust our questions about the world, then they must include subjective worlds and objective experiences, as well as the definition of the world as a form of experience that by itself and *protentively* (Schutz 1970, p. 137) purports an objective reality through forms of subjective perception.

If by art pedagogy's conscious recognition of paradox we come to reject the fallacy of education as a system of coherent necessities, and thereby assert education's singularity, then human responsibility would hold even higher stakes in terms of the decisions that society must take about education. I would argue that if educational discourses and their practices were to recognise and legitimise paradox, then arguments for education's autonomy would be even stronger than in the case of a system of education that is universally assumed as a schooled necessity.

By a conscious recognition of paradox, we mean that learning is recognised on the grounds of individual responsibility. As an individual concern, the particular is an object of a subject that is *conscious* of the world. While classical definitions of consciousness have often implied the need to act and change the world, what is here meant by consciousness has nothing to do with an assumed guarantee of progress or some illuminated path

to absolute truth. *Consciousness is aligned to the responsibility by which we presume an intentional relationship with the world as a polis that is conscious of its agonistic limitations.* As the world is an objective reality that includes us as individuals amongst the rest of humankind, the consciousness that makes us aware of this world is founded on the myriad contradictions that make this world, as expressed by the contingencies and interpretations that we have.

I hasten to add that this does not mean that reality "includes us" as if the *real* was an external being that moves us around at its own will. Rather, *we* continuously include reality in the overall construction of how *we* (as the human species) *see* ourselves as an integral part of an objective universe. Yet as we are here speaking about art, how we see ourselves in this reality takes an interesting turn.

Now if Marcuse (2002, p. 75) is right when he states that "artistic alienation is sublimation," and that this "creates the images of conditions which are irreconcilable with the established Reality Principle but which, as cultural images, become tolerable, even edifying and useful," then here we have yet another confirmation that art is a way of engaging the world by paradox and aporia. Yet, Marcuse also adds that "this imagery is invalidated" because the paradox was disentangled and normalised within a dialectic that renounced itself through permanent synthesis, and thereby a condition of *one dimensionality.* The incorporation of artistic alienation "into the kitchen, the office, the shop; its commercial release for business and fun is, in a sense, desublimation—replacing mediated by immediate gratification." Marcuse explains that "it is desublimation practiced from a 'position of strength' on the part of society, which can afford to grant more than before because its interests have become the innermost drives of its citizens, and because the joys which it grants promote social cohesion and contentment." (Marcuse 2002, p. 75).

So does this mean that all is lost and the world is doomed to eternal one dimensionality? Is art that weak that it can't sublimate anymore? Again, depending on how one reads Marcuse, the context is marked by unresolved contradictions: "The Pleasure Principle absorbs the Reality Principle; sexuality is liberated (or rather liberalized) in socially constructive forms." (Marcuse 2002, p. 75). Later he adds, "It appears that such repressive desublimation is indeed operative in the sexual sphere, and here, as in the desublimation of higher culture, it operates as the by-product of the social controls of technological reality, *which extend liberty while intensifying domination.*" (Marcuse 2002, p. 76 emphasis added).

The scenario being presented by Marcuse also needs to be read against what he says later on where he states that "the powerless, illusory truth of art (which has never been more powerless and more illusory than today, when it has become an omnipresent ingredient of the administered society) testifies to the validity of its images. The more blatantly irrational the society becomes, the greater the rationality of the artistic universe." (Marcuse 2002, p. 243). Rather than some kind of reprieve, this recalls what, in the first part of this chapter, is identified as the third role for pedagogy, denoting the stage that moves on from the agonistic condition of dispute to that of marching, moving and passing. Thus, while the first role of pedagogy denotes performance and intention as it engages with an ontology of *information*, this is confronted by a pedagogy of *infatuation*, where as discussed with Kundera's art in mind, learning begins to be replaced by a pursuit of what is here distinctly identified as the absorption of the Reality Principle by the Pleasure Principle.

From the position of art's engagement with education, this state of affairs begins to show that the model of learning as growth, understood from the argument of development and creativity, is made redundant. It seems that the need to sublimate becomes akin to that of intentionality by which mere experience is deemed *erratic*. To take this on board would also imply that we do not simply stake education within the interstices of learning and unlearning. This would not only become insufficient, but also pose a limit to the context where, as Marcuse put it, liberty is extended within an intensification of domination.

It seems to me, if we have to sustain the argument for consciousness as being akin to moments of liberation, then any central pedagogical character of consciousness to speak of must be made evident by an outright *refusal* of education as a teleological project. If, on the other hand, we were to regard education as that which counters the normalisation and desublimation of the world, then what emerges from the interstices of learning and unlearning is yet to be defined. For sure, what we must define is not whether we should sustain the notion of learning as a process of education—within or outwith the school—but where we begin when we speak of the urgency by which we could exit the one-dimensional conditions that have imprisoned us in the four walls of the polis. Thus, while it is evident that to eliminate paradox is to eliminate the case for learning, the case for learning itself risks becoming redundant by its inability to confront repressive desublimation.

VII. If art were a tool of mediation, it would be a mere semblance of freedom, thereby losing the ability to claim autonomy. When we speak of art's autonomy, we also mean that there is no such thing as a *return* to a unitary origin, or a *fulfilment* of a preordained end. Rather, art *emerges* and *approaches* the world as a *dialectical* state of affairs where firstly, as a making, it remains anomalous of a universal or foundational principle, and secondly, it rejects anything that appears to be given *a priori* in its form or content.

Pinter and Hegel

LENNY (…) Come on, be frank. What do you make of all this business of being and not-being?

TEDDY What do you make of it?

LENNY Well, for instance, take a table. Philosophically speaking. What is it?

TEDDY A table.

LENNY Ah. You meant it's nothing else but a table. Well, some people would envy your certainty, wouldn't they Joey? For instance, I've got a couple of friends of mine, we often sit round the Ritz Bar having a few liqueurs, and they're always saying things like that, you know, things like: Take a table, take it. All right, I say, *take* it, *take* a table, but once you've taken it, what you going to do with it? Once you've got hold of it, where you going to take it?

MAX You'd probably sell it.

LENNY You wouldn't get much for it.

JOEY Chop it for firewood.

(Lenny looks at him and laughs) (Harold Pinter (1999), *The Homecoming,* Act II, pp. 83–84.)

Where art breaches philosophy, freedom and truth are relayed to other manners, some of which might move into morality wearing the mask of deception, while others are distracted by elusion under the pretext of desire. Yet questions remain. What is bequeathed by philosophy in this case? Is this art's offering, which goes further than what philosophy could no longer bequeath? In Pinter, a dialogue about a table and legs has a way of becoming intimate, and begins to articulate a world of desire, as it manoeuvres itself into the sphere of manipulation, and a multiplicity of meanings intent to distract, but also to amplify the possibilities by which we present ourselves to each other as bodies with expression.

RUTH: Don't be too sure though. You've forgotten something. Look at me. I ... move my leg. That's all it is. But I wear ... underwear ... which moves with me ... it ... captures your attention. Perhaps you misinterpret. The action is simple. It's a leg ... moving. My lips move. Why don't you restrict ... your observations to that? Perhaps the fact that they move is more significant ... than the words which come through them. You must bear that ... possibility ... in mind. (*Silence*). (Pinter 1999, Act II, pp. 83–84)

While one could dismiss this dialogue as a sardonic commentary on a degenerated conversation by which people feel comfortable to speak at cross-purposes in order to hint what one may or may not intend to say, the point here is that speaking at cross-purposes implies a specific function of power. In this relationship, power emerges from the sheer relatedness of one person with another. Somehow, when one or two meet in anyone's name, there is a power relation that is slowly negotiated. Yet, in situations like these, there may be other implications, such as avoiding the question, or indeed detracting from having a conversation. If, as in this case, the excuse is that of being, then here we are not simply avoiding philosophy by posing a question of desire. Rather we are taking a philosophical question of being into the realms of desire because that is, ultimately, where it should be. In this way, the discussion is extended into a further field that appears to be unlinked, yet which has a sense of purpose in that it insist on being purposeless.

In Pinter, the dispassionate purpose of philosophy may have been botched. This recalls the issues that Socrates had with opinion and the deviation from an argument constructed on logical grounds. However, in Pinter's case, the dialogue does not go unlearnt or dutifully forgotten as in the case of Mahfouz's Sheikh, who seems to care no more for grammar. The way this discussion evolves invites us to move between boundaries. In this case, they are boundaries set between philosophy (via the question of being) and art (as something akin to the realm of desire qua sublimation). The reason for moving out of the realms of logic, grammar, learning or unlearning pertains to the fact that ultimately Pinter is an artist, and his work is following the opportunities that we take from making art, and by which we aim to alienate the real from its factual immediacy. Whether art falls squarely within the realms of desire is another question. However, there is always the temptation to argue that if art could easily manoeuvre itself within the realm of desire, then this carries us into the realms of aesthetics, where several educators would argue there is a case for *learning* to be made.

Whether it is legitimate or not to bring "back" art into learning or unlearning would pertain to a *nostalgic* question. By this, I mean that somehow art is often regarded as a form of return, a homecoming, indeed a nostalgic affair. To that effect, nostalgia is not simply a yearning for a memory, but a powerful move "back" to a presumed origin. In this respect, art is assumed as a form of transportation that carries back what has become unlikely to ever be able to return.

This desired assumption of a return is a fallacy. If anything, when art is prompted to articulate a sense of belonging, the outcomes clearly take an inverse direction where the return is made into a future, projecting the manufactured assumptions of what a homecoming could be or is desired to become. More so, this subverts the very notion of a reversed teleology by which some would want to believe that one could retrace one's being into a past. That is at best articulated as a mirage into a presumed future that will never happen. In this respect, a homecoming in art remains avant-nostalgic in that it speculates on what-is-yet-to-come through a constructed mirror of what-might-have-been.[11]

Through this mechanism, many have built a case on art which not only forecloses a return, but also reinforces the anomalous nature by which desire in art is aesthetically posed and pedagogically assumed. The false yearning of a return by which Odysseus partook of his ordeal in a journey that left him with nothing is instilled in us by the same sense of moral fatalism, by which we have taken religious figures and built entire institutions around them. As we continue to accede to such constructs, we struggle to make a case for art as homecoming, as indeed we make of art education a case for redemption when in effect we know that there is no such thing as a return to one's origin. If there is such a scenario as the promised land, then this must be stolen and taken away from those who are living there. For good reason, we invariably find that the results are not only problematic, but simply anathema—as indeed Pinter shows in this very work.

Thus before anyone breaks into song and begins to wax lyrical on the virtues of aesthetic education as a form of return to the idea and understanding of being, to begin to make a case for aesthetic education, one must take a very different route into an *aesthetic* narrative, which is underpinned by the impossibilities that prompt it.

The question thereby remains: would chopping a table for firewood ultimately articulate the sense of being by which we approach it, legs and all? The question is as comical as it is deceptive, in that it may well remain

immoral to some and pleasant to others. As an artist, Pinter's aim is to cast doubt on anything one could imagine. He has no answers because that would turn his work of art into a manual of instruction with answers and methods that one presumes to follow and understand. The philosophical trope of the table appears innocent enough until one starts speaking of underwear, until the suggestive language becomes desirable in what appears intimate yet even vulgar. The prudish would move away and find nothing aesthetical about suggestions like these. Yet the point is made from an equally aesthetic position. After all, desire is at the centre of the aesthetic value by which art gains its own specificity. What is anomalous is the projection of learning on it, as if it is meant to convey meaning or moral instruction against all odds.

Art's Logic of Emergence

Hegel argues that art reveals an interaction between freedom, truth and universality. In art, universality is actualised as freedom. Art "is the freedom of intellectual reflection which rescues itself from the *here* and now, called sensuous reality and finitude." (Hegel 1975, p. 8). In this respect, art mediates freedom with truth. But if we stop there, art remains instrumental, and by consequence what freedom it may reveal to us will remain limited. If we are satisfied with art as an instrument of mediation, art remains a semblance of freedom, but in effect it will be heteronomous, where it would simulate a virtual truth, and where it remains dependent on external needs that subject it to mediate, without the ability to claim autonomy. For art to emerge within what Hegel calls the Spirit—which even for us living in the twenty-first century would still denote a historical state of affairs by which human beings could lay claim to be true to their world—art cannot be reduced to an instrument.

To sustain its autonomy, art has to *emerge in* (and therefore *approach*) the world as a *dialectical* state of affairs. Art is dialectical in the sense that it mediates by negating an exclusivist notion of truth so it could expose the untrue. On its presumption of universality, art operates within the parameters of historical contingency, and thereby relates to the realms of the particular. It is free because its appearance within the Spirit happens by means of the sensuous unworthiness of matter. In the first place, art is a making, and to that material effect, it remains anomalous of the Spirit.

Hegel never attends to the anomalous in art in this way. His approach to it as a making is always enhanced by the assumption that it would sub-

late its material and contingent limitations. Hegel's mechanisms of negation are not equivalent to anomaly. Hegel's dialectic is animated by the desire to reach a resolution, a judgemental notion that is never "deferred to infinity," as he would say of Kant's noumenal wildcard. Even when the logic of the dialectic is assumed within concrete and historical conflicts that could be identified with forms of negation, Hegel holds fast to a mechanism by which conflict is elevated into a state of affairs that ultimately contains negation within rational assumptions.

So in constructing his defence for art, Hegel adds that in terms of the unease by which art's mediation is seen as less worthy, and in terms of "the *element* of art in general, namely its pure appearance and *deceptions*," such unworthiness would hold only "if pure appearance could be claimed as something wrong." "But," he argues, "appearance itself is essential to essence. Truth would not be truth if it did not show itself and appear, if it were not truth *for* someone and *for* itself, as well as for the spirit in general too." This resolves the initial argument for art as actuality where "only beyond the immediacy of feeling and external objects is genuine actuality to be found." (Hegel 1975, p. 8).

Hegel's case for art is that it mediates between the immediacy of the particular and the permanence of the universal. However, this is neither straight forward, nor does it presume some teleological form of ascendancy. Art's emergence is not identitarian in form, nor does it strive to prove or sustain anything *a priori* in its content. Though Hegel remains an idealist, and to that extent, his logic is based on presumed outcomes rather than causal chains, his process retains a high degree of speculation. This means that although history throws at us a degree of uncertainty in terms of the outcomes that emerge from their historical contingencies, ultimately with art being a human activity, it seeks to move beyond the circumstantial limitations that mark its origin.

In Hegelian terms, to state that art's dialectical logic remains speculative means that while the first argument for art is that of beauty, which in nature is excluded from scientific precision, in art this limitation must be taken into consideration if it is to compensate by way of its mediation. As it is human (rather than natural), art signifies beauty by making it specific, and thus raises its stakes above nature. For Hegel, beauty in art stands above nature because it is born of the Spirit (1975, p. 1). He argues that formally every human notion, even a useless one, is "higher than any product of nature, *because in such a notion spirituality and freedom are always present*." (1975, p. 2, emphasis added). The spiritual is self-conscious and intelligent where freedom is true to itself. We must

keep in mind that this state of affairs emerges within human consciousness and human freedom. Spirit belongs to human spirituality, which is freedom and intelligence. Hegel's philosophy never leaves this earth: "taken by itself, a natural existent like the sun, is indifferent, not free and self-conscious in itself." (1975, p. 2). In other words, the sun is neither intelligent nor free, but humans are. Spirit denotes the free and the intelligent absolute of the human world.

By the same argument, art's universality cannot be real unless it transpires from the makings of particularity and individuality. Hegel's logic is triangulated. Art as a human making is free and intelligent, and its logic is signified by aesthetics, "the spacious realm of the beautiful" whose province is art (1975, p. 1). So the story goes that "art liberates the true content of phenomena from the pure appearance and deception of this bad, transitory world, and gives them a higher actuality, born of the spirit." (Hegel 1975, p. 9).

What makes this a logical possibility is not the speculative nature of the Idea—as the aspiration towards free and intelligent reality, constructed, as it were, on the assumptions of a salutary dialectic by which the Spirit expands and realises itself. Ultimately, the Hegelian aspiration is borne out of the Enlightenment's desire to reconcile philosophy with science. Accordingly, Hegel's philosophy holds an aspiration for political coherence. To this effect, he wagers logical possibility on a more "tangible" terrain—that of individuality, where the problem of mediation as subservient to the true and the universal is reclaimed as a self-subsisting ground where reflection becomes a mechanism of mutual otherness.

Within the polity of a dialectical logic like Hegel's, individuality stands for "the reflection-into-self of the specific characters of universality and particularity." This unity is a "negative self-unity" that holds "complete and original determinateness, without any loss to its self-identity or universality." (Hegel 1989, §163, p. 226). It is a given of any dialectical structure that it has to be a self-sustained structure, and individuality ultimately provides the means for a dialectical logic to function as such. But it is also a given of any dialectical structure that freedom and intelligence would subsist as forms of negation—in other words as a rupture, or dislocation, or indeed a violence by which any *elevation* or *sublation* of the particular to the universal would happen. This comes at a price. For negation to be subsistent of freedom and intelligence, it cannot result in a mechanism of positive sameness, where antinomies are merely posited. This is where Kierkegaard, (and much later) Adorno, take exception to Hegel.

Impossible Imputation(s)

Before we forget where we left with Pinter, it is worth recalling that then philosophy was never the handmaid of an artistic manual, nor was art expected to move within the travails of the philosophical. In this respect, rather than a parting of ways, there remains a specificity by which art, even when endowed with such mediational powers given it by Hegel, has the choice to refuse—indeed renounce—this claim, while it sustains its dialectical logic by dint of the autonomy which, in effect, Hegel and Pinter both give art. The distinction by which philosophical assumptions begin to partake of an artistic function is never denied to those philosophers who seek to find ways out of what they would regard as a *system*.

Unlike Marx's claim that Hegel was standing on his head, Kierkegaard and Adorno's exception to Hegel's triangulated world is far more aggressive, and to an extent, it is such because they seem to partake of art's *gran rifiuto*, which in its original case—that of Dante's—presumed what was then considered to be the worst refusal that an anointed Vicar of Christ could do: abdicate from the throne of Peter.[12]

In their refutation, Adorno and Kierkegaard take on the dialectic, which in their minds should carry the speculative premise to the absolute consequence of negation rather than find a positive resolution in some external process such as the State or the Monarchy. In terms of art, this has even more drastic effects, as art's dialectical logic moves from being crucial to its mediational role to becoming critical in its assumption of its inherent paradox.

If art has to reveal freedom and truth by the mechanisms of a self-subsistent individuality, it would also warrant that individuality emerges as a non-identical self. Because Hegel cannot but take art's emergence into the realms of history (because its aesthetic mission must always partake of history through the emergence of the Spirit), art as a making must also hold individuality as a repository of the will where *to make* implies *the will to make*. After all, intelligence implies a will for self-consciousness, and a will to freedom is intelligent by means of the *dynamic* that moves the potential towards the act. Hegel takes care of this dynamic by operating it as negation.

This leads us to the path where, with respect to the logic of negation for the self to subsist, its relationship with both form and essence becomes

anomalous by necessity. This is because if, in its "deepest interests of mankind, and the most comprehensive truths of the spirit," art comes to express the *Divine* by placing itself "in the same sphere as religion and philosophy," then its outcome will be more akin to sin than to virtue (Hegel 1975, p. 7). For art to reveal truth and freedom by the manner of individuality—where "negative self-unity has complete and original determinateness, without any loss to its self-identity or universality" (Hegel 1975, p. 7)—it cannot avoid sin. Kierkegaard presents sin in the following quandary:

> Sin is this: before God, *or with the conception of* God, to be *in despair at not willing to be oneself, or in despair at willing to be oneself.* Thus sin is potentiated weakness or potentiated defiance: sin is the potentiation of despair. The point upon which the emphasis rests is before God, or the fact that the conception of God is involved; the factor which dialectically, ethically, religiously, makes 'qualified' despair (to use a juridical term) synonymous with sin is the conception of God. (Kierkegaard 1974, p. 227)

To live with this quandary, seeking not to avoid sin (without necessarily seeking it), while refusing to be in despair (even when, ultimately sin equates itself with "the conception of God"), we need some *pragmatic* handles. Assuming that art is an intelligent action, one could argue that art signifies unity by ways of a voluntary and somewhat aggressive form of estrangement. Art negates itself as a universal language because of its speciality, but in being special it reflects *unto itself* other grammars that equally claim to be either (a) universal to the conventions of all species, or (b) peculiar to the conventions of a defined genus, or (c) both at the same time. In other words, the quandary of sin is "neatly" avoided.

The Hegelian argument implies that art asserts itself as necessary. In line with the grammar of self-subsistence, art has to breach the here and now by self-reciprocation where the elevation of peculiar existence to universal reality is made possible. For Hegel, "pure self-reciprocation is (...) Necessity unveiled or realized." (Hegel 1989, §157, p. 219). After Wittgenstein, we assume this as a tautological proposition. After Kant, we would still identify this state of affairs as antinomical, especially if we want to keep our focus on the necessary transgression of the dialectic.

Likewise, we would contend with Lyotard (1988) that this state of affairs resides within the labyrinth of the *différend*, as it seems difficult for it to impute itself for the breach of self-reciprocation when to do so art needs to negate itself as art—after which there will be nothing to impute. Again the avoidance of sin comes true by sidestepping it through the aporetic nature of both the argument and the sheer matter of an act being (qua *becoming*) art.

Yet for Hegel, necessity is one step in the ascendancy (the emergence) to the concreteness of the Notion. What mediates this ascendancy is Freedom as "the truth of necessity," while in turn, the Notion as "the truth of substance" presents "an independence which, though self-repulsive into distinct independent elements, yet in that repulsion is self-identical, and in the movement of reciprocity still at home and conversant only with itself." (Hegel 1989, §158, p. 220). In its concreteness, the Notion subsumes everything else by necessity, and this is where Hegel's measure of truth arises as tautology—at least as we now understand art in its particularity, whereby its emergence is only understood and assumed through its historical contingency.

But Hegel sees no problem in this because the ultimate mediating moment would be an individuality that sits between contingency and necessity. This seems to operate as the grand mediator, the Notion, which "is concrete out and out: because the negative unity with itself, as characterization pure and entire, which is individuality, is just what constitutes its self-relation, its universality" (Hegel 1989, §158, p. 220). Yet Hegel sees in this an antinomy that has to be resolved. But he also concedes that "the functions or 'moments' of the notion are to this extent indissoluble" while "the categories of 'reflection' are expected to be severally apprehended and separately accepted as current, apart from their opposites." (Hegel 1989, §164, p. 228). As expected, Hegel seeks to resolve the argument by triangulating identity, difference and ground: "Universality, particularity, and individuality are, taken in the abstract, the same as identity, difference, and ground. But the universal is self-identical, with express qualification, that it simultaneously contains the particular and the individual." (Hegel 1989, §164, pp. 228–229).

This indicates the limits of Hegel's system, as a system whose ambition was to do away with any concept of limitation, let alone contingency. Somehow the crux of his triangulation remains a notion of individuality which, according to him, "must be understood to be a subject or substratum, which involves the genus and species in itself and possesses a substan-

tial existence." Here one finds no separation, but an "explicit or realized inseparability of the functions of the notion in their difference." (Hegel 1989, §164, pp. 228–229).

VIII. We speak of art's autonomy in its *emergence* because as we describe art, we describe ourselves. As an attribute of life and art, colour is one of the cases by which we make the world. In turn, to speak of colour is to say something about the words by which we name the world. To name is to reveal a law. When women and men become artists, they confirm that art is a form of life, often described through the use of language-games. As descriptions and games imply a law, they emerge from negotiations between human beings. The law— whether negotiated in a language-game, or accepted as *given* prior to any experience—must not only appear and emerge from its acts of mixing contexts and forms, but also allow us to affirm the plural nature of individual definitions by which art engages with the world.

If art is to reveal the interaction between freedom, truth and universality because of its power to penetrate into the "hard shell of nature and the ordinary world," (Hegel 1975, p. 9) then it has two alternatives: (a) As an expression of individuality, art could *enclose* the difference between the *dialects* of the particular and the *lingua franca* of the universal by *foreclosing* negation by means of itself—where the Notion's triangulation of identity, difference and ground is retained as equilateral; (b) Alternatively, art recognises *dialect* and *lingua franca* on the first level (which did not satisfy Hegel), where identity, difference and ground are "severally apprehended and separately accepted as current." (Hegel 1989 §164, p. 228). This condition will approximate what Lyotard terms as the *différend*, which is "a case of conflict, between (at least) two parties, that cannot be equitably resolved for lack of a rule of judgement applicable to both arguments." (Lyotard 1988, p. xi).

In this respect, we need to look at art from *outside*, from those externalities that are attributed to art, as they appear to belong to art. Here I have in mind two major attributes by which we approach art from outside. The first is *colour*, as assumed in its physical and phenomenological definitions. The second is the *name* by which we assume art to have an inherent law, and to which it is often held to account particularly when art is regarded, as in this chapter, as being autonomous in import, relation and modality.

Yellow, Blue and God

Considered in a general point of view, colour is determined towards one of two sides. It thus presents a contrast which we call a polarity, and which we may fitly designate by the expressions *plus* and *minus.*

Plus	Minus
Yellow	Blue
Action	Negation
Light	Shadow
Brightness	Darkness
Force	Weakness
Warmth	Coldness
Proximity	Distance
Repulsion	Attraction
Affinity with acids	Affinity with alkalis

— Johann Wolfgang Goethe (1987, §696, p. 276), *Theory of Colours.*

Goethe's world of colours is that of an optimist. It nurtures freedom and hope. It is a world of promise. It pursues an idea of totality only to value and enhance the plurality of detail. It upholds minute observable detail, yet it never becomes fragmentary. Goethe's *Theory of Colours* has its origin in the disposition of a man of method and science. Given Newton's scientific explanations, there is no doubt that Goethe gets the science of colour wrong. However, his mistakes are neither false nor deceitful. Though his conclusions are scientifically wrong, his conviction that men and women are the first measure of scientific truth retains solid veracity. In Goethe's world, theory is primarily human. For him, the exact sciences come second to the exactness of human measure—which leaves us to conclude that his take on colour is markedly phenomenological.

Goethe places no limits on his intent to enlighten human reason by its possibilities. He makes no compromise even when it becomes clear that the scientific truth of colour was in Newton's gift, not his. As Wittgenstein (1990) put it, Goethe's theory "has not proved to be an unsatisfactory theory, rather it really isn't a theory at all. Nothing can be predicted with it." (I, §70, p. 11). Somehow, the feeling is that his project is a conceptual process with which human perception comes to terms with being

as a whole. Goethe's language speaks to the whole person and avoids essentialism. His narrative wishes for a special place where representation is considered a privilege of the human imaginary. As he put it to Zelter, by making use of its sound senses, the human *per se* is "the finest and most exact physical tool" that one could find. Conceding that there are limits and that "there is a lot that cannot be measured" and which cannot be determined by experimentation, Goethe argues that human beings hold a higher position than any experiment or measure. "In all its mechanical subdivisions," Goethe tells Zelter, "what is a string to the musician's ear? Indeed, one could ask: what are all of nature's elementary phenomena with respect to man who has to chain and modify them in order to assimilate them?" (Goethe, cited in Lukács 1971, pp. 130–131).

Music is not calculable by the perfection of an electronic tuner or a metronome's accuracy. Even when pitch and rhythm are essential to music, an assumption made on the grounds of their measure will not tell us much about the performance of a Brahms, let alone a Stockhausen. What Goethe considers as paramount is not the external precision of a tuner or metronome, but the aesthetic comprehension of music as a human form of being. Likewise, colour is a concept of being, not a natural element handed down to us by prismatic calculation.

Wittgenstein argues, "Someone who agrees with Goethe believes that Goethe correctly recognized the *nature* of colour. And nature here is not what results from experiments, but it lies in the concept of colour." (Wittgenstein 1990, I §71, p. 12). Like sound and the musician, colour and human beings operate on the development of concepts by which the case of the world—which constitutes the facts of human life and history— are lived and understood. At least that is Goethe's implication when he goes at length to draw out the pedagogical implications of colour in their moral and philosophical associations.

> When the distinction of yellow and blue is duly comprehended, and especially the augmentation into red, by means of which the opposite qualities tend towards each other and become united in a third; then, certainly, an especially mysterious interpretation will suggest itself, since a spiritual meaning may be connected with these facts; and when we find two separate principles producing green on the one hand and red in their intenser state, we can hardly refrain from thinking in the first case on the earthly, in the last on the heavenly, generation of the Elohim. (Goethe 1987, §919, p. 352)

Yellow and Blue, in their mutual saturation, augment to red to complete the triad of primary colours. This is a simple mutual relationship where yellow and blue's respective addition and subtraction complement action with negation, light with shadow, proximity with distance, repulsion with attraction ... and so on. It is a basic notion, similar to the principles by which God was fashioned in the Judeo-Christian universe. Order and disorder become Elohim in their mutual relationship.

In Goethe, the notion of the universe's chromatic harmony has some lasting roles to play. Though similar to Dionysius, the Aeropagite's quest for the harmony of the universe (and God)[13], Goethe goes beyond some poetic formula. Goethe's science is authentic in that it appreciates a universe where the complementary behaviour of colour rests deep within the mechanism of the signs and symbols by which human beings have developed a language of colour. Wittgenstein takes Goethe's opposition to the mathematical exteriorisation of colour beyond humanist poetics and back into the realms of language's *logic of the possible* as distanced from the presumed certainties of the *logic of the case*.[14]

> One thing is irrefutably clear to Goethe: no lightness can come out of darkness—just as more and more shadows do not produce light. —This could be expressed as follows: we may call lilac a reddish-whitish-blue or brown a blackish-reddish-yellow—but we *cannot* call a white a yellowish-reddish-greenish-blue, or the like. And *that* is something that experiments with the spectrum neither confirm nor refute. It would, however, also be wrong to say, 'Just look at the colours in nature and you will see that it is so'. For looking does not teach us anything about the concepts of colours. (Wittgenstein 1990, I §73, p. 12)

In *Goethe and The Scientific Tradition*, Nisbet (1972, p. 74) argues that "it is futile to clamour for the reinstatement of ideas which have been conclusively refuted by subsequent research, and many of which (...) were not in any case original to Goethe." This conforms, somehow with Wittgenstein, when he argues that, "a construct may in turn teach us something about the way we in fact use the *word*." (1990, I §4, p. 2, added emphasis). Just as the construct of a theory of colour has a lot to say about words (and how we verbalise our perceptions), in reading Goethe's observation (in parallel to Wittgenstein's remarks), one has something to say about the *word* itself. In saying something about the word *per se*, we also have something to say about the word as a *name* by presuming a wider context for a *law*.

To Mix

Note Wittgenstein's parenthesis after the word "mixing" in the following:

> People might have the concept of intermediary colours or mixed colours even if they never produced colours by mixing (*in whatever sense*). Their language-games might only have to do with looking for or selecting already existing intermediary or blended colours. (Wittgenstein 1990, I §8, p. 3 emphasis added)

The phrase "in whatever sense" brings up the question "In what sense?" This question might begin to explain why the philosopher puts *sense* in parenthesis. Sense is implied in its plurality, that is, as a number of *senses*. Sense also implies intention. "In whatever sense" may also mean "whatever the intention of *mixing* may be" or "whatever the act of *mixing* may mean to *us*."

In trying to find a meaning for *sense*, one finds that "in whatever sense" could imply a number of meanings: (a) mixing as an act; *fusion*; (b) mixing as action; with a brush or spatula on a palette; or with a stick in a pot; (c) mixing (as in *entangling*) the meanings of colours; (d) mixing as in *blending* one colour with another; and (e) mixing as in *mix-up*, or *confusion*.

This raises a further question: How would *sense* explain intention and the act of mixing? Which brings us to the definition of our perception in terms of the words we use and in the same way art is verbalised in its various contexts—philosophical, aesthetic, pedagogical or even political.

One objection could claim that this analytic approach adds nothing to the theory or the aesthetics of colour, and less so to our understanding of art. Wittgenstein defined the *nature* of colour in Goethe as "the *concept* of colour." As a concept, colour is transformed from a category of science to a category of discourse as a narrative about language, its actions, its makings and the rules it sets for practice.

Elsewhere, Wittgenstein makes a distinction between *red* (or *blue*, or *yellow* …) as a proper concept and *colour* as a pseudo-concept. This follows the distinction he makes between "what is the case" and "what is possible." "Grammar is not the expression of what is the case but of what is possible. There is a sense therefore in which possibility is logical form." (Wittgenstein 1980, p. 10). He goes on to argue that "there are no logical concepts, such for example as 'thing,' 'complex' or 'number'. Such

terms are expressions of logical forms, not concepts." (ibid.). By drawing examples from colour further on, the distinction between logical forms and concepts becomes clearer:

> 'Primary colour' and 'colour' are pseudo-concepts. It is nonsense to say 'Red is a colour', and to say 'There are four primary colours' is the same as to say 'There are red, blue, green and yellow'. The pseudo-concept (colour) draws a boundary *of* language, the concept proper (red) draws a boundary *in* language. (Wittgenstein 1980, pp. 10–11.)

I would suggest that as logical form, the possibility of colour (as red, blue, yellow ... etc.) goes beyond the case by which "colour" is externalised into a pseudo-concept. As a proper concept, the expression of what is possible is returned to grammar.[15] As an act of *mixing,* colour is regarded in the sense of this very important distinction between a proper concept and a concept that may or may not inform colour *per se.* I would suggest that this distinction remains irrelevant outside the boundaries of philosophy, unless colour is recognised by a number of language-games. As a language-game, the mixing of colour implies a diversity of applications. Mixing colour becomes perception, as well as interaction, having concepts, seeing difference and in turn defining the grammars of seeing. In defining the application of colour as a continuous negotiation of this diversity, a child who is mixing colour in school would not only mix hues for her picture, but also construct a concept for life.

Like the child's mixing of paints, there is an artist who is mixing colour in her studio. But does the artist mix colour on the palette in the same way a decorator would mix colour in the pot? If the answer is in the affirmative, then we must ask "How?" If the answer is "No," then one needs to establish "Why?" Science in Newtonian terms is unable to answer these questions. According to Wittgenstein, neither does Goethe's theory of colour would be able to do so because in speaking of the character of a colour, one thinks "of just *one* particular way it is used." (Wittgenstein 1990, I §73, p. 12).

The individual nature of colour as a proper concept would have many answers. In establishing the role of colour, the act of mixing colour (in its various meanings) has to be read in the *intentional* contexts of the construct and application of colour. Once intention becomes the convention for the concept of colour, a further question would arise: Does "mixing" as a language-game imply the *subject* (i.e. the agency of *seeing* a colour)

in the same ways Goethe argues with regard to the physiological aspect of colour? Here Goethe seems to have an answer: "We naturally place these [physiological] colours first, because they belong altogether, or in a great degree, to the subject—to the eye itself." (Goethe 1987, §1).

To Appear

In thinking "of just *one* particular way it is used" (Wittgenstein 1990, I §73, p. 12), the conventions behind the intention that we put to words in the sense by which we qualify the mixing of colour must revisit this idea of the subject. If we do not consider how the eye (as the subject) *presents* us with a particular way we use colour, the notion of colour falls back on being an externalised pseudo-concept. Yet colour as a language-game implies more than one subject. This is because when insisting (as in the particular case of mixing) that colour is a phenomenon—that is, an *appearance* that we tend to *see* from within—we have to account for the discussions raised by the subject-object.

We must ask further questions, such as: Does "mixing" imply a social form of definition? Is "mixing" a cultural language? Is "mixing" an aesthetic judgement? Is "mixing" political? Is "mixing" scientific? Is "mixing" an ethical phrase? (… and so on.). As a way of understanding these questions, I suggest that we consider two models of explanation: (a) Goethe's reference to what he calls the ur-phenomenon with respect to his theory of colour; and (b) Wittgenstein's colour-blind tribe.

Nisbet (1972, p. 36) defines Goethe's ur-phenomenon as that "under which the quality common to all instances under investigation is revealed in an unusually striking fashion." In the *Theory of Colours*, Goethe defines ur-phenomena as "primordial phenomena, because nothing appreciable by the senses lies beyond them." However, Goethe argues that this gives ur-phenomena a vantage point in that "they are perfectly fit to be considered as a fixed point to which we first ascended, step by step, and from which we may, in like manner, descend to the commonest case of everyday experience." (Goethe 1987, §175, pp. 71–72).

Goethe's reference to ur-phenomena, as a possible approach to a subjective explanation of atmospheric colours, confirms his refusal to reduce his definition of colours to a particularity without context. In view of his method of analogical inquiry, one is not surprised to find how Goethe weaves the concept of colour as a particular form into a Leibnizian chain. In this methodology, "observers of nature will carry such researches fur-

ther, and accustom themselves to trace and explain the various appearances which present themselves in every-day experience on the same principle." (Goethe 1987, §173, p. 71). Note how the method pertains to *tracing* and *explaining* a number of appearances by which one would then ascertain how a chain of other appearances (phenomena) come together and inform our everyday experience. Goethe's aim is to explain the "most splendid instances of atmospheric appearances" in the vivid terms of the origin of this chain of appearances.

In its emergence into being and knowledge, the subject is the beholder of these appearances, as the eye is the beholder of colour. If we were to deduce a pedagogical mechanism by which ur-phenomena would provide us with a ground for the gradual construction of knowledge, one could argue that this process of learning is entirely alien to a reductionist process of elimination or selection. Goethe's ur-phenomena highlight an entelecheic chain that moves from possibility towards its fulfilment. This process also recalls the Aristotelian distinction between passive imitation and active representation.

Ur-phenomena bring actuality to representation and by participating in (and thus empowering) the domains of the subject, they mediate (and bring) potentiality to its fruition. In this way, the subject moves away from beholding colour as a particular, and assumes it within a chain of phenomena that give colour individuality.

Turning to Wittgenstein's model of inquiry, one finds that intention *as* individuality moves intention by means of a universal convention, which has nothing to do with Goethe's phenomenal chain, even if in some ways it appears similar in its implications.

> Imagine a *tribe* of colour-blind people, and there could easily be one. They would not have the same colour concepts as we do. For even assuming they speak, e.g. English, and thus have all the English colour words, they would still use them differently than we do and would *learn* their use differently. Or if they have a foreign language, it would be difficult for us to translate their colour words into ours. (Wittgenstein 1990, I §13, p. 4)

The colour-blind tribe begins to confirm that there is "no *commonly* accepted criterion for what is a colour, unless it is one of our colours." (Wittgenstein 1990, I §14, p. 4). This runs contrary to Goethe's method of analogy and brings this issue to a sharp edge, which brings

Wittgenstein to the now-famous conclusion that "There is no such thing as phenomenology, but there are indeed phenomenological problems." (1990, I §53, p. 9).

Then again, away from Goethe and Wittgenstein, the poet has a very different approach to such questions. George Seferis concludes his poem "Rocket" with a decision:

> I can't live
> only with peacocks,
> nor travel always
> in the mermaid's eyes. (Seferis 1981, p. 475)

Seferis's decision is sharp and categorical. The sense with which a mermaid's eyelids conceal "a thousand antennae" to "grope giddily" and "to find the sky" has another sense of mixing. In this case, metaphor blends with reality, exactness becomes one with possibility and the determined is confused with the *what-might-be*. Beyond Wittgenstein or Goethe's philosophical limits, Seferis's poetics yield to their own poetic instinct: like the mermaid's eyes, the colours of the peacock are sonorous and harmonious. They are possibilities of certainties. But they could never become hard fast possibilities because contrary to customary belief, poetry never nurtures nonsense.

Names

His three [distinct] names are so particular to him. The first one (by which he was registered) is Guido di Pietro: affectionately called Guidolino. (Was this given to him because as a child he was small and rather frail? For similar reasons one of his religious Fathers, the Dominican Pierozzi Antonio, became Antonino, and then Sant'Antonino).

He took his second name, Giovanni da Fiesole, when he entered the religious order: probably, with the known intention to honour another of his religious Fathers, the Dominican Giovanni Dominici; (...)

These two names belong to his [personal] history; but the third, Beato Angelico, was given to him, during and after his life-time, by his popular legend. It is no coincidence that it is by this name that he is familiar to the world.

— Elsa Morante (1970, p. 5), *Il beato propagandista del Paradiso* (Heaven's holy propagandist)

A common misconception about naming often assumes that names are given and received, but never assumed by those who are named. To name is to objectify what is being named. Elohim, Hashem or Yahweh are names given to "He who is never named," the God of the three Abrahamic faiths.[16] There is a negotiation between human will and theological definition in the process of naming a holy entity such as God. How could the creator's name—that is, define, let alone make—their Creator? Vico (1998) tells us that epistemologically this is impossible, as what we name or indeed define and know is what we make. Thus a name becomes a case if one assumes that it is normally received, but never presumed by whoever bears it.

Fra Angelico was an image-giver who used colour *ontologically*, by a way of *being*. As in ways of doing, in art, ways of being hold no mysteries, especially when one takes on what is understood to be an artist. Being an artist implies the act of using colour as a form of life. To say that colour is a form of life is to make a concrete statement as saying that art is a way of being. Colour is a form of life because for artists colour belongs to those ways to *doing* art. *Doing* art bears a heavier significance than making (as in *manufacturing*) art. Fra Angelico was an artist because his way of life was intimately articulated by art. Being a Dominican, and therefore a mendicant friar, Fra Angelico's being an artist was part of formation sustained by a call, or vocation, which reflected a theological choice. Just as being a member of a religious Order like that of the Mendicants[17] meant *living* a life of poverty together with most of the people who either begged or lived a life of subsistence, so being an artist meant that one's form of life *subsists* on divine providence and a full engagement with the world through prayer. Prayer remains key to Fra Angelico's works of art. They are an engagement with colour, as well as light, and all those forms of appearance that together would make a phenomenological chain that we now call "art."

Fra Angelico gave the secular world (from within his mendicant life) an image of heaven. His heaven was absolved from a fixed form. This happened on two planes: *theologically* by means of his depiction of Divine Grace, and *artistically* by means of the fluidity of light. Fra Angelico reclaimed the humanism of space from the flatness of a monistic theocracy. As a mendicant, he also brought his faith closer to the people, whose life also followed a mendicant lifestyle.[18] He propagated the sanctity of human history and painted its stories for the contemplation of an ultimate form

of salvation. In his work, redemption emerged from the concepts of light and colour, only to be returned to the aspirations of human beings (saints and sinners alike).

In his art, Fra Angelico appropriated the manner of naming for himself. His was a process that, like most artists', settled its own meanings with the possibilities of the phenomena of a spiritual order where a number of names would facilitate a special kind of art. Like his names, Angelico's paintings were never objects of external acts of certainty. Truth was art's subject just as the eye was that of his colour and light. Even today, as we look at his paintings and maybe forget their original context, one can still see how the idea of truth as received by art implied that Angelico participated in the rendition of Truth's appearance.

Like the name and the colour, art retains the power to facilitate truth as a phenomenological mechanism by which subjects come to behold aspects of a comprehensive reality. In this way, the image is empowered and achieves a degree of autonomy. The autonomy of the image follows a similar course by which Angelico achieved an accrued autonomy as Guidolino, Giovanni da Fiesole and ultimately as "Beato Angelico." The latter name remained a "beatification" that was enacted by the people, rather than the Pope. This is indicative of Angelico's ultimate autonomy, which his name gained by dint of his art. Ultimately, Angelico retained for himself and his art a full and viable individuality.

Law (or a Problem)

Here, I would like to momentarily return to Wittgenstein's two arguments: (a) that colour concepts are not universal, and (b) that phenomenological problems do not constitute a phenomenology.

As a language-game, the negotiation of a commonly acceptable and effective definition of colour calls for an agreed ground on which a name *gives* logical form to the convention by which we agree and define something. If one accepts that colour concepts could never be universal, then one must establish whether the act of *naming a colour* belongs to the criterion for what is a colour. Furthermore, if one accepts (on the other end of Wittgenstein's argument) that phenomenological problems *do* exist, they do not necessarily constitute an identifiable phenomenology. If one attends to Goethe's assertion that problems with some kinds of colour-perceptions are phenomenological problems (where

Goethe indicates atmospheric colours, as an example), then a further question becomes pertinent: Is the *naming of a colour* a phenomenological problem?

If naming a colour *is* a phenomenological problem, then it would have to ascend or emerge according to the law of phenomena as an ur-phenomenon. As Goethe puts it, nature "makes no jumps. It could not make a horse, for example, if it had not first made all the other animals, by way of which, as on a ladder, it ascends to the structure of the horse." (Nisbet 1972, p. 11). This calls for a convention for negotiating the laws of colour with the evolution of colour. The implication of a law—whether negotiated in a language-game or accepted *a priori*—must also legitimise the plural nature of individual definitions of colour.

Furthermore, if naming a colour *is* a phenomenological problem, then we have to establish which of the following is true. On one hand, we can either argue that it is necessary for the naming of a colour to ascend to a totality presumed by law. On the other hand, there could be an argument stating that the naming of a colour does not presume a law, because if it did so, it must provide a solution. If it *had* a solution, it would cease to be a problem. It is important to bear in mind that in presuming a law for a chain of appearances, we have to presume a phenomenology. This would mean that Wittgenstein's case for a phenomenological problem will have to be reversed, and any argument for naming a colour would be premised on a phenomenological method.

Were we to conclude that naming a colour *is not* a phenomenological problem, then would this imply that we have to refrain from the whole issue of ur-phenomena and refuse a totality which is presumed by (Goethe's Liebnitzian) construct of a phenomenal chain? By refusing this construct of progressive causality, the naming of a colour cannot tally with a scenario of a *necessary* language by which we would establish an agreed recognition of colour. Rather, naming a colour would be construed as situational and thereby contingent. This also means that colour would have to provide itself with a syntax that functions as a semantic ground that would infer and endorse itself as a self-named construct. Furthermore, it would imply that naming-a-colour cannot presume a universal law. If it does presume a self-named convention, it will be determined by the individuality that infers it as if it were continuously self-adopted by its own grammar.

The bottom line of the argument for a law of colour represents nothing but one fact: a general law and a universal meaning for naming a colour is either a tautology or nonsense. Wittgenstein's conclusion rejects the

establishment of any *theory* of colour. This is because a theory of colour would suggest "the logic of colour concepts," and more importantly it only achieves "what people have often unjustly expected of a theory." (Wittgenstein 1990, I §22, p. 5).

IX. Art's remit has no boundaries except its own. This is where art's event is marked by the freedom by which we name the world and give it purpose through names, colours and laws. Yet, art is also a sign that has no instrumental purposiveness as it frequently presents itself as an *empty signifier*. An empty signifier moves beyond the law when this becomes insufficient and irrelevant. Only the contingency of phenomena could explain how an empty signifier is presumed by the *condition* of these events. At will, such phenomena could *interrupt* by way of *transpiring* the absence of law. In their separate singularity, art and education become such phenomena.

By replacing theory with a *logic* of colour one rejects the argument that because we have no criterion for what is a colour it should be implicit. Here we find a split between object and subject (or a difference between individual and universal names). Beyond any distinction between subject and object, a *logic* of colour would take the defining (and learning) process back into the specificity of the subject. It makes no difference whether the subject is colour itself or the agent of its mixing (and definition). In Wittgenstein's words: "When dealing with logic, 'One cannot imagine that' means one doesn't know what one should imagine here." (Wittgenstein 1990, I §27, p. 6).

Any logic of colour concepts is distinct from the possible or impossible general criterion to name a colour. It follows that in the logic of naming my colours, I do not assume a law. Rather, I (a) recognise the specificity of colour as an act of self-mediation (and self-naming); and (b) negotiate the *form* with the *meaning* of colour. The examples of an artist and a child, both mixing colour in their different intentional contexts, provide a parallel distinction.

The artist will recognise the specificity of colour as an act of self-mediation (and self-naming). She negotiates her form with the act that names the form, in her act of giving a form to a name. When a child is mixing colour ("in whatever way"), she will likewise negotiate her laws because she remains aware (in *act* and *fact*) of the irrelevance of a law. Because she does not need a law, the child is free to negotiate her colour mixing. Her main objective

lies in the epistemological participation by which colour must be mixed and by which the child gains something from colour's signifying influence. As meaning takes over the form of colour, one could see how strictly speaking, the language-game of colour lies within the child's remit.

Art's Event

Naming a colour is an *event* because it marks the moment when colour gains individuality. While naming a colour does not affect the colour *per se* (i.e. in its physical state), it bears effect on its appearance just as questions bear an effect on how they are answered and contextualised. The act of naming is not dissimilar from questioning. Heidegger (1987, p. 5) describes questioning as "a privileged happening," an *event* where "the content and the object of the question react inevitably on the act of questioning." This means that such questioning "is not just any occurrence but a privileged happening that we call *event*."

In naming a colour, we encounter an *event*. This event is *conditioned* by how we play the language-game by which we name our colours. As previously suggested, the language-games in play define the mixing of colour (and thus, colour itself) as an act of perception, interaction, having concepts, seeing difference, and building chromatic grammars by which we name our self.

In naming a colour, the name corresponds with a specific set of objectives by which we identify colour with *purpose*. The purpose of colour has to do with the objective grounds without which the act of naming a colour becomes mere speculation. So the event of naming is not a speculative moment of phenomenology. Rather it has a *legislative purpose*, what Wittgenstein identified in possibility as a logical form, even when it does not respond to a speculative law. The event of naming is significant because it confirms colour's possible logical form while precluding it from becoming law. So while rejecting the notion of a general criterion for naming a colour, naming a colour remains pertinent to its objects.

The act of naming a colour is a pragmatic event that corresponds to specific moments of reality. It has nothing to do with conceptual abstraction and cannot afford to become an object of speculation. As a pragmatic event colour retains two forms of possibility. In the first instance, colour is purposeful. It provides the tools with which the logic of colour can function. Also colour is always seen as a proper concept. This means that colour mediates itself—that is, it provides us with the scenario where red as red does not suffice unless it is seen as specific to its act *as* red (not as blue, or reddish green; yellow or reddish orange).

Art as Sign

Wittgenstein's colour-blind tribe does not have the same colour concepts as those of the colour-sighted. However, like a colour-sighted tribe, they partake of the event of naming their colours by which they communicate. Any colour is specific to its logical purpose. It is difficult for the colour-sighted to translate the colour-blind's colour-names, and it is difficult for the former to understand the latter's colour language-games. But it could be argued that as different events, the colour-sighted and the colour-blind's naming presume a common need to uphold the specificity of colour in their language-games.

However, while we can say that the colour-blind tribe shares with the colour-sighted a common necessity (that of the *event*), one cannot say that the colour-sighted event shares the same name with that of the colour-blind tribe. The purpose of the event is different, even if the event as a purpose is common to both. This reiterates the fact that the naming of the event is the *condition* posed by the language-game that defines colour. The outcome of colour sighted language-games poses a *condition* informed by questions of perception, interaction, concept and difference that differ according to the concept of the colours that are *seen*. At this point, one becomes aware that the word *blind* in the term colour-*blind* confirms the limitations found in the vocabulary that is used by a colour-sighted majority. This vocabulary is insufficient when it comes to defining the nature of the colour-blind's sight. Wittgenstein's notion of colour-blindness is primarily concerned with such a limit, where what is assumed to be superior is in effect much more inferior and incomplete.

As exposed by the logic of the colour-blind tribe, the limited definition of colour-sightedness takes us to the definition of colour as a sign. If there is a central condition to the naming of colour, it must fall within the realms of its semiotic nature. When we speak of colour, we need to draw a distinction between its meaning and its form. In its syntactical structure, the logic of colour is distanced from colour's semantic necessity. It becomes an empty signifier. Ernesto Laclau (1996, p. 37) argues that "an empty signifier can, consequently, only emerge if there is a structural impossibility in signification as such, and if this impossibility can only signify itself as an interruption (subversion, distortion, etc.) of the structure of the sign."

If we argue that the condition posed by the language-game that names a colour presumes an empty signifier, and if, in addition, we say that this has the purpose to legitimise the event that names the colour, then how

could an empty signifier have a purpose? Wittgenstein (1990, I §14, p. 4) remarks that "there is no *commonly* accepted criterion for what is a colour, unless it is one of our colours." Going with this conclusion, we have to ask: How could the name of a colour function on a unitary purpose (such as art or education) if the naming of a colour could not presume universality? If the event of naming a colour presumes a purpose for colour in the form of its objective ground, then it is not an empty signifier. Likewise, if the same naming does legitimise an act, it already has signification. This presents us with the condition of the event of naming as a tautological cycle. This also raises a question about the way with which a cycle could fit within "an impossibility" as shown above by Laclau (1996, p. 37).

In the process of signification, the empty signifier lies *beyond* the name and the event because it is found beyond the law. The condition has to be explained not in terms of the law, but in terms of the phenomenon. This could only reiterate what we have established earlier: a general law is insufficient and renders itself irrelevant when trying to apply a universal semantic for naming a colour. Only the situational contingency of phenomena could explain how an empty signifier is presumed by the *condition* that controls the event of naming colour. Because it is an "interruption," the phenomenon subverts the law and stands outside the law. It actually *transpires* the very absence of the law.

In a Kantian manner, one could argue that the phenomenon (which is *neither* a phenomenology *nor* a phenomenological problem) is an *a priori* assumption of the condition that names the event. Placed within the order of a meta-language, it would assume its own law in various ways: as "a kind of knowledge, a past, a memory, a comparative order of facts, ideas, decisions." (see Barthes 1973, pp. 126–127).

Like Kant's notion of judgement, a meta-language has no legislative reality. But unlike judgement, it does not need a legislative reality to be linguistically expressed. This is because a meta-language (which includes images, sounds, colour, forms, desires …) is never limited to linguistic expressions alone. Unlike judgement, a meta-language would neither have nor would it need a "territory with a certain character for which no other principle can be valid." (Kant 1974, Introduction §III, p. 13). As in the case of art, within its specificity, a meta-language (which does include events of artistic activity but not exclusively) would mediate its own ground. A meta-language (which is *neither* a "phenomenology" *nor* a "phenomenological problem") does not fill an absence between cognitive faculties and the faculties of desire. Rather, it belongs to both while it may well remain absent from both cognition and desire.

X. Art and education are moments of hegemony. Yet we have established that while art is bound to sustain contradiction, it cannot be *applied* through politics or education. Epistemologies that conflate art with education are useless. If art and education were exercised as hegemonic moments to seek coherence and identity, they would fail. Hegemonic conditions that are forced through art and education are artificial constructs. Rather than the certainties of social and cultural common sense on which constructivists have relied in attaining consciousness and emancipation, what really matters is the singularity of categories that succeed by dint of their contingent and contradictory praxes. Hegemony will only prevail if its contingent conditions are preserved within a *universality of particulars*. This is only attained when art and education are sustained as empty signifiers that refuse to function as methods of measure and equivalence.

> When people are in a situation of radical disorder, people need some kind of order, and the nature of the particular order is secondary. This relationship in which a certain particular content assumes the function of a universal fullness which is totally incommensurate with it is exactly what I call a *hegemonic relationship*. (Laclau 1999, p. 7)

We are still unresolved as to how colour is an empty signifier. We need to establish how colour as form relates to its meaning. We are still unclear as to how, by accepting that there are no universal criteria for naming a colour, the logic of colour makes the event of naming a phenomenological problem. We have to establish how, confronted by the structural impossibility of its signification, the condition that makes the event of naming the possible could stand as such.

My attempted explanation came from excluding the law from this structural impossibility. But this leads to another kind of impossibility where colour cannot be a sign (as a unified form and meaning) and where it remains an empty signifier (as a form without meaning). This suggests that a phenomenological problem is impossible. It also brings us back to square one as it means that a reason must be found for the presumption of a universal condition by which naming a colour is regarded as a phenomenological problem, even if this condition is limited to the individuality of colour.

At this point, an answer cannot be found in the logic of colour. We have to move into the *politics* of the meta-language within which art, amongst other, entertains its autonomous capability of dealing with external manifestations such as *name* and *colour* by which art itself is often defined and

referenced. Here I seek an explanation beyond the customary canon of art theory or philosophy of art. Rather, I would like to engage with political theory, and more specifically the dialectical logic by which Laclau's work deals with difference and equivalence as implied by what he calls "concrete struggles," where the relationship becomes evidently hegemonic. As I try to find a way of explaining art though a discourse of naming, logic and the law, I would then move to the epilogue for this chapter in which I would attempt to draw together the loose ends by which art and education could find ways to avoid becoming coextensive in their different legislative, semiotic and political *whereabouts*.

Laclau (1996, p. 41) presents a situation where the "meaning (the signified) of all concrete struggles appears, right from the beginning, internally divided." Struggle implies not simply an internal dispute, but also a struggle with what confronts it. In this respect, Laclau presents two meanings: the first one "establishes the differential character of that demand, (ibid.)" and the second one "establishes the equivalence of all these demands in their common opposition to the system (ibid.)." This immediately presents a contradiction, not only in the directions expected, which seem to go in their opposite ways, but also in how without a certain or clear strategy we are presented with a series of possibilities that are "simply the result of every single struggle being always already, originally, penetrated by this constitutive ambiguity." (ibid.).

The parallel positioning of the logical problematic of colour and the political problematic of signification (or indeed meaning) within "concrete struggles" (which we find expressed in art and related contexts that emerge in the aesthetic imaginary) might begin to explain why many epistemological questions (such as those which relate art with education) remain unanswered. Both issues are tied to the fundamental distinction between what is *said* and what is *shown*, as Wittgenstein's classic distinction goes where "What *can* be shown *cannot* be said," (Wittgenstein 1992, §4.1212).

Wittgenstein's statement cannot remain formulaic and must be understood on the grounds of practice where signs are confronted by symbols and where meaning often challenges form. In art, this is easily illustrated by how what is said and what is shown remain distinct. If we distance our argument from Wittgenstein's logical exposition of colour, we could begin to see how the manner by which colour relates to a sign and that of "concrete struggles" shares a degree of commonality with both art and the polity (which includes the sphere of education).

As we move from practice to theory and back, we realise how this permeates struggle because at the end of the day, art exists in its relationship to a *polity*, whether inferred from a law presumed *a priori* from the name-event of narratives like those of colour, or from a legislative structure presumed by the "concrete aim of the struggle." More so, art answers to the same ground of dispute and learning by which we have identified a third moment of pedagogy—after the moments of description (qua reason) and infatuation (qua desire)—where the *agón* expresses and relates to a commonly assumed set of problems that emerge from the tension between exclusive and sectarian forms of *citizenhood* and an emancipatory and critical citizenship.

In concrete struggle, we presume a political syntax that has to do with how we supplement language with a system of images that invests meaning with form and vice versa. Indeed, "that which mirrors itself in language, language cannot represent" (Wittgenstein 1992, §4.121, p. 79) because its form (the signifier) is distanced from the meaning (the signified). While the signified poses a political question, the signifier's interest belongs to logic. The signified has to practically *say* what the signifier has theoretically *shown*.

Being the domain of the signified, the political question reveals, by its presence, the insufficiency of our sign systems. While this is no excuse to dismiss language and its consequent sign systems as incomplete, we cannot forget that the questions that are raised also come down to the individuality of the facts that are involved—whether they happen to be colour, learning, perception, opinion or struggle. One could suggest that phenomenological problems are mainly forms that do not have corresponding meanings by necessity. Phenomenological problems are called into question when a number of ethical issues are raised. In this context, a moral imagination that begins to articulate how we approach such insufficient sign systems may well have to do with the convention of colour as a communicable category (which is a myth). Likewise emergent political imaginaries are likely to respond to a collective objective that prompts and calls for some form of political struggle that aims to redress the injustices that sectarian and exclusive polities are likely to sustain. Laclau argues that such a contradictory movement is bound to operate in a way that both asserts and proscribes its own singular possibilities. This is because such a situation infers such movement *a priori* by a form (the signifier) that is absent from the meaning (signified).

A Pedagogical Solution?

In its autonomy, art is bound to capture this dilemma, and it is all too quick to sustain this contradictory set of currents and counter-currents. Art also struggles to put this across when it comes to operating in heteronomous ways, that is, when someone tries to apply it through spheres like politics or education.

These questions also raise the legislative issue of the event whose naming is insufficiently signified by the totality it infers from its own individuality. Thus, would the signifier be the cause or the effect of the contradictory movement? Would the contradictory movement (which, in the case of colour, we identified as the *condition* for the name and the event) be the ground rule for those language-games that stake the meaning of the concrete struggle, and the semantic negotiation of a collective convention?

This question might find an answer in the analogy of *mixing*. It is by now clear that *mixing* is an event that beholds colour to its specificity. Mixing is akin to a learning process that names (and regales with speciality) colour in its individuality. By implication, mixing also names the world in its actuality—that is, as an emerging state of affairs by which women and men give each other meaning and significance through a viable meta-narrative of sign systems, of meanings and of forms. Here one begins to realise that learning and struggle are equivalent (often interchangeable) categories. More so, the politics of colour bears a direct relevance to the pedagogy of colour, and with it the pedagogical relations by which we name the world.

To name the world is to assume a ground of sorts that articulates a moral imaginary by which culture serves as a pedagogical as well as an ethical ground of signification. This kind of signification is very evident in Antonio Gramsci's quest for a cultural answer to what his contemporary *pragmatist* theorists of language have seen as a linguistic obstacle to the elimination of illusory contrasts.[19] Gramsci argues that the obstacles of language are caused by socio-historical differences and distinctions as reflected in common language (*linguaggio*). His instinct favours equivalence, which, as cited above, Laclau considers impossible in the case of the concrete struggle, mostly because "the function of representing the system as a totality depends, consequently, on the possibility of the equivalential function neatly prevailing over the differential one; but this possibility is simply the result of every single struggle being always already, originally, penetrated by this constitutive ambiguity." (Laclau 1996, p. 41).

Gramsci proposes that the position taken by a pragmatist theory makes it even more important for us to recognise what he calls the "cultural moment" (*momento culturale*). "Across board, culture brings together a larger or lesser number of individuals on many levels; more or less on a level of expression where they understand each other at different stages ... and so on. It is such diversity and social-historic difference that is reflected in common language (*linguaggio*), bringing about those 'obstacles' and 'causes of error' which the pragmatists have discussed." (Gramsci 1975, pp. 30–31)

The "cultural moment" bears upon all activities that we collectively are responsible for. In this respect, a collective moment—indeed a collective sense of humanity—begins to signify heterogeneity. In Gramsci's opinion, "the importance of the question of language in general—that is, the collective achievement of the same cultural 'climate'—becomes evident" by this need to articulate a heterogeneity collectively (Gramsci 1975, pp. 30–31).

In Gramsci's mind, this is an intrinsically pedagogical issue, where the relationship between teacher and pupil is active and reciprocal, and where the teacher is at times pupil and the pupil is at times teacher. Gramsci adds that the pedagogical relationship cannot be limited to the school. Rather, it is extended to the social and cultural aspects of human relationships where every hegemonic relationship is recognised as pedagogical. On this plane, there seems to be an equivalence that ultimately metes out and rationalises the relationship. At the very least, it rationalises the struggle.

Laclau's Model

Unlike Gramsci, Laclau goes beyond equivalence. The hope that ultimately the hegemonic-pedagogical axis will prevail over the hegemonic-coercive structure is, in Laclau's definition of hegemony, overtaken by the prevalence of empty signification.

To start with, Laclau (1996) argues that the "presence of empty signifiers (...) is the very condition of hegemony." (p. 43). He regards this as a way of moving beyond what he regards as a stumbling block in most theories of hegemony, including Gramsci's. In order to avoid this stumbling block, we need to understand what the broader aims for emancipation really mean. Laclau identifies two possibilities by which we can do so.

The first one has to do with society being regarded as "an addition of discrete groups, each tending to their particular aims and in constant collision with each other." (Laclau 1996, p. 43). Here, Laclau explains,

"'broader' and 'wider' could only mean the precarious equilibrium of a negotiated agreement between groups, all of which would retain their conflicting aims and identity." (p. 44). However, this is problematic to regard as hegemonic (and thereby, in our case, pedagogical), because "'hegemony' clearly refers to a stronger type of communitarian unity than such an agreement evokes." (p. 44).

The second possibility is that "society has some kind of pre-established essence, so that the 'broader' and 'vaster' has a content of its own, independent of the will of the particular groups, and that 'hegemony' would mean the realisation of such an essence." (Laclau 1996, p. 44). The problem with this is that it:

> would not only do away with the dimension of contingency which has always been associated with the hegemonic operation, but would also be incompatible with the consensual character of 'hegemony': the hegemonic order would be the *imposition* of a pre-given organisational principle and not something emerging from the political interaction between groups. (Laclau 1996, pp. 43–44)

Going by Gramsci's pedagogical qualities of hegemony, one could see why Laclau's critique has a lot to contribute to the difficulties, which are aggravated by the coextension of art, culture and education. If, as in the first instance, art, culture and education are exercised as hegemonic moments by which a precarious equilibrium is negotiated between groups in order to attain a false sense of social coherence and identity, then this fails pathetically because the hegemonic conditions are forced, and therefore, constructed artificially by those progressives and liberals who think that a socially just and a pragmatic arrangement could be manufactured on the back of a negotiated settlement, which does not reflect the social and economic realities.

In other words, if the school is used as a hegemonic instrument for wider democratisation to mediate society through art and culture, this will lead to failure. This is because such constructs would be precariously negotiated on assumptions without having any regard to the grounds on which they continuously emerge. This attempt will also backfire because the hegemonic opportunities by which the school would do so would not only come disjointed, but also move in the opposite direction by incrementing the condition of oppression and de-sublimation—thereby confirming Marcuse's scenario of one dimensionality.

In the second instance, if through art and culture, the pedagogic condition of hegemony assumes that there is a pre-established *essence* or *totality* by which society would bring together pragmatically and progressively (what Gramsci sees as) a broad and vast content that it presumes to have, it would be ignoring many groups whose intentions do not conform with this essence or totality. This hegemony would (a) fail to realise this presumed social and democratic essence and (b) suppress the very contingency by which it has sustained itself as a hegemonic operation. This means that it would find no way of connecting with what has been assumed as a "consensual character of 'hegemony'," thus resulting in the stultification of those possible political interactions between the groups that make society in the first place.

Laclau's solution runs contrary to both Gramsci and the approaches taken by progressive, liberal and constructivist strategies with which we are all too familiar in educational discourse. More so, it contradicts those forms of discourse that seek to co-opt art education with forms of critical pedagogy by which they claim to liberate social consciousness from reification. In response to these scenarios, which Laclau identifies as stumbling blocks in the theories of hegemony, he suggests that "if we consider the matter from the point of view of the social production of empty signifiers, this problem vanishes." (Laclau 1996, p. 43).

How? One might ask. Laclau's approach is clear: from the point of view of the social production of empty signifiers, "the hegemonic operation would be the presentation of the particularity of a group as the incarnation of that empty signifier which refers to the communitarian order *as an absence, and unfulfilled reality.*" (Laclau 1996, pp. 43–44 emphasis added).

We can see how the *cultural moment* as ethically imposed to resolve the syntactical problem of language would, in Laclau's model, go beyond Gramsci's and most of the progressive and liberal assumptions that have been applied to education, the arts and culture in the wider literature of critical pedagogy. Rather than the certainties of social and cultural common sense on which constructivist theories have relied in attaining forms of emancipation—be it social, educational, cultural or artistic—Laclau's analysis dwells on the singularity of categories that are incongruent from a universal point of view, but which would gain strong feasibility from the perspective of their individual and contingent praxes.

As this somehow goes back to the dialectical logic by which Hegel assumes art from the realms of individuality, which in this chapter I took further into the realms of historical contingency, Laclau's position re-

defines Gramsci's notion of a *cultural moment*. More in line with the negative nature of *Bildung* in Hegel, and less in line with the collective ambitions of Gramsci's theory of hegemony qua education, Laclau's strategy does not arise from a common urge to unify the heterogeneous consequence of syntactic individuality into semantic universality. Instead it does the contrary. Laclau's strategy is primarily aimed at the recognition and use of the condition by which a signifier is emptied into a vehicle of semantic transformation, and where in return the signified makes possible "the presentation of the particularity of a group as the incarnation of that empty signifier which refers to the communitarian order as an absence, and unfulfilled reality." (Laclau 1996, p. 44).

In this respect, the hegemony (and with it art, culture and education) is preserved if the mechanism by which language seeks to universalise itself (as a would-be remedy for syntactic obstacles) is suspended. Another way of looking at this suspension of hegemony is to look at it as a reversal into the *universality of particulars* by dint of individuality. Again this goes back to our discussion of the Notion, or individuality, which (as seen in Hegel's dialectical logic) continues to sustain the possibilities of a dialectical procedure even when it appears to foreclose it through triangulation.

Laclau's model allows us to retain the necessity of universality (whether as a syntax or as a mechanism for struggle) by containing it within the specificity of language-games that create a multiplicity of events, and that result in a multiplicity of meanings. On the other hand, Gramsci's solution, like Goethe's cyclic chain, poses a phenomenal ladder as the solution for the phenomenological problem.

Additionally, Laclau's model values empty signifiers, and does not see any viable solution in the attempt to *transform* them into signs of equivalence. This urges us to read further into Wittgenstein's logic of colour as one instance in the logic of the possible where the quick fix of rational certainty—be it democratic, educationalist, liberal, progressive or indeed critical—becomes somewhat irrelevant.

In this chapter, I wanted to show how the ultimate choice for art and education is not one between individuality and collectivity. Rather the choice is found in how our forms—indeed what we *make*—could value difference and make it work. As art, our forms of making could only lead to the meaning of difference once we endorse difference as that which emerged in Wittgenstein's model of colour and Laclau's model of concrete struggle.

To use the analogy of the colour-blind tribe, colour-blindness becomes the rule and not the exception. Only the possibility of its plurality as colour-blindness-es would begin to articulate a strategy by which we could approach and get close to achieving emancipation through the possibility of the same paradox by which art approaches the need to learn as a form of unlearning. Here the penultimate word must go to Wittgenstein when he asks, "Can one describe to a blind person what it's like for someone to *see*?" His answer is crystal clear, yet somehow challenging: "Certainly. The blind learn a great deal about the difference between the blind and the sighted. But the question was badly put; as though seeing were an activity and there were a description of it." (Wittgenstein 1990, I §81, p. 13).

Come to think of it, it may well be that the answers given to us by the politics of social reform, democracy, liberty and education were not exactly wrong. Many answers were right. But a great insurmountable obstacle remains in the question.

SUMMATIVE CONCLUSION

By way of summarising the overall themes of this chapter, I will here list the ten corresponding axioms that introduced this essay's Sections.

I. Art education's viability comes from the specificity of art and the singularity of education as autonomous spheres of human endeavour, and as phenomena of human freedom and intelligence.

II. A possible rejection of schooled art is sought in the variegated distinctions that emerge from art's facticity and autonomy, where the dialectic takes precedence over method.

III. Art seeks to unlearn the grammar of an ideational prototype. As unlearning, art thereby confirms our contingency. By asserting their own vernacular understanding of the world, women and men reaffirm freedom and intelligence on whose horizons art regains autonomy.

IV. Art reveals how pedagogy moves beyond mere technical procedure. By dint of education's singularity, *pedagogy* provides an agôn, an opportunity for argument that stems from the recurrent moments of human expression in the moments of *information* and *infatuation*. Being coextensive and never deterministic,

information and infatuation broadly explain how, by its intimacy with knowledge and desire, pedagogy takes an immanent form.

V. While as agôn, pedagogy ties desire to knowledge, by its transitory nature, it moves into a third moment: that of the political. A split between *citizenhood* and *citizenship* challenges pedagogy as a political affair. As a schooled moment, *citizenhood* is set within a history of standardised monoliths. As we think of a counteroffensive, we await the praxis of citizenship, which is potentially realised through the singularity of education and the autonomy of art.

VI. As art's autonomy reveals its paradoxical nature, the fallacy of *education as a system of coherent necessities* is confirmed. Rather than invalidating education, this restores its singularity. Education cannot be gambled within the interstices of learning and unlearning. If, on the other hand, we were to regard education as that which counters the normalisation and desublimation of the world, then what emerges from the interstices of learning and unlearning is yet to be defined.

VII. If art were a tool of mediation, it would be a mere semblance of freedom, thereby losing the ability to claim autonomy. When we speak of art's autonomy, we also mean that there is no such thing as a *return* to a unitary origin, or a *fulfilment* of a preordained end. Rather, art *emerges* and *approaches* the world as a *dialectical* state of affairs where firstly, as a making, it remains anomalous of a universal or foundational principle, and secondly, it rejects anything that appears to be given *a priori* in its form or content.

VIII. We speak of art's autonomy in its *emergence* because as we describe art, we describe ourselves. As an attribute of life and art, colour is one of the cases by which we make the world. In turn, to speak of colour is to say something about the words by which we name the world. To name is to reveal a law. When women and men become artists, they confirm that art is a form of life, often described through the use of language-games. As descriptions and games imply a law, they emerge from negotiations between human beings. The law—whether negotiated in a language-game or accepted as *given* prior to any experience—must not only appear and emerge from its acts of mixing contexts and forms, but also allow us to affirm the plural nature of individual definitions by which art engages with the world.

IX. Art's remit has no boundaries except its own. This is where art's event is marked by the freedom by which we name the world and give it purpose through names, colours and laws. Yet, art is also a sign that has no instrumental purposiveness as it frequently presents itself as an *empty signifier*. An empty signifier moves beyond the law when this becomes insufficient and irrelevant. Only the contingency of phenomena could explain how an empty signifier is presumed by the *condition* of these events. At will, such phenomena could *interrupt* by way of *transpiring* the absence of law. In their separate singularity, art and education become such phenomena.

X. Art and education are moments of hegemony. Yet we have established that while art is bound to sustain contradiction, it cannot be *applied* through politics or education. Epistemologies that conflate art with education are useless. If art and education were exercised as hegemonic moments to seek coherence and identity, they would fail. Hegemonic conditions that are forced through art and education are artificial constructs. Rather than the certainties of social and cultural common sense on which constructivists have relied in attaining consciousness and emancipation, what really matters is the singularity of categories that succeed by dint of their contingent and contradictory praxes. Hegemony will only prevail if its contingent conditions are preserved within a *universality of particulars*. This is only attained when art and education are sustained as empty signifiers that refuse to function as methods of measure and equivalence.

NOTES

1. For a fascinating discussion of Nebrija's project and the implications that it had on how social institutions are universalised by the State, see Illich (2009b, pp. 33–51).
2. Recently, the notion of *Lego*, this time as a company, took an interesting turn with its refusal to provide Ai WeiWei with bricks that he requested to build his latest installation. The reaction was interesting in that this triggered a new kind of crowd sourcing, with many, including children, offering the artist their own Lego bricks. The political twist on this, involving the Chinese authorities' dislike for Ai WeiWei's work and the withdrawal of Lego as a corporation,

seems to jar with the universalistic claim inhered in the concept of Lego *per se*, as a tool for play, creativity and education. For details of the story, see http://www.theguardian.com/artanddesign/2015/oct/25/ai-weiwei-swamped-by-lego-donation-offers-after-ban-on-use-for-political-artwork

3. Poole's context is mainly to do with whether Kierkegaard chooses to use a "Hegelian Lego" in his reconstruction of the concept of irony. Poole wonders if "[b]y the hallucinating use and reuse of a set of terms, infinitely recombined, the reader [of *The Concept of Irony*] gets the impression of a kind of vast intellectual mobile, a work of kinetic art that revolves and rotates and glitters in conceptual space. This multiple redefinition of terms drives constantly toward creating an aporia: that is its aim." (Poole 1993, p. 49).

4. Here, *intentions* follow Searle's sense, by which, he says, "I use 'intentionality' as a technical term meaning that feature of representations by which they are *about* something or *directed at* something." (Searle 1995, p. 7n).

5. I refer to Thomas Nagel's discussion of reality in the opening chapters of his seminal work *The View from Nowhere* (see Nagel 1986 pp. 24ff).

6. The *Langenscheidt Classical Greek-English* dictionary cites the meaning of *ágo* as follows: *trans.[itive]* to lead away, off, on, towards, to conduct, drive, bring, convey, fetch, to take along: to estimate; to direct, command, rule, instruct, guide; to keep (a festival), to spend. — *intr.[ansitive]* to march, move, pass.

7. *Agó* and *agón* mean the following: assembly that implies both a consensual meeting place, as well as a place of combat, where there is contest or dispute. This advances a further implication for an agency that moves towards dispute in terms of legality, but also of argument per se. These words also imply the idea of exertion, labour, struggle and danger.

8. Here, I am not suggesting that there should be a rule where the etymological origin of a word dictates what it should do after so many centuries of usage. However, it is interesting to re-evaluate what we mean by pedagogy, particularly when we know that the word brings up diverse meanings in other languages. Nonetheless, I remain steadfast on refusing to reduce the meaning of pedagogy to that of a technique of teaching, something that is often the case when the word is used in a climate of training-oriented profes-

sional studies in education. Surely, the discipline is too rich in lineage and connotation to remain bereft of a wider context of meaning, particularly when a wider and richer usage of *pedagogy* remains the case in continental scholarship in education.

9. Note the word *curriculum* as derivative of *curro*: a running, at a run, a race, from which the further meanings of "raceground," "course" and "lap" are derived.

10. For my discussion of exclusion in art and education, see my book *Art's Way Out. Exit Pedagogy and the cultural Condition* (Baldacchino 2012).

11. For my critique of nostalgia and the fallacy of art as a form of return, see Baldacchino & Diggle (2002) and Baldacchino (2015b, pp. 27–30).

12. Given that only recently the Catholic Church has witnessed another *gran rifiuto*, this time from Benedict XVI, who only follows Pope Gregory XII's resignation from the Papacy in 1415, it now seems that Dante's horror at the abdication of Celestine V in 1294 is rather overstated.

13. In his *Art and Beauty in the Middle Ages*, Umberto Eco describes Dionysius the Areopagite's work *De Divinis Nominibus* (*On the Divine Names*) as "a work which describes the universe as an inexhaustible irradiation of beauty, a grandiose expression of the ubiquity of the First Beauty, a dazzling cascade of splendours." For further discussion cf. Eco (1986, pp. 18ff).

14. On the distinction between the logic of the case and the logic of possibility, see *Wittgenstein's Lectures. Cambridge, 1930–1932* (Wittgenstein 1980, pp. 10ff).

15. In the context of this chapter's central discussion—art and education—this distinction should introduce a similar distinction between learning and unlearning as proper concepts (of possibility *qua* name) while distancing them from the pseudo-concept (of form *qua* technical practice).

16. One must bear in mind that just like God, Dieu or Iddio, Allah is a noun meaning "God" who in effect remains unnamed.

17. There were five original mendicant orders: the Franciscans, Dominicans, Carmelites, Augustinians and the Servites. Unlike monastic orders, the mendicants sustained themselves by a life of begging, thus living like the majority of the population, by living in the streets before they began to live in friaries and convents,

which were distinctly different from the feudal estates held by the old monastic orders.

18. For a brilliant description of subsistence and the mendicant economy of the middle ages, see Ivan Illich's book *Shadow Work* (Illich 2009b), especially Chap. III.

19. Gramsci refers specifically to G. Vailati's book *Il linguaggio come ostacolo alla eliminazione di contrasti illusori* (see Gramsci 1975, p. 30).

REFERENCE

Adorno, T. W., & Goldmann, L. (1977). To describe, understand and explain. In L. Goldmann (Ed.), *Cultural creation in modern society*. Oxford: Blackwell.

Baldacchino, J. (2012). *Art's Way out: Exit pedagogy and the cultural condition*. Dordrecht: Sense Publishers.

Baldacchino, J. (2015a). ART ± EDUCATION: The paradox of the ventriloquist's soliloquy. *Sisyphus: Journal of Education, 3*(1), 55–71.

Baldacchino, J. (2015b). Art's foreignness as an 'exit pedagogy'. In T. Lewis & M. Laverty (Eds.), *Art's teachings, teaching's art: Philosophical, critical and educational musings, Contemporary philosophies and theories in education* (Vol. 8, pp. 19–31). Netherlands: Springer. doi:10.1007/978-94-017-7191-7_2.

Baldacchino, J. (text), & Diggle, J. (images). (2002). *Avant-nostalgia. And excuse to pause*. Aberdeen: Robert Gordon University.

Barthes, R. (1973). *Mythologies*. London: Paladin.

Derrida, J. (1994). *Aporias* (T. Dutoit, Trans.). Stanford: Standford University Press.

Dewey, J. (1905). The realism of pragmatism. *The Journal of Philosophy, Psychology and Scientific Methods, 2*(12), 324–327.

Dewey, J. (2000). *Liberalism and social action*. Amherst: Prometheus Books.

Eco, U. (1986). *Art and beauty in the middle ages* (H. Bredin, Trans.). London: Yale University Press.

Goethe, J. W. (1987). *Theory of colours*. Cambridge, MA: MIT Press.

Gombrich, E. H. (1978). *The story of art*. London: Phaidon.

Gramsci, A. (1975). *Il Materialismo Storico e la Filosofia di Benedetto Croce*. Editori Riuniti: Torino.

Greene, M. (1988). *The dialectic of freedom*. New York: Teachers College Press.

Heaney, S. (1998). *Opened ground, poems 1966–1996*. London: Faber and Faber.

Hegel, G. W. (1975). *Hegel's aesthetics. Lectures on fine art* (T.M. Knox, Trans.) (Vol. 1). London: Oxford University Press.

Hegel, G. W. (1989). *Hegel's logic, being part one of the encyclopaedia of the philosophical sciences* (W. Wallace, Trans.). London: Clarendon Press/Oxford University Press.

Heidegger, M. (1987). *An introduction to metaphysics* (R. Mannheim, Trans.). London: Yale University Press.

Hippocrates. (n.d.). Aphorisms (F. Adams, Trans.). In *The Internet classics archive*. Online at http://classics.mit.edu//Hippocrates/aphorisms.html. Accessed 10 Nov 2015.

Horkheimer, M. (1974). *Eclipse of reason*. New York: Continuum.

Illich, I. (2009a). *Tools for conviviality*. New York: Marion Boyars.

Illich, I. (2009b). *Shadow work*. New York: Marion Boyars.

Kant, I. (1974). *Critique of Judgement* (J. H. Bernard, Trans.). New York: Hafner Press/Collier-Macmillan Publishers.

Kierkegaard, S. (1974). The sickness unto death. In S. Kierkegaard (Ed.), *Fear and trembling and the sickness unto death*. Published as one volume. W. Lowrie (Ed.). Princeton: Princeton University Press.

Kundera, M. (1991). *Immortality* (P. Kussi, Trans.). Faber and Faber: London.

Laclau, E. (1993). Politics and the limits of modernity. In T. Docherty (Ed.), *Postmodernism a reader*. London: Harvester Wheatsheaf.

Laclau, E. (1996). *Emancipation(s)*. London: Verso.

Laclau, E. (1999). Hegemony and the future of democracy: Ernesto Laclau's political philosophy. Lynn Worsham and Gary A. Olson (interviewers). *Journal of Advanced Composition, 19*(1), 1–34.

Leibniz, G. W. (1995). Monadology. In G. H. R. Parkinson (Ed.), *Philosophical writings*. London: Everyman.

Lukács, G. (1971). *Prolegomeni a un' Estetica Marxista, Sulla categoria della particolarità*. Rome: Editori Riuniti.

Lyotard, J-F. (1988). *The differend, phrases in dispute* (G. Van Den Abeele, Trans.). Manchester: Manchester University Press.

Mahfouz, N. (1998). *Echoes of an autobiography* (D. Johnson-Davies, Trans.). New York: Anchor Books.

Marcuse, H. (2002). *One-dimensional man*. New York: Routledge.

Morante, E. (1970). Il beato propagandista del Paradiso. In *L'Opera Completa dell'Angelico*. Milano: Rizzoli.

Nagel, T. (1986). *The view from nowhere*. Oxford: Oxford University Press.

Nagel, T. (1991). *Mortal questions*. Cambridge: Cambridge University Press.

Nisbet, H. B. (1972). *Goethe and the scientific tradition*. London: Institute of Germanic Studies, University of London.

Pinter, H. (1999). *The homecoming*. London: Faber and Faber.

Plato. (1989). Symposium. In E. Hamilton & H. Cairns (Eds.), *Plato, collected dialogues*. Princeton: Princeton University Press.

Poole, R. (1993). *Kierkegaard. The indirect communication*. Charlottesville: University Press of Virginia.

Quine, W. V. (1987). *Quiddities. An intermittently philosophical dictionary*. London: The Belknap Press of Harvard University Press.

Schutz, A. (1970). *On phenomenology and social relations*. Chicago: University of Chicago Press.

Searle, J. R. (1995). *The construction of social reality*. London: Allen Lane, The Penguin Press.

Seferis, G. (1981). *Collected poems* (E. Keeley & P. Sherrard, Trans.). Princeton: Princeton University Press.

Vico, G. (1998). *On the most ancient wisdom of the Italians*. Ithaca: Cornell University Press.

Wittgenstein, L. (1980). *Wittgenstein's Lectures. Cambridge, 1930–1932* (D. Lee, Ed.). Oxford: Basil Blackwell.

Wittgenstein, L. (1990). *Remarks on colour* (G. E. M. Anscombe, Ed., L. L. McAlister & M. Schättle, Trans.). Oxford: Basil Blackwell.

Wittgenstein, L. (1992). *Tractatus Logico-Philosophicus* (C. K. Ogden, Trans.). London: Routledge.

Deleuzian Projections

The Disappeared Future of Arts-Based Research, Parts I–VI: Towards a Reality-Without-Givenness

Jessie L. Beier and Jason J. Wallin

Prognosticated in the speculative thought of Jean Baudrillard (2005), it might be conjectured that today, the planet has been remade as a work of art. This transformation, Baudrillard suggests, marks the revolutionary pinnacle of contemporary artistic thought characterized by the transaesthetic metamorphosis of reality, or rather, a commitment to the idea that all objects, fragments, and details might exert a force of aesthetic attraction and enigma reserved previously to the idealized aristocratic forms of the modern period. Precognitive of contemporary fashions in arts-based research and theory, Baudrillard speculates on the now transpired event of arts' invasion into every sphere of reality by which the world has been redrawn along a vector of its becoming-art. Irrespective of their banality, every object, detail, and fragment will be liberated and ascribed its moment of aesthetic valourization (Baudrillard 2005). This transaesthetic

J.L. Beier (✉) • J.J. Wallin
Department of Secondary Education, University of Alberta,
Edmonton, AB, Canada

© The Author(s) 2017
j. jagodzinski (ed.), *What Is Art Education?*,
DOI 10.1057/978-1-137-48127-6_9

recreation of reality has made manifest a world of flows, of molecules, and organs without bodies—a world of seemingly vital objects liberated from semiotic and material overdetermination through relational interplay and the complex connectivity of rhizomatic thinking. Herein, arts-based research rejoins today with the revolutionary impulse of contemporary art in its liberation and combinatorial novelization of social sign systems.

While such directions have undoubtedly catalysed an alternative to the problem of representation suffusing the orthodoxies of the academy, the liberation of the object lauded via the becoming-art of reality obfuscates a darker scenario in which art and object have become indexed to one another in an act of general equivalency. However, occulted and distant the object might be, it is nevertheless made to refer to the idea of art and its corollaries of artistic genius, human creativity, and productive vitality. Alongside the critique of representation and methodological dogmas well underway in arts-based research then, the transference of reality into aesthetics commences a collusion whereby all that transfigures, denies, and exceeds art becomes absorbed by the idea of art, and its assimilative commitment to the a priori aesthetic becoming of reality. Aesthetics, or rather, transaesthetics, has become a strange attractor towards which the whole of reality is drawn.

Prologue: This Canvas Earth

Baudrillard's (1998) weird science-fiction speculation on the transference of reality into art might today be thought alongside the contemporary geological epoch provocatively dubbed the Anthropocene. Characterized by the inscription of human creation and invention upon the geological record, the Anthropocene is an index of anthropocentrism through which the planet has been ostensibly recast in conformity with human desire and will. From the liberation of earth-locked oil, the manipulation of chemical, genetic and atomic processes, and transformation of ecologies for agricultural production and resource extraction, the materiality of the planet has become transformed in relation to its meaning, utility, and aesthetic reference for us. This is to say, if not hyperbolically, that the Earth has become the ultimate aesthetic product of human activity, terraformed in the image and purpose of a distinctly Western teloi.

Corollary to the anthropomorphic manipulation of the planet for us insists what Baudrillard (1998) refers to as the art of disappearance. While contemporary fashions in arts-based research and theory reserve special

status for production and praxis as dominant modes of being, Baudrillard's (1999) speculative weird fiction controverts this fascination by attending to the collusion of art and disappearance. That is, the aestheticization of reality proselytized by Baudrillard prefigures a scenario in which the world is proffered to human taste and desire, if not more generally a metaphysical presumption that the world is given to its a priori resemblance to human life. By extension, we might suggest that the lauded status of artistic praxis and production in arts-based research found particular conditions of obfuscation. Specifically, the transferential elevation of the world as a sensible and cognate order for-us occludes the noumenal or occulted regression of things from phenomenal excavation. Simply, the desire to produce and semiotize the world intimate to much arts-based research is imbricated with the disappearance of an occult and unfathomable world outside the interests of human life. This act of disappearance marks both the contemporary trajectory and highest function of art, which aims not only at the disappearance of reality qua simulation but also at the masking of such disappearance (Baudrillard 1997).

The art of disappearance extends into contemporary fashions in arts-based educational research (ABER),[1] where the world is often vitalized but for-us, or otherwise, in the image of anthropic aesthetic countenance in which the vitality[2] of the creative human manifestor and its sensible semio-aesthetic productions constitute a new privileged metrics for registration of meaningful work, if not 'life itself'. Throughout the field of ABER is commenced the liberation of the world unto art and aesthetics by which the world itself is ostensibly elevated via its synthesis with creative human labour and production. Herein, the object appears always-already indexed to its givenness as either actually or potentially aesthetic. More generally still, the object appears as if its significance was predicated on its discovery and adumbration by human creators, through which its attributed qualities and contents reflect in our own concerns. What has disappeared in this scenario but the part maudite (accused share) of ABER's liberatory project? Today, it seems that the pulse of the field remains committed to the aesthetic reterritorialization of the world into networks of interminable exchange and commutation that the surplus value of the sign might be plumbed ad infinitum (Baudrillard 1993). Everything is not only made to mean but also to produce meaning interminably. Against such optimism, Baudrillard eulogizes that the adventure of art is over. In lieu of art's capacity to negate reality or palpate the unreal, Baudrillard contends

that there is now only the semio-urgy of the world's disclosure and the submission of reality to aesthetics, culture, and museumification (p. 17).

The presumption of the world's prior givenness to aesthetics seems to constitute an engrained feature of the field's dominant methodologies, premised as they are on an uncomplicated transference of things unto both aesthetics and aesthetic meaning for us. Herein, the very idea of arts-based research is founded upon disappearance. In commitment to the aesthetic becoming of reality, objects are disappeared via the presumption of their becoming-art, where what resists in such transference is evacuated as to indexically substantiate the correspondence of objects and aesthetics, objects, and their human manifestors. Simply, the field is undergirded by the presumption that everything is on its way to becoming-art. Such a scenario is already anticipated by art's transaesthetic proliferation across the social field. This is to say that the ease with which arts-based research conceptualizes the becoming-art of the world is forestalled by the fact that everything has already become aestheticized.

All objects, details, and fragments are made to be seen, narrativized, and revealed in their meaningfulness, or otherwise, stripped of their secrecy and illusion and rendered as value (Baudrillard 1997). The decentering of the field, and its subsequent potentialization of all resources conceptual and material, denotes that nothing is beyond redemption. Yet, as the familiar claim goes, the proliferation of art portends its end, for where everything is or becoming-art signals an acceleration towards banality. This scene characterizes the contemporary state of art, where the banality of the object is elevated to the banality of the given world (Baudrillard 2005). Yet, not even banality figures as a contemporary impediment to art or arts-based research. Today, art is played out in dromological terms of productive and combinatorial speed (Virilio 2002). As art disappears into the rhizomatic delirium of financial capitalism, so too has ABER become a fetish commodity proliferating under an accelerative logic of capture evidenced in the abundance of academic and populist books, educational resources, academic tribes, and ABER/ABR public-relation gurus that have emerged on the scene in the past decade.

There is, of course, nothing scandalous about the philosophical presumptions of the field. Where everything is already given to aestheticization, we are quite beyond good and evil, much less beauty and ugliness (Baudrillard 1997, p. 20–21). This said, we might rejoin with the particular challenges of the Anthropocene in order to palpate a wholly other dimension of disappearance. For where the field appears to presume the world's

givenness to art, it is in the geological event of the Anthropocene and the planetary repercussions of climate change that we might vaguely detect a general reversal of our contemporary commitments. Foremost in this reversal is an encounter with the outside of arts-based research in which the world does not simply recede from its becoming-art but also supersede its transaesthetic mutation through the violence of ecological transformation where the expenditure of inhuman energies fatally intervenes against both the anthropocentric givenness of the world and its aesthetic anthropomorphization. Such intervention is, as Baudrillard (1999) develops, the event of the object's revenge in which the part maudite or accursed share reverses the metastices of the object's over-representation or liberation into all-too-human systems of circulation and exchange that remain a central feature in the productivity of arts-based research.

The revenge of the object intimate to the geological event of the Anthropocene portends a moment in which the very theorization of the object, its aestheticization, and meaning for us becomes exhausted. In lieu of another theory of the object, Baudrillard elides, what is required today is kind of oppositional theory-object in which the object avenges itself by escaping systems of de/coding and interpretation (Baudrillard 1999, p. 20). Here, the revenge of the object palpates an alien 'problematic field' through which the future of arts-based research might be speculatively re-evaluated. Such revaluation should not be confused with novelty, for the reorganization of the planet ushered by the Anthropocene necessitates an encounter with a litany of dizzying prospects, from the transpiration of a world out of synch with human will and desire, the introjection of indifference and nihilism against the fashions of optimism and hope, through the question of how art will be seen but from an inhuman perspective after the extinction of human life, where it will insist as a stratum in the geological record (Colebrook 2014).

PART I: AFFIRMATIVE REDEMPTION AND MEANING 'FOR US'

If the revenge of the object proselytized by Baudrillard (1999) has general implications for ABER, it is in the revelation of an outside thought to the fundamental philosophical commitments of the field. Of foremost concern herein is its presumption of the world's givenness to aesthetics, and corollary belief in the redemption of the world through art. Here,

the interdisciplinary decentering of ABER and its subsequent proliferation across disciplinary domains stands as a prime example, where the field's cutting-edge theoretical and methodological comportments are made to permit virtually everything within their scope of rehabilitation (Baudrillard 2004). Simply put, everything becomes both permitted and submissible to aesthetic interpretive representation. Such a commitment extends today into the materiality of the world itself, where objects are made to reflect according to a distinctly human vantage by which they are made to appear given for us. As it is in the vogue emergence of vitalist thinking with ABER scholarship, the world is so often reduced to a world anthropomorphized to reflect those qualities that human life likens best to itself.

While premised on the idea of creative invention and liberation from enunciatory stagnation, the commitment to redemption where everything is made to fall within the scope of ABER harbours a horrific dimension. That is, where everything is presumed redeemable, the very notion of an outside unremittant to aesthetic representation or artistic sense is annihilated. Put otherwise, iterations of arts-based research nascently premised on the idea of the world's givenness to artistic representation eradicate a particular strategy of disappearance that is not yet to be recuperated via production, but rather, marks a reversal in which the object becomes radically antagonistic to interpretive capture or dialectical submission to meaning or sense. Such radical antagonism denotes a mode of irreconcilability and metamorphoses antithetical to human desire, prefiguring in this way the fatality or exhaustion of contemporary human thought (Baudrillard 1999, p. 18).

The notion of a radically antagonistic object scarcely enters into the domain of arts-based research and for good reason, for where the field has become entwined with the idea of the world's redemption, the presumption of a bright and hopeful future for-us has become an overwhelmingly prevalent sentiment. Concordant with the field's presumption of a friendly future is its general comportment to only happy or affirmational affects in which the field's image of creative transformation is in many iterations inscribed. This affective commitment not only assures the contemptible status of negative critique and the misanthropic refusal of community happiness, but more significantly, cancels out a field of virulent affects as much part of this world as happiness or hope. For ABER, it seems that Hell no longer exists, or, rather, there is no Evil beyond recuperation into the radiant universe of positive creation and semiotic expressive potential. Such general evacuation of Evil from arts-based research is perhaps

unsurprising insofar as the field is antedated by the domestication of horror within the happy consumer simulacrum of contemporary art and its attendant markets.

For its implicit fidelity to happiness, friendly futures, and good thoughts, the whitewashing of negativity perpetuated via the commitment to redemption commences an unanticipated horror. For where ABER presumes the givenness of the world to redemption, creative liberation, and positive invention, it coincides with an image of human production as a privileged mode of being, and hence predestines the world to reflect anthropomorphically. Accelerated further, the idea of the world's liberation into aesthetic meaning for-us obliquely coincides with the end-game of modernity; that is, the evacuation of the world's reversibility in order that it be made to submit to the meanings and forms attributed to it anthropocentrically.

PART II: THE ECOCATASTROPHE OF ALL-TOO-HUMAN CREATIVITY

Today, we are living out the horror of an aspiration that the world be remade into a work of art. The face of human creativity modern art desired to project upon the planet returns in monstrous contortion, manifest today in the form of plastiglomerate shoreline flotsam, redrawn contours of planetary ecologies, and bioaccumulated plastics, chemical toxins, and heavy metals in organic and inorganic life. Astride unprecedented rates of ecological and species collapse, unabated material and animal exploitation, and the acceleration of human population growth, mounting scientific consensus predict unalterable ecocatastrophy by the year 2040. Gaia hypothesist James Lovelock (2007) has described this ecocatastrophy in terms of revenge, in which the ideal environmental conditions for human life intimate to the Holocene are catastrophically transformed. As we have begun to fathom, the Anthropocene era marks the rise of an inhospitable planet no longer resemblant with the desire or will of the human species. We no longer live on the utopic blue marble captured in Apollo 8's famous image of the Earth entitled 'Earthrise'. As McKibbon (2011) elides, in an era of mega-fires, drought, and acidifying[3] oceans, it is apt to rethink the planet in a manner that no longer evokes a sense of familiarity or nostalgia for-us. In lieu of the 'Earth', McKibbon defers to the neologism EAARTH.

What might the Anthropocene and the limit it portends for human creativity entail for ABER? We might begin to redress this question with the rather pedestrian if not horrifying observation that the problems advanced by the Anthropocene have been scarcely detected within ABER scholarship. While the field is by no means beholden to take up the challenges advanced by this emerging geological epoch, it is generally evident that ABER scholarship labours in overt acquiescence to an image of the world overdetermined by the nostalgic idealism of the 1960s Green movement, circumventing by way of this commitment an encounter with the dark realities of present planetary transformations. This criticism might be aimed most obviously at the a/r/tography movement and the image of a holistic natural world privileged throughout its corpus. As nascently developed in Arts Based Research: A Critique and Proposal (jagodzinski and Wallin 2013), a/r/tography not only advances an image of the natural world cleaved from culture but also posits through much of its work the idea of nature as a backdrop submissible to the 'living inquiry' or praxis of its proponents, who often discover in nature meaning for-us and in our image.

More directly, the natural world a/r/tography advances presume an image of nature that reflects the lauded humanistic virtues of holism, equilibrium, balance, and contemplation. Herein, the claim that a/r/tography posits a mode of working alongside nature becomes suspect, in that the image it produces anthropically reduces the world to repeat in accordance to its key methodological signifiers. As an art of disappearance, the world is not only brought into general equivalency with a/r/tographical praxis but also obfuscated in the simulation of ecology suited ideally to human life. This, Thacker (2011) advances, constitutes an act of anthropic subversion whereby the world is remade in stealth fidelity to human desire and will. This is, of course, to disappear the dark ecologies of fragmentation, putrification, and sickness radically out-of-step with the idealism of the 1960s Green Movement, as it is to occult the wide reaching challenges of the Anthropocene for ABER scholarship. Further, anthropic subversion recedes from a host of metaphysical, ontological, and philosophical challenges coextensive with the climatological and geological upheavals of the Anthropocene. The anthropic conceit that the world is for us is herein confronted with the horrific thought of an impersonal planet in which human life and vitality no longer figure as privileged modes of being (Thacker 2011).

Revenge is, of course, an all-too-human sentiment. It is perhaps more suitable to suggest that the Anthropocene palpates a mode of pessimism in which we are confronted not with the vengeance of an anthropomorphized planet, but more horrifically, a planet indifferent to the transcendent status and primacy ascribed to human life. Herein, the Anthropocene constitutes a mode of reversal in which the planet for-us is thrown into metaphysical contortion. Such upheaval introduces a new problematic for ABER scholarship wed to the humanistic virtues of holism and equilibrium, if not the privileged position attributed to human creativity and artistic genius more generally. For what the Anthropocene portends is the emergence of an object that no longer finds equivalency in human creative desire, but rather, detaches along an unfathomable vector without-us (Thacker 2011).

That arts-based research frequently situates itself in relation to social, political, and ecological backdrops is, of course, not errant. Rather, if we might entertain an error, it is that ABER does not yet go far enough. For what remains intimate to much contemporary ABER but the latent presumption that the world conforms to human thought, or rather, that the world exists by dint of our ability to think and create it? The revelation of the Anthropocene is that this presumption no longer holds, or rather, that this presumption has been reversed with fatal consequence. The acceleration of carbon emissions, toxification of planetary oceans, and radical transgression of ecological carrying capacities[4] have already inexorably altered the planet (jagodzinski 2014). As accounts on planetary transformation from the Stockholm Resilience Center report, it is too late to go back (Adam 2008; jagodzinski 2014). Here, ABER's indexical relation of the planet to human creation and vitalism constitutes a disastrous contemporary delusion insofar as it disappears an inexorable encounter with the limits of human creation, meaning, and vitality. Where ABER demonstrates an often obsessional preoccupation with the question of how we might live, it disappears an encroaching confrontation with how we might die. The savage conditions advanced by the Anthropocene call for new modes of 'believing in this world', where belief itself is recapitulated alongside pressing questions of death and extinction, or as Cioran (2012a) posits 'it is too late to relearn...dying out?' (p. 155).

PART III: ALLEGIANCES TO 'LIVED ORGANICITY' AND AN ESSENTIALLY HUMAN EXPERIENCE

The challenge of the Anthropocene for contemporary arts-based research emerges again in relation to what Colebrook (2014) dubs the triumph of lived organicity. While the field has long demonstrated fidelity to the role of the body in meaning making and non-representational artistic production, this commitment is today accelerated through the recuperation of vitalist materialist thought and naïve modes of relational analysis. Where contemporary trends in ABER scholarship are marked by a return to life as an affirmation of affect and material difference, such a presumption potentially maintains that both 'thinking and theory are primarily organic' and further, always-already correlative to the 'raw life' (zoe) of the organism (p. 38, 70). Not only does this commitment privilege vitalism as a primary condition for life, but fails to question why artistic thought should be made to return to affective and embodied forms of existence in the face of non-human, or rather, non-organismic vectors of planetary transformation, geotrauma, and extinction coextensive of the Anthropocene (p. 40). More pointedly, the correlation of life and vitalism in ABER labours in anthropic subversion of the inhuman, and in particular, of 'life forms' that do not reflect the ideals of human consciousness and productivity. As Cioran (2012) sombrely elides 'life is only a prejudice' (p. 90). The ascription of human vitality to the meaning of 'life' herein functions to perpetuate a romantic ecological ideal that falls short of apprehending the dark ecology of a planet both composed of dead matter and populated by 'things' possessed of an unfathomable will occulted from rehabilitation into human systems of significance (Thacker 2015).

This general critique rejoins with a horrific prospect of the Anthropocene. In an era of mass extinction and encroaching ecocatastrophe that speculatively foretells a future without human life, or rather, human life as it is presently organized, the generalized return to organicity, and the raw life of the organism as a foundation for sensation and thought appears anachronistic. As rates of species extinction accelerate to the number of 100 extinctions per million species a year (De Vos et al. 2014), the return to inter-relational vitalism disappears as the bleak reality of species loss and the speculative moment when the (human) organism will no longer insist to either passively 'think' or sense the world. As Colebrook (2014) sombrely elides, '[t]here was a time, and there will be a time without humans' (p. 32). For Colebrook (2014), the encroaching event of extinction makes

apparent that 'what we are is not something essential' (p. 13). Starkly put, the necessity of prolonging the 'human' or organism as an image of thought implicitly worth preserving must be put to question, as it is in Weisman's (2007) The World Without Us, where the 'liberation' of forces from under patterns of human representation is imagined from the vantage of the world-without-us (Colebrook 2013).

Only 'after the death of man' as a transcendent index for meaning might 'we' fathom the always-already inhuman queerness of a planet receding from human will (Colebrook 2011, p. 11). Here, the Anthropocene portends a time when we may no longer be either human or organism, but rather, as geological or technological strata persisting after our disappearance as organisms. Herein, Colebrook levies an implicit reversal of ABER's commitment to vitalist thought, for though we are living out a moment in which lived organicity is again valorized, there persists nevertheless the impossible question of how we are and will be thought from a vantage outside the human. Such a question not only pertains to the ways in which we have become epigenetically and physiologically 'thought' by chemotoxic, radioactive, heavy metal 'actants', but more expansively, how our productivity and consumption will be 'thought' as a geological marker imprinted upon the planet. This speculative scenario posits a limit that no longer presumes thinking as organic, but rather, via an impersonal vantage through which human life might nevertheless be 'read' and 'envisioned'.

What ABER's return to the organism as a privileged mode of artistic being disappears is the becoming-imperceptible of organic life, or rather, the radical becoming of organic life along a vector of its own disappearance. It is this very omission that is today reversed insofar as the Anthropocene deviates from the conceit that the world is for-us. Linked directly to effluent runoff, resource extraction, and climate change, scientists have today identified over 400 planetary dead zones or hypoxic ecologies incapable of supporting life (Zielinski 2014). Palpating an image of the planet without-us, these and other contaminated zones such as Chernobyl, Fukashima, and the future Northern Alberta suggest a fatal reversal of our presumed ontological immortalism (Thacker 2011). Extending into a host of speculative fictions concerned with the imaginary exploration of the world after man,[5] the Anthropocene marks a geological moment in which the vaunted position of human vitalism and embodiment become subverted in lieu of more horrific and uncertain horizons for thinking.

Constituting a bleak reversal of organicity proselytized by the world without-us, the Anthropocene suggests a vector of becoming that eclipses

the fundamental givenness of subject and organism that continue to found much arts-based educational scholarship. Even the vogue uptake of the posthuman and its contingent attachment to the decentred (human) organism has scarcely begun to imagine the indifference of either the inhuman or impersonal outside vantage beyond the gaze of the organism. Herein, the prospect of extinction short circuits the readymade link between perception and organism, dehabituating thought from organismic survival and the paralyzing familiarity of all-too-human 'life' (Colebrook 2014, p. 61). In lieu of founding arts-based education research in the perception of the organism, the vectors of extinction wed to the Anthropocene engender the question of how we will be seen from the vantage of no one and nobody (Colebrook 2014). This implicates how art might be read as a stratum of planetary transformation, and further, how it might be thought from the vantage of a time 'beyond human reading' (p. 23).

PART IV: THE EXHAUSTIVE COLLAPSE OF HUMAN MEANING MAKING

Extinction pertains not simply to organisms, but to meaning itself. In the wake of the Anthropocene, orthodoxies of human meaning making have begun to collapse into conceptual exhaustion. '[T]he environment' venerated from the vantage of human aesthetic and biological value, 'nature' as a romantic essentialism distinct from economic and cultural milieu, and 'human adaptive optimism' as the conceit of limitless human adaptation have become obsolete (Oreskes and Conway 2014). Beyond the problematics the Anthropocene poses for ABER's veneration of the world's givenness to art, its idealization of 'green' ecology, and reification of the organism as a fundamental metric of meaning making, exists a darker scenario in which we are confronted by a world receding from human meaning making more generally. As an overarching commitment, the labour of arts-based research pertains overwhelmingly to the representation of the given world as it is according to the phenomenal experience of human activity. Accelerated via the vehicles of narrative inquiry and autoethnography, the field today reflects a preoccupation with the representation of experience, but from the perspective of a single species. While such experience is of course varied and differing, the commitment nevertheless suggests complicity with the Anthropocene's synonymous designation—the homogenocene. For where ABER's critical-analytical commitment lies in

the excavation of interior human experience externalized in the phenome-nal world of humans, it nascently suggests that there is but the readymade conceptual affordances and interpretive indices of the given world.

While the Anthropocene etymologically refers to 'the age of humans', the reversal of human interest and teloi it commences suggests a concomi-tant era of misanthropic subtraction, where the orthodoxies of human conceptual systems and modes of knowing are confronted by the emer-gence of hitherto occulted worlds non-resemblant to the world presumed by humans (Thacker 2011). As Eluard portends, 'there is another world, and it is this one' (Wark 2014). Eulard's insight prefigures the contempo-rary speculative work of Anthropocene climatologists, who suggest that the death of the world as we know it will not be the death of the world per se, but rather, that in the wake of ecocatastrophe, new worlds may begin to flourish (Wade 2015). This posed, a prominent insight emerging from the Anthropocene pertains to the fact that other worlds have always-already flourished irrespective of their registration by humans.

The faint detection of such worlds has long been the fascination of the weird and science-fiction genres, the very function of which has aimed to dehabituate thought from the image of a given world. Herein, ABER's compulsive drive to represent, or better, over-represent reality through the varied vehicles of representation it mobilizes confronts a horrific limit. Specifically, where the Anthropocene's reversal of human exceptionalism palpates the prospect of unfathomable non-human worlds, ABER is con-fronted by the noumenal pessimism it implicitly disappears in its presump-tion that the world-for-us is contiguous with the world-in-itself, or rather, that the world is but the externalization of interior processes, and the a priori givenness of the world to rational sense (Thacker 2015a). Here, ABER's commitment to multiple-representation and semiosis appears as a panicky evasion of exhaustion prefigured by noumenal transpiration of the non-human. Put differently, where we are now confronted with worlds that recede from those systems of knowing and representation that con-tinually attempt its capture, we are confronted by the inconsolable realiza-tion of the poverty of thought.

That ABER's commitment to meaning making now extends along every possible vector of representation and aesthetics implicitly contends that there must be more (Thacker 2015a). Astride this gambit, however is a scenario in which we have already realized a limit. As Baudrillard (1990) elides, with modernity we have already realized the overproduction of 'signs, messages, ideologies, and satisfactions' (p. 2). More significantly,

the attempt to represent and excavate reality today points to our inability to do so. In the face of complex geotraumatic upheaval, the presumption that there must be more is beset by the prospect that current fashions of thought have reached a terminus outstripped by the vast inhuman complexities of geological and ecological change. Already, the fields of cosmology, geology, and population biology register a finitude to human immortalism that is concomitantly a finitude of thought itself (Thacker 2015a). This begets the question of what should be done with thought and representation in the face of their exhaustion and extinction as a relic of a bygone era?

Canadian literary critic, environmental activist and novelist Margaret Atwood, speculates that the time for producing 'realistic fiction' is over (Neary 2015). In an age of tumultuous social and planetary change, Atwood contends that fiction must be delinked from the demand that it reflect reality. For as Atwood asserts, there no longer exists sufficiently stable ground on which to base realistic fiction. While enigmatic, Atwood's gambit might be expanded in a manner that commences new metaphysical conditions for believing in the world. Such an upheaval constitutes an immediate challenge for ABER, for where much of its fictional work aspires to reveal the reality of social structures and events for humans, the revelatory function of such work often reproduces the general schema of the given world, arriving at an image of reality that looks much like the one it began with (Thacker 2015a).

In the wake of the Anthropocene and its derealization of human scale, time, and history, we have perhaps begun to witness the 'futility of the realist impulse' (Thacker 2015a, p. 150). As the planet recedes from the image of the world's givenness to human thought and analysis, realism becomes exposed as the ambit of human philosophical privilege, and the attempted disappearance of what realism cannot fathom; that is, the gap between the given world and the world occulted from human thought (Thacker 2015a). That arts-based research might recommence a belief in a world not yet stricken by the poverty of all-too-human thinking necessitates the counter-actualization of those theoretical systems, 'hallowed texts', and consecrated masters received and championed in the academy (Wark 2014, para. 6). Such a commitment not only necessitates acknowledging the 'conservative habits' of critical thought,[6] but the doomed future of 'answering... contingencies with... old quotations'[7], interpretive schemas, and disciplinary dogmas (Wark 2014, para. 6).[8] In the face of encroaching conceptual exhaustion, the task of critical thought and

research must involve the dismantling of habitual 'discursive games' and dilated beyond the scope of the given world (para. 8).

Here, we might rejoin with the 'detotalizing capacity of speculative imagination' to not only postulate vectors of the future, but as Reed (2014) argues, to map such vectors upon the present (p. 530). This tactic palpates the question of how ABER might be reoriented in a manner adequate to not only the acceleration of planetary change (the question of what accelerates), but the encroachment of speculative, post-Anthropocene futures from which we might mobilize new dispositions for living and dying. For with the introduction of new problematic fields, speculative thought produces conditions for the dehabituation of thinking and action insofar as they are opened to 'what awaits at the edge of epistemic certainty' (p. 530). Put otherwise, it is in fabulation that we might eclipse the axioms of the given, rehabilitating futures disappeared in their dogmatic tethering to the anthropomorphized image of the world and its grounding in the humanist conceit that the world-for-us constitutes the horizon for all potential worlds (Reed 2014). This is indeed an escape, where what is evaded is the reduction of thought to an existent set of analytic and conceptual affordances.

PART V: EPISTEMOLOGICAL MISTAKES AND TOPOLOGICAL EXPERIMENTS

ABER claims to bring together scholarly inquiry and creative processes for the purpose of exploring questions and expressing knowledge not necessarily accessible or re-presentable through other means. As we have seen, however, ABER's supposed liberatory project continues to operate through the deep-seated anthropocentric assumption that the world can be correlated and interpreted through all-too-human regimes of representation. As a result, ABER propagates the uncomplicated transference of the world, even in its current state of degradation, unto both aesthetic redemption and the production of knowledge that is always-already correlated to meaning made for us. The epistemological assumptions operating in and through arts-based scholarship must therefore be questioned, particularly given the geological events of the Anthropocene and the planetary repercussions of the impending ecocatastrophes that have come to characterize our contemporary existence. In order to overturn these common-sense assumptions about knowledge, it is therefore necessary to experiment

with alternative epistemological speculations where knowledge is instead understood in terms of its power to eclipse the axioms of the given world, thus repositioning ABER as a 'problematic field' through which the future of educational research might be speculatively re-evaluated in terms of its capacity to rehabilitate otherwise disappeared futures.

The epistemological limits portended by contemporary approaches to ABER ultimately work to disappear the inherent noumenal or occulted regression of things through coding mechanisms that can be interpreted and understood by the so-called human subject. As we have seen, this 'art of disappearance' (Baudrillard 1998) hallows the world's givenness to art through the idealization of epistemological modes such as those propagated through 'green' ecological thinking and an unquestioned fidelity to the reification of the human body as a fundamental mode of meaning making. This disappearance, in turn, gives rise to particular methodological and epistemological commitments that operate through the ongoing aesthetic reterritorialization of the world through organizations of interminable exchange and correlation, which at the same time, disappear the limits and boundaries between disciplines and fields of study while habituating conceptions of knowledge to the image of a given world. In educational domains, for instance, the increasing promotion of arts-integration across the curriculum operates as both a technique for generating intellectual challenge, inquiry skills, and initiative, as well as a mode for reproducing the vocational knowledge and skills that have been recognized as integral for participation in today's globally-connected economy (Aprill 2010; Elkins 2008; Eisner 2002; Trilling and Fadel 2009). Likewise, in the world of business, artistic practices are now recognized as popular technologies with which we can better approach the 'creative economy', offering business leaders important lessons on how to take criticism, increase motivation and audience engagement, and produce bigger, better solutions to business problems (Pink 2005; Bell 2008). This transaesthetic metamorphosis of all disciplines under the seemingly affirmational project of 'art' provides a means to an end; that is, an end wherein human subjects can accumulate and apply the necessary skills and knowledge recognized by the interconnected global project of designer capitalism.

At first glance, this metamorphosis, and its necessary disappearance of boundaries and constraints, may seem fruitful in terms of thinking knowledge and its limits in alternative ways. Upon closer examination, however, it becomes clear that this art of disappearance effectively reproduces homogenous epistemological definitions overcoded by pre-existing

images of what has been considered 'useful' or 'good' by dominant social, political, and economic organizations of the past-present. Such epistemological commitments, which are now characteristic of arts-based research approaches more generally, fail to recognize how these assumptions about knowledge perpetuate the compulsive drive to correlate and over-represent reality through the limiting boundaries and categories produced by the human species. It is this correlationist tendency that ultimately works to limit how knowledge is, or might be conceptualized otherwise.

The legacy of correlationism is a key factor in the way ABER continues to operate. Quentin Meillassoux (2008) articulates this legacy in *After Finitude: An Essay on the Necessity of Contingency*, in which he outlines the problem of correlationism as the philosophical commitment that access to the world is only ever access to the correlation between thought and its object. As Meillassoux writes, the thesis of correlationism asserts 'the essential inseparability of the act of thinking from its content [such that] "[a]ll we ever engage with is what is given-to-thought, never an entity subsisting by itself"' (Meillassoux 2008, p. 36). In ABER, the problem of correlationism therefore pertains to a presupposed philosophy of access that assumes that reality exists only to the extent that we, as humans, are able to think it. This correlationist legacy is apparent in Baudrillard's concept of transaesthetic metamorphosis, operating through the veneration of the world's givenness to an art that always-already exists. Likewise, through the idealization of 'green ecologies', and the drive to redeem the world through art, credence is given to images of thought that have been considered 'good' in the past, in turn essentializing those images of thought as fundamental realities. In light of the growing warnings of anthropogenic climate change and planetary degradation, however, it has become clear that what has been considered 'good' in the past fails to respond to the real, material conditions of the present. The fidelity to lived organicity (Colebrook 2011) within ABER, for instance, has positioned the human body as a fundamental and essential correlate with which meaning making can and should occur. This reification of human exceptionalism, and the corollary preoccupation with the representation of sense experiences from the perspective of the human species, fails to recognize the other flows of life that flourish irrespective of their registration by human subjects. In brief, the correlationist legacy through which ABER continues to operate produces a poverty of thought in terms of how knowledge itself is conceptualized.

How, then, might arts-based research be able to produce knowledge that is more adequate to the challenges raised by the Anthropocene? In his discussion of the nature and origin of the mind, Spinoza (2009) posits that in order to understand what constitutes knowledge we must distinguish between adequate and inadequate ideas. For Spinoza, sense perception; that is, one's individual and phenomenological experience of the world is an inadequate idea due to the fact that this representation is unavoidably coloured by the lens of one's own body (Spinoza 1989). As Spinoza writes: '[i]t follows,[...], that the ideas which we have of external bodies indicate the condition of our own body more than the nature of the external bodies' (Part 2, PROP. 16, Corollary 2). Put otherwise, even through sense experience itself, which in arts-based research practices assumes a direct access point to the world, knowledge is obscured by the correlation of experience to the limits of our own bodies. Similar to the myth of the given world, this epistemological mistake; that is, the idea that the immediacy of what is known can be correlated to the cause of that knowledge, assumes that the body can experience the world in a way that is unaffected by other factors, and thus the world can be accessed as it is given. The myth of the given has been long underscored by the notion that our sensory experience is itself a kind of reliable given, a thought that has come to define both artistic production and reception. In ABER, this unquestioned correlation between the world and sensory experience has been taken as the basis for its own disciplinary development, with the advent of approaches such as a/r/tography, which advances an image of the natural world that is divorced from culture, but nevertheless submissible to human phenomenological inquiry. This epistemological mistake has, in turn, led to the faulty conclusion that it is the critical stripping of art's disciplinary norms, its boundaries and constraints, in favour of a perceptual purity or lived organicity that produces art's own potential for critical development. It is this privileging of human experience that fails to acknowledge the inadequacy of sensory perception as a mode of knowledge production, especially in the face of the continued non-human planetary transformations taking place around us.

In addition to the assertion that sense perception only ever offers an indirect access point to the world, Spinoza also asserts that this mode of knowledge production is also limited in terms of how it understands relationships between bodies, including their effects and causes. As Spinoza writes, 'the knowledge of an effect depends upon and involves the knowledge of its causes' (Part I, Axiom 4). At the same time, however, the mind

cannot process or contain all of the possible causes of a given body, and thus the mind's ideas of external bodies, whether physical or conceptual, are all inadequate. It is through this mode of knowledge that we distinguish, categorize and order things without perceiving the multitude of causes that determine them to be. In this way, the only sort of falsity ideas are capable of is revealed in their inherent incompleteness. In the case of arts-based educational scholarship, the epistemological assumptions through which the field operates are, therefore, only false insofar as they are unable to perceive the connections to other ideas and ways of knowing that constitute these assumptions in the first place. By relying on necessarily limiting correlationist tendencies, arts-based research continues in spite of its own inadequacy, thus limiting conceptions of knowledge production to those which can be correlated to images of thought that always-already exist. In order to recognize its own inadequacy, it is therefore necessary for arts-based research approaches to analyse their own given myths and axioms, particularly in relation to the correlationist legacies and anthropocentric perspectives that have come to dominate both thinking and action in the field. Such analysis necessitates the reformulation and reorientation of knowledge categories, sites and topologies themselves.

As explored above, dominant approaches to arts-based research are founded on a correlationist legacy wherein limits and categories are produced through a priori indexes where knowledge is always made to produce meaning 'for us'. The Earth, for example, has been mapped upon the modernist index and aspiration that it be developed and modified according to distinctly human will and desires. Likewise, distinctions between human and non-human species, between so-called culture and nature, have been produced through particular mappings wherein bodies are categorized based on pre-determined divisions and correlations. In this way, it is the map itself, that is, the human indexes and regimes of representation that have come to create the territory. As Deleuze and Guattari (1987) write, maps have traditionally functioned to produce representations, significations, and layers of readability, such that the subject may inhabit that territory, calling it its own.

Within ABER, it is the map of the world made to mean for us, the given world that has indexed knowledge to this givenness, ultimately impacting the epistemological categories and connections that can and cannot be made. As Deleuze and Guattari (1987) write, however, there are other ways to map a territory. Referring to their concept of the rhizome, the duo posit that, unlike the Cartesian map, which presents itself as a completed

image of any given territory, 'the rhizome pertains to a map that must be produced, constructed, a map that is always detachable, connectable, reversible, modifiable, and has multiple entranceways and exits and its own lines of flight' (Deleuze and Guattari 1987, p. 21). Put otherwise, mapping can operate through the familiar process of starting from a series of axioms (a grid), and organizing bodies based on these re-established categories and limits, or mapping can unfold as a nomadic and referential process wherein territories are created through dynamic vectors that are associative while also non-commutative This alternative conceptualization of mapping offers a more topological approach to the understanding of relationships; that is, this operation conceptualizes relationships not as given states, but for what these relationships can possibly become, where notions of scale and measurement are replaced by concepts of thresholds and trajectories.

Transposed to the site of epistemology, and ultimately ABER, a topological approach would therefore radically extend knowledge from the strictures of correlationist representation, allowing it to explore the elasticity of contexts and thresholds of processes. It must be noted, however, that this extension is not the same as Baudrillard's (2008) conception of a transaesthetic metamorphosis, characterized by the disappearance of boundaries and limits. Instead, a topological conceptualization of knowledge production asserts that generalizations and categories can indeed be created, but only by dropping the assumption that observable qualities, such as those created through sensory perception, always commute. Put otherwise, this epistemological position is constituted through limits and boundaries that offer dynamical modes of circulation and transformation between images of thought, while also acknowledging the inadequacy of its own knowledge production based on the assertion that these relations are never completely contingent. In this way, a topological understanding of knowledge moves away from the postmodern paradigm of 'anything goes' by revealing the inadequacy of our models to think through both our epistemic panic and normative paralysis, thus providing us with the necessary tools to trigger new dynamics that are capable of responding to the pressing challenges characteristic to the era of the Anthropocene. It is these new dynamics in thinking, brought about by alternative speculations and experimentation with the limits and definition of knowledge itself, which might reposition ABER as a radically antagonistic and ultimately productive field of scholarship.

Part VI: The Betrayal of Affirmation

In characteristically pessimistic fashion, Cioran (1999) writes that hope is a contradiction of the future (p. 83). As a prescient caveat on the encroaching uncertainties of the post-Anthropocene and the prospect of an inhuman world-without-us, Cioran symptomatizes hope as a modern form of delirium. In lieu of an encounter with the ruins of thought, of extinction, and exhaustion, hope becomes a vehicle for lying to ourselves (Thacker 2015a, b). Against ABER's pulsional motors of affirmation, this disposition is undoubtedly unfashionable if not outright repugnant. For evidenced in the privileged position accorded to the limitless creative potential of the subject, the necessary production of newness, and distrust of negativity, the field of arts-based research inheres a fundamental commitment to affirmational affects and thought (Noys 2010).

Where negativity insists, it is today recuperated within an affirmational model of life, and subsumed within a broader calculus of positivity and potential (Thacker 2015a). This scenario characterizes the fate of Arts Based Research: A Critique and Proposal (2013), the betrayals of which have been largely recuperated within the field, or otherwise ignored as an act of ignoble or treacherous negativity. This posed the commitment to affirmational affects in the field of arts-based research obfuscates its own betrayal. That is, this affirmational tendency has become a privileged mode of production, one premised on the negation of negation, and as a result the problematics of non-being and non-existence that are corollary to the post-Anthropocene horror of decay, extinction, and thought's absence, are simply not considered. For what the field of arts-based research often dubs 'affirmation' is but the articulation of tolerable thought selecting for the positive (i.e., adaptation, creation, becoming, and evolution) as a claim to 'how things really are' (Thacker 2015a, p. 158). This is to disappear the question of how negation exceeds subjective creativity, newness, and happy affects; or rather, the question of how the Anthropocene might subvert the abuses of romanticism coextensive to the celebration of hope and living well (Cioran 2012). This is to expand those tendencies of doubt already at work within the field by accelerating the question 'where does doubt stop?' (Thacker 2015a, p. 158, added emphasis). As it pertains to the limits of doubt, the field of arts-based research maintains a familiar horizon in self-consciousness, identity production, and creative becoming. There is, of course, nothing errant in this, and certainly, every thinker participates in their own practices of negative non-affirmation. Rather, it

is simply to say that within the field, the commitment to affirmation has disappeared the acceleration of doubt into nihilism, or rather, the 'disenchantment of the world' via the revelation of what it cannot or dare not say (pp. 162–163).

The challenges of the Anthropocene and encroaching events of a post-Anthropocene future necessitate less a new line of flight for arts-based research than a style of non-philosophy through which we might begin to rethink arts-based research in a manner that does not begin with arts-based research (Laruelle 2012). What becomes of arts-based research, for instance, if we begin not within its conceptual affordances or methods, but with a speculative reorientation irredeemable, if not violent, to its habits and prejudices? Ultimately, such a question is less remote to arts-based research than it is the horrific inversion of its key commitments. Within contemporary approaches to ABER, where the fashions of limitless human creativity, meaning making and vital living production have reached their terminus in the Anthropocene, such commitments are confronted by the terrible repercussions of their inertia and intensification brought on by the drive to terraform and correlate the whole of reality under the image of human expressive potential. If the 'revenge' or reversal of contemporary planetary-becomings portends anything, it is a style of disappearance, but from the vantage of the object, or better, the inhuman vantage of a world-without-us. Put differently, both the Anthropocene and encroaching post-Anthropocene moment is a becoming-imperceptible of the human, if but to reveal the dark side of things, or rather, the contortion of metaphysics from the impersonal perspective of no one (Colebrook 2014). This is not the end of arts-based educational thought, but a potential beginning that faces up to an encroaching future in which art and its reasons will necessarily undergo metamorphosis, though not necessarily of its design or will—the vigil of the inhuman over all present ecstasies.

POST-SCRIPT: NOTES ON THE FUTURE(S)

If the Anthropocene can be thought alongside Baudrillard's (1999) advocacy for an oppositional theory-object, such a thought might constitute a sufficient reorientation to the meta-philosophical correlationism and philosophical self-presumptions[9] of ABER (Laruelle 2012). As we have attempted to explore in this chapter, it is via the albeit speculative inhuman vantage of the Anthropocene that we might begin to discern the limitations of ABER vis-à-vis its ways of knowing, and further, by attending to

what such knowing cannot know. Elsewhere, we have dubbed this a matter of disappearance, knowing full well things disappear only as a special effect of correlationism, or rather, the presumed adequation of thinking to the Real (Laruelle 2012). This is not a petition to somehow create a more adequate account of reality, but rather, to palpate the realization that the dominant orientations of ABER need to mutate for particular things to be thought at all (Mullarkey 2013).

ABER's familiar presupposition that reality is given to art and artistic thought suggests a stance that must be put on trial in order for its material tendencies to be re-directed from the authoritarianism of the creative-genius, the correlative presumption of reality's becoming-art, and those reflexive mirror games that condition thought to an image of what-is—as if the horizon of ABER was simply to repeat an image of reality already given to thought (Maoilearca 2015). Against these dogmas, we have aimed herein at reversing the automatic adequation of artistic and philosophical thought to the Real by palpating a style of thinking directed from the Real to artistic and philosophical thought (Mullarkey 2013). To accomplish this reorientation, we need not necessarily evoke the conditions of a planet out-of-synch with the presumptions of ABER, although a critique of ABER's presumed adequacy to the realities of immanent ecological catastrophe remains a quite necessary project. The point is simply that there is no thought adequate to reality, and for this fact, thought must be made to mutate in a manner immanent to the Real, or rather, the flatness of all ontologies without singularity and exclusivity (Mullarkey 2013).

If the arguments advanced in this chapter have general import, it is in their demonstration of thoughts (and not necessarily human ones) for which ABER's dominant positions are inadequate. The aim herein is not to inspire a new form of relationality, which might very well amount to those modes of correlationist adequation from which this essay seeks to escape. Rather, and not without difficulty, we have sought instead to articulate a reorientation capable of negating ABER's presumed sufficiency of thought (Maoilearca 2015). It is important to note that this is not tantamount to an assertion of ABER's end. Instead, it is to advocate a re-direction of arts-based educational thought immanent to the Real—a project that necessitates the radical mutation of its material resources towards realities-without-givenness (Laruelle 2012).

NOTES

1. We switch between 'arts-based educational research' and 'ABER' as it has suited the flow of the chapter.

2. The ascription of human vitality to the meaning of 'life' labours to perpetuate a romantic ecological ideal that falls short of apprehending the 'dark ecology' of a planet both composed of dead matter and populated by 'things' ostensibly possessed of their own unfathomable will (Morton 2010; Thacker 2012). As Thacker speculatively contends via the petrol-horror fiction of Fritz Leiber's 'Black Gondolier', the vaunted position of human vitalism and embodied affect might be subverted that other horizons for thinking such as Leiber's speculation on the unfathomable prospect that 'oil discovered man' might be mobilized (p. 175).

3. Recent geochemical studies on rates of oceanic acidification suggest that current rates of carbon emission parallel those of the Permian Extinction event, which saw 90 % of the planet's species extinguished (Clarkson et al. 2015).

4. The planet has already eclipsed its regenerative 'carrying capacity' by a stupefying 30 %.

5. The frozen images of London in Danny Boyle's (2002) *28 Days Later*, the desolate rendering of the Sydney Opera House in Juan Carlos Fresnadillo's (2007) *28 Weeks Later,* and the decay of New York City figured in Francis Lawrences's (2007) *I Am Legend,* each pertain to thinking the end of the human species from an inhuman vantage beyond organicity or reference for any *body* (Colebrook 2013, p. 26).

6. Where critical thought has become habitually oriented to the critique of superstructure and rise of capitalism as its main objects of critique, Wark (2014) elides, it remains all-too-human in its fidelity to human scales of production and time.

7. ABER and curriculum theory are replete with their own prophets and territories-of-use overdetermining in advance what is possible to think.

8. The Marxian assertion that humans 'alone create their environment' harbours a stealth anthropocentric commitment (Morton 2010, p. 72). By extension, the analysis of superstructure intimate to much educational research belies the fact that all variety of forces (leaf

cutting ants, corals, chthonic upheavals) are at work in producing life (Morton 2010; Wark 2014).

9. Here, we have in mind ABER's treatment of the subject as the privileged site for the manifestation of difference.

REFERENCES

Adam, D. (2008). Too late: Why scientists say we should expect the worst. Retrieved from http://www.theguardian.com/environment/2008/dec/09/poznan-copenhagen-global-warming-targets-climate-change. On 3 Jan 2014.

Aprill, A. (2010). Direct instruction vs. arts integration: A false dichotomy. *Teaching Artist Journal, 8*(1), 6–15.

Baudrillard, J. (1990). *The transparency of evil: Essays on extreme phenomena.* New York: Verso.

Baudrillard, J. (1993). *Symbolic exchange and death* (trans: Grant, I. H.). Los Angeles: Sage.

Baudrillard, J. (1997). Art and artefact (N. Zurbrugg, Ed.). London, UK: Sage Publications.

Baudrillard, J. (1998). *Paroxysm* (C. Turner, Trans.). New York: Verso.

Baudrillard, J. (1999). *Revenge of the crystal: Selected writings on the modern object and its destiny, 1968–1983.* London: Pluto Press.

Baudrillard, J. (2008). *Fatal strategies.* Cambridge, MA: The MIT Press.

Baudrillard, J. (2004). *Fragments* (trans: Turner, C.). New York: Routledge.

Baudrillard, J. (2005). *The intelligence of evil: Or the lucidity pact* (C. Turner, Trans.). New York: Bloomsbury.

Bell, K. (2008). The MFA is the new MBA. Harvard Business Review Online. Retrieved from https://hbr.org/2008/04/the-mfa-is-the-new-mba/

Boyle, D. (Director). (2002). *28 Days later* [Motion picture]. United Kingdom, Spain: 20th Century Fox.

Cioran, E. (1999). *All Gall is divided* (R. Howard, Trans.). New York: Arcade Publishing.

Cioran, E. (2012). *A short history of decay* (R. Howard, Trans.). New York: Arcade Publishing.

Clarkson, M. O., Kasemann, S. A, Wood, R. A., Lenton, T. M., Daines, S. J., Richoz, S., Ohnemueller, F., Meixner, A., Poulton, S. W., & Tipper, E. T. (2015). Ocean acidification and the Permo-Triassic mass extinction. Science 348(6231): 229–232.

Colebrook, C. (2011). Time and autopoeisis: The organism has no future. In L. Giallaume and J. Hughes (Eds.), Deleuze and the body (pp. 9–28). Edinburgh: Edinburgh University Press.

Colebrook, C. (2014). *Death of the posthuman*. Ann Arbor: Open Humanities Press.

De Vos, J. M., Joppa, L. N., Gittleman, J. L., Stephens, P. R., & Pimm, S. L. (2014). Estimating the normal background rate of species extinction. *Conservation Biology, 29*(2), 452–462.

Deleuze, G., & Guattari, F. (1987). *A thousand plateaus: Capitalism and schizophrenia* (R. Hurley, M. Seem, & H. R. Lane, Trans.). Minneapolis: University of Minnesota Press.

Elkins, J. (2008). Introduction: The concept of visual literacy and its limitations. In J. Elkins (Ed.), *Visual literacy* (pp. 1–9). New York: Routledge.

Eisner, E. W. (2002). *The arts and the creation of mind*. New Haven: Yale University Press.

Fresnadillo, J. C. (Director). (2007). *28 Weeks later* [Motion picture]. United Kingdom, Spain: 20th Century Fox.

jagodzinski, j. (2014). An Avant-garde 'without Authority': Towards a Future Oekoumene—if there is a Future? In H. Felder, F. Vighi, & S. Žižek (Eds.), *States of crisis and post-capitalist scenarios* (pp. 219–239). Wey Court East: Ashgate Press.

jagodzinski, j., & Wallin, J. J. (2013). *Arts-based research: A critique and proposal*. New York: Sense Publishers.

Laruelle, F. (2012). *The non-philosophy project*. New York: Telos Press Publishing.

Lawrence, F. (Director). (2007). *I am legend* [Motion picture]. USA: Warner Bros.

Lovelock, J. (2007). *The revenge of Gaia*. New York: Basic Books.

Maoilearca, J. (2015). *All thoughts are equal: Laruelle and nonhuman philosophy*. Minneapolis: University of Minnesota Press.

McKibben, B. (2011). *Eaarth: Making a life on a tough new planet*. New York: St. Martin's Griffin.

Meillassoux, Q. (2008). After finitude: An essay on the necessity of contingency. (R. Brassier, Trans.). London: Continuum.

Morton, T. (2010). *The Ecological Thought*. Cambridge, MA: Harvard University Press.

Mullarkey, J. (2013). How to behave like a non-philosopher. *Speculations: A Journal of Speculative Realism IV* (pp. 108-113). http://www.speculations-journal.org

Neary, L. (2015). Now is not the time for realistic fiction, says Margaret Atwood. Retrieved from http://www.npr.org/2015/09/30/444775853/now-is-not-the-time-for-realistic-fiction-says-margaret-atwood. On 3 Nov 2015.

Noys, B. (2010). *The persistence of the negative*. Edinburgh: Edinburgh University Press.

Oreskes, N. & Conway, E. (2014). 14 concepts that will be obsolete after cata-strophic climate change. Retrieved from http://www.washingtonpost.com/opinions/14-concepts-that-will-be-obsoleteafter-catastrophic-climate-change/2014/07/25/04c4b1f8-11e0-11e4-9285-4243a40ddc97_story.html. On 25 July 2014.

Pink, D. (2005). Revenge of the right brain. Adapted from A whole new mind: Moving from the Information Age to the Conceptual Age. Retrieved online: http://www.wired.com/wired/archive/13.02/brain.html

Reed, P. (2014). Reorientate, Eccentricate, Speculate, Fictionalize, Geometricize, Commonize, Abstractify: Seven Prescriptions for Accelerationism. In R. Mackay & A. Avanessian (Eds.), #ACCELERATE: The accelerationist reader (pp. 521–536). Berlin/London: Urbanomic and Merve Verlag.

Spinoza, B. (1989). Ethics (G. H. R. Parkinson, Trans.). London: Everyman Classics (Original work published in 1675).

Thacker, E. (2011). In the dust of this planet: Horror of philosophy (Vol. 1). Washington, DC: Zero Books.

Thacker, E. (2012). Black infinity; or, oil discovers humans. In E. Keller, N. Masciandaro, & E. Thacker (Eds.), Leper creativity: Cyclonopedia symposium (pp. 173–180). Brooklyn: Punctum Press.

Thacker, E. (2015a). Stary speculative corpse: Horror of philosophy (Vol. 2). Washington, DC: Zero Books.

Thacker, E. (2015b). Tentacles longer than night: Horror of philosophy (Vol. 3). Washington, DC: Zero Books.

Trilling, B., & Fadel, C. (2009). 21st century skills: Learning for life in our times. San Francisco: Jossey-Bass.

Virilio, P. (2002). Ground zero (C. Turner, Trans.). New York: Verso.

Wade, L. (2015). Climate change means one world's death and another's birth. Retrieved from http://www.wired.com/2015/09/climate-change-means-one-worlds-death-anothers-birth/?mbid=social_fb. On 1 Sept 2015.

Wark, M. 2014. There is another world and it is this one. Retrieved from http://www.publicseminar.org/2014/01/there-is-another-world-and-it-is-this-one/#.U3vC3dyE6Ml. On 4 May 2014.

Weisman, A. (2008). The world without us. New York: Picador.

Zielinski, S. (2014). Ocean dead zones are getting worse globaly due to climate change. Retrieved from http://www.smithsonianmag.com/science-nature/ocean-dead-zones-are-getting-worse-globally-due-climate-change-180953282/?no-ist. On 4 Aug 2015.

Betraying Further: Arts-Based Education at the 'End of the World'

jan jagodzinski

Paying a Re-Visit

One might consider this chapter an extended addendum to the *forcework*, to use Ziarek's (2004) conceptual term, which Jason Wallin and I tried to initiate through the publication of *Arts-Based Research: A Critique and a Proposal* in 2013. This addendum is meant to, first and foremost, address a/r/tography once again, as there have been two thoughtful and critical responses to our work in defence of its research methodology, which have emerged since our book's publication: one by Carl Leggo (2014) and the other by Adrienne Boulton-Funke (2014). Both authors are members of the Faculty of Education, at the University of British Columbia, Canada, where a/r/tography was grounded. Consequently, I respond to their proposals and concerns as well as further review my concern with a/r/tography by examining the most recent articulation of its research methodology and theoretical claims as developed by its founder, Rita Irwin.

j. jagodzinski (✉)
Department of Secondary Education, University of Alberta,
Edmonton, AB, Canada

j. jagodzinski (ed.), *What Is Art Education?*,
DOI 10.1057/978-1-137-48127-6_10

The second task, which relates to my subtitle, is to reiterate and further state the 'proposal' part of our book project in relation to where we find ourselves today within 'post-qualitative' research directions that take Deleuze and Guattari as the basis of their 'post' developments. Post-qualitative research methodologies are mapped against the rise of *speculative realism*, which is why the 'end of the world' appears in my title, a position I address towards the end of this chapter.

The basic view, as developed in *Arts-Based Research: A Critique and A Proposal*, was to claim that the methodology called arts-based education was hegemonically representational and anthropocentric. Its idealist tendencies could be found through its embrace of various 'sublime objects,' to use a Žižekian (Žižek 1989) term that defines posthumanism in general.[1] By posthumanism I mean the extensions of humanism that continue under various disguises of postmodernism and poststructuralism where the human subject remains central. This is in distinction to the posthuman where the 'human' in all its possible definitions (man, species, colonial and so on) is radically questioned. This will be one of the points I wish to reiterate further in this chapter despite the rhetoric of a/r/tography research that claims proper names like Jean-Luc Nancy, Giorgio Agamben, Deleuze|Guattari and Brian Massumi. A posthumanist agenda is furthered despite claims that the authors are not doing so as will be demonstrated below.

In my view, posthumanism is not equivalent to a *posthuman* position, which is what Wallin and I advocated in our work that took into account the *nonhuman*, including concepts, affects and percepts and the *inhuman*, including technologies of becoming via artificial intelligence. The 'post' in poststructuralism refers to the obvious break with the subject of humanism, which became extended as a posthumanism through various poststructuralist formulations that emerged in the 80s with the so-called linguistic turn where discourses did away with essences and replaced them with multiplicities of differences (the Other) in relation to the same. This break, however, was away from Descartes and not Kant. Phenomenology and poststructuralism are heirs to this self-constituting subject (Colebrook 1999). In distinction, the 'post' in posthuman refers to a radicalization of the human in relation to the nonhuman and inhuman forces where the anthropocentrism of poststructuralist posthumanism is questioned. A similar argument is developed by Braidotti (2013) utilizing a Deleuze|Guattarian framework and Kolozova (2014) who draws on the non-philosophy of François Laurelle.[2] The point here is that 'material

immanence' is recognized; that is to say, a dimension of materiality that is anterior to the order of language and discourse, and to the work of concepts (cognition) and representation. We shall return to the importance of this in the second part of this chapter.

Reiterating the Radicality of the Posthuman

In the second chapter of *Arts-Base Research*, Jason Wallin and I fixated our analysis on a special issue on arts-based research that came out in *Studies in Art Education* in the year 2006 as it represented an array of methodologies that were generic to arts-based research at the time: quantitative and qualitative, phenomenological, performative, digital (Internet based) and poststructuralist. In the following third chapter, we singled out a/r/tography as it was a research direction that had claimed paradigmatic status in its completeness—it had an established identity; not only did it brand itself effectively within the art education field, as a method, it produced a host of graduate students at the master and doctoral level, each claiming to be practicing its epistemology under its signifier.[3] As a consequence of our analysis, and to maintain our concerns with representation and anthropocentrism, we called on the change of subjectivity to *singularity* and *individuation* following the radical theory of Deleuze and Guattari who drew on Gilbert Simondon to offer a completely differing notion of 'subjectivation' that is most often mistakenly cited as being attributed to Foucault, even as Deleuze made a break with his old friend to question the power|knowledge couplet he had developed. In *Foucault* (Deleuze 1988), Deleuze essentially rewrites his understanding of the 'subject' by rethinking Foucault's oeuvre to arrive at the subject of the fold. Deleuze describes Foucault's subjectivation, not one of coming back to subjectivity to somehow 'rescue' it, but rather the disintegration of the subject by a field of forces where identity no longer survives (*Negotiations*, 93). Becoming is always a deterritorialization, an un-becoming, the undoing givenness of the given.

To question arts-based research's emphasis on anthropocentrism, we continued to draw on Deleuze and Guattari, taking *seriously* their radical materialist claim in *Anti-Oedipus* (Deleuze and Guattari 2004) when they explicitly state 'we make no distinction between man and nature: the human essence of nature and the natural essence of man become one within nature in the form of production or industry' (p. 4). Hence our argument was to shift the ground from posthumanist research methodologies that charac-

terize the field to critical posthuman research where both the *nonhuman*, in relation to anoganic life (what we called *zoë* throughout), and *inhuman*, in relation to artificial intelligence of technologies and the agency of data to further grasp the differential understanding of subjectivity. To that end, in Chap. 4, we drew on Sterlac, Orlan and Wafaa Billal as three artists who were developing forms of a posthuman subjectivity where the assemblages with nonhuman and inhuman were well understood: Sterlac and Orlan's techno-bio experimentation and Wafaa Bilal's performative experimentation with video and game technology by becoming a live target were, we felt to be exemplars of such 'research.' We specifically noted that Bilal performative art was a clear example of counter-actualization.[4] We ended our forcework with a series of *provocations* asking for a turn in arts-based research based on a further decentring of the human.

The next section of this chapter addresses why I continue to fail to understand how a/r/tography is a materialist ontology as its defenders claim in relation to what was our fundamental thesis regarding representation and anthropocentrism, although the names of Deleuze and Guattari continually appear more and more of late (e.g., Carter and Irwin 2014). I argue that in its current form a/r/tography continues the posthumanist paradigm as it began in 2004, although the wording has changed to make it seem *au current* in recognition of a theoretical shift that is taking place in some philosophical sectors. Basically, I see a/r/tography closer to a form of ethnographic action research as a management model capable of coping with difference that circulates within a framework representation given the structural power relations that are in place. Its politics remain democratically conservative and pluralist. Relationality, becoming and affect remain conceptually interpreted in representational terms even at the late date of 2014 given that seven years have passed since a clear statement of what a/r/tography precisely 'is' was articulated by Irwin (2007). This is not to dismiss a/r/tography as a research direction. Rather it is more to distance myself from its approach, confirm my earlier concerns, and further articulate my own 'proposal' for a more radical approach that takes the Anthropocene into account. As stated earlier in our work, nothing the both of us might say will necessarily detract those who practice and accept the tenets of a/r/tography. It may and has had the opposite effect: it has hardened the lines of difference as an ethical and political 'cut' had been made within the field between representational approaches and non-representational ones.

The two sections that follow address responses to the book, while the last two sections discuss post-qualitative research, which is followed by an extension of critical posthuman art education in light of how speculative realism and Deleuze|Guattari do and do not come together in relation to the pressing issues of the Anthropocene.

The Thin Veil of A/r/tography

In an essay[5] that clearly articulates and states what a/r/tography stands for, Being is prominently on display. Irwin writes, 'A/r/tography begins with Being. Perhaps it is all about Being' (Irwin 2007, p. 74; Irwin 2008). One would immediately think because of the capitalization of Being, which appears ubiquitously throughout this essay that this is a clear give-away of a (post)humanist research direction. But this would be an initial mistaken assumption as the philosophy of Jean-Luc Nancy is called on at the start to frame this research, which would suggest otherwise.[6] It is not the theoretical rhetoric that surrounds the claims of a/r/tography research, which make me continue to press its (post)humanist orientation, but the subtle misunderstandings that go on in interpretation, as well as the renewed vigour of anthropocentrism in what this research actually *does*. The subtle distinctions are inserted only when Irwin leaves Nancy's quotations (and Agamben's for that matter) and begins to interpret Nancy's expansion of Being. She says, for instance, 'Moving from common form to singularity are not *events* but rather moments of gradations in many directions. Meaning resides in circulations, multiple circulations traversing many directions simultaneously creating meaning in that which passes between us [then a self-citation is inserted]. This "*in-between*" is neither consistent nor connective but rather *contiguous*' (p. 76, my emphasis added). Irwin is alluding to a rhizomatic metaphor that is interpreted, in this case, as a plurality of positions. The meaning of contiguous is being in actual contact or touching along a boundary or at a point. This reinstates the direct connectivity that is being problematized. This is neither Nancy nor Deleuze but an understanding of meaning and relationship that is consistent with poststructuralism of which neither Nancy nor Deleuze is party to.[7] The in-between for Deleuze and Guattari (1987) is stated enigmatically as:

> Between things does not designate a localizable relation going from one thing to the other and back again, but a perpendicular direction, a *transversal movement* that sweeps one and the other way, a stream without beginning

or end that undermines its banks and picks up speed in the middle (*TP*, 25, added emphasis).

The traversal moment is a lightening flash when the *virtual* components of a heterogeneous series collide. Here is where an event's contingency happens, or simply 'shit happens.' Such events are *incorporeal and virtual*. They are the results of actions and passions of bodies that are not 'moments of gradation' but cuts and wounds—microshocks.

Nancy posits only an originary distance in relations, while Deleuze develops subjectivity through the *event*. There is no 'in-between' in the way Irwin treats this term or the exchanges of communication in a/r/tography. Deleuze's singularity addresses a 'wound' that deterritorializes the self (Sellars 2006). The event in a/r/tography becomes far too pedestrian in its self-reflective moments of communication of so-called becoming, rather than identifying an event's nonconscious elements where a repetition as *Wiederkehr* (repetition that has a 'turn' [*kehr*]) takes place via counter-actualizations[8]. The act of wounding itself is an event, which is then actualized in the wound but not reducible to the wound itself. The non-actualized effects of events, the effects on thought are simply omitted. The event's virtuality is missing in Irwin's account. There is no ethical address to be 'worthy' of the event that shapes us, the *amor fati* that can lead to a 'grand health' as our ideas of wholeness and individuality are disrupted (*WP* Deleuze 1994, p. 159). This means acting out the 'difference' in events. The event in a/r/tography is treated phenomenologically, at best as a *scar*, as an intention of consciousness. This shows itself over and over again in the research where the subject-to-subject communication fingers change much like in any qualitative research. In this sense a/r/tography 'is' research of the scientific sort where the limits of a domain are identified, and art and the teacher as artist is subsumed in this task.

To paraphrase Deleuze (1998), then: art does not communicate, it resists.[9] There is only 'between' in the way relationality is developed by these two theorists. Singularity, for Irwin becomes anthropocentrized throughout her expose of what 'is' a/r/tography, whereas Nancy's singularity does *not* privilege human *Dasein*. Existence is not a property as it is for Irwin. The human being does not constitute the centre of creation. Creation for Nancy (the way the world emerges and exists, *ex nihilo*) transgresses humanity. What Irwin has done is to take important concepts, such as singularity, events, contiguous, in-between and has rewritten or reinterpreted them in standard qualitative relational terms. She has then

imposed a form of (post)structuralism, as the 'elements' (singularities) of her understanding of community *have no independent existence apart from their relations.* It is a constructivist view of community despite the call to Nancy and Agamben rethinking of the 'organic' community. Any idea of the immanence of assemblages escapes her; that is the exteriority of terms and their *capacities,* rather than their interiority of terms and their *properties,* especially as defined by any combination of artist, researcher and pedagogue where, of course, transformation or temporal change *also* must take place. The phenomenon of change is but a banal commonality.

Part of the issue for me is that Irwin understands the plurality of communities, not as Nancian or Deleuzian assemblages, but as theorized in poststructuralist discourse: a subject is a multiplicity of selves, each 'self' governed by particular 'interests' (p. 77) that are embedded within a community[10] Unfortunately, this is not Nancy (nor Deleuze). This is typical (post)humanistic sociological understanding of community, closer to Maffesoli (1996) understanding of urban tribalism, or for Irwin a 'community of practicioners.'[11] It has affinities with more conservative based action-based research models than any form of posthuman research that recognizes a 'differentiated subjectivity' as this research approach remains bound by dialogical investigation ('personal engagement'), and bound up with identities of the self,[12] with standard understanding of reflexion and reflection,[13] where humanism is once again brought in. If this were not so, the label of a/r/tography would not act as the master transcendent signifier that it is, sweeping up difference in the 'name' of difference as it historically transforms itself: a school rather than a movement. This is contrary to Deleuze's transcendental empiricism, the univocity as developed in *DR*, which sloughs off the affections of personality and disperses the subject, ego and self into an anonymous 'one,' the impersonal and indefinite pronoun that is mobilized to create multiplicity. Rather, a/r/tography subsumes the many and enumerates the many in a set or ensemble, one assumes to establish presence in art education research. There is no anonymous murmur or a 'collective assemblage of enunciation' (following Guattari), but the establishment of a marketing ploy that intervenes in the *habitus* of art education.

In her description of the 'City of Richgate [City of Richmond]' project as the paradigm example of a/r/tography, Irwin slips into representation despite the Nancian and later Agamben inflected claims at the start of her paper. 'Being' in capital letters reappears, but this time its work becomes: 'ways of Being in the world (p. 79),' a typical phenomenological move as

confirmed with her mention of Bill Pinar's existentially inflection living curriculum as *currere* (p. 80). This is assured through 'artists, researchers and pedagogues' who 'trouble and address difference and sameness' via 'commitment,' defined as 'a way of being in the world.' The four commitments (to inquiry, to negotiating personal engagement within a community of belonging, to creating practices that trouble and address differences and sameness) rest comfortably within a critically reflexive, but to be sure *representational paradigm* that itself is characterized by difference and sameness.[14] Cautions, checks and balances ('critique must occur,' p. 86) are put in place so that the process does not derail itself into an easy consensus of a closed system, a built-in fail-safe is needed through self-critique, precisely by whom is left open, presumably by the tribal members themselves. So, tacit knowledge, complexity, uncertainty, autopoiesis, rhizome and apprenticeship are other signifiers rolled out to maintain 'becoming' within the curious situation of a representational paradigm that only shows itself via what it 'does' than the rhetoric of its claimed theoretical structure. Becoming is equated simply to temporal change.

It should be pointed out that Nancy's 'being-in-common' is not a sharing of *characteristics or properties*, which seems to be Irwin's understanding, rather it is through the interaction of the *capacities* within the assemblage produced. The properties of an entity are the local results of interactions between entities. Capacities, on the other hand, are powers that an entity possesses, regardless where such powers are exercised or not. To avoid the charge of constructivism that I am presenting, Irwin would have to demonstrate in the 'method' of a/r/tography that a *realist account* is possible, an account that goes beyond her focus on subjectivity as *the* entity; and, further that the reduction of being is not reduced to the local point in time. Why this cannot be illustrated is revealed when the Richgate 'artwork' travelled to China and the 'research' found itself within new assemblages (and *not* communities), receiving quite a different reception. The research's *capacity* changed leaving her to ask when the artwork was brought back again into Canada: 'Should they be more provocative?' with their 'glowing reviews' that were received when 'home,' as it were, back in Richgate. The question is revealing as it confirms that such a methodology presents a paradigmatic example of pluralist democracy at work, support by a Social Sciences and Humanities Research Council (SHHRC) grant that confirms the multicultural values of a Canadian perspective where the 'diaspora' (p. 78) can be addressed in British Columbia.

'Difference is not diversity,' writes Deleuze (1994). 'Diversity is given, but difference is that by which the given is given, that by which the given is given as diverse (p. 222).' Difference, as we argued in our book, has nothing to do within the context of sameness under its label, which a/r/tography continues. Is it not an irony that under the pretence of 'becoming' its label maintains sameness in the name of difference? Identity in all its forms is what Deleuze attempted to overcome (Zourabichvili 2012, pp. 37–38), which is to say the overcoming of *ontology* of Being itself as humanly defined. Yet, Being is carelessly tossed about in her essays. We have here the reinstatement of a tribal identity under its significatory banner: a/r/ography. It turns its subjects into a proper name used to identify the sum of a body's property of expression(s), *especially telling when the tribe publishes an article en masse, which is a common strategy.*

This is not to say that as a research methodology it is somehow not viable. In many respects, a/r/tography presents an *excellent managerial model* to cope with existent differences among 'communities of interest' to arrive at what might be the best understanding (resolved or unresolved) that can be obtained within the difference|sameness representational paradigm Irwin mentions. But it should not be couched in the theoretical discourse of non-representation as claimed, especially not in the name of Deleuze and Guattari. This becomes a form of misrepresentation or better a theoretical misinterpretation that garners currency under false pretences.

Reiterations

In another, more recent update of what 'is' a/r/trography, also within the context of a research conference on arts-based research, Irwin (2014)[15] updates and reiterates her position, this time calling in the 'educational turn [as] witnessed in contemporary art' (p. 21) now also subsumed under a/r/tography. Not much has changed since 2007. It does make evident Irwin's misunderstanding, or rather her understanding of 'relationality' within a representation paradigm of which a/r/tography is anchored; as well her understanding of (pedagogical) 'becoming' as simply another term for 'change' or 'perpetual reconfiguration' (p. 24) and 'endless temporality' (p. 32). Change is nothing more than that. It is a form of inquiry-based education of critical reflection, and the model drawn on by Podesva (2007), that Irwin dwells on, is another good example of a poststructralist model well suited for a society of 'control.'[16]

One should be cautious with this 'pedagogical turn.' Rogoff (2008) tries to problematize this concept in the very same article Irwin mentions and uses it in support of her closing argument. To paraphrase Rogoff, she asks: Can an alternative production of knowledge happen in the gallery and museum that has always been a site/sight/cite of ideology, especially when curators are now in charge? Both Irwin and O'Donoughue (Irwin and O'Donoghue 2012) seem to feel that Nicolas Bourriaud's relational aesthetics should be a model to use in this regard.[17] Besides the scathing critiques of Bourriaud by Claire Bishop and Stewart Martin that O'Donoghue acknowledges (p. 231), but then seems to dismiss, there is Bourriaud's use of *social relationality* that a number of Deleuzian as well as critical theorists (e.g., Hal Foster (2003) summed it up as an 'arty party') have outright dismissed. Bourriaud (2002) claimed he was working within a Guattrian paradigm as 'an art form where the substrate is formed by inter-subjectivity, and which takes being-together as a central theme' (p. 15).[18] Eric Alliez (2010) has called him on his apolitical stance wherein Bourriaud's 'micropolitics' of intersubjectivity turn out to be forms of consensus and conviviality as they take place in art galleries. They become a type of service industry, a 'populism of the multitude,' as Alliez puts it. In short, 'relational culture' as the aesthetics of 'being-together' make up for the perceived inadequacies of capitalism manifested through the alienation of its technologies, a form of immaterial labour.[19] In Bourriaud's account, there is no becoming as understood in Deleuzian terms of difference in-itself. Like Alliez, one should ask how Bourriaud's sampling and mixing practices differ from the sampling and mixing practices offered by consumer culture. Unfortunately, Irwin follows the same logic. Her understanding of affect is that of a 'relational endeavour' (p. 33). Spinoza's ethic (which conspicuously remains unquoted) is stated as follows:'[W]e want learners to feel their capacity to *be affected by, and to affect,* their surroundings including their community and environment' (p. 33, my emphasis). This fits well into the (post)humanist paradigm, as this is an understanding of *affection,* not affect, which is inhuman. Affect is not affection, which in a/r/tography is understood as the various transfers of feelings and emotions.

A/t/tography is yet another phenomenology that has *appropriated* the signifiers of process and anti-essentialist philosophies without acknowledging or recognizing the radical forwarding of difference that remains nonhuman and inhuman. Cartography, becoming, intensity, affect, event, movement, folding, unfolding, rhizome, as a cluster of signifiers are all

taken from the oeuvre of Deleuze and Guattari, and then performed by a traditional subject of artistic expression and research. It is a/r/tography's latest bid to covet the field once more to hold market share. Clever, of course.

In 'Becoming A/r/togrpahy' (Irwin 2013),[20] Irwin begins with a cascade of these signifiers in a two-page introduction, and then proceeds to justify them via a long look back at former research, essentially rewriting a/r/tography's genealogy, maintaining that such intentionality has at long last revealed itself![21] This seems to be a disingenuous move. The title addresses a revisionist history. What should be pointed out is the way the subject in this attempt to rewrite a/r/tography along Deleuze and Guattarian lines is constantly reinstated along rather conventional phenomenological propositions despite the rhetoric that is being marshalled. Becoming is used rather conventionally, again as 'living inquiry …encouraging teacher candidates to question their intentions/actions as they relate to contextual artifacts and experiences acquired throughout the program' (p. 203). Becoming pedagogical turns out to be simply phenomenological explorations. 'To affect and be affected,' often cited in recent a/r/tographical writings as if it was a mantra, without acknowledging Spinoza, is understood in entirely humanist terms.

'We do not know what a body can do' holds that the conditions of actual experiences are not represented through empirical tracings (see *DR*, 95; 221, 321). This statement should not be taken glibly or necessarily positively. Issues of power and desire are very much in play as Jane Gallop (1997) amply shows.[22] The embeddedness of the body in materiality alone is overlooked by a/r/tography; there is no exploration of inhuman and nonhuman assemblages 'working' together in failure as well as success. The idea of event is also understood conventionally; that as embodiment, but no mention is made of counter-actualization where incorporeality becomes crucial for the event to be reimagined. Virtuality seems to be the one signifier that has been missed or overlooked perhaps because it is poorly understood. But more so because the virtual has already been included in experience as phenomenologists do. This centring of the phenomenological subject is most visible when a tribal community is called in en masse regarding the research presented.

In the last part of Irwin's 2013 essay, a 'walking' experiment is discussed. Here the phenomenological subject of ecology that surveys the world for-itself under the auspices of liminality and aesthetics of an 'event' must surely be questioned. The phenomenon of light receives a

neo-romantic treatment, as does 'nature.'[23] The becoming-movement of these 'walks' turns out to be a romantic celebration of vitalism directed towards light; light as subjectivated by the artist and poet in what can only deemed as a 'natural attitude' despite the use of technologies, whether they are Irwin's camera or Carl Leggo's printed and coded words where spacing of letters is at play.

To conclude this section, I continue to fail to see how the subject in a/r/tography is anything more than a form of poststructuralism in relation to any 'new' arts-based research; the address to the nonhuman and inhuman remains silent. 'Nature,' when and if addressed becomes a phenomenological exercise, a world for-us. More often the subject of art education is phenomenological in what it is 'doing' under its newly self-claimed Deleuze-Guattarian direction. The subject, veiled by the rhetoric of non-representational signifiers, still ends up being very Kantian in its orientation. A/r/tography is a territorializing machine that morphs under its transcendent signifier as it rewrites its history. With its primary roots in phenomenology, it then morphed into a poststructuralist form in the late 90s, but now its members are claiming to take on aspects of non-representational theory by seeding signifiers that are then translated back into more phenomenological orientation, which are its beginnings, coming full circle under the same signifier. Deleuze and Guattari, however, purposely created terms that often took on reverse meanings, like 'concept' and 'machine.' They also made a point to change terms from one book to the next to avoid falling into representation, although the terms may have performed the same effect (Hughes, 2008). In this regard, Adrian Parr's (2013) concern should be taken seriously. She writes, 'If concepts such as the fold, force and becoming are not connected to the larger political impulse driving Deleuze and his collaborations with Guattari, the concepts are no longer tools in the way that Deleuze insisted they need to be treated, rather they become so profoundly un-Deleuzian as to be a political distraction' (p. 204).

The morphing of a/r/tography goes on without any self-refleXivity[24] or depth of understanding as to the concepts being appropriated. Its proponents insist on hammering a square peg into a round hole, until it fits. While it makes for an interesting geometrical sculpture of sorts, it's hardly an example of topology, which would require some elegant bends and stretches rather than sprinkling and seeding 'right sounding' signifiers that are trying to accommodate the two shapes in the Emperor's and Empress's new clothing designs. 'As the planks of Theseus' ship needed

repair, it was replaced part by part, up to a point where not a single part from the original ship remained in it, anymore. Is it, then, still the same ship?' The crew and the captain still think so without admitting to the 'repairs.'

... And what of the charge of *ressentiment*? Would that charge be laid against me after this? Deleuze in his work on Nietzsche's thought stressed that affirmation should not mean a blanket acceptance of everything. It too must include critique of the negative 'Will to Power.' Without this, there is also no betrayal.

A Reply To Adienne Boulton-Funke's Refurbishing of A/r/tography

Adrienne Boulton-Funke (2014) wishes to refurbish the Theseus' ship of a/r/tography so that it still floats under the same banner on its mas(k) head, and has the same name inscribed on its bow. Why not throw away the brand name and rename the ship? Too much at stake, I suppose; too much reputation and established tradition to consider sweeping it away during a hurricane or some such creative destructive act. But now the ship has had a complete surgical make over. One wonder's if this ship is still part of the same fleet, it looks so odd in comparison. One can imagine the old captain needing some help in retrofitting it properly so that it can handle the high seas again. Let's hope no mutiny will take place and that the crew continues to pull together.

The recognition by many scholars that Deleuze and Guattari hold a significant place in research is a welcome relief. Adrienne Boulton-Funke recognizes that our review of a/r/tography has merit, and that a/r/tography rehearses forms of (post)humanism and representation even in its 2014 version as argued above. Yet antecedents are found to show that certain planks have been replacing the ship in the past. Springgay et al.'s (2005) essay, in particular is singled out to show the touchstones, even though, in this essay, the authors continue to tout a representational view of 'relationality' and a cognitive understanding of subjective 'loss.' Both are disregarded or not fully understood by Boutlon-Funke.[25]

Through a series of long quotations (one assumes so that she has to get the 'letter' right), Boulton-Funke draws on well-known Deleuzians who have written in art and education, primarily the often cited writings of O'Sullivan, Zepke, Olkowski and the educational philosopher Irene

Semesky whose range runs from tarot cards to Dewey, and her own version of semiotics. Boulton-Funk recognizes that it is a 'poststructuralist subject' (pp. 213–214) that Irwin uses, and tries to displace it by installing the Deleuzian intuitive subject. Unlike Irwin's representational understanding of affect (as affection), Boulton-Funke, via Semetsky, recognizes the importance of affect, precept and concept as the pre-individual subject, covering territory that Jason Wallin and I had already gone over in our *Arts-based Research* book. This 'affective turn' is now being fairly common fare throughout the humanities and marketing journals as it has contagiously spread throughout the Academy. There are its detractors (e.g., Leys 2011), and there are its enthusiasts like Anna Hickey-Moody (e.g., Hickey-Moody 2013), whose attention seems fixated on it for art education. More disparaging perhaps is that consumer capitalism has also latched on to affect within experience. [26] Most curiously, after each 'rule' for methodology of Bergsonian intuition,[27] Boutlton-Funke gives the impression that a/r/tography has already engaged with this 'intuitive method.' That is new to me given the latest account of a/r/t/ography's status in 2014. It is again a rhetorical move to continue the refurbishing plan, scrubbing the barnacles off the ship so to speak.

The biggest plank to be renewed—the poststructuralism of the boat itself that Boulten-Funke attempts to change—is the realization that intuition, as virtual memory, is necessary for a grasp of becoming if the ship is to keep sailing and waving the same flag. The pirate flag could not possibly be hoisted, as that would be a sign of disloyalty. No betrayals here. The question is whether this is enough of a retrofit in relation to the radical gesture Jason and I attempted to put forward? So, what's missing from the newly refurbished ship, despite taking on aboard all of the Deleuzian vocabulary, and the current awakening that maybe the ship has a hole in it, and it's taking in water? And that, with this renewal, the captain's same words can *still* be heard, but now inflected differently, perhaps as a 'voice without organs' calling for an 'art without organs' (more below). Three things that are addressed in the last sections of this chapter, which are blatantly missing in Boulen-Funke's 'bailout': de-anthropocentricism, ethics and critical and clinical politics within capitalism as informed by the event, assemblages and desire.

A Sinking Ship?

The Bergsonism of 1966 that Boulten-Funke calls on to help tread the water is only half the story as in this text Delueze has yet to offer an ethics.[28] In *Difference and Repetition,* he breaks with Bergson over the nature of intensity. Primary difference is no longer the one staged between differences of degrees and differences in kind (as Boulten-Funke seems to think), but resides in the differences that belong to intensity that inform them both. Difference is intensity (*Deleuze* 1994, p. 239). This is a major shift from his Bergsonism and understanding of novelty utilizing virtual time. Boulten-Funke, by relying on this text and the intuitive methodology, is at best able to take in the second temporal notion of time, as developed by the virtual. In his ethics, drawing on Nietzsche, Deleuze introduces the third notion of time, that of the future through the eternal return that goes beyond the repetitions of habit and memory. As Andrew Benjamin (1993, p. 196) has shown in developing Deleuze's event, Bergson's duration is unable to generate a notion of 'transformation.' The past 'endures' in the present but does not dramatically effect it and be radically transformed, which is why Jason and I developed the notion of counter-actualization in our own work. By the time we get to *A Thousand Plateaus* as co-authored with Guattari, the Bergsonian 'creative evolution' has been distanced by 'creative involution,' a point we took up in our own work as explored in the last section of our book where we make a break with the *residual of humanism* in the post-qualitative research methodologies to be discussed below. Unfortunately, Bergson regarded the masculine form as that which sparks female life into matter (Colebrook, 2008). To break with Bergon's residual humanism, Deleuze|Guattari moved into an ethological dimension and machinic thinking.

While thinking necessitates a culture or *paideia* for Deleuze, where the artist has to be affected, there is no 'method' involved. A method implies a collaboration of the faculties, much too harmonious and stabilizing, too determined already by social values and established norms of discipline. The journey may go as far as destroying the mind, as not everyone *should* be an Artaud. This new Meno (*DR* pp. 166–167), where thought is no longer subject to mythical forms of semblance and identity, where learning 'unites difference to difference, dissimilarity to dissimilarity, without mediating between them,' has already be explored for education (see Dejanovic, 2014).

MAKING A BREAK WITH CURRENT POST-QUALITATIVE DELEUZIAN DEVELOPMENTS

Boulton-Funke identifies a host of researchers who have latched onto the Deleuze|Guattari train, collecting passengers as it makes its rounds through the research circles, forming hybrids of the 'post' in qualitative research in particular as they take on their vocabularies.[29] Boulton-Funke (2014) mentions the work of Lisa Mazzei (p. 217) as someone who she believes is the exemplar case to revive qualitative work along Deleuze|Guattarian lines via her VwO (Voice without Organs). While not quite as provocative as Žižek's OwB (Žižek 2003), its differentiation from BwO needs to be 'untangled.' Mazzei (2013) characterizes BwO as an 'organism that is an assemblage of forces, desires, and intensities' (p. 734) *on and through* which interview practices take place. However, VwO is an assemblage of the forces that act on the BwO—namely, 'participants, researchers, interview questions, narrators, becomings, voice, transcripts, and data analysis' (p. 735). They are two distinct concepts, but sometimes this remains unclear.[30] Oddly voice is never articulated in relation to speech nor is it distinguished from noise.

VwO, as near as I can make it out, is simply Mazzei's recognition that, as Deleuze and Guattari tell us in *TP*, there is not just one type of body without organs but several. The body without organs that constitutes the folded sedimentations and coagulations that are involved in the composition of an organism constitute the stratum existing on this body. It imposes its forms, functions and hierarchizations of organization. It seems to me that VwO is simply this strata of the BwO that has formed. Such a claim seems to be confirmed by Mazzei calling on Foucault to describe VwO. 'This assemblage [VwO] would include what Foucault called discourses of gender and professional class status but also economic forces, the particulars of personal histories, struggles and success in the academy, theories producing questions and enactments, previous data and analysis, the other women in the study, and narratives of small time life' (pp. 736–737). It is difficult to say that VwO is anything more than the molarity of signifiers. Voice is being theorized as speech ('words spoken and words written in transcripts', p. 738), as *figure* rather than more radically as *figural*, which would recognize its 'grain' or affect (see Tiainen 2013). It seems Mazzei falls back on poststructuralist tenets. Deleuze and Guattari insist that there is no abstract opposition between the stratified BwO and the destratified plane of consistency. Creative processes inform both the BwO and the

processes of stratification. Yet what seems to be missing in Mazzei's explorations is the radical destratification that voice, and not speech, is capable of remaking the BwO.

Why BwO's strata is termed VwO seems a mystery as the notion of voice remains equated with speech (as Mazzei's 'data' that stands alone devoid of the subject). For Deleuze voice is opposed to speech, especially as developed in his cinema books (Deleuze, 1986; Deleuze, 1989). This radically problematizes the relations between body, sound and logos. The destratifying effects of voice are explored to capture the 'pure image' of the voice that is unchained to the subject.[31] Mazzei's particular take on voice has the advantage of recognizing assemblages and tries to theorize voice as speech differentiated across an assemblage. But, the assemblage is closer to Foucault's *diapositif*. While an affirmative notion of desire is stated, it is unclear how it functions in her post-qualitative interviews. One cannot help thinking that the humanist subject is really not left far behind, and that the feminism she advocates is unable to 'queer' itself to become fully anomalous, transported to another landscape through a sound-image we have yet to confront, which would disturb us as to what 'voice' can *do*. Mazzei's explications of the assemblage (research-data-participants-analysis) still seem caught by her own speech-acts when, what is at issue, is what emerges from the pre-personal series between her and Fran (her research subject). The 'dark precursor'[32] (ground) of the emergence where the ethics and politics come to be considered seems missing. Perhaps no 'event' (i.e., lightening) has taken place between them to disturb the equilibrium of agreement—after all, Mazzei and Fran come from a small town and leaving it behind, but for different reasons. The temporal disjunction of the voice remains too embodied to be eventful.

More interesting explorations of voice have been researchers who have become sensitive to Deleuze|Guattari's understanding of repetition (*ritonelle*) in their discursive exchanges with their research subjects as 'diffraction lines' where assemblages meet and exchange becomes articulated (Geoffey and Pettinger, 2014). The voice here brings us straight into the core of schizoanalysis. Mladen Dolar (2006), drawing on Lacan, has brilliantly shown the metaphysical preoccupations of voice throughout the ages as to the tensions between presence and absence, sound and voice, versus the logos of meaning that has haunted, not only philosophy, but also especially religious discourses. The voice for Deleuze is the indication of full presence, an expression of all possible worlds. The voice is not so much an expression of subjectivity, as it is an expression of the physical nature of

the body—the materiality of the signifier.[33] To take the destructiveness of voice seriously would be to form a schizoanalysis on the research material.

Deleuze made a shift from *Logic of Sense* to *Anti-Oedipus* when it came to voice, moving from Lewis Carol to Artaud where the body without organs (BwO) becomes noise, not sense, as Artaud demonstrates. Mazzei's analysis is confined to the *Logic of Sense* (Deleuze, 2004a) where voice still plays a middle position between noise and speech act, mediating the two. Yet, it seems to me, even this mediating position is not in full play when it comes to Mazzei's interview analysis. BwO in *Anti-Oedipus* is a complete deterritorialization and is equated with the primary order of language—noise where there is no subjective distinction between the world and 'itself,' only intensities-in-motion, affects and sounds of the body (see jagodzinski 2005, pp. 28–29). Voice belongs to sense, the second order of language mediating between noise (BwO) and speech, or full-blown propositional language that humanist and poststructuralist, by way of discourse, qualitative research works with. Sense and nonsense are the genetic elements of language. The voice is the figural of figuration. There is no dynamic genesis here but a static one. These attempts suffer from a failure to theorize the radicalness of the Nietzschean forces Deleuze tried to mobilize in his ethics.

Mazzei rehearses the usual passages from various authors to theorize the pre-subjective voice. Voice has now received a number of responses by other Deleuze-minded qualitative researchers, mainly feminists who have taken on the language of Karen Barad (2007) to differentiate themselves apart from Deleuze and Guattari. 'A diffractive' approach in Hillevi Lenz Taguchi's (2012) case, or, as in Maria Tamboukou's (2008) work, the interest becomes the biographical narratives of women artists. The shift has been from Foucault to Deleuzian assemblages rewritten via Barad's vocabulary. Feminist standpoint theory is undergoing a similar modification (Hughes and Lury 2013), but the question remains as to whether 'gender' continues to be the stumbling block.[34] Rather than the familiar Deleuzeguattarian terms such as assemblage or 'fold,' *entanglement* becomes the new signifier; and the Deleuzian 'cut' now becomes qualitatively 'agential.'

With the word 'post' in front of qualitative research,[35] the question presents itself to what extent can importing Deleuze and Guattarian concepts in various ways is able to free itself from the humanist methodology that has defined the educational field through the previous and various approaches of qualitative research that continue to proliferate?[36] Perhaps

the first question to ask would be whether Deleuze|Guattari's approach, radicalized as a 'methodology' such as schizoanalysis, or perhaps Guattari's (2012) more radical political cartographical approach to assemblages via meta-diagrams of research creation could ever be 'accommodated' in the field of qualitative research; or modified to such an extent that its force of deterritorialization would change both the qualitative research field and their cartographic bio-psycho-socio-philosophy into various hybrid approaches that continue to be reductive of their political endeavour; reminiscent perhaps of so many doctoral thesis that were a mixture of qualitative and quantitative approaches to appease their committees. This process of hybridization will not end as it has already started. But when, for instance, did qualitative research ever escape the clutches of neoliberalism? It has always proven to be most useful method as a marketing tool, just like 'affect' has now become useful to further current forms of consumption. How radical is this current of Deleuze|Guattari appropriation that continues to replace the planks of Theseus' ship to stretch it topologically into something else?

The Question of the Political

One of the most glaring omissions in the series of essays on post-qualitative research (Lather and St. Pierre 2013) is the apolitical appropriation of Deleuze and Guattari. The word 'capitalism' can only be found in the subtitles of *Anti-Oedipus* and *Thousand Plateaus* that appear throughout these essays, but never explored as an important consideration of education in terms, for instance, of control societies that is a major concern for them both. Only Helen Pedersen (2013) powerful essay on the violence to animals within slaughterhouses and the transference of this experience to students through the choreographic assemblages of veterinary medicine is the exception. She persuasively shows how the affect of the students is effectively manipulated to handle the temperament of becoming a veterinarian to manage and continue the reproduction of the slaughter of animals.

Such an analysis is precisely what marketers are doing now by modulating affect to achieve the results needed to continue consumption. Best of all Pedersen, shows the limits of post-qualitative research precisely by bumping up to 'death' that defines the necrophilia of capitalism. She acknowledges that there is no affirmative 'becoming animal' in such an assemblage, and readily admits her mode of analysis is discordant with the

subjective reality of the field notes that describe the conditions. It is the gap *between*[37] that emerges, which she stares into.[38] The Deleuzian event is mentioned in only one essay (MacLure, 2013), and here it is clustered within a paragraph, remaining under theorized. Maggie MacLure, an educational linguist like Mazzie mentioned above, concentrates on language as Deleuze developed it in *Logic of Sense*, rather than the radical shift in *Anti-Oedipus*. Aside from Pedersen's work, one wonders what are the ethical stances being advocated in each essay, not to mention again the absence of the political.[39]

It is interesting to note that the 'new materialism' in these essays is being colonized by various brands of feminism that bring forward the names of Braidotti, Barad, Bennett, Heckmen, somewhat reminiscent of the cheeky remarks of having a fling with the boys by Luce Irigaray when Lacan, Foucault, Derrida and French poststructuralism seemed to have opened up a new theoretical landscape. It seems flings are no longer necessary, only rethinking the same concepts with other signifiers: fold is replaced with entanglement and mangle; assemblages are now entanglements and so on. There are feminist Deleuzians who question the queer directionality of Judith Butler's identity politics, and the outright dismissal of 'becoming woman.'[40] However, the majority of essays in the special issue of post-qualitative research rehearse the available literature with no applications (St. Pierre, 2013; Lather, 2013), while other attempts cannot escape the veneer of humanism.

To the extent that the terms 'research' and 'knowledge' remain as the main signifiers, it seems that 'post' should be replaced with 'neo.' Neo-qualitative research in line with a posthumanism (rather than posthuman) might be more appropriate in terms of the 'entanglements' these essays and those like them mention. Ontology as we know it, as that which confirms the human, should also *not* have a 'post' in front of it, but entirely rethought as ontogenesis. Ontology as 'that which is' remains caught by the various anthropocentrisms of philosophy, rehearsing what the world 'is' from the dominant position of our species that is continually defined by Man. While various feminisms and certainly the most radical Deleuzian queer positions continue to undercut Man, something 'more' is need in the 21st century.

Arts-Based Research at the 'End of the World'

What remains rather disheartening, therefore, despite all the Deleuze|Guattari revival that is taking place in arts-based education and 'post-research' is the continued anthropocentrism in a time when there is, finally, a recognition of our current ecological crisis—by the badly named term, Anthropocene. The fixation on human interaction through all the post-qualitative work (there are exceptions of course, Helena Pedersen being one of them) simply vivifies the misunderstanding of Deleuze|Guattari's project of thinking *beyond* 'the human condition' to expand the horizons by which we think to dissolve it. The posthuman dimension of nonorganic life is glaringly missing.

It is the latter part of the book, Jason Wallin and I presented our proposal by drawing on anomalous artists (Sterlac, Orlan, Bilal as exemplars) who took specific ways of becoming that distanced the human. In his later work, Deleuze nonorganic life is conceived as the nonpsychological life of the spirit. It is a life that gets progressively separated from the field of human consciousness and subjectivity. He distances himself from Bergson's residual humanism. As such Boulton-Funke refurbished a/r/tography, like most post-qualitative hybridic proposals, avoids and skirts anomalous becomings of an ethological ethics in respect to 'nonhuman' becomings of the human—to think the trans- or *over*human. Sterlac, Orlan and Billal cast 'a line to the Outside.' They stop *being subjects* (to insert a double emphasis on 'being' and 'subjects'). Deleuze's position is that the 'human' is a site for the transmutation of forces, a challenge to hylomorphic notion of corporeality that still dominates these recent appropriations of Deleuze|Guattari. Everywhere one looks, as Claire Colebrook (2011) amply shows, it is the affection of the body, the narcissism of the self that passes for affect. The vitalism of affection seems to pervade arts-based research as ecological neo-romantic notions of the artist refuse to go away. It is the attention to the movement of nomadic singularities and fields of intensities that are part of the transcendental energetics of matter, a much more frightening proposition for any form of research. Deleuze again reworks Bergson and 'Bergsonism' in his two books on cinema composed in 1980s to radicalize this potential of nonhuman becomings.

The politics that they call on do require hoisting a pirate's flag, a reiteration of the machinc philosophy where nature|culture are indistinguishable, where the ethical becoming of human bodies explores the possibility of 'becoming woman,'[41] becoming-animal, becoming-molecular and

becoming imperceptible, but thought through for the times 'at the end of the world.' This means, again the recognition of the Outside, to fabricate 'a line of flight.' By this I mean, a time of ecological crises, the recognition of the more-and-other-than-human world as Deleuze thought of it through his 'germinal life' of becoming 'beyond human' (Ansell-Pearson, 1997, 1999). How art invests, investigates, captures, avoids capture and cares in releasing zoë in the clutches of bios is the problematic project. While the label 'feminism' is often marked by this project as 'queer,' I would see 'queer' much like Colebrook (2009) does in her distancing from any form of identity politics that a Butlerian position maintains. But, it should be admitted that Barad's (2007) entanglements appear to be a superior term to *agencements* (assemblages), and the inadvertent fall into images of structuralist thought that the term, assemblages, continues to bring through its over-codification in the English language. Our ship is clearly closer to Guattari's (2000) last work on ecology, as an ethics of 'living beyond' and 'living on.' To this we add the inhuman side: becoming metal, becoming data, becomings through filmic apparatus and bioart. While this is not unproblematic, it is necessary because of the Anthropocene. As Stengers (Stengers, 2008) says, 'To betray is never "in general," is always a matter of encounter and connection. [...] [C]onnection is a matter of "coming into existence", which demands both trust and an art of immanent discrimination, [...] we need some criterion of judgment, "or else, anything would be allowed"' (pp. 39–40).

The human hubris of our earth-destroying fantasies of conquest and consumption prevent us from 'experiencing' the full range of nonhuman powers that interpenetrate us as one species being among many. The approach Jason and I took was to consider the 'speculative realism' that, in many ways, continues the Deleuze-Guattarian direction of thinking 'beyond' the human. Since our co-publication, both of us have attempted to develop independently further aspects of this task (Carlin and Wallin, 2014; Wallin et al., 2013a, b; Wallin 2014a, b, c; jagodzinski 2014b, c). This shift to posthuman education that we advocate recognizes the endeavour of art being involved in the developments of a 'new earth' and 'a people to come' as Deleuze had called for. Speculative realists like Quentin Meillassoux (2008) recognize, following Deleuze and Guattari, that correlationism needs to be surpassed to continue the thought of 'beyond' the human. For Meillassoux, The Outside now becomes 'the great outdoors' that recognizes life anterior to human life on earth, a time that Manuel De Landa (De Landa 1997) has speculated upon (what

Meillassoux calls 'ancestrality' and the 'arche-fossil'), and life posterior to the human, a planet without-us as necessary thought experiments (which Meillassoux calls 'diachronicity').

This bracketing of the human is the germinal life that Deleuze|Guattari attempted to trace with their post-Darwinian twists when grappling with the thought of the nonorganic life and inhuman (technological artifice, data—and not tools), an approach to life and death that tries to overcome the personalist ethics of the 'I' and the 'self' to open up the human to the *over*human through creative involution that coexists with creative evolution. Such an endeavour gives death quite a different conceptualization than that of the Freudian death drive. Death points to the play between organismic and the nonorganismic, and on the human plane this amounts to the play between the self and the field of intensities and singularities that present new possibilities of existence. Death becomes a vitalism that can open up organic life. This is a Spinozian position as the 'free' person thinks of death as the 'least' of all things.'[42] This does not mean a person's unity is not haunted by death rather the 'free' person is equal to the creative person who finds new ways to 'free' him/herself from the limits of being. It is only through this rethinking of death that the biopolitics of capitalism can be overcome. When bracketing the human, the Outside is that death, which is also the demonic and the monstrous, as the 'dark precursors' to be encountered.

Perhaps Negarestani (2011) captures it best through the concept of 'necrocracy.' 'Necroracy suggests the strictures of the conservative economy not in regard to life but in regard to ways the organism dies; and it is the way of returning to the originary death that prescribes the course of life for the organism' (p. 192).[43] Jason and I singled out three artists, Sterlac, Orlan and Bilal who were affirming life in death; they are the nomads of a desert island, a place of their 'second birth' as Deleuze (2004b, p. 13) would maintain, after their death had taken place.[44] We might think of the performance artists, Marina Abramović and Tehching Hsieh (together with Orlan, Sterlac, Billal) as similar travellers and explorers of these desert terrains that become the blank canvases of a 'second origin of the world [...] more important than the first' (ibid.). These artists' anomalous 'way of life' deals with thresholds, limits, transformations, connections, disconnections (cuts), complications, closed systems and open systems. My concern over post-qualitative research is for its residual humanism that refuses to go away despite the claims of doing so is perhaps best expressed by the way Deleuze replaces 'anotherness' for the 'Other'

on these deserted islands.[45] If this is 'research,' it is research that addresses a 'new world' and 'a people-yet-to-come' so vital in the moment of history we, as species, find ourselves in. This is admittedly is a hermetic aspiration to renew the earth.

The proposal in our book forwards the event—in this case the Anthropocene—and its counter-actualizations as the 'method' that artists follow through repetition of its problematic. The event always offers the unthought as its arrival; time is always out of joint, offering the glimpse of the third synthesis of time: the eternal return of renewal. We based our proposal for the future of arts-based education precisely on this as its most radical Xpression.

An Addendum After the Addendum: A Reply To Carl Leggo: Riffling of/f the Riffing

Carl Leggo (2014) has responded to our book, *Arts-Base Research: A Critique and a Proposal,* through 25 'riffing' comments. As I know Carl personally, I will address each point using his first name as a sign of friendship and respect. These replies are best read concurrently with Carl's text to grasp the play of juxtapositions as each number refers to the 25 numbers in Carl's review.

[1]. It was indeed good fortune to have stumbled on Carl Leggo's review of our work. I had hoped that there would be a response from the ABER community to this work, indeed I expected a challenge to it as we wrote within its cover. The good fortune is that it was a poet who answered back. Although not claiming full representation of the ABER community, certainly Carl's voice as a founding member of a/r/tography or a close member of its community carries weight. I say good fortune because the 'true' function of play is on display, rather than its perversion where work and play collapse in the name of the creative industries. I hope to return the playful favour.

[2]. At first, I was unable to print the pdf file of Carl's essay my university library had supplied me. But, using Adobe I was able to 'translate' it into a doc. file so that it could be printed, and I could then read it. When I began to read, my name appeared as Gagodzinski. I thought, 'well, isn't that nastily playful of Carl,' to change my name to Gagodzinski! In the English language that

works very well, gag, gagging, gagged, gagosized. Less so in the Polish as no one would pronoun the 'g' as hard, but soften it. My last name then sounds like some magicians abracadabra word. It turns out that OCR made a made a 'mistake.' Carl was never that nasty, at least not with my proper name! But who knows, maybe I, as part of the 'we,' will live up to my machinic name by the end of this response? The machinic agency of data intervenes throughout, not only in this OCR incident, like the fly landing in the typewriter in Terry Gilliam's film *Brazil*, changing the destiny of the protagonist via one alphabetical letter, but the fortuitous spelling errors found in our book (but were they spelling 'errors'?) enabled Carl to playfully riffle and riff throughout it, generating an intense flow: an excellent example of inhuman data at work shaping him as its shapes me now.

[3]. *On betrayal.* As Isabelle Stengers (2008) notes: ''[I]t is crucial to note that 'a line of flight,' in Deleuze and Guattari's definition of the term, does not entail denouncing the territory but "betraying" it; bringing into disclosure an ingredient that both belongs to the territory and connects with an outside against which this territory protects itself. Such an outside is not "absolute" one that would transcend the territory and allow it to be defined by what it refuses or protects itself against. Furthermore, the outside of the territory and the definition of this outside as "dangerous" were produced together with the territorial refrain (*ritournelle*), shaping both the inside and what is kept outside' (p. 42). We named this Outside as being the nonhuman and the anthropocentrism that is the refrain of arts-based research epistemologies. We were fairly explicit in our introduction on the 'type' of betrayal we performed. Carl changes this to an accusation that our account was 'simply inaccurate.' Jason and I never thought that there was an 'accurate' account of arts-based research to begin with. This would mean that the other accounts we have read were 'accurate,' and we were just too stupid to realize it. Yet, soon anthologies will emerge to give us the 'true' account as to how arts-based research really 'happened' listing the 'key' articles in this develop(ed)ing field. Visual Studies has already gone through this academic exercise to name names.

[4]. Carl asks whether there need be a difference between mythologization and critical elaboration. Nothing succeeds like

aestheticization today. Not only does fact and value implode through clever presentational rhetoric, what counts is the performance of the image. How well does it affect others? So, rather than the words of Leonard Cohen, to whom Carl calls on to make his point, the sober words of Gramasci may be just as appropriate here: 'The starting-point of critical elaboration is the consciousness of what one really is, and is acknowledging thyself as a product of historical process to date which has deposited in you an infinity of traces, without leaving an inventory' (*Prison Notebooks*).

[5]. Carl throws bullets of alliteration at us, accusing us of 'fundamental fervour' and 'double-cross.' Seems odd that 'fundamentalists' like us would seed the text throughout with aphorisms, proposals and provocations?

[6]. Irony like cynicism is to be avoided. I prefer humour myself. 'Irony relies on the logic of the signifier; in order for a sign to mean it must have a lawfulness that transcends any specific speech act' (Colebrook 2004, p. 140). Whereas humour and satire focus on bodies, particularities, noises and disruptions that are in excess of the system and law of speech. So I like Carl's line 'I drink, therefore I am pee pee.'

[7]. Carl says we offer a 'gift' as we think a/r/tography as not being radical enough. *Gift* in German means poison, but gift can be a cure as well. The first part of this chapter reconfirms our critique of a/r/tography. It supports the self-service industry, which Carl, surprisingly accepts!

[8]. Carl, you should read Delezue|Guattari on the *ritonelle*. Your recall of 'A Whiter Shade of Pale' will certainly become 'whiter' with such an understanding.

[9]. Yes, it seems at first glance that *no-body* 'hegemonizes' the field of arts-based research. That's the magic of the disappearing act. The hedgehog is invisibly 'white,' coming out only at night to feed.

[10]. Carl, this is a nice found poem. We can live with it. Especially the last line 'While the mention of idiocy will no doubt arouse suspicion, the term should not be taken pejoratively.' To this should be added 'We should always raise the idiot's question: 'what *is* arts-based research?' to further the mystery.

[11]. Carl's riffling on 'deter' and 'defer' is really brilliant here, as he himself demonstrates. Our book should have another term added to the two already mentioned: 'denounce.' We think it should be 'denounced' as well, to complete the cluster of responses.

[12]. It's worth repeating Nietzsche here: 'Human all too human.'

[13]. We are not so sure that a/t/tographers 'do not wear club colors.' It seems obviously tribal to us, not only in publishing as a cluster but also in the branding. The signifier seems to shelter the 'network of scholars,' some more loyal than others, I would imagine.

[14]. Yes, agreed, there is no 'I' that is not several. Our point precisely: it is a poststructuralist subject that is being worked with in a/r/tography, not a 'cracked' one as explicated in *Difference and Repetition*.

[15]. Absolutely, a/r/tography is a process. That in-itself is a no-brainer. All signifiers change. But a/r/tography is also a territorializing machine that captures everything in a site under its transcendent label to capture market share. And, yes we are not a/r/tographers. But Rita Irwin *is*, and she articulates what a/r/tography 'is' in what are three articles, some seven years apart, as presented in conferences on art education research. This is where she 'names' the method and its movement. It seems very clear, to me at least, what a/r/tography 'is.'

[16]. Difficult sentence, to be sure. Carl is right: one can't speak in a generalization that says: 'contemporary art is neuronal art.' We can only say that the neuronal image has received a great deal of traction.

[17]. The questions Carl raises plague all of research, which makes us wonder how the endeavour is shaped by an ontology that is charged through our anthropocentric endeavours.

[18]. Sterlac, Orlan, Bilal are so extreme that no one dare follow. As singularities they stand out, they are anomalous. Artists like Marina Abramović also show us performances that de-subjectify existence, and hence, like some 'astro-knot' who risks the voyage, creates assemblages that force encounters that can penetrate the order of habits and clichés.

[19]. I can only answer the charge that arts-based research was too narrowly interpreted as visual art education in the sense that the

critique of representation as posthumanism takes a fairly large swath through all the arts, including poetry.

[20]. Adding 'fascist' to the list was certainly not facetious on Carl's part as he says. This is a real surprise coming so late in his review. The comment is made regarding our understanding of Deleuze|Guattari's 'facial machine,' a well-known concept that has been used in postcolonial discourse, and to critique media representation, especially celebrity status. It was precisely fascism that Foucault praised Deleuze and Guattari for dispelling in his forward to *Anti-Oedipus*. Does Carl think out provocations are fascist? The Freudian slip seems to say so.

[21]. Carl makes an ironic gesture in his rejection of Dolce & Gabbana to Deleuze & Guattari. He readily admits he has never read them preferring a slate of more idealist philosophers who forward the imagination (Jung, Hillman and Levinas). This is where his love is found, what speaks to him most. It's as telling as our pull towards Deleuze and Guattari.

[22]. What can we 'say' to a poetic response? It just does ...

[23]. Yes, the event and encounter are beyond the 'count.' 'And so it goes on.'

[24]. Guess we are on different busses. I have stopped drinking, so I am unable to join in the course line, '99 Bottles of Beer on the Wall,' but well ... I can wave as the bus passes by.

[25]. Like you, Carl I have 'only just begun' to exceed the alphabet that you riffed in your last alphabetic poem, like Deleuze's *L'Abécédaire*. While the concepts invented have not caught on, it has not been from the lack of trying to develop them such as self-refleXion and Xpression to distance myself from posthumanism. These seemed to have joined other 'failed' concepts like cite|sight|site as a skewing of Lacan's three registers, and a host of other portmanteau words. It seems none have the staying power of a/r/tography.

NOTES

1. In postmodernism, the sublime has received the most attention understood from various positions as the unknown, be it through the mathematical or dynamic sublime as conceptualized by Kant in his *Critiques*. An object remains 'sublime' to the extent its 'distance'

impacts on our sensibilities. Hence, when the object becomes too 'close,' it can traumatize us; when it is 'too far,' it can become an object of 'sublime beauty' via a contemplative attitude. Along this continuum of maximum to minimum intensities the various 'objects' in research are in movement, foremost among them are those objects called 'art.' To say that 'art' is a 'sublime object of ideology' following the thought of Žižek (1989), is to say that art becomes a profoundly *empty* master signifier of the *transcendental idealized imagination,* sustained by a field of art educators whose world of research, education and practice revolves around such identifiable 'objects' understood in the widest sense (performative, immaterial and so on). The obverse side of this position is presented by such social researchers as Pierre Bourdieu, where in his books like *Artistic Taste and Cultural Capital* and *Distinction,* art is stripped of its sublimity, but then—through such sociological levelling—art becomes just another form of cultural capital, merely a social category of representation: art loses its potential to *affect* across categories such as social class, gender, ethnicity and sex through its *force*. Both positions are dichotomies of each other: idealization vs. categorization.

2. While Deleuze and Guattai and François Laruelle share the same conviction that representation needs to be overthrown, it seems that Laurelle misconstrued Deleuze and Guattari's as presenting a 'philosophy,' which they clearly were not; while Laurelle for a long period in his own development presented his non-philosophy as a form of scientism, which Deleuze acutely pointed out. Kolozova (2014) makes no mention of Deleuze|Guattari in her overcoming of poststructuralism via Laruelle. She does, however, show how poststructuralism is yet another extension of the humanist project. Braidotti, in distinction, is acutely aware of the tension between posthumanism and the posthuman.

3. In the same year (2006), a massive compilation of arts-based research dissertations appeared in *Canadian Journal of Education* (Sinner et al., 2006). It might be duly noted that neither Agamben, Deleuze nor Guattari appears in this review. Nancy is mentioned by one researcher but not as a prime philosophical reference but somehow positioned along with Derrida and Merleau-Ponty? A/r/tography at this time was qualitatively and phenomenologically biased.

4. For a full explanation of Bilal's counter-actualization, see jagodzn-ski and Wallin (2013).

5. See Irwin (2007). This essay, as she states, is a significantly revised essay by the same name that appeared in Springgay et al. (2008; Irwin, 2008). Often, with a/r/tography's referencing that purposefully and politically includes group publication as a tribal collective, either as essays or as edited books, it is difficult to attribute who said what, a difficulty we found when we first reviewed its methodology in our book. Here, however, the essay is a clear statement of what a/r/tography research "is" given it was part of an arts-based research conference.

6. Nancy, it should be noted, drew his understanding of 'being with' as developed in *Being Singular Plural* from Deleuze's writings (Nancy 2000, p. 8; p. 198).

7. I follow Keith Ansell-Pearson (1999) in rejecting that Deleuze was a poststructuralist, a common claim in the secondary literature. Deleuze never called himself a poststructuralist. As Pearson maintains (Ansell Pearson, 1999, p. 79), Deleuze should not be subsumed with Foucault and Derrida as his thought is more indebted to Henri Bergson's biophysical concerns. Deleuze already had the idea as early as 1954. Guattari especially is adamant about this disassociation (see Guattari 1995a, pp. 109–13, and Guattari 1995b, pp. 114–117.

8. On counter-actualization, see jagodzinski 2013, and Beighton 2015, pp. 152–159.

9. "[A]rt is what resists even if it is not the only thing that resists" (Deleuze 1998, p. 19).

10. So for Irwin (2007), in typical fashion maintains that the art theoretical, practical, artistic, pedagogical "interests" (p. 77) come together in a "relationality of belonging" (p. 78).

11. Tribes in Maffesoli's sociology are microgroups of people who share common interests in urban areas, held together by a structure of feeling and similar worldview. This seems to be a more accurate view of what Irwin understands as community, especially as it reflects the publication style of a/r/tographers.

12. '[T]he self is what emerges from the learning experience' (2007, p. 88); 'It is all about the creation of knowledge, the creation of self, the creation of the world around us (p. 83).

13. '[T]he evolution of research questions becomes more recursive, reflexive, reflective and responsive' (p. 84).

14. It is precisely 'difference' within 'sameness' that the entire work Deleuze's *Difference and Repetition* (Deleuze 1994) goes about dismantling to grasp difference in-and-of itself. Irwin and company are using the critique of difference within the methodology of critical theory, but not Nancy's assemblage understanding of community, and certainly not Deleuze from whom Nancy developed his own trajectory.

15. The heart of this article is about a 'The Summerhill Residency' project, which was an experimental intervention with education teacher candidates that took place in 2012, along with her colleague Dónal O'Donoughue, involving two invited artists. Both authors, under separate proper names, reflect on this experience in a co-authored article (Irwin and O'Donoghue 2012).

16. Control society is Deleuze's (1992) description of how time and space are now modulated as an open system. Podesva (2007) lists ten features of a system that support the new rhetoric of 'learning to learn,' the perpetual act of educating oneself within today's global capitalist expectations.

17. The co-authored essay makes an effort to separate both authors' independent voices. As Irwin has top alphabetical billing, one assumes that the 'relational aesthetics' is closer to her thoughts and has more commitment than O'Donoghue. But this is only a speculation on my part.

18. On a careful examination of Guattarian assemblages, Henrick (2014) reiterates Bourriaud's misappropriation of his thought in the long last section of *Relational Aesthetics*. 'Bourriaud in fact concludes his book *Relational Aesthetics* with a long section on Guattari, which should be read as nothing more than a gross misappropriation that brings Guattari's radical and *dissensual* micropolitics back into the fold of trendy neo-liberal museum speak' (p. 65, added emphasis).

19. For those who wish to follow this up, see my take on Bourriaud where he offers a variation of Deleuze via his 'ivy' replacing the rhizome as the new 'radicant' emerges (jagodzinski, 2014a).

20. 'Becoming' in the title has been purposefully bolded. A/r/tography remains neutral.

21. 'While the above two studies were not directly informed by the work of Deleuze and Guattari (1987), Massumi (1992), Ellsworth (2005), and others, lines of inquiry with other projects informed by these scholars were soon making connections with what was experienced and learned in these studies' (Irwin 2013, p. 202).

22. Gallop's case of lesbian sexual harassment is explored by Patton (2000) and commented on by Braidotti (2002, pp. 30–31). The entanglement, to use a popular term, of power and desire within the classroom

23. This charge is made against the extraordinary explorations of light, for example, by artists such as James Turrell, and the tension between *lux* and *lumen* has historically raised, not only in aesthetics, but within animist discussions. Here we have the phenomenological understanding of light as withdrawing and revealing in both the photographs and the poetry. Turrell, on the other hand, explores the non-phenomenological problem of light: light as such, the being-light of light or givenness in-itself.

24. The capital X in self-refleXivity is to differentiate its meaning from the poststructuralist meaning of 'self reflexivity.' The X refers to the virtual dimension of all language. The point is to claim that nowhere within the writing on a/r/tography have there been any attempts to clarify and justify any new concepts that are being introduced, while the old ones belong to a former paradigm are being overturned. An example of self-refleXivity would be Ludwig Wittgenstein's shift from his early *Tractatus Logico-Philosophicus* to the posthumously *Philosophical Investigations* where all of his early work is overthrown through a consummate working through.

25. Boulton-Funke writes: 'In taking up notions of a condition (*relational aesthetic inquiry*) and concepts (rendering)' (p. 211, added emphasis). And again: '[W]hat research should be when a *relational aesthetic inquiry* approach is envisioned' (p. 216, added emphasis). Relational aesthetic inquiry in this case refers to Nicholas Bourriaud. 'Loss is also metonymic, allowing knowledge to be split open, revealed, and ruptured' (p. 216). This is not 'loss' according to Deleuze's notion of the subject, which reworks Foucault's memory loss (Deleuze, 1988). It is uncertain if Springgay (Springgay & Rotas, 2014), a loyal member of a/r/tography, is still on board or jumped the Theseusian ship as she has now adopted the language of Brian Massumi and Erwin Manning

by calling her work 'research creation.' Or maybe she has become a double agent in this case?

26. These developments have been nicely analyzed by Mark Andrejevic (2013).

27. There are three: stating and creating problems, discovery of genuine differences in kind, apprehension of real time.

28. This comes later as he works through Nietzsche with an ethics of the eternal return.

29. The qualitative research specials where Deleuze and Guattari are being picked up are increasing. 'Thinking with Deleuze in Qualitative Research' appeared as a special in *The International Journal of Qualitative Studies in Education* (Mazzei and McCoy 2010). A renewed attempt was made in 2013 under the 'post' qualified as edited by Lather and St. Pierre from which Boulton-Funke draws some of her insights. We shall focus our attention on that special later in this chapter.

30. '[T]he interview must be thought as an assemblage as are the organism (BwO) and voice (VwO)' (p. 735).

31. Throughout his cinema books Deleuze calls on directors who play with the voice's materiality as pure sound that can confound the clichés of a body's expected utterances. In his analysis of Samuel Beckett's four plays for television, Deleuze (1995, p. 9) also proposes a *Langue III*, a language that is about visual or aural images that detaches itself from bodies. He also speaks of a 'strange language within language' that is capable of destratifying the stratas of the BwO. These 'atypical marks of expression' include 'Péguy's repetitions, Artaud's breaths, the agrammaticality of Cummings, Burroughs and his cut-ups and fold-ins, as well as Roussel's proliferations, Brisset's derivations, Data collage, and so on' (Deleuze 1988, p. 109). These example, taken from literature and poetry, shed light on the limitations and difficulties of 'interview methodology' as finding the deterritorialized voice that would re-do the BwO.

32. Dark precursor for Deleuze refers to the imperceptible virtual 'background' that is the quasi-cause of an actualized event. It is impossible to articulate which of the incorporeal elements of an assemblage as composed of the forces of a heterogeneous series of things can be identified as 'directly' the cause of an event. Hence, quasi-cause is used.

33. In an amazing exploration of the materiality of the voice, Tiainen (Tiainen, 2013) provides a succinct analysis how this takes us into posthuman direction linking the 'human' voice at the level of the figural with animal, natural, technological and machinc (sonic) milieus.

34. I refer to the question of 'gender' as anchored in postmodernism, posthumanism and (by extension) to some post-qualitative research that remains 'feminist' to the outstanding essay by Colebrook (2006).

35. I refer to the dozen essays on post-qualitative research that claim to appropriate Deleuze and Guattari as part of their research strategies into qualitative educational research as invited by Patti Lather and Elizabeth St. Pierre (2013). Lather's involvement in the past has been with post-structuralist feminism and a concentration on Derrida. Elizabeth St. Pierre, who has a linguist background, also comes from a feminist poststructuralist position. She has been involved in bringing Deleuze and Guattari into qualitative research discussion.

36. I am thinking, for example, of my friend Joe Norris who, along with Rick Sawyer (Sawyrer and Norris 2012), have developed what they call 'duoethnography,' which is slowly becoming recognized by the practitioners of qualitative research.

37. To reiterate, 'between' is not 'in-between' as theorized by a/r/tography's poststructuralism.

38. '[S]laughterhouse zooethnography materializes 'post-qualitative' differently, bringing qualitative research to an ontological and epistemological endpoint' (Petersen 2013, p. 728). From our viewpoint, what Petersen has done is counter-actualize the event of her joining the vet students in the slaughterhouse through this 'research.' Green (Greene 2013), who was given the task to review these essays, as a 'senior' qualitative researcher with some 50 years of experience, was not able to comment on Petersen essay because of its content. Petersen, through her descriptions of the way animals are slaughtered, provides the 'percepts' and 'affects' that are necessary to get at the nerves of those who are willing to 'read on.' Green's refusal on whatever 'grounds' simply confirms the ethics and politics that emerge when Deleuze|Guattari are taken seriously.

39. Greene (2013), an educational psychologist and qualitative researcher, was asked to respond to these essays. Among her complaints was the failure of the essays to develop what she sees as a 'public good,' and whose interests did they serve (hence the apolitical aspect); there was the complaint also of no 'systematicity,' which would provide a shared understanding of how some knowledge about the world is obtained; the charge that these essays were a retreat into the 'mind,' and were not really compelling for her is also telling; the wholesale rejection of representation bothered her; too much stress on the 'new' (hence creativity was insufficiently developed), and the responsibilities of the 'I' were insufficiently embraced (hence a failure of getting across Deleuze|Guattari's transcendental empiricism).

40. On the response that questions Butler's use of thinking 'queer' as a form of identity politics from a Deleuzian perspective, see Colebrook (2009). Colebrook also rethinks 'becoming woman' via Virginia Woolf (see Colebrook, 2013).

41. The controversies regarding 'becoming woman' have caused some tensions among Deleuzian feminists. Some, like Braidoitti, do not favor this move. A generous response to her position can be found in a recent collection of supporters (Blaagaard and Van de Tuin, 2014), but seriously questioned by anthropologists like Henrietta Moore (2014) in this collection. Karen Barad, it seems to me, uses similar concepts as Deleuze and Guattari, but given them other names so as to seemingly cut ties with any 'masulinization' of theory. Is her queering the sexes radical enough, as Deleuze and Guattari attempt to theorize n-1 sexes? (Berressem, 2005–2006). Other feminists, notably an earlier writing by Grosz (1993) with her thousand tiny sexes, and Colebrook (2013) still see merit in this concept of 'becoming woman.'

42. E4: PROP. 67 A free man thinks of death least of all things; and his wisdom is a mediation not of death but of life (Spinoza, 2000).

43. Negarestani's 'radical paranoia' is extreme as its end game seems to maintain that 'survival' seems superfluous. '[W]hen it comes to the exteriority of life to the living being, survival is intrinsically impossible' (Negarestani 2008, p. 210). The question, for me, is that nihilism remains unresolved. In a similar and difficult way, Patricia MacCormack (2014) in her own development of 'ahuman theory,' asks this same question regarding such suicide, and the cessation of

reproduction as responses to an ethics beyond the human. She quotes Spinoza as well, 'A free man thinks nothing less than of death, and wisdom is a mediation on life' (p. 181). There are many passages where the 'end of the human' is called on as a thought experiment as a way of achieving wisdom through a meditation on life. Not an easy or comfortable task. 'Ahuman theory consistently seeks the silencing of what is understood as human speech emergent through logic, power and signification.' [...] 'Abolitionist ahuman ethics are only truly possible if we are not here' (p. 183). MacCormack and Negarestani seem to be on the same page. Negarestani can write, 'if life is the source of living then why do we need to survive?' (Negarestani 2008, p. 210), and MacCormack equally so: 'Death in nature which opens other worlds is the simple presence of life living. The absence of the human is the most vital living yet to be accomplished: it is life lived as life' (p. 184). These difficult remarks suggest that only by giving up grasping our 'survival' as a yet another humanism in disguise as we continue to be the legislators and signifiers of things, can death be rethought in the way Spinoza projects living life as a 'free' person. MacCormack called on Serres's meditation on death (Serres 2002, pp. 111–114) as opening up these new creative spaces that have yet to be accessed. '[L]ife that is good is interested only in death, which, in exchange, shapes it' (Serres, p. 114).

44. '[F]rom the deserted island it is not creation but re-creation, not the beginning but a re-beginning that takes place. The deserted island is the origin, but a second origin. From it everything begins anew' (Deleuze 2004b, p. 13).

45. The notion of Deleuze's 'another' is developed by Dolphijn (2012). In his analysis of Tournier's Robinson in the novel *Friday*, Dolphijn points out that Robinson had to 'think' the deserted island he had landed on as 'another' island, which, in order to reveal itself, required that he give up capitalism and Christianity. In this way Robinson becomes 'the man without Others on his island' as an enigma of *openness*. Every artist in his/her research must wipe away the traces of the past to face a 'pure' emptiness that, in itself, presents us with the enigma of nihilism: why something rather than nothing? What then would be new conceptual personae for us today given such a challenge? Perhaps it is the *return* of the haunt of the demon(ic) as Thacker (2011) is developing it, or are we to

accept the transhumanist visions of the future where the body is to be abandoned via technology as long argued by Hans Moravec (1998)? Experiments like *Friday* present us with a utopianism that can be imagined within the 'now.'

REFERENCES

Alliez, É. (2010). Capitalism and schizophrenia and consensus: Of relational aesthetic (Tim Adams, Trans.). In S. Zepke & S. O'Sullivan (Eds.), *Deleuze and contemporary art* (pp. 85–99). Edinburgh: Edinburgh University Press.

Andrejevic, M. (2013). *Infoglut: How too much information is changing the way we think and know.* New York/London: Routledge.

Ansell Pearson, K. (1997). *Viroid life: Perspectives on Nietzsche and the transhuman condition.* London/New York: Routledge.

Ansell Pearson, K. (1999). *Germinal life: The difference and repetition of Deleuze.* London/New York: Routledge.

Barad, K. (2007). *Meeting the universe half-way.* Durham: Duke University Press.

Blaagaard, B., & Van de Tuin, I. (2014). *The subject of Rosi Braidotti: Politics and concepts.* London/New Delhi/New York/Sydney: Bloomsbury.

Beighton, C. (2015). *Deleuze and lifelong learning: Creativity, events and ethics.* New York/London: Palgrave Macmillan.

Benjamin, A. (1993). *The plural event. In Descartes, Hegel, Heidegger.* London: Routldge.

Berressem, H. (2005–2006). "n-1 sexes," *rhizomes* 11/12. Available at http://rhizomes.net/issue11/berressem/index.html

Bourriaud, N. (2002). *Relational aesthetics.* Dijon: Les Presses du Réel.

Boulton-Funke, A. (2014). A critique and a proposal: A/r/tography and arts-based research as methodology. *Visual Inquiry: Learning & Teaching Art, 3*(2), 207–221.

Braidotti, R. (2002). *Metamorphoses.* Oxford: Blackwell.

Braidotti, R. (2013). *The posthuman.* Cambridge: Polity Press.

Carlin, M., & Wallin, J. (Eds.). (2014). *Deleuze and Guattari, politics and education: For a people –yet-to-come.* London/Delhi/New York/Sydney: Bloomsbury.

Carter, M. R., & Irwin, R. L. (2014). Between signification and illumination: Unfolding understanding a/r/tographical turn on practicum. *International Journal of Education & the Arts, 15*(2), 1–19 . Available at http://www.ijea.org/articles.html#vol15.

Colebrook, C. (1999). *Ethics and Representation: From Kant to Post-structuralism.* Edinburgh: Edinburgh University Press.

Colebrook, C. (2004). Humour and irony – Deleuze and Guattari. In *Claire Colebrook, Irony* (pp. 140–152). London/New York: Routledge.

Colebrook, C. (2006). Postmodernism is a humanism: Deleuze and equivocity. *Women: A Cultural Review, 15*(3), 283–307.

Colebrook, C. (2008). On not becoming man: The materialist politics of unactualized potential. In S. Alaimo & S. Heckman (Eds.), *Material feminisms* (pp. 52–84). Bloomington: Indiana University Press.

Colebrook, C. (2009). On the very possibility of queer theory. In C. Nigianni & M. Storr (Eds.), *Deleuze and queer theory* (pp. 11–23). Edinburgh: Edinburgh University Press.

Colebrook, C. (2011). The earth felt the wound: The affective divide. *Journal for Politics, Gender and Culture, 8*(1), 45–58.

Colebrook, C. (2013). Modernism without women: The refusal of becoming-woman (and post-Feminism). *Deleuze Studies, 7*(4), 427–455.

Dejanovic, S. (2014). Deleuze's new Meno: On learning, time, and thought. *The Journal of Aesthetic Education, 48*(2), 36–63.

De Landa, M. (1997). *A thousand years of nonlinear history.* New York: Zone Books.

Deleuze, G. (1986). *Cinema 1: The movement-image* (H. Tomlinson & B. Habberjam, Trans.) Minneapolis: University of Minnesota Press.

Deleuze, G. (1989). *Cinema 2: The time-image* (H. Tomlinson and R. Galeta, Trans.). Minneapolis: University of Minnesota Press.

Deleuze, G. (1988). *Foucault* (Seán Hand, Trans.). London: The Athlone Press.

Deleuze, G. (1992). Postscript on societies of control. *October, 59* (Winter), 3–7.

Deleuze, G. (1994). *Difference and repetition* (Paul Patton, Trans.). New York: Columbia University Press (DR in text).

Deleuze, G. (1995). The exhausted (A. Uhlmann, Trans.). *SubStance, 24*(3, 78), 3–28.

Deleuze, G. (1998). Having an idea in cinema (On the cinema of Staub-Huillet) (Eleanor Kaufman, Trans.). In E. Kaufman and K. J. Heller (Eds.), *Deleuze and Guattari: New mappings in politics, philosophy, and culture* (pp. 14–22). Minneapolis/London: University of Minnesota Press.

Deleuze, G. (2004a). *Logic of sense* (M. Lester with C. Stivale, Trans.). London/New York: Continuum.

Deleuze, G. (2004b). *Desert islands and other texts, 1953–1974* (M. Taormina, Trans., Lapoujade, D., Ed.). Los Angeles/New York: Semiotext(e).

Deleuze, G., & Guattari, F. (1987). *Thousand plateaus: Capitalism and schizophrenia* (R. Hurley, M. Steem, & H.R. Lane, Trans.). Minneapolis: University of Minnesota Press (*TP* in text).

Deleuze, G., & Guattari, F. (2004). *Anti-oedipus: Capitalism and schizophrenia* (R. Hurley, M. Seem & H. R. Lane, Trans.). London: Continuum.

Dolar, M. (2006). *Voice and nothing more.* Cambridge, MA: MIT Press.

Dolphijn, R. (2012). Undercurrents and the desert(ed): Negarestani, Tournier and Deleuze map the polytics of a 'new earth.'. In L. Burns & B. M. Kaiser

(Eds.), *Postcolonial literatures and Deleuze: Colonial pasts, differential futures* (pp. 199–216). London/New York: Palgrave Macmillan.

Foster, H. (2003). Arty party. *London Review of Books, 25*(23) (December) n.p. Retrieved from http://www.lrb.co.uk/v25/n23/hal-foster/arty-party

Gallop, J. (1997). *Feminist accused of sexual harassment.* Durham/London: Duke University Press.

Geoffey, A., & Pettinger, L. (2014). Refrains and assemblages: Exploring market negotiations and green subjectivity with Guattari. *Subjectivity, 7,* 385–410.

Greene, J. C. (2013). On rhizomes, lines of flight, mangles, and other assemblages. *International Journal of Qualitative Studies in Education, 26*(6), 749–758.

Grosz, E. (1993). A thousand tiny sexes: Feminism and rhizomatics. *Topoi, 12,* 167–179.

Guattari, F. (1995a). The postmodern impasse. In G. Genosko (Ed.), *A Guattari reader* (pp. 109–113). Oxford: Blackwell.

Guattari, F. (1995b). Postmodernidm and ethical abdication. In G. Genosko (Ed.), *A Guattari reader* (pp. 114–117). Oxford: Blackwell.

Guattari, F. (2000). *Three ecologies* (I. Pindar & P. Sutton, Trans.). London/New Bruswick, Athlone Press.

Guattari, F. (2012). Schizophrenic cartographies (A. Goffey, Trans.). London: Bloomsbury Press.

Hetrick, J. (2014). Video assemblages: 'Machinic animism' and 'asignifying semiotics' in the work of Melitopoulos and Lazzarato. *Footprint: Deft Architect Theory Journal, 14*(Spring), 53–68.

Hickey-Moody, A. (2013). Affect as method: Feelings, aesthetics and affective pedagogy. In R. Coleman & J. Ringrose (Eds.), *Deleuze and research methodologies* (pp. 79–95). Edinburgh: Edinburgh University Press.

Hughes, J. (2008). *Deleuze and the genesis of representation.* London/New York: Continuum.

Hughes, C., & Lury, C. (2013). Re-turning feminist methodologies: From a social to an ecological epistemology. *Gender and Education, 25*(6), 786–799.

Irwin, R. (2007). Communities of a/r/trographic practice engaged in critical inquiry. In J. A. Park (Ed.), *Art education as critical inquiry* (pp. 76–89). Seoul: Mijinsa Press.

Irwin, R. (2008). Communities of a/r/trographic practice. In S. Springgay, R. Irwin, C. Leggo, & P. Gouzouasis (Eds.), *Being with a/r/t/geography* (pp. 71–80). Rotterdam: Sense.

Irwin, R. (2014). Turning to a/r/tography. *Journal of Art Education (KoSEA), 15*(1), 21–40.

Irwin, R. (2013). Becoming A/r/tography. *Studies in Art Education: A Journal of Issues and Research, 54*(3), 198–215.

Irwin, R., & O'Donoghue, D. (2012). Encountering pedagogy through relational art practices. *International Journal of Art and Design Education (IJADE)*, *31*(3), 221–236.

jagodzinski, j. (2005). *Musical fantasies: A Lacanian approach*. New York: Palgrave Press.

jagodzinski, j. (2013). Counter-actualization: The art of Wafaa Bilal. *Performative Paradigm*, *9*. Available at: http://www.performanceparadigm.net/category/journal/issue-9/

jagodzinski, j. (2014a). The 'relations' of relational aesthetics within altermodernity: Revisiting the case of Nicolas Bourriaud. *ETUM-E-Journal for Theatre and Media* *1*(1), 1–8. Available at: http://ejournal.theaterforschung.de/index.php?journal=ausgabe1

jagodzinski, j. (2014b). 1780 and 1985: An avant-garde without authority: Addressing the anthropocene. In I. Buchanan & L. Collins (Eds.), *Deleuze and schizoanalysis of visual art* (pp. 149–171). London/Delhi/New York/Sydney: Bloomsbury.

jagodzinski, j. (2014c). An avant-garde without authority: Towards a future oekumene—if there is a future? In H. Felder, F. Vighi, & S. Žižek (Eds.), *States of crisis and post-capitalist scenarios* (pp. 219–239). Burlington/London: Ashgate Press.

jagodzinski, j. (2016). A response to: 'Deconstructing Deleuze and Guattari's A Thousand Plateaus for music education.' *Journal of Aesthetic Education 50*(3): 101–121.

jagodzinski, j., & Wallin, J. (2013). *Arts-based research: A critique and a proposal*. Rotterdam/Boston/Taiepei: Sense Publishers.

Kolozova, K. (2014). *Cut of the real: Subjectivity in poststructuralist philosophy*. New York: Columbia University Press.

Lather, P., & St. Pierre, E. A. (Eds.). (2013). Special issue: Post-qualitative research. *International Journal of Qualitative Studies in Education*, *26*(6), 629–633.

Lather, P. (2013). Methodology-21: What do we do in the afterward? *International Journal of Qualitative Studies in Education*, *26*(6), 634–645.

Leggo, C. (2014). Riffing while riffling: 25 poetic ruminations. *Visual Inquiry: Learning & Teaching Art*, *3*(2), 93–107.

Leopold, A. (1941/1999). The round river – A parable. Round river. Undated manuscript. In C. Meine & R. Knight (Eds.), *The essential Ado Leopold: Quotations and commentaries*. Madison: Madison University of Wisconsin Press.

Leys, R. (2011). The turn to affect: A critique. *Critical Inquiry*, *37*(3 Spring), 434–472.

Maffesoli, M. (1996). *The time of the tribes: The decline of individualism in mass society*. London: Sage Publications.

MacCormack, P. (2014). After life. In P. MacCormack (Ed.), *The animal catalyst: Towards a human theory* (pp. 177–188). London/Delhi/New York/Sydney: Bloomsbury.

Mazzei, L. (2013). A voice without organs: Interviewing in posthumanist research. *International Journal of Qualitative Studies in Education, 26*(6), 732–740.

Mazzei, L. A., & K. McCoy (Eds.). (2010). Thinking with Deleuze in qualitative research. *International Journal of Qualitative Studies in Education, 23*(5), 543–556.

MacLure, M. (2013). Researching without representation? Language and materiality in post-qualitative methodology. *International Journal of Qualitative Studies in Education, 26*(6), 658–667.

Meillassoux, Q. (2008). *After finitude: An essay on the necessity of contingency* (R. Brassier, Trans.). New York: Continuum.

Moore, H. (2014). Living in molecular times. In B. Blaagaard & I. Van de Tuin (Eds.), *The subject of Rosi Braidotti: Politics and concepts* (pp. 47–55). London/ New Delhi/New York/Sydney: Bloomsbury.

Moravec, H. (1998). When will computer hardware match the human brain? *Journal of Evolution and Technology, 1* . Available at: http://www.transhumanist.com/volume1/moravec.htm.

Nancy, J.-L. (2000). *Being singular plural.* Stanford: Stanford University Press.

Negarestani, R. (2008). *Cyclonopedia: Complicity with anonymous materials.* Melbourne: Re.press.

Negarestrani, R. (2011). Drafting the inhuman: Conjectures on capitalism and organic necrocracy. In L. Bryant, N. Srinicek, & G. Harman (Eds.), *The speculative turn: Continental materialism and realism* (pp. 182–201). Melbourne: Re.press.

Parr, A. (2013). Politics + Deleuze + Guattari + Architecture. In H. Frichot & S. Loo (Eds.), *Deleuze and architecture* (pp. 197–214). Edinburgh: Edinburgh University Press.

Patton, P. (2000). *Deleuze and the political.* London: Routledge.

Pederson, H. (2013). Follow the Judas sheep: Materializing post-qualitative methodology in zooethnographic space. *International Journal of Qualitative Studies in Education, 26*(6), 717–731.

Podesva, K. L. (2007). A pedagogical turn: Brief notes on education as art. *Fillip, 6.* (Summer). Retrieved from http://fillip.ca/content/a-pedagogical-turn

Rogoff, I. (2008). Turning. *e-flux journal, 11* (November) Retrieved from http:// www.e-flux.com/journal/turning/.

Sawyrer, R. D., & Norris, J. (2012). *Duoethnography.* New York/Cary: Oxford University Press.

Sellars, J. (2006). An ethic of the event. *Angelika, 11*(3), 157–171.

Serres, M. (2002). *The natural contract* (E. MacArthur & W. Paulson, Trans.). Ann Arbor: The University of Michigan Press.

308 J. JAGODZINSKI

Sinner, A., Leggo, C., Irwin, R. L., Gouzouasis, P., & Grauer, K. (2006). Arts-based educational research dissertations: Reviewing the practices of new scholars. *Canadian Journal of Education, 29*(4), 1223–1270.

Spinoza B (2000 [1677]). *Ethics* (W. H. White, Trans.). Revised by A.H. Stirling. Intro D. Garrett. Ware: Wordsworth Editions.

Springgay, S., Irwin, R. L., Leggo, C., & Gouzouasis, P. (Eds.). (2008). *Being with a/r/tography*. Rotterdam: Sense Publishers.

Springgay, S., Irwin, R., & Wilson-Kind, S. (2005). A/r/tography as living inquiry through art and text. *Qualitative Inquiry, 11*(6), 897–912.

Springgay, S., & Rotas, N. (2014). How do you make a classroom operate like a work of art? Deleuzeguattarian methodologies of research-creation. *International Journal of Qualitative Studies in Education, 28*(5), 552–572. doi :10.1080/09518398.2014.933913.

St. Pierre, E. A. (2013). The posts continue: becoming. *International Journal of Qualitative Studies in Education, 26*(6), 646–657.

Stengers, I. (2008). Experimenting with refrains: Subjectivity and the challenge of escaping modern dualism. *Subjectivity, 22*, 38–59.

Taguchi, H. L. (2012). A diffractive and Deleuzian approach to analyzing Interview Data. *Feminist Theory, 13*(3), 265–281.

Tamboukou, M. (2008). Machinic assemblages: Women, art education and space. *Discourse: Studies in the Cultural Politics of Education, 29*(3), 359–337.

Thacker, E. (2011). *In the dust of this planet: Horrors of philosophy 1*. Winchester, UK and Washington, USA: Zero Books.

Tiainen, M. (2013). Revisiting the voice in media and medium. *European Journal of Media Studies, 2*(2), 383–406.

Wallin, J., et al. (2013a). Putrid Deadagogies: Zombie life and the rise of the cha-osmopolis. In J. Burdick, J. A. Sandin, & M. P. O'Malley (Eds.), *Problematizing Public Pedagogy* (pp. 40–51). London/New York: Routledge.

Wallin, J., et al. (2013b). One hundred trillion anomals take the stand. *Journal of Curriculum and Pedagogy, 10*(1), 11–13.

Wallin, J. (2014a). Toward a posthumanist education. *Journal of Curriculum Theorizing, 30*(2), 39–55.

Wallin, J. (2014b). Dark posthumanism, unthinking education, and ecology at the end of the anthropocene. In N. Snaza & J. A. Weaver (Eds.), *Posthumanism and Educational Research* (pp. 134–147). London/New York: Routledge.

Wallin, J. (2014c). Dark pedagogy. In P. MacCormack (Ed.), *The animal catalyst: Towards ahuman theory* (Chap. 9). London: Bloomsbury Publishing.

Ziarek, K. (2004). *The force of art*. Stanford: Stanford University Press.

Žižek, S. (1989). *The sublime object of ideology*. London: Verso.

Žižek, S. (2003). *Organ without bodies: Deleuze and consequences.* London/New York: Routledge.

Zourabichvili, F. (2012). *Giles Deleuze: A philosophy of the event* (Kieran, A. Trans., Lambert, G. & Smith, D. W., Ed.). Edinburgh: Edinburgh University Press.

INDEX

© The Author(s) 2017

j. jagodzinski (ed.), *What Is Art Education?*,

DOI 10.1057/978-1-137-48127-6

liberal, forms of associated living, 171
liberty, 166, 167, 171, 194, 228
life, 3, 4, 8, 10, 11, 18, 21, 24, 25,
 28–30, 41n8, 42n12, 43n28,
 45n37, 47n50, 52n78, 66, 74,
 75, 77–9, 100, 105–7, 116, 118,
 122, 123, 149, 163, 164, 166,
 168, 171–5, 178, 180, 181, 184,
 185, 188–91, 204, 206, 209,
 213, 214, 230, 233n17, 241,
 243–50, 255, 259, 262n2,
 263n8, 270, 281, 282, 287–9,
 301n42, 301–2n43
life and death, 3, 75, 289
line of flight, 8, 40, 260, 288, 291
linguaggio. See Gramsci A.
linguistic turn, 268
lived organicity, 248–50, 255, 256. *See
 also* vitalism
logic, 2, 7, 37, 45n37, 50n72, 66,
 75, 91, 103, 107, 108, 131, 172,
 173, 175, 178, 188, 191,
 197–202, 207, 216, 218, 219,
 221, 222, 227, 228, 233n14,
 242, 276, 284, 286, 292,
 302n43
logic of emergence, art's, 198–201
logic of the case, 207, 233n14
logic of the possible, 207, 228
Lukács, G., 206
Lux and Lumen, 36, 298n23
Lyotard, J-F., 203–5

M
MacCormack, P., 301–2n43
Machado, Antonio, 178
machine, 9, 32, 33, 37–9, 70, 71, 75,
 79, 79n3, 124, 168, 170, 278,
 293, 294
machine orientated ontology (MOO),
 32–4

machinic, 17, 21, 38, 39, 46n46, 65,
 70, 71, 75, 76, 79, 281, 291
machinic assemblage, 70, 75
Mahfouz, N., 172, 173, 197
Malik, S., 30, 31, 36, 49n59, 49n60
Marcuse, H., 191, 193, 194, 226
marketers, 16, 23, 285
Massumi, B., 8, 12–14, 43n26,
 45n42, 48n58, 80n8, 129, 138,
 155–8, 268, 298n21, 299n25
material immanence, 8, 122, 269
Maturana, H. R., 11, 21, 75
Mazzei, L., 282–4
MacLure, M., 286
Meillassoux, Q., 255, 288, 289
 correlationism, 285, 288
Melville, 65
memory, 34, 48n58, 76–9, 95, 102,
 114, 127, 134, 135, 172–4, 176,
 180–2, 184, 185, 187, 188, 197,
 220, 280, 281, 298n25
meta-language, 219–21
method, 1, 6, 9, 46n46, 114, 132,
 166, 167, 185, 187, 188, 198,
 205, 211, 212, 215, 220, 229,
 231, 260, 269, 274, 280, 281,
 285, 290, 293
Michelangelo, *The Last Judgment*, 70
microconscious, 13–23
misanthropic subtraction, 251. *See also*
 anthropocene
mixing, 80n8, 204, 208–10, 212, 216,
 217, 223, 230, 276
mix-up, 208
Moby Dick, 65, 66
modalities of difference, 75
momento culturale. See cultural
 moment; Gramsci, A.
monad, 99, 100, 177
monument, 5, 10, 20, 49n62, 102
monumental, 5, 22, 101–3
Morante, E., 213

Printed in the United States
By Bookmasters